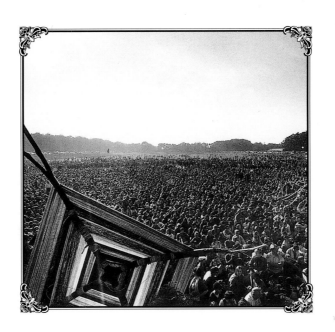

I Want to Take You

HIGH

The Psychedelic Era 1965-1969

The Rock and Roll
Hall of Fame and Museum

Edited by
James Henke
with
Parke Puterbaugh

Essays by
Charles Perry
and
Barry Miles

CHRONICLE BOOKS
SAN FRANCISCO

In Association with
Sarah Lazin Books
and
Alexander Isley, Inc.

Library of Congress
Cataloging-in-Publication Data available.

ISBN 0-8118-1700-8 (Pbk)
ISBN 0-8118-1725-3 (Hc)

Printed in Hong Kong.

Distributed in Canada by Raincoast Books
8680 Cambie Street
Vancouver, B.C. V6P 6M9

24681097531

Chronicle Books
85 Second Street
San Francisco, CA 94105
Web site: www.chronbooks.com

Rock and Roll Hall of Fame and Museum
Web site: www.rockhall.com

Editor: James Henke
Associate Editor: Parke Puterbaugh
Assistant Editor: Erin Hogan
Photo Editor: Julie Claire Derscheid
Assistants: Tanala Osa-Yande, Sharon Koller

Cover lettering by Pentagram
Cover and book design by Alexander Isley, Inc.

Produced by Sarah Lazin Books

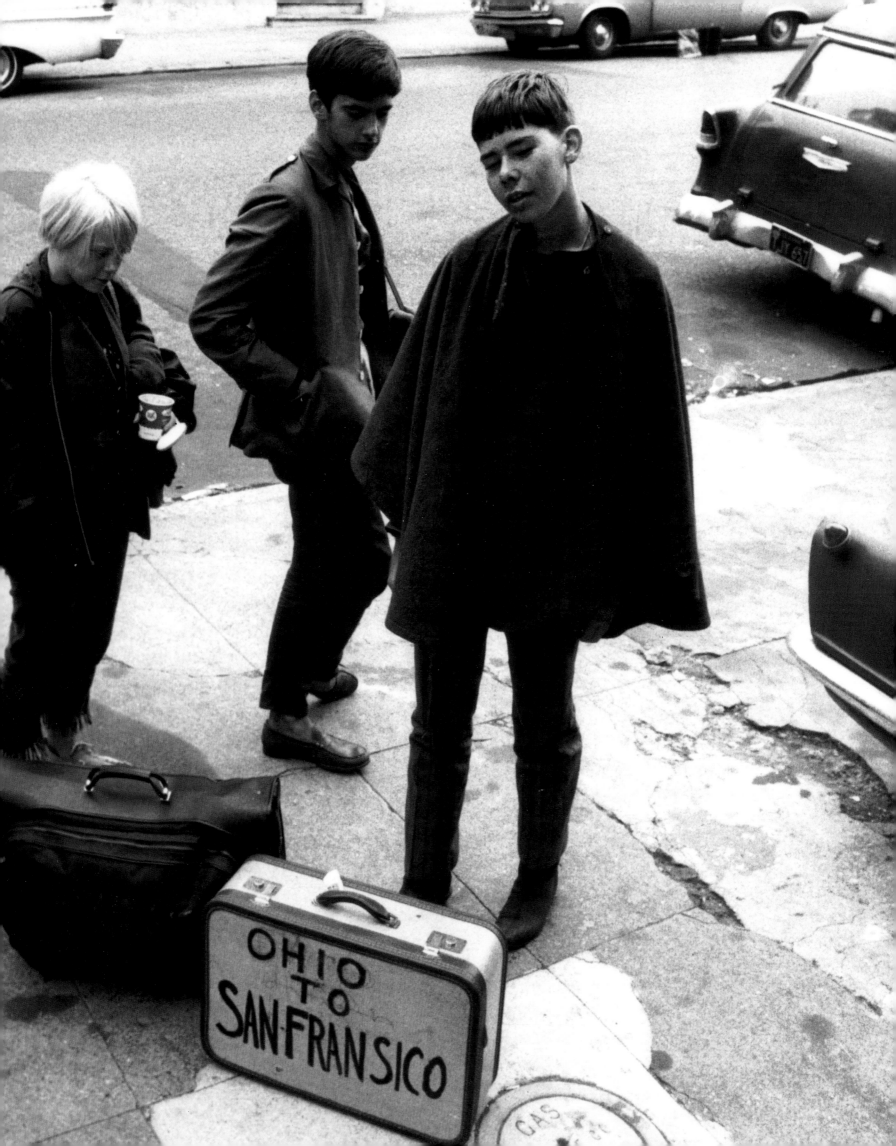

INTRODUCTION *by James Henke*10

SAN FRANCISCO *by Charles Perry*

The Red Dog Saloon12
16
Junior-Grade Hipsters22
26
A Tribute to Dr. Strange32
38
Kesey's Acid Tests42
48
The San Francisco Sound54
58
Psychedelic Chaos62
72
The Flowering of the Haight78
84
The Ballrooms ...90
102
The Be-In ...118
130
The Media ...138
144
Monterey Pop ..150
156
The Haight Explodes162
176
By the Time We Got to Woodstock180

THE PSYCHEDELIC 100 *by Jon Savage*190

Acknowledgments201

Contributors ...202

Credits ..204

Index ..205

LONDON *by Barry Miles*

.........Wholly Communion

.........The Underground Salons

.........The Real Summer of Love

.........Spontaneous Underground

.........The Pink Floyd Sound

.........International Times

.........UFO Is Born

.........The Technicolour Dream

.........Sgt. Pepper

.........Busted

.........British Psychedelia

.........Things Turn Political

THE SUMMER OF 1967 will forever be known as the Summer of Love. It was a landmark year, not just in the history of rock & roll, but in the history of our culture.

Nowadays, when artists take years to complete a single album, it is hard to imagine the kind of creative explosion that occurred back then. In that one year, the Beatles released *Sgt. Pepper's Lonely Hearts Club Band, Magical Mystery Tour* and a two-sided hit single, "Strawberry Fields Forever"/"Penny Lane." Cream, formed in late 1966, put out their first album, *Fresh Cream*, in January and released *Disraeli Gears* in December. The Rolling Stones issued *Between the Buttons, Flowers* and *Their Satanic Majesties Request*. Jefferson Airplane put out *Surrealistic Pillow* and *After Bathing at Baxter's*. The Jimi Hendrix Experience, Pink Floyd, the Grateful Dead, the Doors, Big Brother and the Holding Company, Country Joe and the Fish, Buffalo Springfield, the Velvet Underground and Moby Grape all released their debut albums in 1967.

Nineteen sixty-seven was also the year of the first Human Be-In, which was held in San Francisco's Golden Gate Park in January. In April, an all-night concert called the 14-Hour Technicolour Dream took place at Alexandra Palace in London. Three months later, the International Love-In, another all-night event, was held at Alexandra Palace, while out in California, in June, the Monterey International Pop Festival brought together an unprecedented group of American and British rock artists, including Big Brother and the Holding Company (with Janis Joplin), the Who, Jimi Hendrix, Simon and Garfunkel, the Mamas and the Papas, Otis Redding, Buffalo Springfield, the Grateful Dead, the Byrds, Paul Butterfield and Ravi Shankar.

In 1967, the first issue of *Rolling Stone* magazine was published in San Francisco on November 9, and a Top Forty radio veteran named Tom Donahue helped father "underground" radio, also in San Francisco. Meanwhile, in England, "pirate" radio— literally broadcast from ships at sea—was making waves. In June of 1967, Paul McCartney admitted taking LSD, and Mick Jagger and Keith Richards spent the night in jail after being busted for drugs. By the end of the year, more than 460,000 U.S. troops were waging an unpopular war in Southeast Asia; over 13,000 had already been killed in battle.

The list could go on and on, and by any standard, 1967 was a remarkable year. But the events of that year did not occur in a vacuum. Nineteen sixty-seven just happened to be the year that the media realized that something strange was going on. People were openly using drugs like marijuana and LSD—and talking about it in the press. People were living in communes and traveling in weirdly painted buses.

The pill had radically altered sexual mores. People were getting their news and information from alternative sources: the underground press and underground radio. Rock & roll concerts were being advertised by intricately drawn, brightly painted posters, and onstage, the performers were being illuminated by bizarre light shows. Rock & roll had entered the psychedelic era, and suddenly, the music that only a few years earlier had been dismissed as a teenage fad was shaping our culture.

To celebrate the thirtieth anniversary of the Summer of Love, the Rock and Roll Hall of Fame and Museum, which opened in Cleveland in 1995, has undertaken its first major in-depth temporary exhibition, called *I Want to Take You Higher: The Psychedelic Era 1965-1969*. Both the exhibit and this book examine this period of massive social, cultural and political change. The first rumblings of what we now call psychedelia were heard as early as 1965—when the Beatles released *Rubber Soul*, when Ken Kesey began holding Acid Tests near San Francisco, when a Beat-poetry reading at the Royal Albert Hall caused a like-minded group of people to coalesce in London, when a San Francisco group called the Charlatans took over as the house band at the Red Dog Saloon in Virginia City, Nevada.

By 1966, psychedelia was in full bloom, particularly in San Francisco and London, the two cities that both this book and the Hall of Fame's exhibition focus on. But in fact, so pervasive was its impact that, by the late Sixties, psychedelia was omnipresent. Dancehalls, patterned after San Franciso's Fillmore Auditorium and Avalon Ballroom, had sprung up all over the United States. Virtually every major city had an under-

Rock & roll, which only a few years earlier had been dismissed as a fad, was now shaping our culture

ground newspaper and an underground radio station. Psychedelia's influence could be seen in fashion, art and literature. And Woodstock, held in 1969, demonstrated to the world—and to Madison Avenue—that this movement was not limited to a handful of weirdos.

To tell this story, we have relied on firsthand accounts from two writers, Charles Perry and Barry Miles, who were actively involved in the events of the era. We have also gone back to many of the key figures—the musicians, the poster artists, the activists—to get their recollections of the period. Donovan, Grace Slick, Country Joe McDonald, Mickey Hart, Bob Weir, Jorma Kaukonen, John "Hoppy" Hopkins, Kevin Ayers, Peter Jenner, Joe Boyd, Victor Moscoso, Nigel Waymouth and others reflect on the era, offering behind-the-scenes stories and anecdotes.

In many quarters, it is now common to blame all of the social ills of the Nineties on the events described in this book. And indeed, the world had not become a perfect place. Drugs, for example, fueled many of the artistic and cultural developments of the period, but they also took their toll. Some of the period's brightest lights, such as Jimi Hendrix, Janis Joplin, Jim Morrison and Jerry Garcia, died premature deaths, at least in part because of their abuse of drugs. Yet this period, unlike the Nineties, was a time of hope, a time of optimism. It was a period when people valued personal freedom and social equality. It was a time when anything seemed possible. People thought they could change the world—and they did.

JAMES HENKE *November 1996*

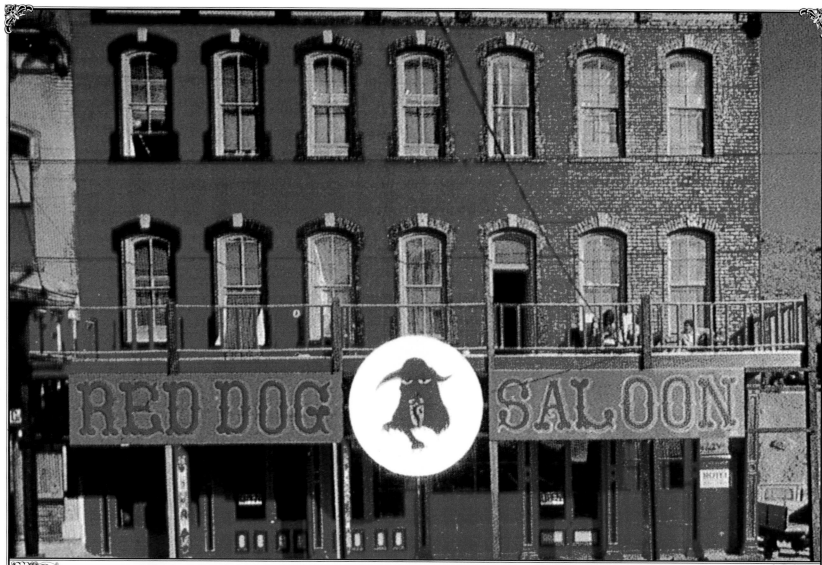

For weeks, strange young people had been running around sleepy Virginia City, Nevada

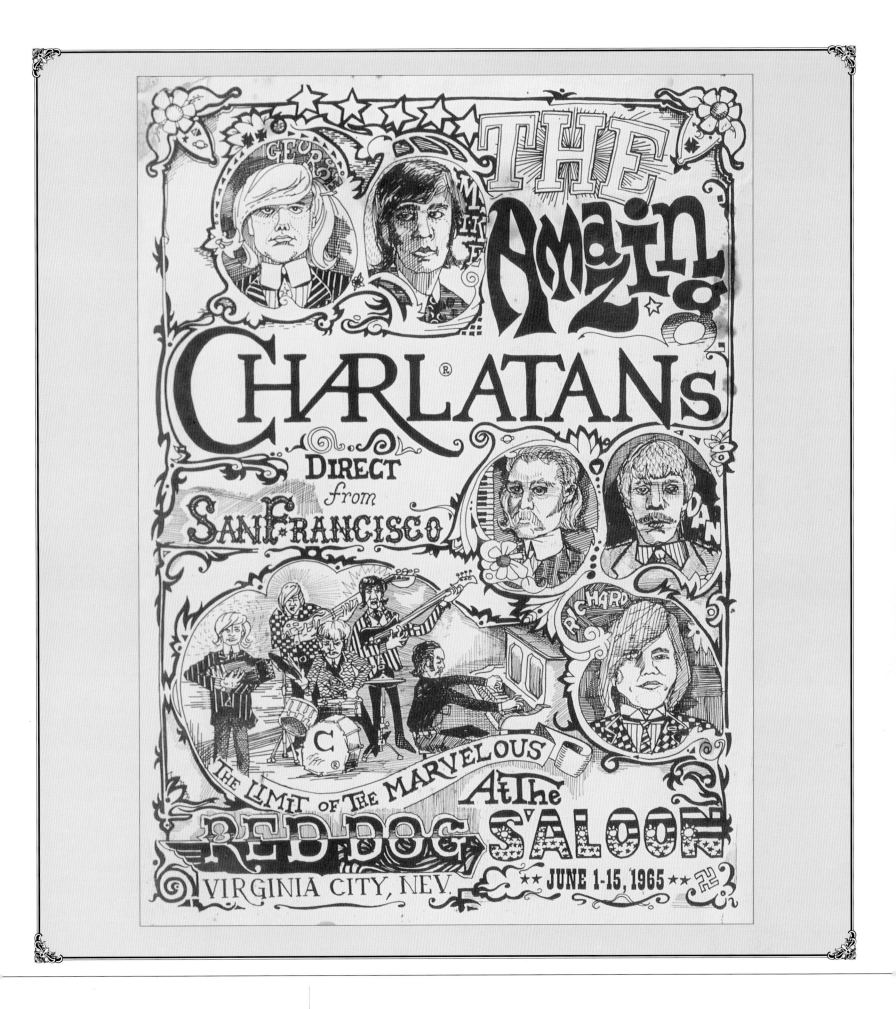

Beatles George Harrison and John Lennon are unwittingly dosed with LSD by their dentist, who slips it into their coffee at a dinner party.

For weeks, strange young people had been running around sleepy Virginia City, Nevada, furiously remodeling the hundred-year-old Comstock House hotel. They had put in crystal chandeliers, an antique mirror-backed bar, thousands of dollars' worth of red-and-turquoise velvet drapes. They came up wearing city clothes but after a while began dressing as if they seriously believed they were living in the Old West.

The locals wondered what was going on, particularly when that new sign went up out front. The one of a slavering red dog.

When the Red Dog Saloon finally opened to the public, on June 29, 1965, the sheriff came by to have a look. What he saw was enough to warm a man's heart. A lot of locals took the town's heritage lightly, but these mysterious young people were into it. The waitresses wore saloon-maid bodices and net stockings, and the bartender had on a striped shirt with sleeve garters. Quite a few customers were even in period costume.

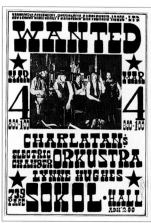

Maybe the entertainment, a rock band in cowboy clothes that had trouble telling one end of their instruments from the other, wasn't authentically Old West, and in the old days there probably hadn't been a Washo Indian bouncer in a Rainbow Girls sash or a box of flashing lights on the stage, but altogether the sheriff was moved to join the frontier fantasy. He walked up to the bartender and offered to leave his gun at the bar in accordance with the code of the West.

"Check my gun?" asked the sheriff.

"Sure," said the bartender.

He squinted down the barrel, fired off two shots into the floor and handed it back. "Works fine, sheriff," he said.

The Red Dog Saloon (preceding pages, left), a refurbished Wild West bar that featured the Charlatans as its house band, is where a budding community of psychedelic cowboys came together in the summer of 1965.

Group members Michael Ferguson and George Hunter designed a poster (preceding page) for their debut at the Red Dog. Known as "The Seed," it is an important early example of rock poster art.

Another early music poster (left), by San Francisco artist Alton Kelley, announces a March 4, 1966, triple bill headlined by the Charlatans.

George Hunter and Mike Wilhelm of the Charlatans and Jerry Garcia of the Grateful Dead (opposite, from left) share a laugh. Of the Charlatans' antiquarian look, Hunter says, "It was relatively easy to go out and find a lot of clothing from the turn of the century in thrift shops and antique stores. It was a fairly conscious effort we were making."

The Charlatans were conceived in San Francisco, but we were the big fish in a small pond at Virginia City. There's a documentary about the Red Dog that certainly makes the case for that whole San Francisco thing having germinated up there. I have to admit I never really thought of it like that. But that's because I was in the middle of it. Seeing the movie and hearing all these people rattle on about it makes that scene in Virginia City seem all that much more significant. I think the same stuff would've happened anyway. But you never know what direction it might have taken. It certainly did appear that we were playing a more significant role up to that point than I had thought in terms of giving direction to the whole thing.

With our look, we placed ourselves at the beginning of the Twentieth Century. We thought about it, and the idea was that if you are experimenting in the time frame of the 1910s, you've got everything from horses to airplanes to deal with. If you're making a movie or whatever, you would have all those elements to work with.

The other part of it was not wanting to be associated with the British Invasion. Everybody and their brother was doing that. It was that peculiar point in time when there were these groups like the Knickerbockers. Even the Byrds, when they started, were affecting that English look, and the Monkees as well. Nobody seemed to have their own identity. Everyone was sort of mimicking the Beatles and the Stones, really, at that point. So we were looking for some strong American identity. That's what we were about. ✳

FEBRUARY '65

1 1 *The first sustained bombing raids against the North Vietnamese by U.S. forces are ordered by President Johnson.*

2 1 *Malcolm X is gunned down by assassins in New York City at a Harlem rally.*

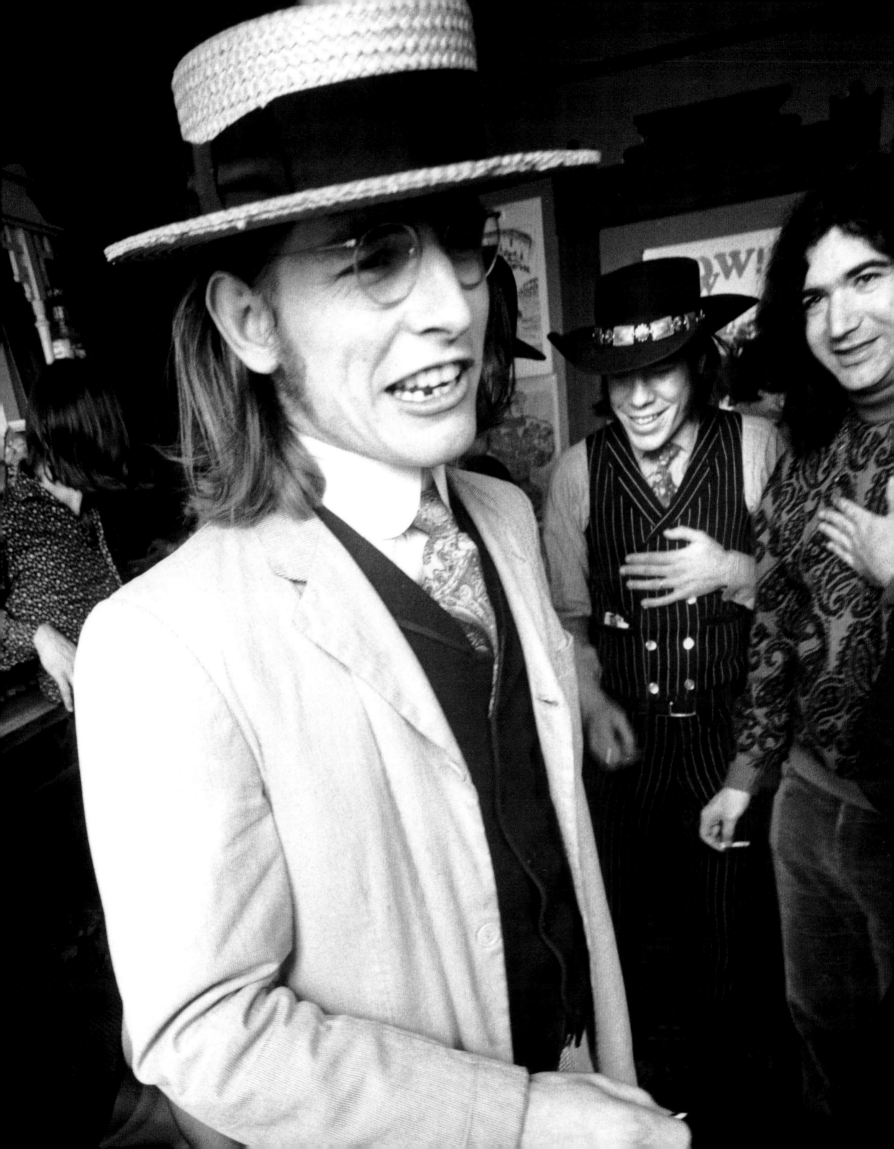

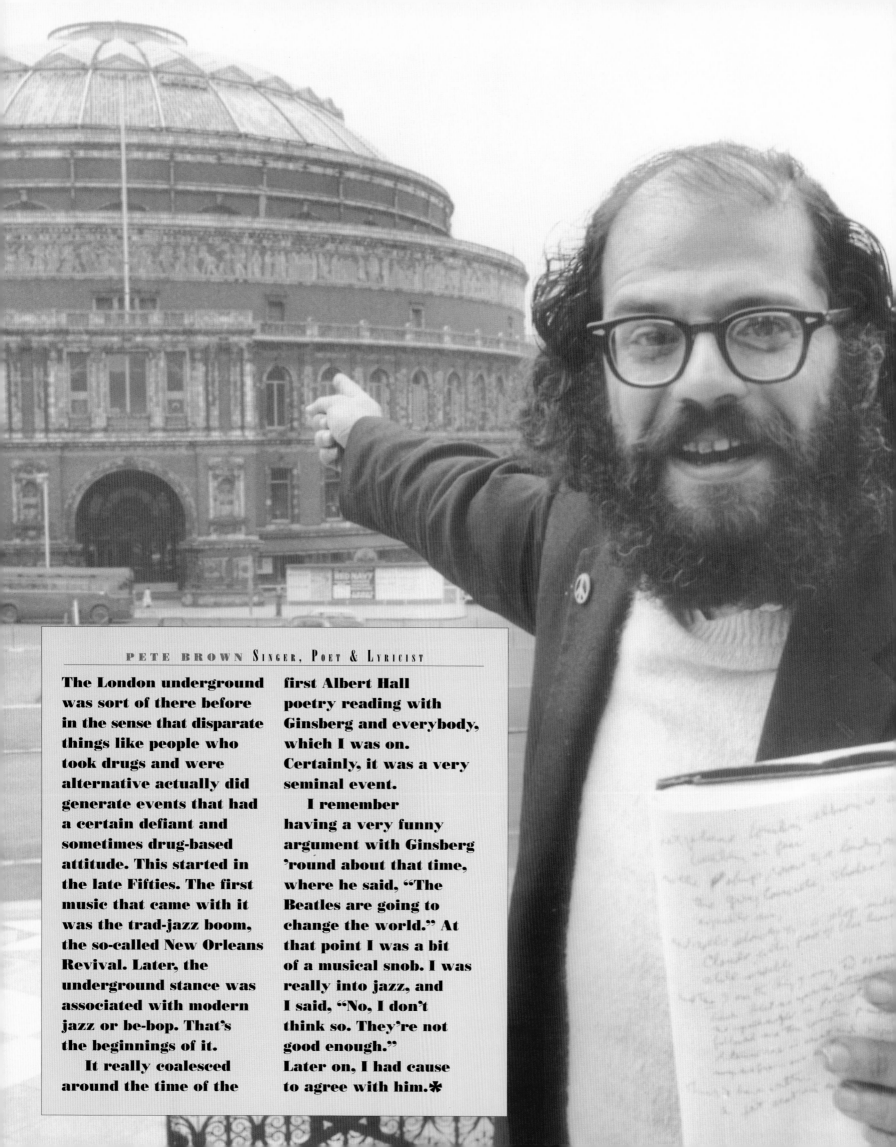

PETE BROWN Singer, Poet & Lyricist

The London underground was sort of there before in the sense that disparate things like people who took drugs and were alternative actually did generate events that had a certain defiant and sometimes drug-based attitude. This started in the late Fifties. The first music that came with it was the trad-jazz boom, the so-called New Orleans Revival. Later, the underground stance was associated with modern jazz or be-bop. That's the beginnings of it.

It really coalesced around the time of the first Albert Hall poetry reading with Ginsberg and everybody, which I was on. Certainly, it was a very seminal event.

I remember having a very funny argument with Ginsberg 'round about that time, where he said, "The Beatles are going to change the world." At that point I was a bit of a musical snob. I was really into jazz, and I said, "No, I don't think so. They're not good enough." Later on, I had cause to agree with him.✳

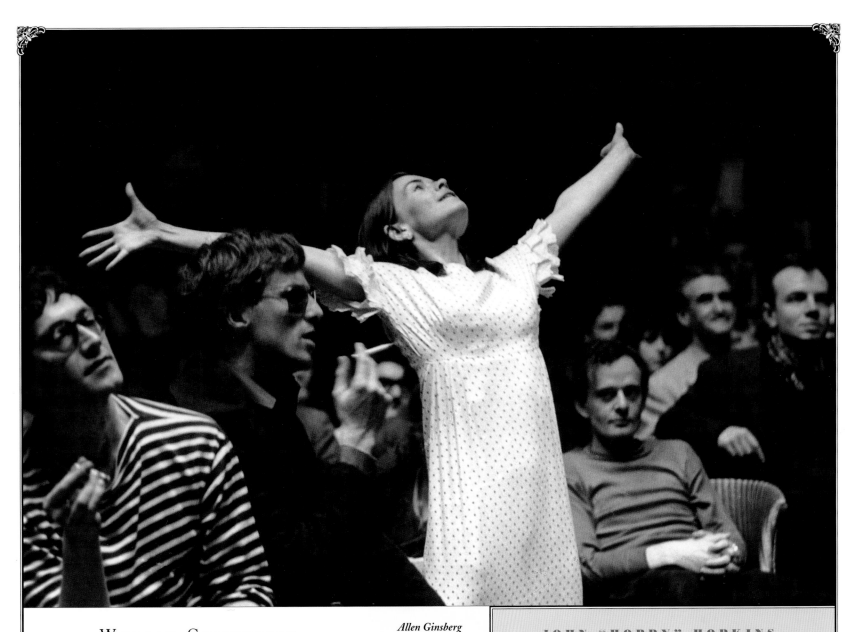

WHOLLY COMMUNION

⚊⚊ 🇬🇧 ⚊⚊

By general consensus, the era of British psychedelia began with the "Poets of the World/Poets of Our Time" reading at the Royal Albert Hall. Held on Friday, June 11, 1965, the event was preserved as *Wholly Communion*, which was the title given the film and book documentaries that followed. At the time I was running the paperback department of Better Books, a Soho shop in central London specializing in avant-garde and Beat Generation literature. We had had a reading

Allen Ginsberg points the way toward the Royal Albert Hall (opposite), site of the 1965 "Poets of the World/Poets of Our Time" event, a spirited poetry reading and free-form happening (above) that served to galvanize the London underground. Pictured are Michael Horowitz and John Esam, from left, with an ecstatic audience member, and Russian poet Andrei Voznesensky, at right.

The Albert Hall poetry reading was a pivotal point. It was sort of like a paradigm shift. Something happened at that point. It was significant, for sure. Everybody was surprised at the turnout except the people who thought it could be done. It's sort of like when you haven't had a fuck for a long time, you build up a charge. Well, I think a charge had built up in England, and that sort of helped it to go off.✳

MARCH '65

8 President Johnson sends the first combat troops to Vietnam.

18 A Soviet cosmonaut becomes the first person to walk in space when he leaves the Voskhod II space capsule.

The Albert Hall is a vast circular building seating 8,000. As the audience arrived, they were handed flowers by prototypical flower children who wore long flowing dresses and had their faces painted with paisley patterns. Bottles of wine were passed around, and incense and pot smoke wafted into the dome. A dozen bemused schizophrenics brought along by psychiatrist R.D. Laing blew bubbles and danced to music heard only in their own heads. The featured poets were Ginsberg, Ferlinghetti and Corso. Voznesensky sat in the audience but did not read. Indira Gandhi, the future prime minister of India, attended as Ginsberg's guest.

At one point Dutch poet Simon Vinkenoog, high on acid, snatched the microphone and ran round the hall screaming, "Love, love, love. . . ." The party atmosphere had little to do with the poetry. It was as if 7,000 people had suddenly recognized each other for what they were: a new community of spirit that would soon enough become a full-fledged underground scene in London.

In September 1965, a smiling young Englishman named Michael Hollingshead arrived in London from Timothy Leary's headquarters in Millbrook, New York. He brought with him boxes of literature — copies of *The Psychedelic Experience* and *The Psychedelic Reader* — and half a gram of LSD, enough for 5,000 doses. Hollingshead first turned Leary on to the drug in 1961 and lived at Millbrook for several years, guiding visitors on acid trips. Leary instructed him to set up a center in London for spreading the gospel of acid.

In 1965, the drug was not yet illegal. Hollingshead's plan was to introduce as many influential people to LSD as possible as quickly as possible. Toward that end, he opened the World

room with a small stage, and when Allen Ginsberg visited the shop in June 1965, I had asked him to read. Though it wasn't advertised, the reading drew a standing-room-only crowd that included Andy Warhol and Donovan. A recording was released as *Allen Ginsberg at Better Books.*

After the reading, Ginsberg had mentioned that Lawrence Ferlinghetti was in Paris, Gregory Corso was in Rome, and Russian poet Andrei Voznesensky was arriving from Moscow. Ginsberg proposed a group reading. As Better Books only held about fifty people, several larger venues were suggested. A New York friend of Ginsberg's asked, "What's the biggest place in town?" The answer was Albert Hall, and an evening two weeks hence was booked.

The original plan was for internationally known poets alone to read. British poets demanded to be on the bill, however, and soon an ad hoc committee took over the organization of the event. The list of poets grew to eighteen, many of whom had never before read anywhere larger than the upstairs room of a pub.

"Raise your hands if you've dropped acid!" Members of Dr. Timothy Leary's commune in Millbrook, New York, engage in an Eastern dance (above). Participants included Leary (at left) and Billy Hitchcock (in center), owner of the Millbrook estate (opposite).

2 1 Led by Dr. Martin Luther King Jr., thousands of civil rights demonstrators march from Selma to Montgomery, Alabama, in support of black voting rights.

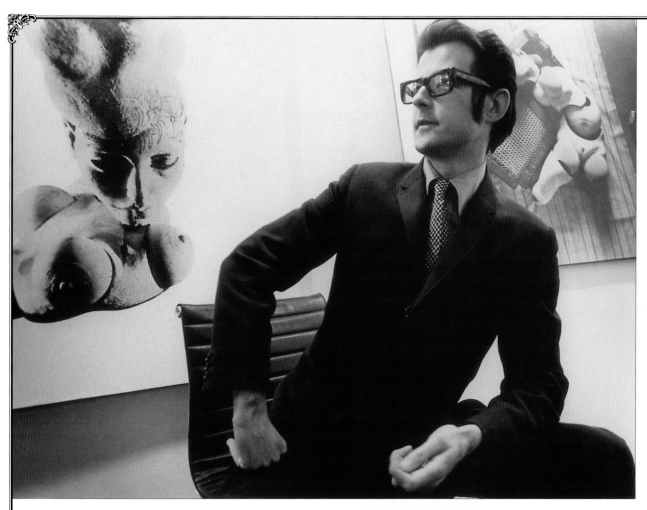

As he put it in his autobiography, *The Man Who Turned On the World*, "There was a problem, a self-indulgence of mine, which earned me some social suspicion, if not also social ostracism." He shot speed seven times a day, smoked pot and hash continuously and dropped doses of acid larger than 500 micrograms three times a week. He would drift into a zombielike state and then have to inject himself with dimethyl-tryptamine (DMT) to jolt himself back to life.

People began avoiding the center, expecting that it would be raided at any moment. One of Britain's tabloid papers, *The People*, exposed Hollingshead in an article headlined *The Men Behind LSD—The Drug That Is Menacing Young Lives*. The police arrived in January 1966, and Hollingshead was busted. He received twenty-one months in prison for possession of less than an ounce of hashish and a negligible amount of marijuana.

Psychedelic Center (WPC) in an expensive flat on Pont Street. During its brief life, the WPC attracted a huge number of visitors. The aristocratic Chelsea set was well represented by art expert Christopher Gibbs and art dealer Robert Fraser, as well as by the children of Britain's ambassador to the United States.

Other visitors included surrealist artist Sir Roland Penrose; psychiatrist R.D. Laing; filmmaker Roman Polanski and his girlfriend Sharon Tate; novelist William S. Burroughs; poet Alexander Trocchi; and millionaire Victor Lownes, who founded the London Playboy Club with Hugh Hefner. Workshops in "consciousness expansion" were held at several locations. Visiting musicians included Donovan, Eric Clapton, Peter Asher and Paul McCartney, who was the only Beatle that attended.

The center quickly fell into squalor as Hollingshead became progressively unbalanced.

Dr. Timothy Leary (opposite), high priest of altered consciousness and founder of the League for Spiritual Discovery (LSD), stands beneath the Village Theater marquee in New York City. He presented his "Celebration #2" there in October 1966.

Art dealer Robert Fraser (above) owned a fashionably hip gallery in London, and his home salon was frequented by old-money aristocrats and pop stars alike, including Keith Richards and Paul McCartney.

The center had been open for less than three months, but in that time Hollingshead had fulfilled his mission, introducing hundreds of people to acid. His role as acid acolyte in London was quickly taken up by John Esam, a poet from New Zealand. Esam had intense, piercing eyes and wore his straight black hair like a skullcap. Nicknamed "the Spider," he approached his mission with an evangelical zeal and dispensed thousands of trips. Esam was a lodger at 101 Cromwell Rd. in West Kensington, where he slept in a windowless shack that he had built in the corridor, as there were no spare rooms.

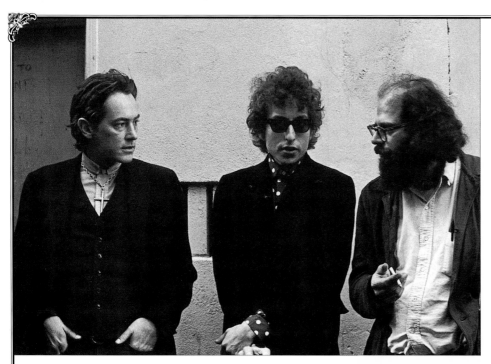

JUNIOR-GRADE HIPSTERS

Hippies, they called us. Junior-grade hipsters. Baby beatniks. But we weren't just young; we represented something *new*. We didn't wear black existential clothes like the Beats; we were into color, costume, flamboyance. Dapper mustaches on the men, rather than grumbling beards, and bright mini-skirts and patterned stockings on the women. Our music was the rock & roll of the Beatles and the Rolling Stones, to the horror of the jazz-loving Beats and the puritanical left-wing folk musicians.

We were into drugs, but not heroin and alcohol. We smoked marijuana and sold some for pocket change, and we took LSD for — but how could we say why we took LSD? Dropping acid was not a rational thing to do. You never knew what you'd experience — mystical bliss or cosmic nightmare. The biggest problem with LSD was the fact that it spoke revelations of the utmost urgency and profundity, but if you tried putting them into words, nothing came out but wretched banalities like "All is one" or "All is love" or "All is consciousness energy."

Poets and hipsters Michael McClure, Bob Dylan and Allen Ginsberg (above) in San Francisco. This 1965 portrait was originally intended for the inside jacket of Dylan's **Blonde on Blonde** *album but not used.*

Beat Generation poets and artists pose as a group outside City Lights Bookstore (opposite). Top row: Stella Levy, Lawrence Ferlinghetti. Center row: David Meltzer, Michael McClure, Allen Ginsberg, Daniel Langton, "Steve" (a friend of Ginsberg's), Richard Brautigan, Gary Goodrow. Bottom row: Robert LaVigne, Shig Murao, Larry Fagin, Leland Meyezove (foreground), Lew Welch, Peter Orlovsky.

Better not to profane the message by speaking of it directly. Better to advert to the secret revelations, if at all, in ambiguous puns like "the one I love" (which secretly meant the One-Eye Love, the cosmic consciousness that sees through all our eyes) and to honor the glory of the trip by living lives of color, adventure and playfulness. If only more people could know what LSD was like, we were sure there would be no war and the world would become a utopia.

Some people took steps to spread the gospel. A college roommate of mine named Augustus Owsley Stanley III had recently bought enough raw lysergic acid to make a million and a half doses of LSD, and one of his original batches of acid was up there in Virginia City on opening night.

But how many acidheads were there? There was no way to tell how big this secretive psychedelic scene was in 1965. Still, there was the fact that a couple of hundred people drove up from California to check out the Red Dog Saloon over the next few weeks.

We also started hearing about LSD parties thrown by novelist Ken Kesey at his home on the peninsula, near the campus of Stanford University. He'd gotten busted for marijuana in April 1965, but instead of laying low, he asked a journalist named Hunter Thompson to introduce him to the Hell's Angels, the most feared motorcycle gang in California. In August, Kesey boldly threw a party for them at his home. Astonishingly, the burly bikers hit it off with Kesey's hippie friends, and they started coming to his weekly parties up in the hills.

After you walked over a little footbridge to Kesey's property, you were in a kind of forest play-room full of people reeling around on acid. There were bizarre things to look at, such as grotesque assemblies glued together from doll parts. Out among the woods were giant metal sculptures you could crawl into and a growing armory of electronic gadgets, including microphones and amplifiers for anybody who wanted to say or play something weird while being stoned.

11 *The "Poets of the World/Poets of Our Time" poetry reading is held at London's Royal Albert Hall. The event, which features readings by such renowned poets as Allen Ginsberg, Lawrence Ferlinghetti, Alexander Trocchi and Christopher Logue, is the first stirring in what will become known as the London underground.*

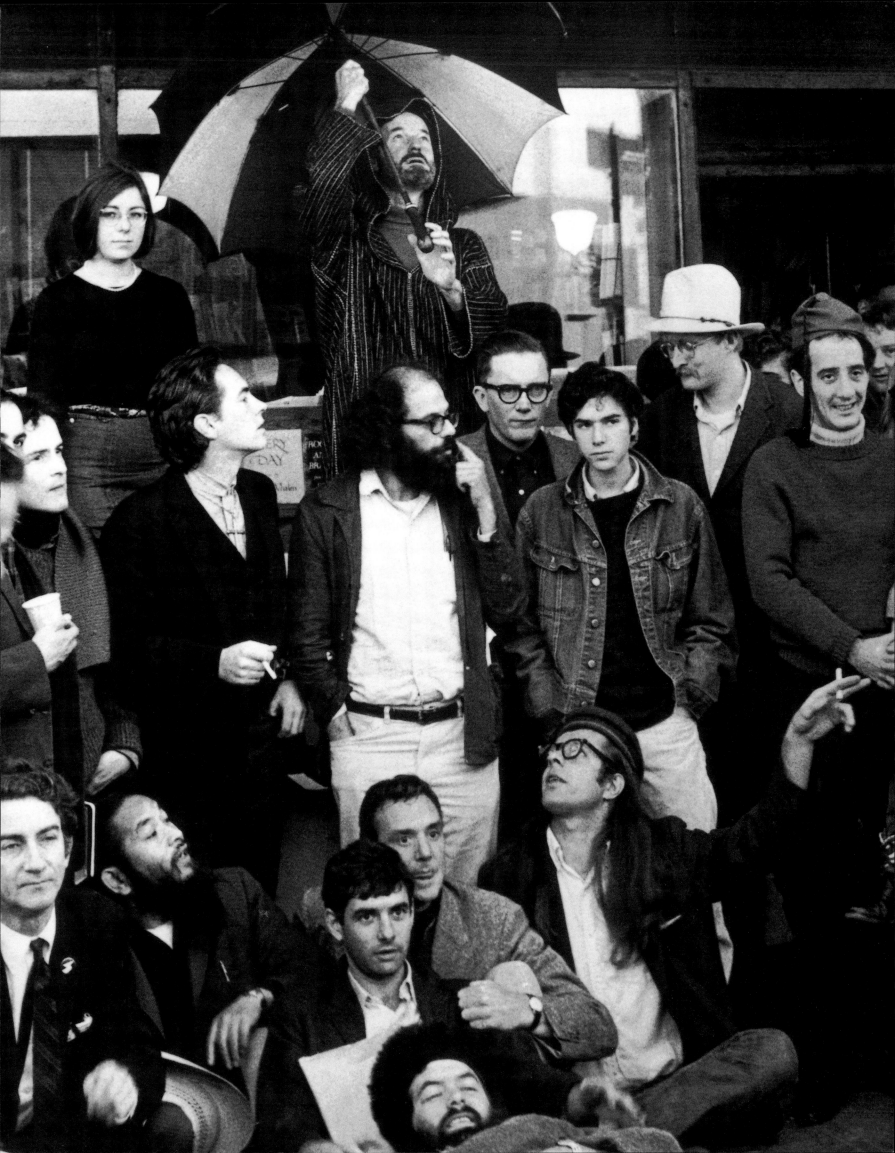

LSD

THE CONSCIOUSNESS-EXPANDING DRUG

Edited by DAVID SOLOMON

Introduction by Timothy Leary, Ph.D.

Contributors: Aldous Huxley
William S. Burroughs
Alan Watts
Dan Wakefield
Humphry Osmond, D.P.M.
Jonathan O. Cole, M.D.
Huston Smith, Ph.D.
Roy R. Grinker, Sr., M.D.

*LSD guru
Dr. Timothy Leary
spread his message via
spoken-word albums.
Mounting interest
in hallucinogens
during the mid-Sixties
generated such books
as* LSD: The
Consciousness-
Expanding Drug, *which included essays
by Leary.*

1 2 The Beatles are named members of the Most Excellent Order of the British Empire (MBE) by Queen Elizabeth II. They will be awarded their medals in the Great Throne Room at Buckingham Palace on October 26.

What was really going on in San Francisco in the early Sixties was a whole other thing most people don't know about. The underground scene was really a lot heavier than what was publicized and what people think happened— you know, hippies playing music with flowers in their hair, all that crap.

kind of crazy motherfucker in the world. It was kind of cool to be in on something that nobody else knew about. Early on, there was a big scene that was totally invisible. If you knew the right address and knocked on the door, you could walk through that door into a whole other world.

there was nothing happening. It was like a secret society. Things like that have to exist secretly. That's why when they brought it into the public eye, it sort of went away.

That early side of San Francisco was never really publicized. There was a while when the place

That early side of San Francisco was never really publicized. There was a while when the place was just totally free.

Basically it was an out-growth of the Beat Generation in the North Beach section of San Francisco. I first started hanging out there back when there were no hippies. There were beatniks and crash pads, poets and painters, every kind of drug imaginable and every

You'd go to, say, 1090 Page Street, open up the door, and there'd be a fourteen-bedroom Victorian house with something different going on in every room: painters in one room talking to each other, musicians in another room. It was really cool, and to all outward appearances,

was just totally free. You could go anywhere, do anything you wanted, and nobody hassled you. The spotlight wasn't on everybody. As soon as the spotlight came on and there was money to be made, then it went the way of all things. ✲

14 - 18 *Voting rights protests in Jackson, Mississippi, result in 856 arrests.*

29 *The Red Dog Saloon opens its doors in Virginia City, Nevada. The Charlatans are the house band. The event is advertised on a poster as "The Limit of the Marvelous."*

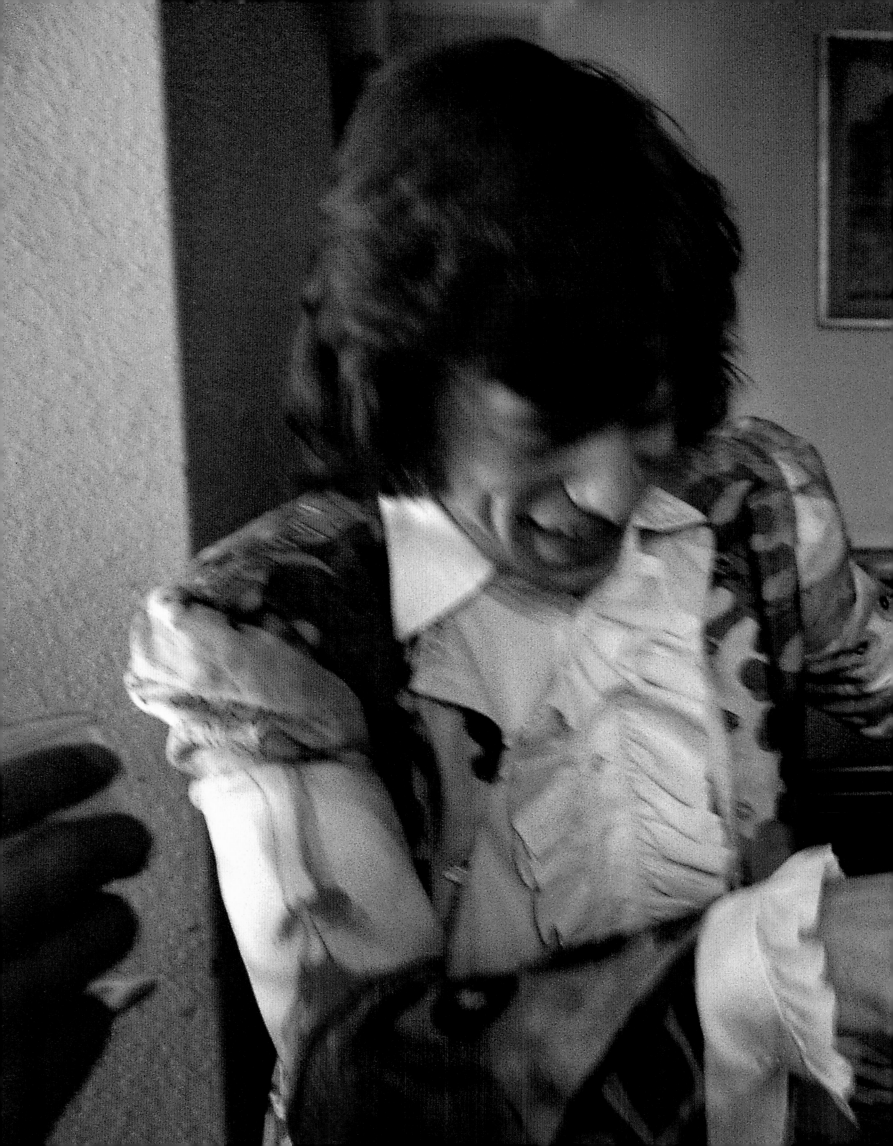

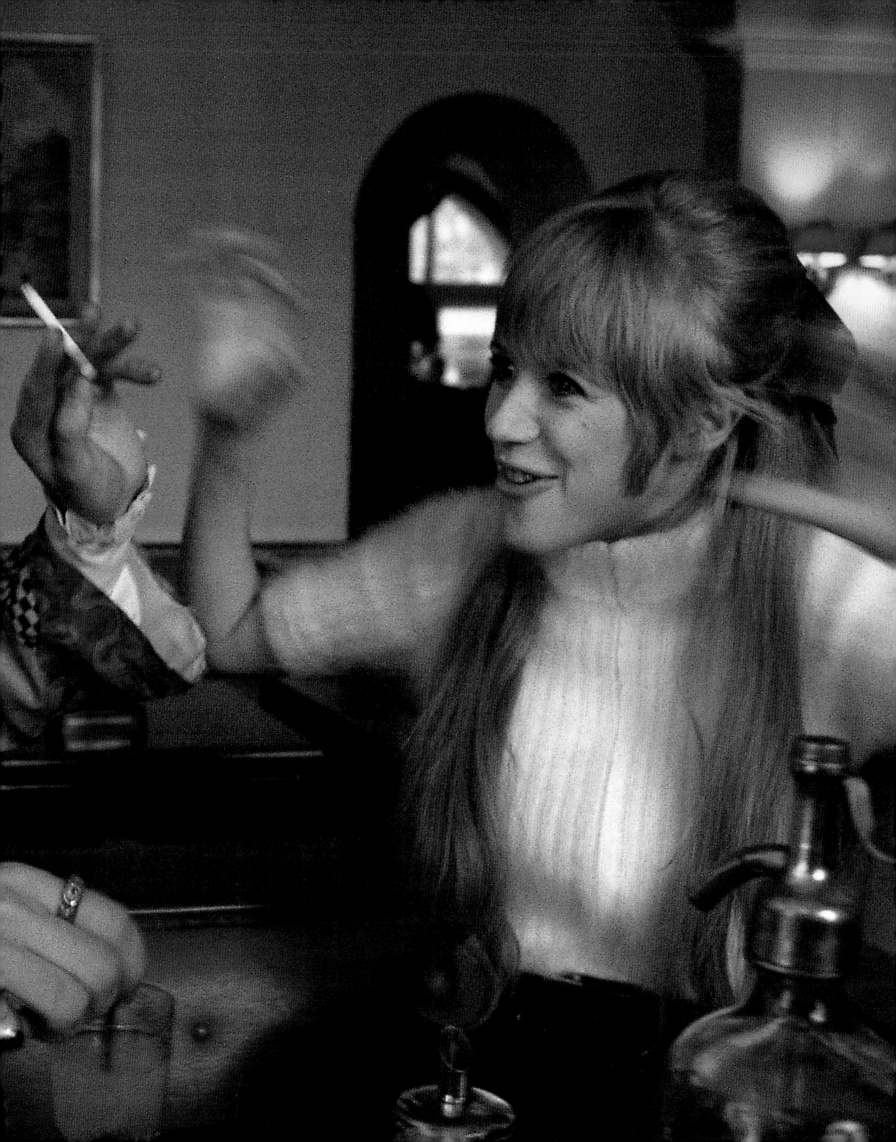

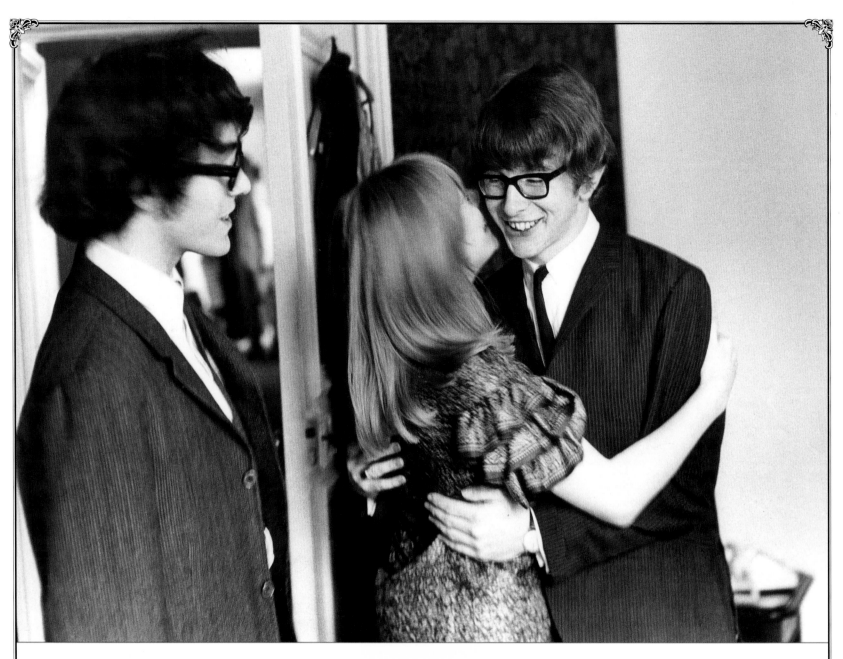

THE UNDERGROUND SALONS

Because there was no public transportation after midnight and pubs shut down at 10:30 p.m., most socializing in London took place at homes and flats such as that at 101 Cromwell Rd. Similar "salons" sprang up all over. The flat shared by Marianne Faithfull and John Dunbar was one of the most prominent. Visiting American writers and musicians stayed

One of London's swingingest couples, Marianne Faithfull and Mick Jagger (preceding pages), make merry. John Dunbar, Marianne Faithfull and Peter Asher (above) celebrate at a party in 1965. Barry Miles (opposite) helped bridge the worlds of literature, music and pop culture at Indica.

there for months at a time. Donovan, Paul McCartney and Robert Fraser were regular visitors, playing tapes, smoking pot and tripping. Marianne recalled the first time Dunbar and a friend took acid: "I was in bed pregnant, and my mum was staying. I had a pre-acid lecture [from Dunbar]. 'Now Marianne, we are going to take this new drug. You have to be really nice to us and not say anything nasty or bring me down!' They wanted pillows, so John came in and took them. Then he took the [comforter] and finally the mattress. I was lying on the springs. My mother walked

1 0 *"(I Can't Get No) Satisfaction," by the Rolling Stones, tops the U.S. charts.*

1 5 *The world sees the first pictures of the planet Mars transmitted by the Mariner 4 space probe.*

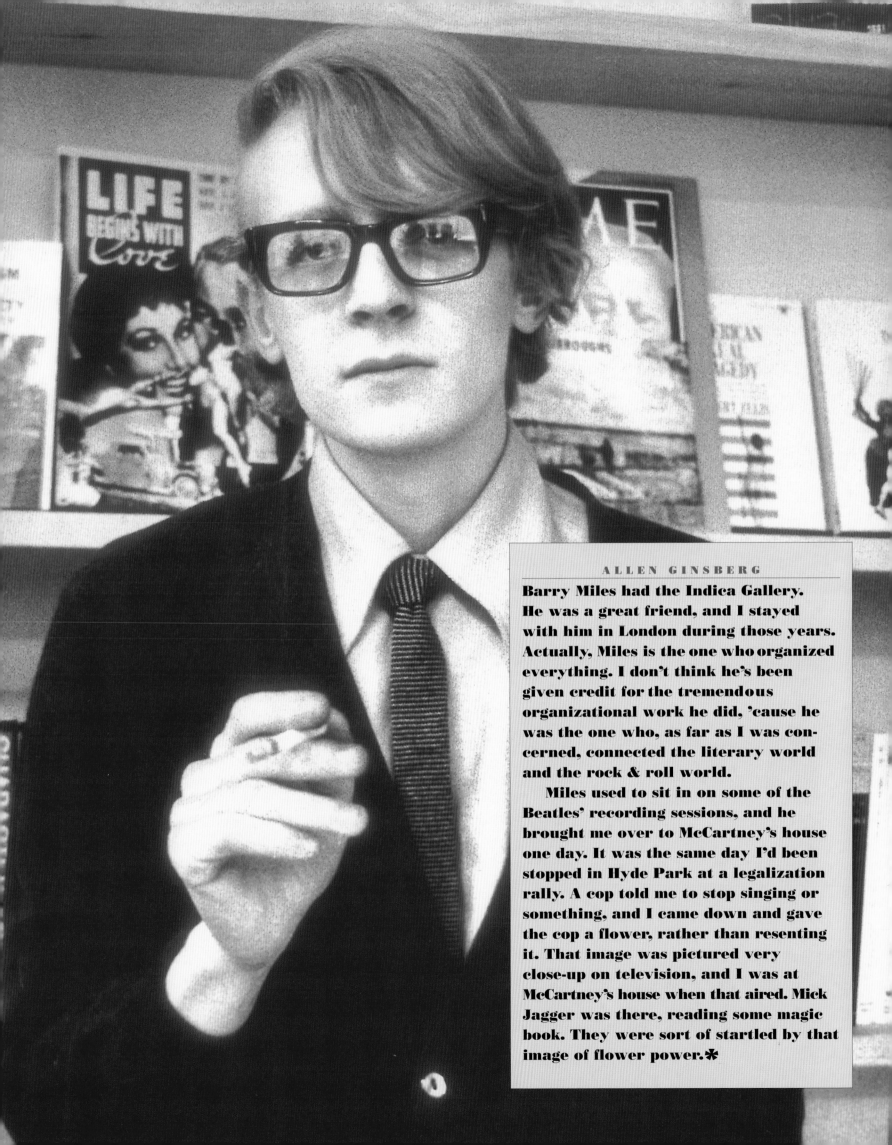

ALLEN GINSBERG

Barry Miles had the Indica Gallery. He was a great friend, and I stayed with him in London during those years. Actually, Miles is the one who organized everything. I don't think he's been given credit for the tremendous organizational work he did, 'cause he was the one who, as far as I was concerned, connected the literary world and the rock & roll world.

Miles used to sit in on some of the Beatles' recording sessions, and he brought me over to McCartney's house one day. It was the same day I'd been stopped in Hyde Park at a legalization rally. A cop told me to stop singing or something, and I came down and gave the cop a flower, rather than resenting it. That image was pictured very close-up on television, and I was at McCartney's house when that aired. Mick Jagger was there, reading some magic book. They were sort of startled by that image of flower power.✱

INDICA BOOKS Limited
102 Southampton Row,
London W.C.1. 405.5824

B.Miles P.Asher M.Asher J.Dunbar
Secretary: M.Henshaw
Registered office: 20 Fitzroy Square, W.1.

Sample letterhead from the Indica Books and Gallery, co-founded by Miles, Asher and Dunbar. Above, a brocade jacket belonging to Donovan (opposite) who turned psychedelic in 1966 with songs like "Sunshine Superman." "Poets have a sense of place," says Donovan. "My place was London, and I sang about it."

in and was appalled. 'Where's the mattress?' I said they were doing an experiment."

Another popular salon was at 1 Courtfield Rd., where Anita Pallenberg, Brian Jones and Keith Richards all lived. Robert Fraser's flat on Mount Street attracted new pop aristocrats like McCartney and the Stones, as well as artists, writers and visitors from New York. Fraser always had the best drugs and cocktails, and he constantly adjusted the lighting for maximum effect and the guests for maximum kudos.

In August 1965, I began making plans to open a bookshop of my own. Dunbar was thinking of starting an experimental-art gallery, so it seemed a good idea to combine forces. Dunbar's best friend was Peter Asher, who was then quite successful as the bespectacled half of the pop duo Peter and Gordon. Peter put up the money for the bookstore and gallery, and a company called MAD (Miles Asher Dunbar, Ltd.) was formed. We called the shop Indica, after cannabis indica, the scientific name for a type of marijuana. The name was well suited to the times.

DONOVAN

In late 1965 was the change. I'd made two folk-style records, the second of which was *Fairy Tale*. It was definitely a black-and-white folk period, as it were. But in that album *Fairy Tale* was a song called "Sunny Goodge Street," which was clearly a departure. It was jazz-classical fusion. That song had within it the embryo of everything I would do in '66: project mystic lyrics, touch on mythological figures and experiment.

Mickie Most, the producer, John Cameron, the arranger, and I became a trio, and away we went. They would listen to what I had in mind and sounds that came to me. I heard the sounds in my head, and Cameron would write them down. That lasted all the way through '66 for the *Sunshine Superman* and *Mellow Yellow* albums. It was a tremendously powerful departure.

Sunshine Superman is now considered my psychedelic album. It was experimental. The "psychedelic sound" is considered to be mostly an "electric" sound, yet on my *Sunshine Superman* album I used jazz, classical, ethnic, troubadour and rock sounds in a fusion. I developed the "mystical" sound to present lyrics of self-realization. My own psychedelic journey was not to just "get high." I followed the path Aldous Huxley described in his book *Doors of Perception*. Most people think the "trip" was a hallucination, not real. I consider the psychedelic experience to be a view into the true reality behind the illusion the mystics call "Maya." ✱

25 *Bob Dylan appears at the Newport Folk Festival with an electric band and is booed by folk purists. His single "Like a Rolling Stone" had been released five days before.*

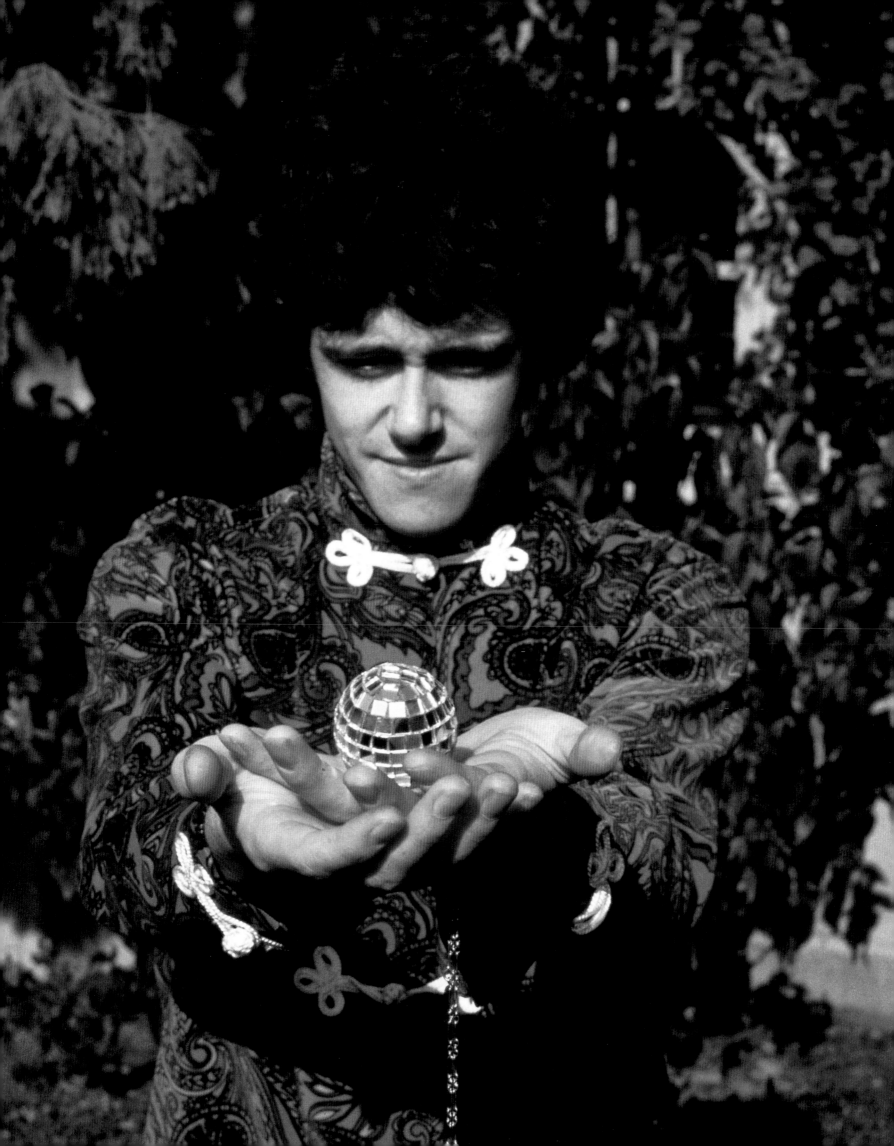

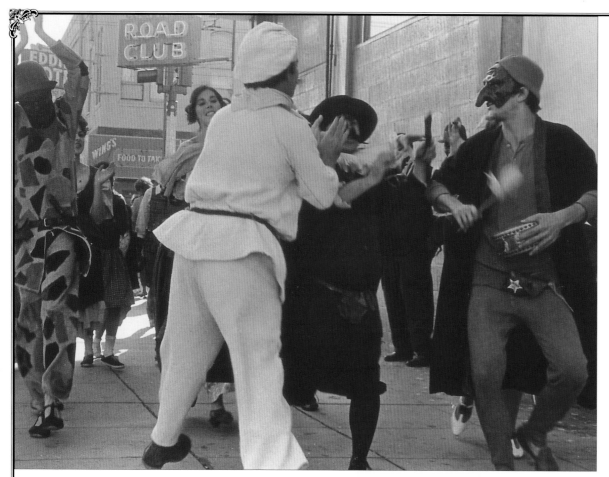

Country Joe McDonald, played the song on a flatbed truck in the parade, and copies of the record were sold for fifty cents at the demonstration.

The parade was stopped at the city limit by the Oakland police — and, to everybody's surprise, by the Hell's Angels, who turned out to be patriotically opposed to the war protesters. After a lot of excitement and confusion, the marchers retreated to Berkeley. The press went crazy trying to identify the bad guys at this event. Was it the "peacenik" antiwar demonstrators or the dreaded Angels?

It had been quite a day. The next night there was a rock & roll dance at Longshoremen's Hall, a big San Francisco union hall on the outskirts of Fisherman's Wharf. A number of those who came had been in the march. In fact, some Hell's Angels came, too.

A group of friends calling themselves the Family Dog had advertised the dance as "A Tribute to Dr. Strange" with posters suggesting the "mystic spell" patterns used by comic-book superhero Dr. Strange. These were crossed with the involuted doodles people tend to make while stoned on LSD. It was like a gigantic *beaux-arts* ball, with hundreds of dancers in costumes: Edwardian, cowboy, Beatles-style mod, pirate, free-form. Allen Ginsberg was there in the white hospital-orderly gown he'd taken to wearing in India. Usually Ginsberg was the most exotic creature in any room, but here he wandered around half the night gaping at all the strange young people.

True, you couldn't hear very well in the rackety octagonal building, with its plate-glass windows on every side, but it didn't seem to matter. There were the Charlatans, dressed to the nines as

A Tribute to Dr. Strange

The San Francisco Mime Troupe acting out and acting up on the streets of the city in 1964. A November 1965 benefit to raise money for the troupe's legal defense, in the face of charges relating to an obscenity issue, became a seminal event in the evolution of the San Francisco scene.

Around the country opposition was growing to the Vietnam War. On October 15, at the suggestion of its Berkeley chapter, the international Vietnam Day Committee organized protests in cities around the United States and some foreign countries. The University of California — as Berkeley's newly founded "underground" paper, *The Barb*, headlined it — was now the "Center of Worldwide Action."

The plan called for a big rally on campus followed by a march into Oakland to protest at the army induction center. During the parade, you could hear "I-Feel-Like-I'm-Fixin'-to-Die Rag" — a war protest song featuring electric guitar and jug-band instruments — wafting from apartment windows along the parade route. The song's author,

JULY '65

28 The U.S. increases its troops in Vietnam from 75,000 to 125,000 and begins doubling the number drafted for combat duty. In announcing this escalation, President Johnson states, "We will not surrender, and we will not retreat."

A lot of people in San Francisco got together with the same idea, just like grunge kids get their own gangs together on Avenue A in New York today and have their own culture, their own community, their own friend-ships. Except we were doing it at a time when it was less well-known to do that. There were precedents, like the Modernists of the Twenties: Ezra Pound, James Joyce and T. S. Eliot in Paris. So Haight-Ashbury was a continu-ation, another manifestation of things that had happened before in history. But it was like a coalescence of the free sexual revolution, the marijuana revolution, the drug revolution, politi-cal revolution, liberation movements of all kinds. We were getting together to have a be-in. The purpose was just to be there. That was the whole point. This was after the sit-ins, and the idea was more Buddhist-influenced: to be there, to simply be there, not having to do anything particular except to enjoy the phenomenon of being together outside of the realm of the state.✽

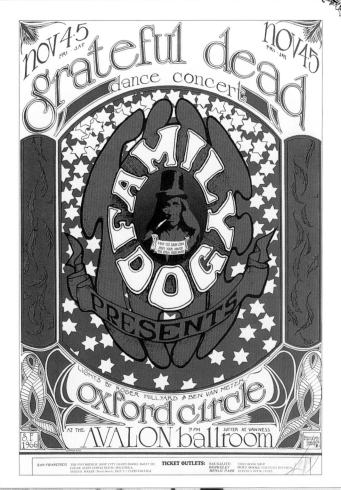

Three-fourths of the original Family Dog (below), pioneering promoters of dance concerts in San Francisco at places like Longshoremen's Hall and the Avalon Ballroom: Luria Castell, Ellen Harmon and Alton Kelley (from left). Not shown is Jack Towle, who shot this 1965 photograph. Kelley and partner Stanley Miller (a.k.a. Mouse) designed numerous posters, including one for a weekend stand by the Grateful Dead at the Avalon in November 1966 (right).

cowboys, playing a hypnotic rendition of the old C&W hit "Wabash Cannonball." Jefferson Airplane came attired in mod clothes, singing anthems of love in mysterious, hollow harmonies. Then there were the Great Society, a new band whose lead singer, a former fashion model named Grace Slick, wore a smashing pastel-purple outfit and sang in a ferocious contralto.

At the end of the dance, people picked up litter. Amazing. At traditional rock dances held in armories and high school gyms, there was often trouble with angry, boozed-up teens throwing bottles. This one, though, had been filled with awe and loose, blissful energy.

JULY '65

2 9 **Help!, the Beatles' second film, makes its world premiere in London. It will open in the U.S. in New York on August 23.**

3 0 **The bill creating the Medicare program is signed into law.**

The Instant Action Jug Band, which included Barry Melton and Joe McDonald (foreground, from left), performs on a pickup truck at an antiwar march in downtown Berkeley in August 1965. Seconds after this picture was taken, tear gas was lobbed into the crowd. Soon after the march, McDonald and Melton formed Country Joe and the Fish and recorded one of the premier antiwar anthems of the Sixties, "I-Feel-Like-I'm-Fixin'-to-Die Rag."

AUGUST '65

6 *President Johnson signs the Voting Rights Act.*

1 1 *Race riots break out in the Watts area of Los Angeles. Over the next week, rioting claims 34 lives and results in $200 million in property damage.*

Sometime in 1966, Country Joe and the Fish went up to Vancouver to play the Kitsilano Theatre. On the way up, our drummer, Gary "Chicken" Hirsch, said he had just figured out that banana peels have qualities similar to marijuana. His theory was that if you dried out a banana peel and smoked the white pulp on the underside, you would get high. At that time, the band was living on peanut-butter-and-banana sandwiches. All the ingredients

Kitsilano Theatre stage crew pointed to a water jar and said, "We just dissolved a hundred tabs of LSD in that water jar. If you want any, just help yourself." So we all took a couple sips off the water jar, did our sound check and went back to the psychedelic shop. We felt the banana peels, but they were still too wet to smoke. After a while, we returned to the theater, took a couple more hits off the water jar and played our

is incredible!" Afterward, we went all over Vancouver telling people that bananas get you high.

We returned to the Bay Area and almost immediately played a benefit to legalize marijuana. At that event, we passed out five hundred banana joints and told everybody that bananas get you high. A few days later, I got up to get breakfast at the Berkeley co-op, and there were no bananas in the banana bin.

"Banana Turn-On: New Hippie Craze"

were cheap. We were just throwing the peels away, so this sounded like a great idea.

We went over to the theater, and across the street was a psychedelic shop. While the roadies were setting up the equipment, we went to the grocery store on the corner and bought a bunch of bananas. Then we went to the psychedelic shop and asked if we could use the back room, where there was a kitchen, to dry out the banana peels. We turned the stove on a low temperature so that we wouldn't destroy the THC in the banana peels. We ate the bananas and put the peels in, then left to see how sound check was coming.

While we were waiting, the

first set. At intermission, we checked out the banana peels. Well, they seemed like they were ready, so we rolled about twenty-five banana joints. We started smoking them and looking at each other, saying, "You gettin' high?" "No, you gettin' high?" "I don't know, man, maybe."

We went back across the street for the second set, took a couple more hits off the water jar and played our second set. After the second set we just *ran* across the street because of those bananas. We started puffing the banana joints and looking at each other and saying, "Man, this shit is really working! I'm getting really ripped! This stuff

I went over to Safeway, and there were no bananas there either. Then I noticed a huge headline in the *San Francisco Chronicle* that said: *Banana Turn-On: New Hippie Craze.* Well, you couldn't get a banana in the Bay Area that day.

We all forgot about it until three months later. I was reading the newspaper, and way in the back was a little headline that said *Drug Enforcement Agency Smokes Banana Joint.* The article said that the DEA puffed a banana joint through its joint-smoking machine, and it told them that bananas do nothing. Then I remembered the psychedelic water and thought, "Ah, that explains everything." ✱

1 3 *The Matrix, a music club in San Francisco's Marina district, opens for business. Jefferson Airplane is the house band.*

3 1 *A new law makes it illegal to burn a draft card. The first conviction for this offense is handed down on February 10, 1966.*

THE GREAT SOCIETY

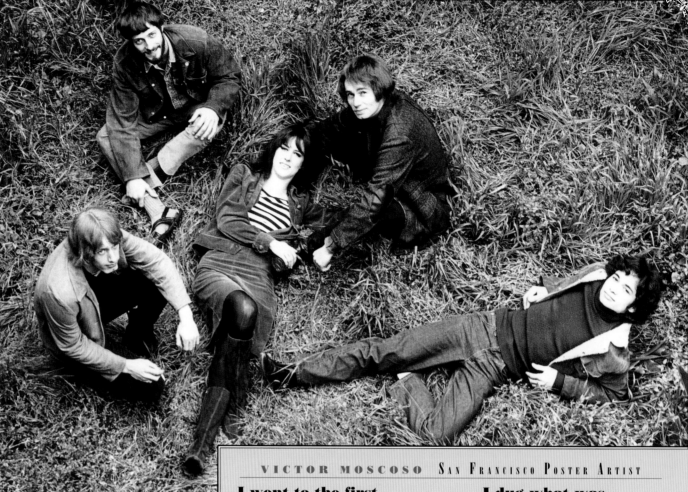

When the San Francisco Mime Troupe, a satirical theater group, was busted over an obscenity issue, its business manager, Bill Graham, staged a benefit to raise money for the group. He stressed the anticensorship angle and aimed for the San Francisco arts crowd. The young actors rented a white Cadillac and drove through downtown San Francisco passing out invitations to the "Appeal Party," as they called the event, held at the Mime Troupe's loft in the area south of Market Street.

As it turned out, those who came were mostly the same people who had been going to the Family Dog dances. It wasn't the satirical comedy troupe or the folk musician or the jug-band composed of New York poets that drew them. They came to see the Jefferson Airplane.

The loft had been painted bright colors. Bananas and bunches of grapes hung from the ceiling.

VICTOR MOSCOSO SAN FRANCISCO POSTER ARTIST

I went to the first Family Dog dances at Longshoremen's Hall, "A Tribute to Dr. Strange" and "A Tribute to Sparkle Plenty." This was 1965. What I saw blew me away. Here were freaks, street people, beatniks, artists, poets. You know, the dregs of society, the fringes of society, those that barely were in the society—garbage pickers, petty dope dealers — having a great time getting stoned and making music. It was far-out. I mean, it just blew me away.

I dug what was going on. I dug the scene. In fact, all I wanted to do at that point was event posters, as if I understood intuitively that this was a historical opportunity. This was Big Brother and the Holding Company. This was the Doors. I knew these were historical events, and they've got the dates on them so you can line them up and see the progression. That's what I wanted to do. I stopped painting. I turned on, tuned in and dropped out.✱

Michael Hollingshead opens the World Psychedelic Center in London. Hollingshead, who first turned Timothy Leary on to acid in 1961, moved to London with 5,000 doses of LSD and instructions from Leary to promote "spiritual and emotional development."

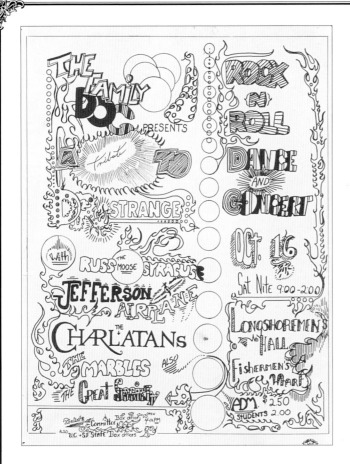

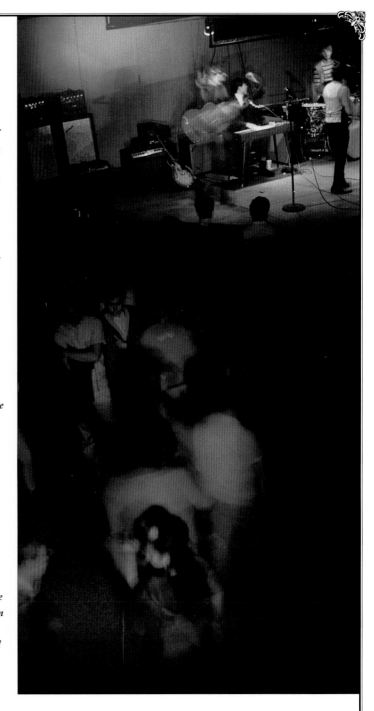

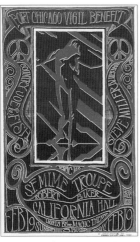

The Great Society (opposite) was one of the earliest groups on the San Francisco scene. They played at "A Tribute to Dr. Strange," the prototypical psychedelic dance concert held at Longshoremen's Hall on October 16, 1965. The group included brothers Jerry and Darby Slick and Jerry's wife, vocalist Grace Slick. The group's most obvious asset, she joined Jefferson Airplane late in 1966. A handbill for "A Tribute to Dr. Strange" (above left) lists the groups that appeared at this momentous concert. They included the Marbles, shown performing (right); the Great Society, making their second public appearance; the Charlatans, fresh from their summer at the Red Dog Saloon; and Jefferson Airplane, nearly a full year before the release of their first album. The San Francisco Mime Troupe joined Country Joe and the Fish and the Steve Miller Band at a benefit concert at California Hall (below left) in 1967.

Art films were shown on screens made of bedsheets. Light shows of colored pigments were projected on the walls. Here was another place to act as weird as you felt! When the doors opened at dusk, a line already stretched around the block in the loft's deserted, light-industrial neighborhood.

At midnight there was still a line, but the police ordered the party shut down. Talking fast, Bill Graham pleaded with them: Don't shut us down, officer, all these celebrities are winging in from Las Vegas to support the dear old Mime Troupe. Sinatra! Liberace!

The police agreed to allow new people to come in if those who had already been at the party for a long time left — but only as long as the room's official maximum capacity of five hundred was not exceeded. The police counted people entering and leaving at the door, but they didn't know about the freight elevator. There were still six hundred people in the loft when the Appeal finally closed down at 6:30 a.m. Sinatra and Liberace never showed up, of course, but Allen Ginsberg was still there, chanting Indian mantras as the remaining revelers cleaned up the floor before leaving.

A headline in the San Francisco Examiner about the Haight-Ashbury district is headlined A New Haven for Beatniks.

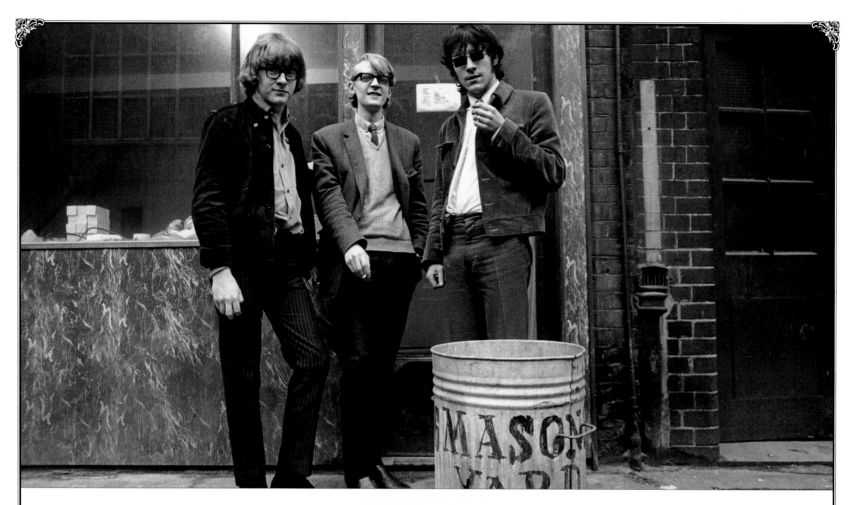

THE REAL SUMMER OF LOVE

Popular myth holds that 1967 was the Summer of Love in London and San Francisco. The truth of the matter is that 1966 was the real Summer of Love in both cities and that 1967 was the beginning of the end.

The year 1966 was a time of tremendous activity in the London underground. It marked the formation of the London Free School, the opening of Indica, the launching of *International Times* and the UFO club, the first psychedelic posters, the release of the Beatles' protopsychedelic *Revolver* and the mind-blowing early performances of Pink Floyd and Soft Machine.

Paul McCartney became involved with Indica through Peter Asher. Paul's girlfriend was Peter's

The proprietors of Indica Books and Gallery — Peter Asher, Barry Miles and John Dunbar (above, from left) — pose outside their shop on January 28, 1966, shortly before its official opening. John Lennon (opposite), photographed on the grounds of his home at Weybridge in 1965, presages the Beatles' turn toward psychedelia with a visible blow for flower power.

sister Jane; all three lived with the Ashers' parents. McCartney was the only Beatle in town. The others lived in the stockbroker belt, about an hour outside London. For several years, until John Lennon and Yoko Ono got together in 1968, McCartney was the Beatle who attended gallery openings, opening nights, lectures and avant-garde concerts. Lennon remained home with his wife Cynthia and son Julian, growing progressively frustrated at his domestication. McCartney, meanwhile, helped ready Indica's premises by painting the walls.

A few days before Indica's opening in February 1966, McCartney pulled up in his Aston Martin and staggered in with a huge parcel. For several days he had been behaving mysteriously in the Asher household, refusing to allow Peter into his room. Unknown to anyone, McCartney had personally designed and hand-lettered Indica wrapping paper and had it printed. The parcel he delivered contained 1,000 sheets of that wrapping paper.

OCTOBER '65

1 5 *Antiwar protest in Berkeley draws 14,000 marchers, who are met en route to the Oakland army base by police and the Hell's Angels. The next evening, a dance concert billed as "A Tribute to Dr. Strange" is put on by the Family Dog at Longshoremen's Hall. The Charlatans, the Great Society and Jefferson Airplane perform.*

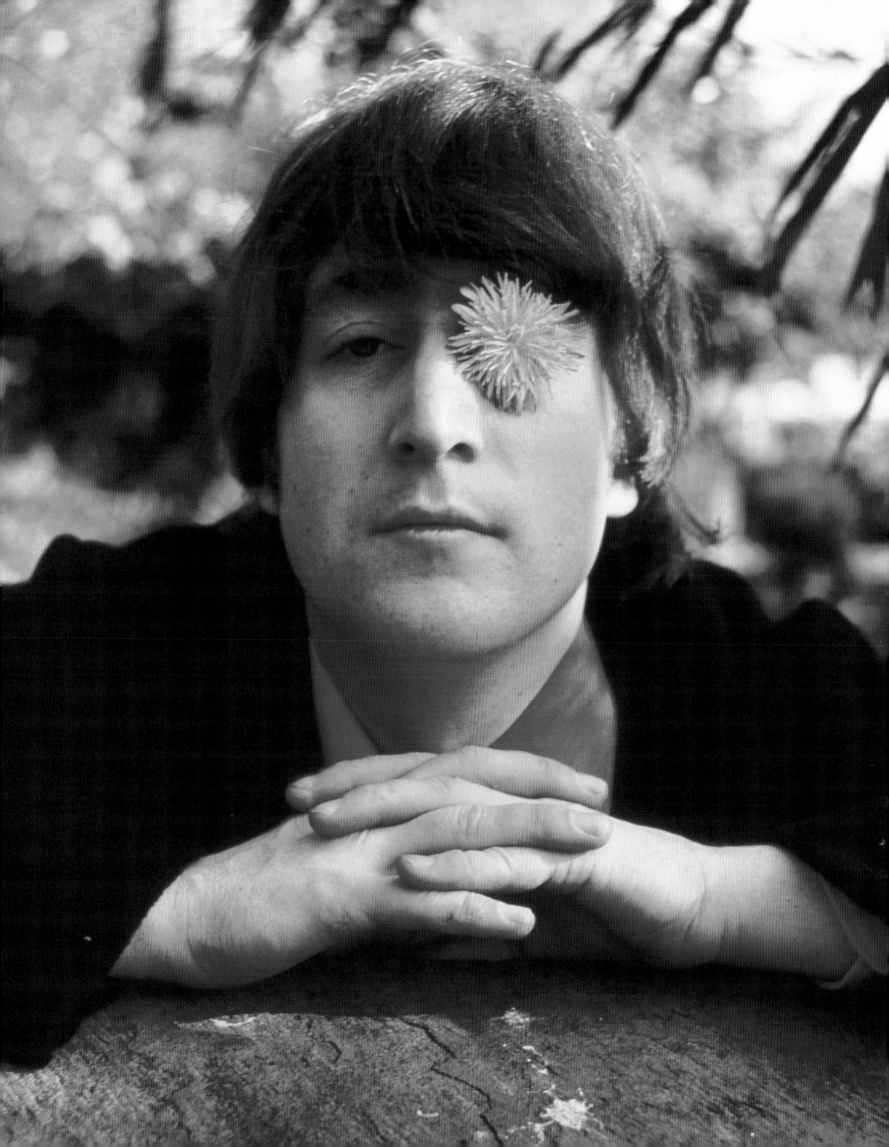

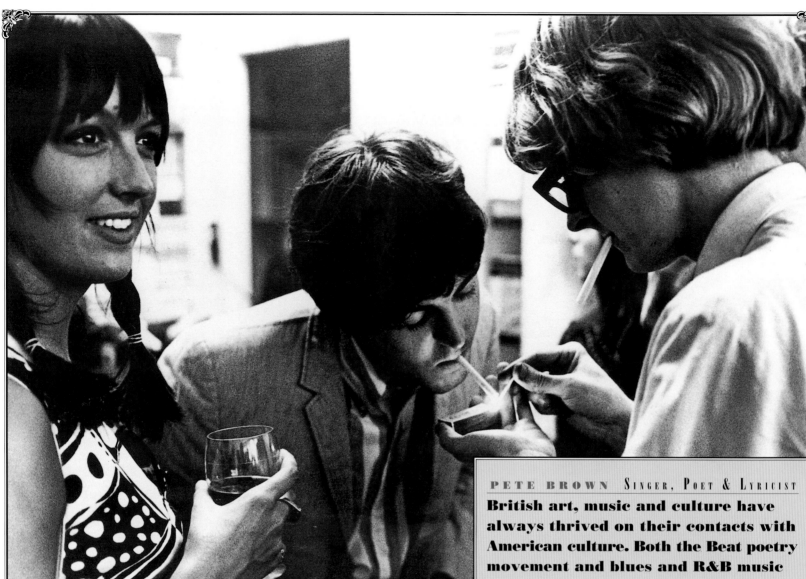

McCartney stopped by Indica in March with Lennon, who professed to be looking for a book by someone named Nitz Ga. After a few awkward moments I decoded the visibly self-conscious Lennon's request, and he was soon mollified with a copy of *The Portable Nietzsche*. Scanning the shelves, he came upon *The Psychedelic Experience*, a primer on drug-taking by Timothy Leary. Lennon curled up with the book on an old settee in the middle of the shop. In Leary's introduction he came upon this line: "Whenever in doubt, turn off your mind, relax, float downstream." It became the first line of "Tomorrow Never Knows," the Beatles' first truly psychedelic song.

Lighting up cultural horizons at Indica (above) with Maggie McGivern, Paul McCartney and Barry Miles. McCartney provided 1,000 sheets of personally designed wrapping paper (opposite) for the shop's opening. It was at Indica that John Lennon browsed a copy of **The Psychedelic Experience** *and a Beatles classic was born.*

PETE BROWN Singer, Poet & Lyricist

British art, music and culture have always thrived on their contacts with American culture. Both the Beat poetry movement and blues and R&B music were very welcome at the time. Britain was a tiny country that was very stifling. The openness and experimental qualities of American poetry and the drive and intensity of American music were absolutely necessary to help us create the things that we did.

It's a funny thing, but when you're dealing with your information second-hand, it all gets very distorted. You produce a very strange version of the thing that inspired you. Little elements of Haight-Ashbury and things like that did occur in Britain, but in a very odd way. Certain aspects of it caught on and others didn't.✱

24 The second Family Dog affair, "A Tribute to Sparkle Plenty," features the Lovin' Spoonful and the Charlatans.

29 The Who release "My Generation."

OCTOBER '65

INDICA ST. JAMES.

MASONS

INDICA BOOKS AND GALLERY.

OFF DUKE ST.

INDICA

YARD INDICA

NIGEL WAYMOUTH BRITISH POSTER ARTIST

Drugs. Pot and LSD. It's as simple as that. Suddenly, we were in Disneyland. We thought it was some sort of Arcadia.

We wanted to break free from that rigid, classic . . . I mean, the early Sixties had been full of kitchen-sink dramas and black-and-white films, and everything was reality. Suddenly, things like Fellini and the Beatles and the Stones and pop art all came bursting out. There was a sort of liberation and idealism. It was pretty naive by today's standards, of course, but at the time we thought we were going to change the world. And this was how we illustrated it. We designed the clothes and put up the posters and left it to the rock stars to make the music.✻

6 *Bill Graham organizes a legal fund-raiser for the San Francisco Mime Troupe, who have been busted for performing in the park without a permit. This wildly successful "Appeal" is evidence that a new kind of community is taking shape.*

KESEY'S ACID TESTS

Ken Kesey decided to go public with his own parties. On November 27, 1965, he put up a small poster in a bookstore advertising an "Acid Test" in a private home. It was clear to an acidhead what Kesey hoped to do: throw a big party where everyone took LSD and made some collective cosmic breakthrough. Not by meditation and listening to Indian music, the way Timothy Leary was recommending on the East Coast, but by courting the unexpected. If you came to an Acid Test, you'd find Kesey's Merry Pranksters messing with microphones and gadgets, plus a light show, a slide show about American Indians, a rock band called the Warlocks, Kesey's own musical group (the Psychedelic Symphonette) and lots of weird people.

In 1964, novelist and agent provocateur Ken Kesey (above) embarked on a cross-country trip with his Merry Pranksters aboard a school bus that was given a psychedelic paint job (opposite). It was an expedition fueled not only by gasoline but by LSD, which was plentifully ingested by Kesey's counterculture pioneers searching for new horizons.

But how to describe what he was inviting people to? Kesey considered it participatory theater, like the Happenings that were the current rage in the art world. Everybody paid a dollar admission, including Kesey.

In December, Kesey held a public Acid Test at a bar in Oakland. It was advertised by a bizarre poster showing a Greek statue that was saying: *Only one way out! I'll take the course myself!* Hundreds of people came. A week later Kesey threw another Acid Test in a remote community north of San Francisco.

Each Acid Test was larger than the one before it, and amazingly, no lightning bolt struck it down. Maybe Kesey was right. Maybe you didn't have to think about the squares and the police at all. Maybe by overcoming fear, by taking LSD boldly and disregarding the consequences, you could make your breakthrough.

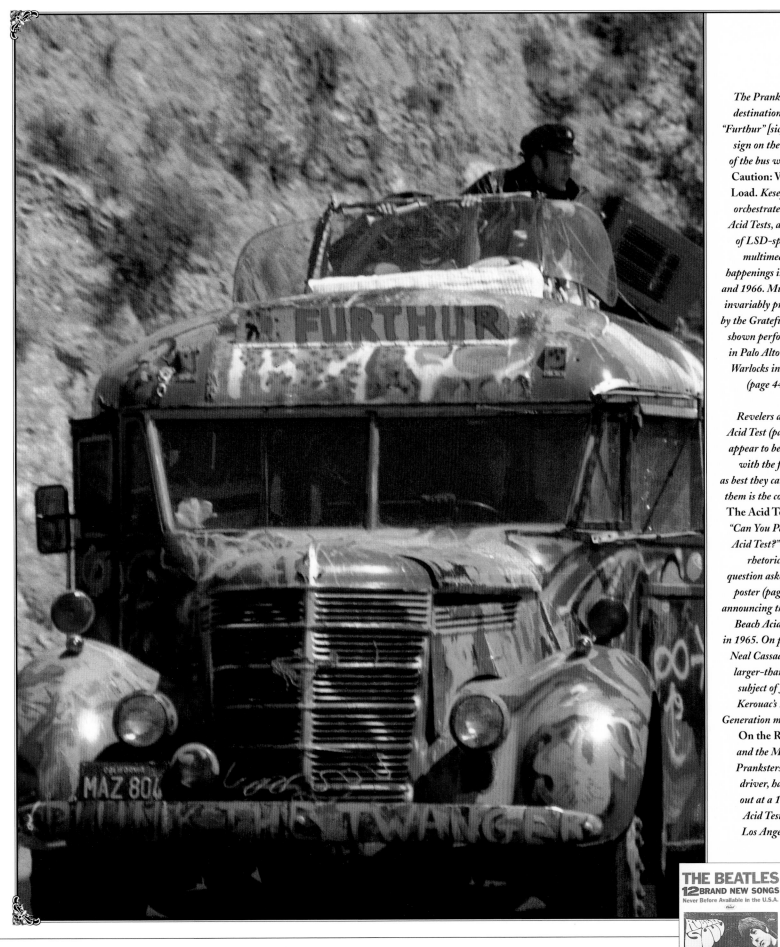

The Pranksters' destination was "Furthur" [sic], and a sign on the back of the bus warned **Caution: Weird Load.** *Kesey also orchestrated the* **Acid Tests,** *a series of LSD-spiked multimedia happenings in 1965 and 1966. Music was invariably provided by the Grateful Dead, shown performing in Palo Alto as the Warlocks in 1965 (page 44).*

Revelers at an Acid Test (page 45) appear to be going with the flow as best they can; below them is the cover for **The Acid Test** *LP. "Can You Pass the Acid Test?" is the rhetorical question asked by a poster (page 46) announcing the Muir Beach Acid Test in 1965. On page 47, Neal Cassady, the larger-than-life subject of Jack Kerouac's Beat Generation manifesto* **On the Road** *and the Merry Pranksters' bus driver, hangs out at a 1966 Acid Test in Los Angeles.*

 **3 The Beatles release Rubber Soul in the U.K. It is**

D E C E M B E R ' 6 5 **distinguished by its psychedelic lettering, the presence**

 **of sitar on "Norwegian Wood" and a marked turn**

 **toward Dylanesque, introspective themes.**

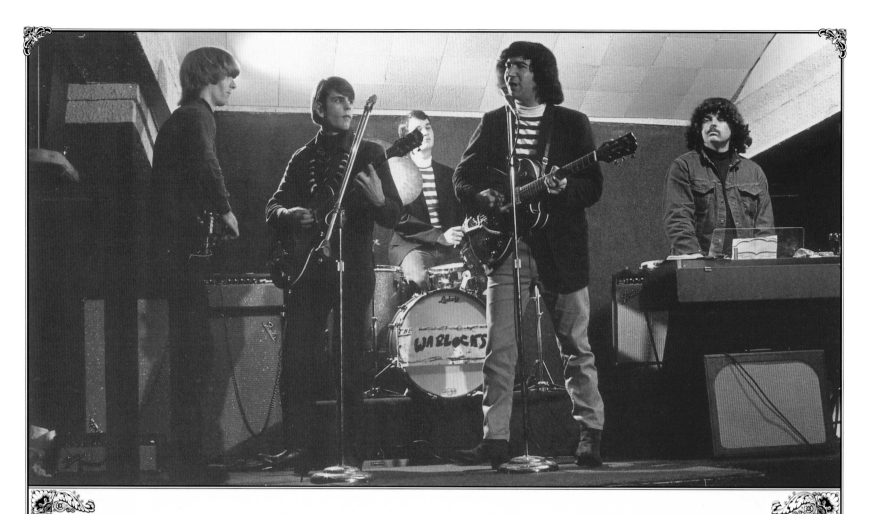

By overcoming fear, by taking LSD boldly & disregarding consequences, you could make your breakthrough

DECEMBER '65

4 *The second Acid Test is held at a house in San Jose following a Rolling Stones concert. Hand-lettered invitations reading Can You Pass the Acid Test? are given out, and 400 revelers show up. The Grateful Dead, who have recently changed their name from the Warlocks, perform.*

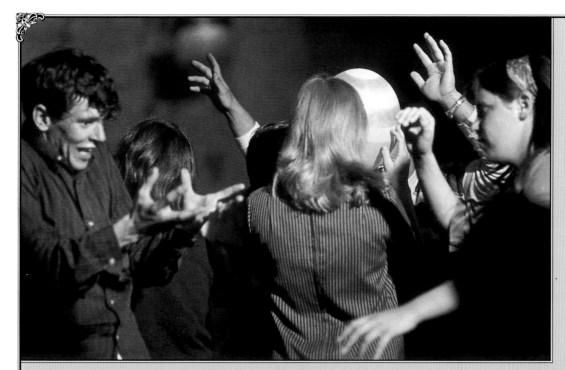

here or there that would occur and then dissipate. A lot of lights, a lot of sound, a lot of speakers all around the room. You would walk by a microphone, for instance, and maybe say something and then a couple minutes later you'd hear your own self in some other part of the room coming back at you through several layers of echo. The liquid light-shows began there. I think it was the first time anyone saw them. People were rather gaily adorned: dyed hair, colorful clothing and stuff like that. And everybody was loaded to the gills on LSD.

There was a lot of straight-ahead telepathy that went on during those sessions. We learned during those sessions to trust our intuitions, because that was about all we had to go on. When you learn to trust your intuitions, you're going to be more given to try things, to experiment. And you're going to be more given to extemporaneous assaults of one sort or another. We learned to start improvising on just about anything.

We were participants, and so were they. We were all just making waves, as big and bold as we could, and seeing where they rippled against each other and what kinds of shimmers that all caused.✳

BOB WEIR GUITARIST FOR THE GRATEFUL DEAD

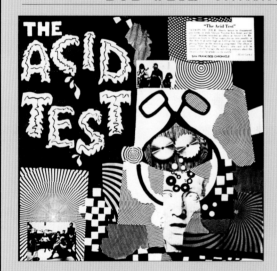

We did the first one or two Acid Tests as the Warlocks and then changed our name to the Grateful Dead. I was having every bit as much fun as I could possibly have. I was a kid in a candy store. All the stuff that was happening was new: this rock & roll explosion, the Acid Tests and all that kind of stuff. No one had ever even imagined that stuff like that could possibly happen until it did. It was actually better than realizing my dreams.

I think the Dead played all the Acid Tests except for one. There was an Acid Test somewhere, maybe in Mexico, that we didn't get to. The Acid Tests were complete chaos with little knots of quasi-organization

JANUARY

8 *The largest Acid Test yet draws 2,400 people to San Francisco's Fillmore Auditorium. The Grateful Dead play while banks of audiovisual equipment create a chaotic backdrop of light and sound.*

21 - 23 *The multimedia Trips Festival is held at Longshoremen's Hall in San Francisco. A psychedelic poster handbill promises slides, movies, sound tracks, flowers, food, rock 'n' roll eagle lone whistle, indians and anthropologists revelations . . . & the unexpectable. The Grateful Dead and Big Brother and the Holding Company perform, and Owsley's latest batch of acid is circulated.*

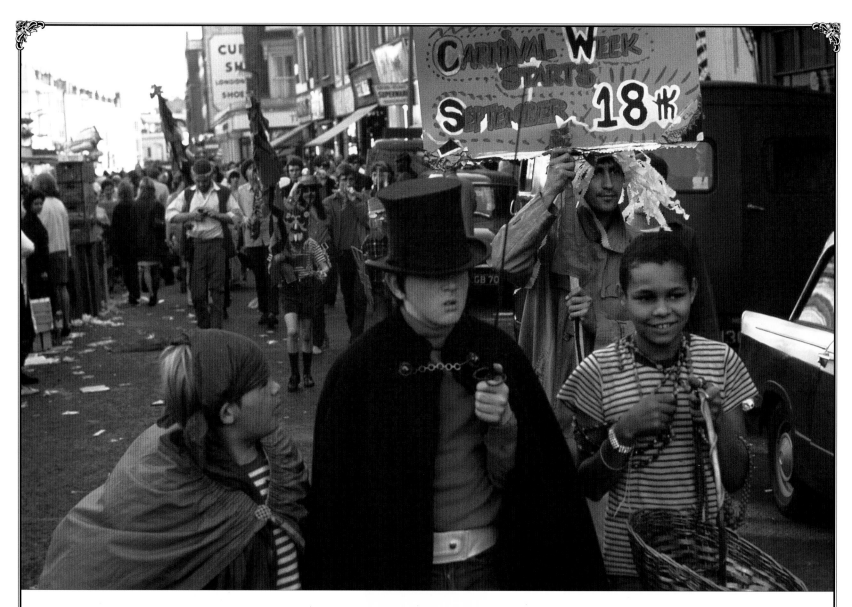

SPONTANEOUS UNDERGROUND

Many people in the underground believed the way to alter society was through education. To that end, John "Hoppy" Hopkins and community activist Rhaunie Laslett founded the London Free School in Notting Hill in March 1966. At LFS, people studied issues affecting their lives, such as housing problems and race relations. The activists at LFS included photographer Graham Keen (who later ran *International Times*), Peter Jenner (who became Pink Floyd's manager) and

In 1966, the London Free School revived the Notting Hill Fair and Pageant, which included a parade (above) down Portobello Road. John "Hoppy" Hopkins (opposite, top), widely regarded as the voice of the underground, co-founded the UFO club. AMM (opposite, bottom), an experimental free-form group, performs at the Spontaneous Underground.

black community leader Michael de Freitas (known as Michael X).

In July 1966, the London Free School organizers revived the long-dormant Notting Hill Fair and Pageant. The week-long street fair ended with a parade. A Caribbean steel band led the floats, which were followed by jazz bands and children in fancy dress. Twenty-five hundred whites and West Indians mingled in the streets. From this humble beginning, the Notting Hill festival has since grown to become the largest in Europe, attracting more than one million people each August.

Stephen Stollman — an American who came to London to scout new talent for his brother's avant-garde record label, ESP — believed things

3 0 *The first of several weekly Spontaneous Underground events is held at London's Marquee club. The mimeographed handbill promises Donovan/ Mose Allison/Graham Bond/Pop/Mime/Kinetic Sculpture/Discotheque/Boutique. Pot and acid are plentiful.*

The London Free School was more of a hype than a fact, actually. It was an intention that never got fulfilled properly. Quick history goes like this: Michael X, who tried to be England's answer to Malcolm X, owned a house in Notting Hill, which is a down-and-out place to be. The basement was vacant, and it was really a beaten-up, horrible little place. He had some idea about some black kids who weren't getting their education and reckoned they should be. We had some ideas about what we could do. The idea was to put on some free classes for the local kids. We could turn them on and feel pleased that we'd done something, and it would help Michael in what he was doing.

Well, I don't remember a single class actually happening in a formal way, although there were often gatherings of people. In a way it was like walking back into the Middle Ages: cooking on an open fire with a burned-out hearth in a basement in the middle of London. I tried to keep the administrative side together. As a result I had some debts caused by the London Free School, things like printing a magazine or leaflet or organizing something and putting money down. I used to earn quite good money as a photojournalist, but I got more interested in this underground stuff and was earning less and less money.

At any rate I thought, "Why don't we put on a benefit to pay off these debts?" We did it in late November 1966.

It was more like a happening than a programmed event, but people came and paid some money on the door. I realized that if we did it again next week more people might come and we'd be able to pay off the debts. So we had another benefit, and these people called the Pink Floyd came to play. Nobody could really understand their music, but it was very nice. At the same time, these other people came along with a slide show using liquid slides. The combination of the Floyd's music and the slide show and the general sort of unpredictable anarchist happening atmosphere caused more people to come. ✱

Indica, a bookshop, art gallery and gathering place for London's hip aristocracy, opens for business. It is a joint venture of book dealer Barry Miles, pop star Peter Asher and art dealer John Dunbar.

would happen spontaneously if you provided a space for people to perform. He rented the Marquee club one Sunday afternoon and invited key figures on the London scene to "the Spontaneous Underground." His invitations promised "costume, masque, ethnic, space, Edwardian, Victorian and hipness generally . . . face and body makeup certainly." On the appointed day, people drifted to the Marquee dressed in Edwardian and other period finery, dragging yards of fabric found in the streets of the nearby garment district. Poets Spike Hawkins and Johnny Byrne arrived wearing long overcoats and mufflers; onstage, they read poetry and performed conjuring tricks.

Donovan appeared wearing red and black makeup. Each eye bore the outline of the Egyptian Eye of Horus. He brought six sitar players and a conga drummer and sat cross-legged onstage. The next day, he was unable to remember even being

The Graham Bond Organisation (below) performs at the Marquee club in 1969. Organist Bond steered his group from jazz and rhythm & blues toward a darker, more underground sound in the late Sixties, reflecting his growing involvement with drugs and black magic.

there. The Graham Bond Organisation, one of Britain's best rhythm & blues bands, played a memorably weird set. Having gone off psychedelia's deep end, Graham made black-magic gestures and fixed a fierce gaze upon audience members as he tilted and slammed his Hammond organ.

The Spontaneous Underground immediately became the central gathering place for the underground. It had the same liberated atmosphere of the Albert Hall reading. Pot and acid were plentiful; alcohol was unnecessary. Each week's entertainment was wilder than the preceding week's. The second week, a classical pianist calmly played her way through a Bach prelude as Ginger Johnson and his African Drummers pounded cross-rhythms and blew trumpet reveilles. They concluded by banging on a huge, hollow tree trunk. By this time, the stage was barely visible through clouds of pot smoke. Had the police

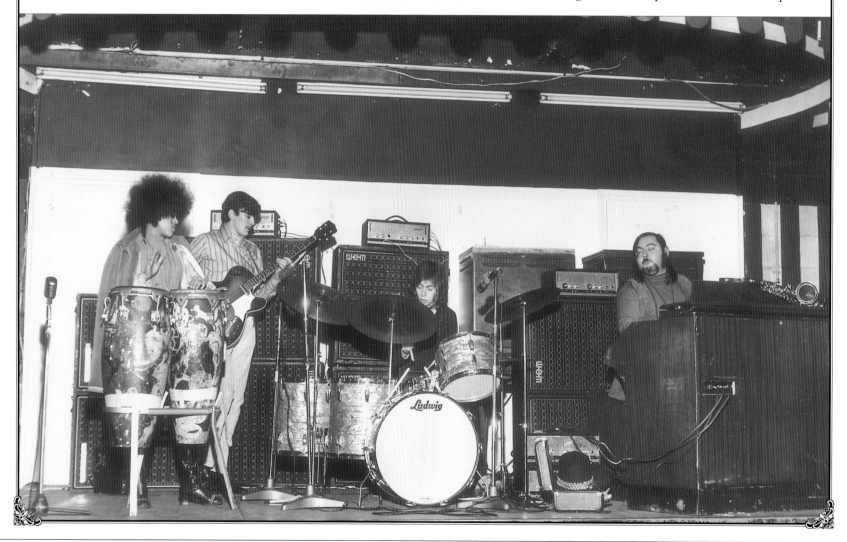

4 - 6 *Bill Graham promotes his first for-profit dance concerts at the Fillmore Auditorium, charging two dollars at the door.*

been on their toes, they could have rounded up the whole London underground scene in one fell swoop.

One of Soft Machine's ever-changing lineups played on March 13, joined by conga drummers and other percussionists. A young woman sat onstage while a friend trimmed her long red hair. A large heap of jelly (known in the United States as Jell-O) became a regular feature at early underground events such as this one. Invariably, someone would strip and roll around in it.

The most memorable Spontaneous Underground event, held in June 1966, featured performances by AMM and the Pink Floyd Sound. AMM was a free-form group on the forefront of avant-garde experimentation. They used whistles, sirens, tapes and electric toys that were allowed to run loose or vibrate on a steel tray. AMM's performance broke down the barriers between artist and audience. Each sound constituted a part of the piece, whether it originated onstage or in the crowd. There was no melody, no rhythm, no score.

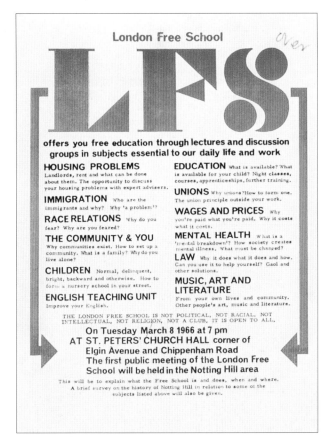

London Free School

LFS

offers you free education through lectures and discussion groups in subjects essential to our daily life and work

HOUSING PROBLEMS
Landlords, rent and what can be done about them. The opportunity to discuss your housing problems with expert advisers.

IMMIGRATION Who are the immigrants and why? Why 'a problem'?

RACE RELATIONS Why do you fear? Why are you feared?

THE COMMUNITY & YOU Why communities exist. How to set up a community. What is a family? Why do you live alone?

CHILDREN Normal, delinquent, bright, backward and otherwise. How to form a nursery school in your street.

ENGLISH TEACHING UNIT Improve your English.

EDUCATION What is available? What is available for your child? Night classes, courses, apprenticeships, further training.

UNIONS Why unions? How to form one. The union principle outside your work.

WAGES AND PRICES Why you're paid what you're paid. Why it costs what it costs.

MENTAL HEALTH What is a 'mental breakdown'? How society creates mental illness. What must be changed?

LAW Why it does what it does and how. Can you use it to help yourself? Gaol and other solutions.

MUSIC, ART AND LITERATURE From your own lives and community. Other people's art, music and literature.

THE LONDON FREE SCHOOL IS NOT POLITICAL, NOT RACIAL, NOT INTELLECTUAL, NOT RELIGION, NOT A CLUB, IT IS OPEN TO ALL.

On Tuesday March 8 1966 at 7 pm
AT ST. PETERS' CHURCH HALL corner of
Elgin Avenue and Chippenham Road
The first public meeting of the London Free School will be held in the Notting Hill area

This will be to explain what the Free School is and does, when and where. A brief survey on the history of Notting Hill in relation to some of the subjects listed above will also be given.

London Free School flier, March 1966 (left). Graham Keen, an editor for International Times (above). IT served as a forum for underground politics and pop culture (following pages).

JOE BOYD CO-FOUNDER OF THE UFO CLUB

There was a quote that used to be on the masthead of *International Times* for a while and certainly was one that you saw around a lot: "When the mode of the music changes, the walls of the city shake." That was the feeling.

In a way, the politics were the politics of ecstasy, with a small *e*. It was a political statement to get stoned and listen to somebody improvise on an Indian modal scale for twenty minutes with an electric group playing around him. It was just subversive. It was not much different from San Francisco. The politics were embedded in the attitudes toward sex, drugs and music that were implicit in the audience. The fact that what we were doing upset the establishment was part of the point.✳

17 *Under the aegis of Chet Helms, the Family Dog promotes a concert at the Fillmore Auditorium billed as "The First Tribal Stomp." By April, Helms will have taken over the Avalon Ballroom, and Bill Graham will manage the Filllmore.*

NOTTING HILL MAP INSIDE

19 *A revamped Big Brother and the Holding Company debuts at the Avalon Ballroom with a bluesy new singer from Texas named Janis Joplin.*

I WANT TO TAKE YOU HIGHER

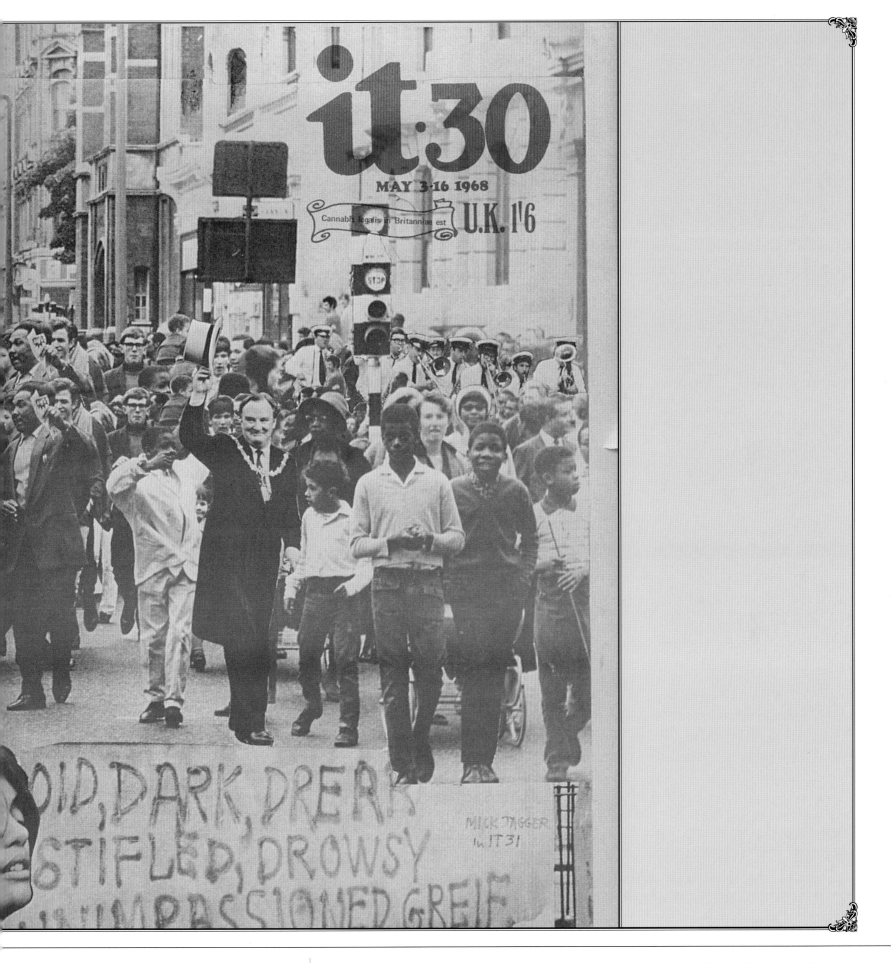

it.30

MAY 3-16 1968

Cannabis legalis in Britanniae est

U.K. 1'6

OID, DARK, DREAR STIFLED, DROWSY ...IMPASSIONED GREIF...

MICK JAGGER in IT 31

6 *The London Free School, an attempt to provide practical educational opportunities for London's working poor, is launched. Key figures in the London underground, including Peter Jenner and John "Hoppy" Hopkins, are involved in this effort to democratize education in class-bound Britain.*

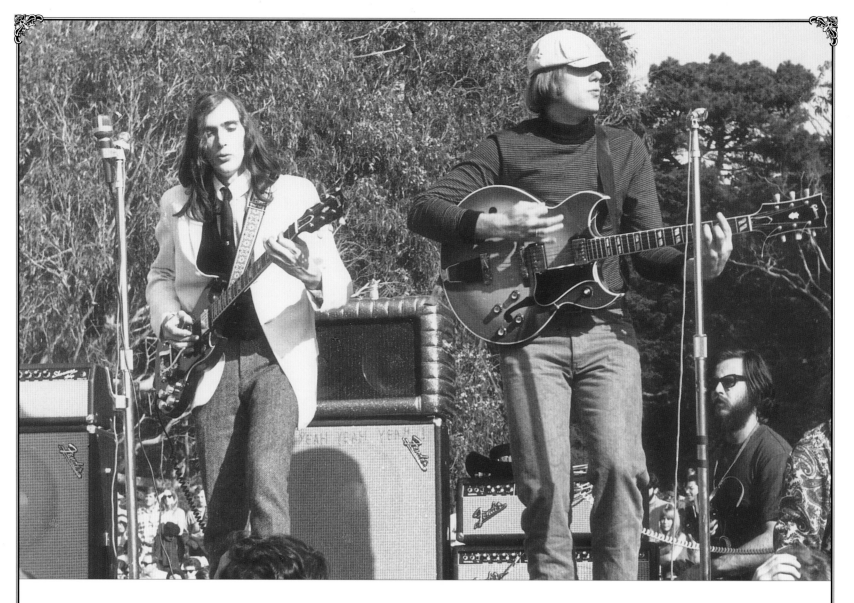

THE SAN FRANCISCO SOUND

The world of rock & roll was growing ever more interesting. Bob Dylan had a hit entitled "Like a Rolling Stone" that, at six-plus minutes, broke the Top Forty time barrier. The Beatles had begun doing more lyrical, existential songs, such as "I'm Looking Through You" and "You Won't See Me." The cover of their new album, *Rubber Soul*, was illustrated with bizarre foreshortening and distorted lettering, and one song actually contained the words "I get high."

In addition, they used a sitar on "Norwegian

Quicksilver Messenger Service (above) regularly played the Avalon Ballroom (poster at right) and became known for extended jams on old rhythm & blues numbers such as "Who Do You Love." Opposite page, from left: David Freiberg, Greg Elmore, Gary Duncan, John Cipollina, Jimmy Murray.

Wood," and everybody knew acidheads were into sitar music. Was it too crazy to imagine that the Beatles, the most popular musicians in the world, were getting psychedelic? It was such a wild and secret dream that hippies scarcely dared to think about it.

More bands were showing up on the San Francisco scene. At the first Family Dog dance, guitarist John Cipollina climbed onstage

MARCH '66

25 - 27 *Huge antiwar protests, parades and rallies are held in seven American cities. The largest protest draws 25,000 in New York.*

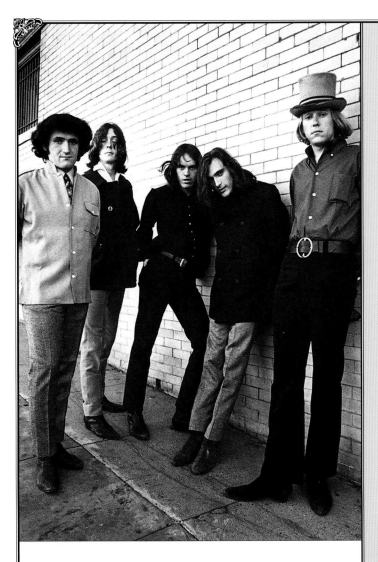

and surveyed the audience, awestruck by their numbers. His band, Quicksilver Messenger Service, had actually recorded a song, "The Star-Spangled Banner." The Committee, a San Francisco political comedy group, asked Quicksilver to record a rock version of the national anthem to play between sets at the Committee's shows. "Sure," said the band members. "Just get us the words."

The rockin' anthem featured Cipollina's swooping, crystalline guitar lines, and the actors liked it so well they paid the band two ounces of grass, rather than the agreed-upon one, and invited them to play at their Christmas party for $150. It was a big success. The Committee's friends liked Quicksilver's music, and the grateful band couldn't believe they had earned so much money just for playing six hours of music.

GARY DUNCAN
GUITARIST FOR QUICKSILVER MESSENGER SERVICE

David Freiberg was a folksinger. John Cipollina had played both rock & roll and folk music, too. Those guys knew all the finger-picking licks that folksingers play, and I didn't know any of that stuff. It was great for me because I got to pick their brains.

We shared everything we had: food, women, houses. Quicksilver had a very creative two-year period during which we made the first album [*Quicksilver Messenger Service*] and the second album [*Happy Trails*]. In the beginning, we didn't really have that drive to become stars. We were more concerned with making sure we always had enough dope. We were beatniks. We weren't going to play the game.

We took a lot of drugs. I'd take acid fourteen or fifteen days in a row until I got tired, then lay off for two or three days and go back at it again. That period of time in the Sixties there, just for a while, was a very up type of music. It may not have been the best technically, but the feeling in all the music was very up because everybody was taking acid. Prior to that the drug of choice had been heroin or speed, and after that it went back to heroin and speed. If you look around today, you see top groups OD'ing on heroin. I don't understand the music they play except that it's very depressing, most of it, and that's where it comes from. It stems from what kind of drugs they're taking.

Quicksilver would just take a song with a beat that we liked. The song was secondary, as far as lyrics were concerned. There were certain tunes that had a lick or a beat or a certain groove that lent itself to playing for a long time. So we'd sing the words and then fuck the words and just play. Endings and beginnings were real hard, so we'd just keep going until we fell apart. We were real unrestricted. We might play a song for two hours, 'cause we couldn't figure out how to stop. One guy would be trying to stop and another guy would get the wrong signal and start playing something else, and we'd just play for another fifteen or twenty minutes. ✱

8 *While many among the young question organized religion, the cover of Time magazine asks, Is God Dead?*

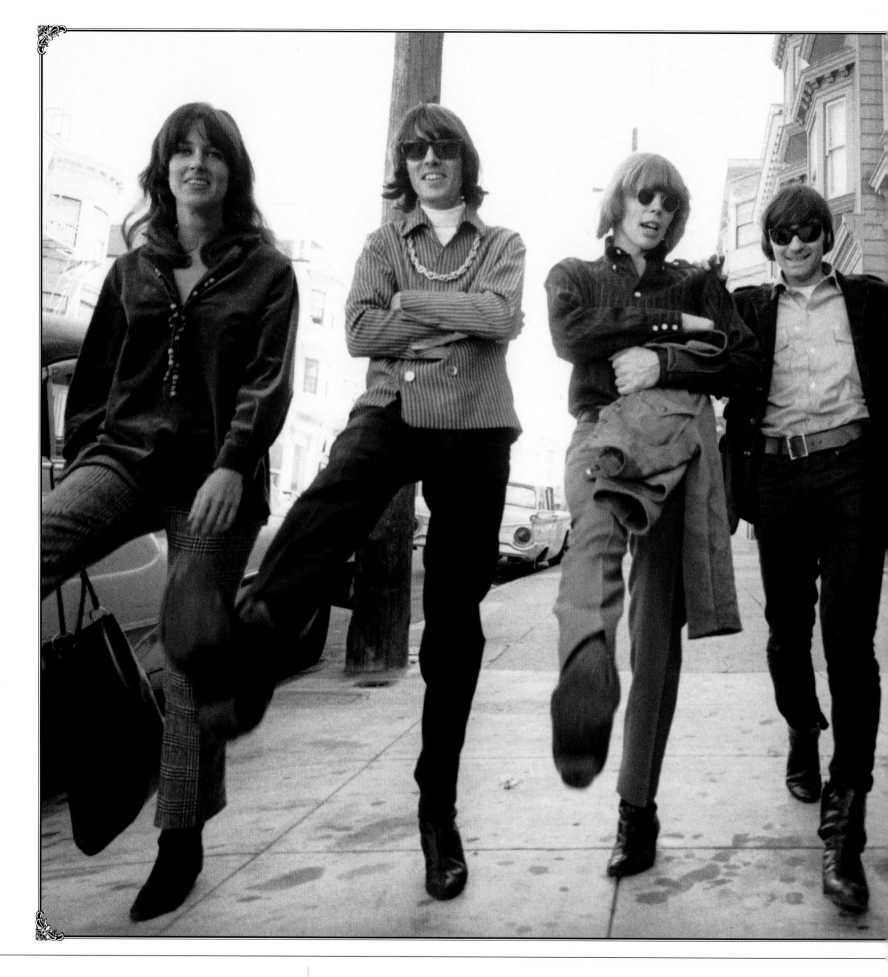

5 Black voting-rights activist James Meredith is wounded by gunfire while walking along a Mississippi highway. His shooting will further galvanize the civil rights movement.

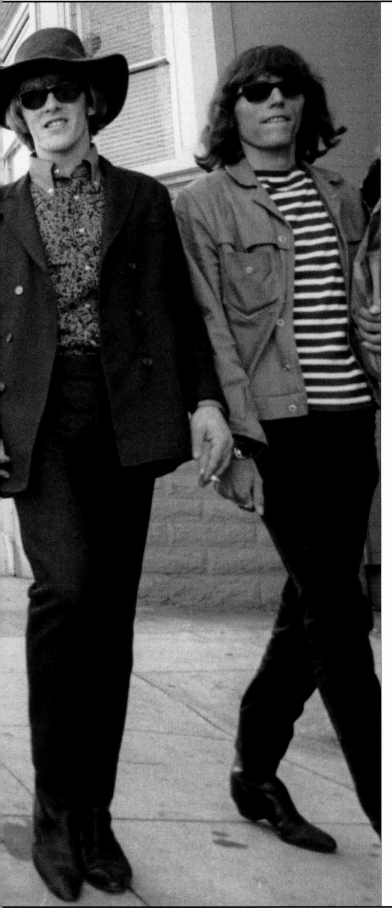

Jefferson Airplane kick up their heels on Haight Street during the heady year of 1967, when both Surrealistic Pillow *and* After Bathing at Baxter's *were released. "What we were doing wasn't anything like what had come before," says Grace Slick. "We wanted to keep expanding in some form. Sometimes we weren't very good at it, but we tried." From left: Slick, Spencer Dryden, Jack Casady, Marty Balin, Paul Kantner, Jorma Kaukonen.*

JORMA KAUKONEN
GUITARIST FOR JEFFERSON AIRPLANE

Even though I got a college degree in sociology, being a sociologist was furthest from my mind and being a musician was foremost on my mind. When I graduated and Paul Kantner asked me to join the Airplane, none of us had any idea that we would be at least partial creators of a psychedelic sound. Heck, I barely knew what psychedelics were.

I think all of us pretty much wrote our own rules as we went along. Jack Casady was the only member who'd played in a rock band. The transformation into psychedelia really made itself, because we didn't know what we were transforming into. In the beginning, I had a Rickenbacker twelve-string that Paul made me get, and I was using a lot of folk-blues techniques. Later on, beginning with *Surrealistic Pillow* and moving into *After Bathing at Baxter's*, I began to learn about the electric guitar per se. But it really was an ongoing process, and I didn't have the slightest idea what was going on.

As we got into it, the creative force we had at the time made me realize, "Hey, this is really cool!" In the beginning I wanted us to sound like a blues band, but after a while I realized it was pretty much going to dictate its own sound, and it was nice to be along for the ride.✳

JUNE '66

29 *American troops bomb the North Vietnamese capital of Hanoi for the first time in a marked escalation of the war effort.*

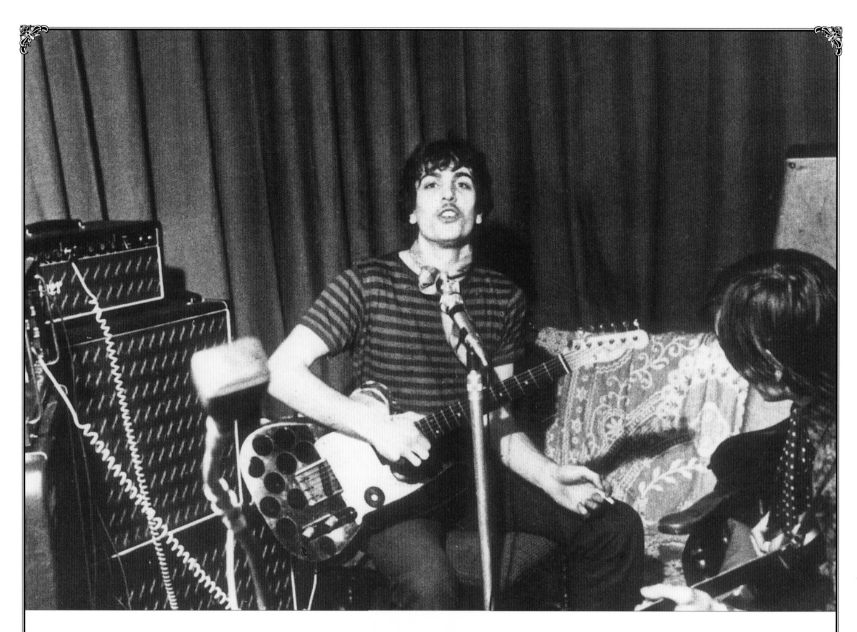

THE PINK FLOYD SOUND

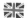

The Pink Floyd Sound had been formed in autumn 1965. Syd Barrett had moved to London from Cambridge to attend art school the previous summer. He shared a room with an old schoolmate, Roger Waters, who had arrived two years earlier to study architecture. Waters teamed up with fellow students Nick Mason and Rick Wright. Soon an embryonic version of Pink Floyd came together with the addition of guitarists Barrett and Bob Klose. Barrett thought up their

Pink Floyd co-leaders Syd Barrett and Roger Waters (above) shown rehearsing in 1966. Their influential debut single, "Arnold Layne," was produced by Joe Boyd, co-founder of the UFO club, where Pink Floyd pushed the boundaries of sight and sound.

name by joining the first names of bluesmen Pink Anderson and Floyd Council. Barrett later claimed the name was transmitted to him by a UFO. By then, he may have believed it.

When Pink Floyd played, movies were projected onto the stage and colored lights pulsated in time to the music, making it hard to see their faces. The continuously shifting light show rendered the group's members anonymous — an element of the Floyd's act that stayed with them. "The whole mixed-media thing started happening in 1966," bassist Waters recalled. "We had a Sunday afternoon at the Marquee with film going and us banging and crashing away."

3 1 John Lennon sparks a furor when these remarks, first published in Britain back in March, are uncovered by the U.S. press: "Christianity will go. It will vanish and shrink. I needn't argue about that, I'm right and will be proved right. We're more popular than Jesus Christ now." The first Beatle bonfire — in Birmingham, Alabama — occurs on this date.

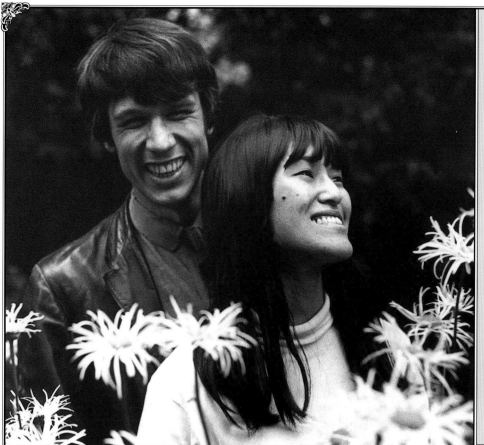

PETER JENNER Co-Manager of Pink Floyd

There was this gig called the Spontaneous Underground at the Marquee club on a Sunday night in 1966. I went down to watch it and saw the Pink Floyd there. I thought, "Oh, they're interesting, they're avant-garde," because they were doing improvisation and making noise with reverb and things. They were into noise, and I was into noise.

They intrigued me. It wasn't just another beat group. They were playing some rather ordinary blues and pop songs, but then there would be this long improvised solo thing. Instead of howling blues guitars, it would be all this noise, which keyboardist Rick Wright and guitarist Syd Barrett made. That's certainly what turned me on. ✳

The band met Peter Jenner, their first manager, at that Marquee show. "I arrived around 10:30," Jenner recalled, "and there was this strange band playing a mixture of R&B and electronic noise. Between routine numbers like 'Louie Louie' and '(I'm A) Road Runner,' they were playing these very weird breaks. It was all very bizarre and just what I was looking for — a far-out, electronic, freaky pop group." With Jenner in charge, the Floyd were drawn into the London underground scene. He immediately booked them to play a London Free School gig at All Saints Hall in Notting Hill.

"There were about twenty people at the first show," said Roger Waters. "A hundred showed up the second week. After that, it was three to four hundred, and then you couldn't get in." Waters claimed Pink Floyd hadn't actually heard any of the West Coast groups who would appear to be obvious role models. This wasn't entirely true, as Barrett was familiar with *Fifth Dimension* by the Byrds and the eponymous first album by Love, another

Peter and Sumi Jenner (above) on their wedding day in July 1966. Jenner co-founded the London Free School and co-managed Pink Floyd. This program (right) is from the first psychedelic tour of the U.K. It featured Pink Floyd, Jimi Hendrix, the Move and Amen Corner.

groundbreaking band from Los Angeles. Barrett was introduced to Love by Jenner, who hummed the guitar hook from their version of "My Little Red Book" to him. Barrett tried playing it back on guitar, but it came out quite differently. He used those very chord changes in "Interstellar Overdrive," the most emblematic of Pink Floyd's early compositions.

AUGUST '66

Jefferson Airplane Takes Off, the San Francisco group's debut album, is released.

2 9 *The Beatles perform their final concert at Candlestick Park in San Francisco.*

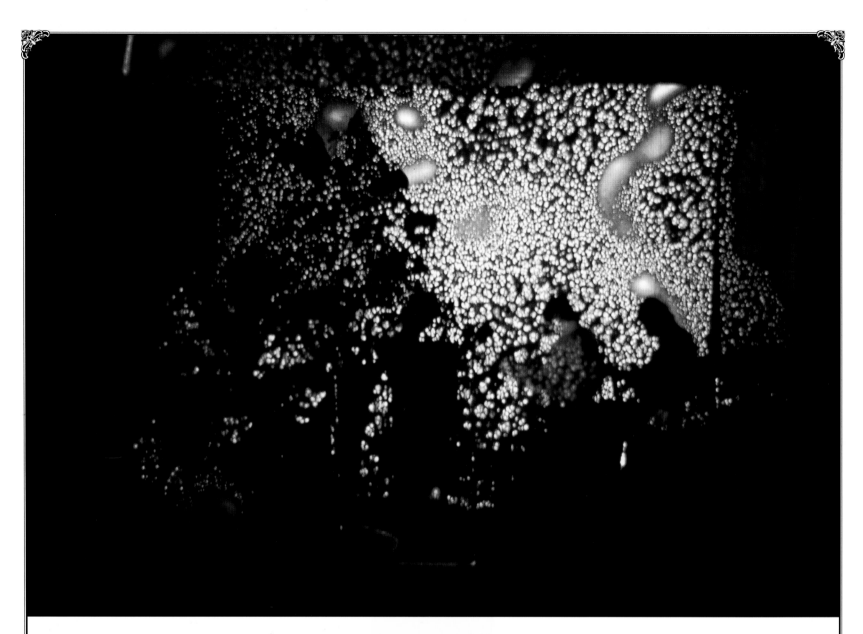

Acid was Barrett's drug of choice. He and Jenner smoked pot and tripped together. "I don't think Syd was a man of the times," observed Nick Mason, the group's drummer. "He didn't slot in with the intellectual likes of the London Free School people. But Syd was a great figurehead. He was part of the acid culture."

Late in 1966, an American couple named Joel and Toni Brown arrived in London with a light show they had developed while living at Timothy Leary's Millbrook commune. At Pink Floyd's first LFS show, they set up a projector for their colored slides and began casting strange images over the group. Jenner quickly built one of his own spotlights covered with bits of

Pink Floyd, accompanied by a light show, set the controls for the heart of the sun at an October 1966 concert at the London Free School (above). The Byrds, shown performing on **Ready Steady Go!** *in November 1965 (opposite), were very influential among London's underground musicians — more so, some say, than the San Francisco groups.*

tinted plastic. The lights were turned on and off with ordinary light switches. This rudimentary arrangement was Pink Floyd's very first light show. It was immeasurably improved by Joey Gannon, a teenage student at an art school where the Floyd played that November. By the end of the year, the group had developed the pulsating liquid slides that would come to characterize most of the London psychedelic light shows.

"The main element of the underground that we tuned into was mixed media," Mason said. "We may not have been into acid, but we understood the idea of a happening. We supplied the music while people did creative dance, painted their faces or bathed in the giant jelly."

S E P T E M B E R ' 6 6

3 **Donovan's jazzy psychedelic single "Sunshine Superman," whose flip side is intriguingly titled "The Trip," rises to #1 in the U.S.**

1 9 **Timothy Leary, founder of the League of Spiritual Discovery (LSD, for short), proclaims acid to be the sacrament for his new religion.**

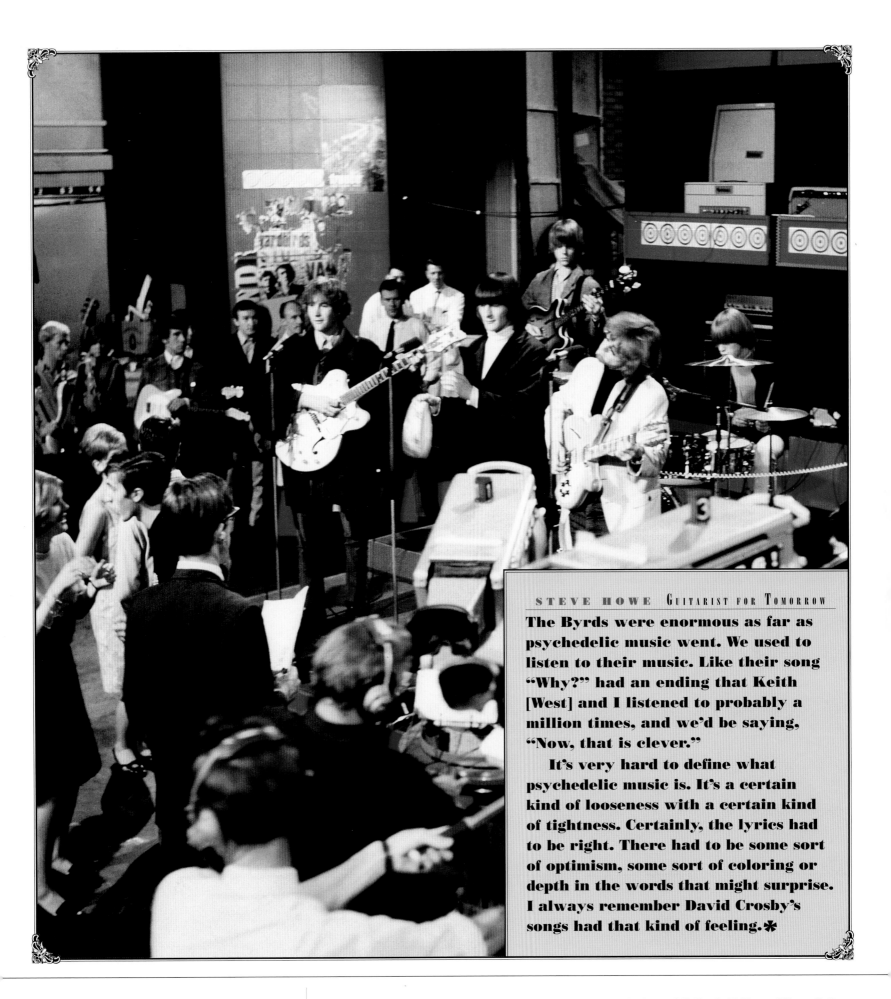

The Byrds were enormous as far as psychedelic music went. We used to listen to their music. Like their song "Why?" had an ending that Keith [West] and I listened to probably a million times, and we'd be saying, "Now, that is clever."

It's very hard to define what psychedelic music is. It's a certain kind of looseness with a certain kind of tightness. Certainly, the lyrics had to be right. There had to be some sort of optimism, some sort of coloring or depth in the words that might surprise. I always remember David Crosby's songs had that kind of feeling.✻

SEPTEMBER '66

20 The first issue of the San Francisco Oracle is published. Editor Allen Cohen promises the magazine will "confront its readers with a rainbow of beauty and words ringing with truth and transcendence."

PSYCHEDELIC CHAOS

⚑

In a neglected San Francisco neighborhood known as the Haight-Ashbury district, a marijuana legalization activist named Chet Helms was running jam sessions with the aim of putting together a band. So many people started coming that he tried to discourage them by charging admission, but that just made people figure there was really something going on. Within a few weeks, three hundred people a night crowded into the basement music room at 1090 Page St. Big Brother and the Holding Company emerged from the jam sessions. Their members included Peter Albin, a little guy with a startlingly deep voice, and a guitarist known as Weird Jim Gurley. Of course, Janis Joplin would eventually become their vocalist.

Big Brother and the Holding Company (below) trip the light fantastic at their rehearsal studio. A psychedelic poster for a Big Brother concert (opposite) plays up the skyrocketing popularity of singer Janis Joplin. The Grateful Dead and friends spill out of their communal home at 710 Ashbury St. (page 64). Jerry Garcia and his wife, Carolyn (a.k.a. Mountain Girl), are shown on page 65 (top), while Garcia cultivates his Captain Trips persona (bottom).

PETER ALBIN
BASSIST FOR BIG BROTHER AND THE HOLDING COMPANY

When Big Brother was a foursome, I did a lot of the singing. But I realized my limitations. Since some of the other groups in the city had female vocalists, it kind of influenced us. There were a couple of people we auditioned before Janis Joplin came up, but we pretty much knew Janis was going to be able to cut it and would bring some other things to the group that would be pretty good.

At that point, we were playing all this free-jazz rock & roll just as much as the Grateful Dead were and maybe even a little more so. Our fans, when they first heard us with Janis at the Avalon Ballroom, said, "Oh, get rid of the chick. She's going to ruin your freedom." ✳

6 Possession of LSD is made a misdemeanor and sale of the drug a felony in the state of California. The event is marked by the peaceful "Love Pageant Rally" in Golden Gate Park, "to affirm our identity, community and innocence from influence of the fear addiction of the general public as symbolized in this law."

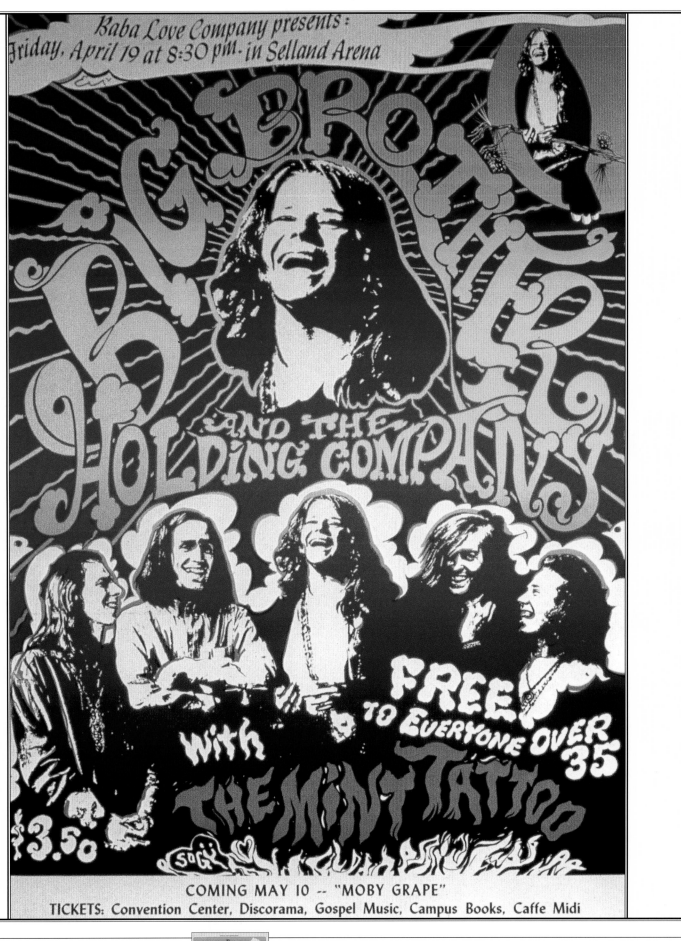

11 **International Times,** *Britain's first underground paper,* *is launched with an "all-night rave" at London's Roundhouse.* *Featured performers include Pink Floyd and Soft Machine,* *both accompanied by light shows.*

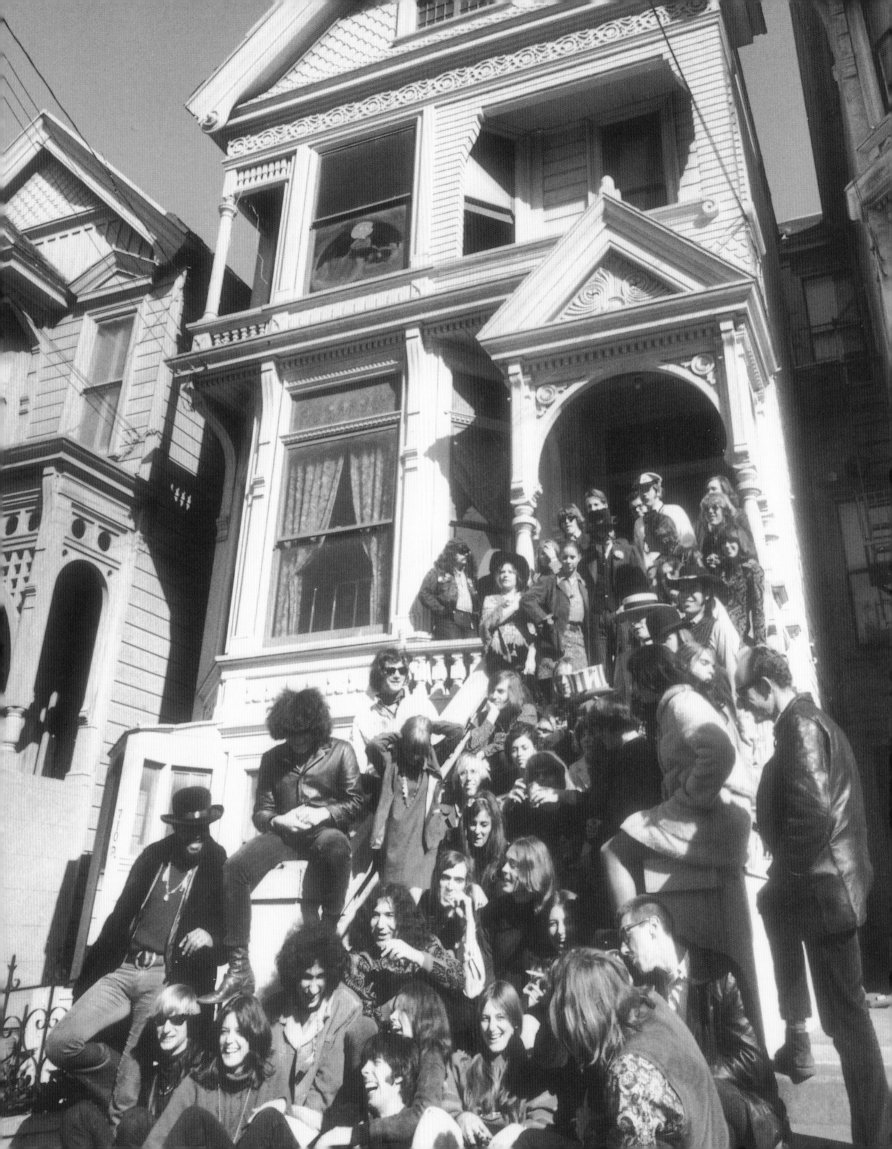

So then we broke into the front of the store, because he had a key, and got a bunch of instruments. We played for most of the evening, had a great time and decided we had enough talent there to start a jug band.

We started Mother McCree's Uptown Jug Champions, and it became real popular. I was sixteen at the time. I was playing a little guitar. Mostly I was playing washtub bass and jug and singing. Around a year later, the Beatles hit it big and electric instruments were starting to look more and more attractive to us. We became the Warlocks after that. Jerry, Pigpen and I formed the Warlocks, with the addition of Billy Kreutzmann on drums and Dana Morgan Jr., son of the music store owner, on bass. In the spring of '65, we added Phil Lesh.

The Warlocks did Rolling Stones tunes, blues tunes and jug-band tunes. Pigpen was way into the blues so we did a lot of that kind of stuff. His dad was an R&B disk jockey. And we began doing some tunes we wrote ourselves. ✱

BOB WEIR GUITARIST FOR THE GRATEFUL DEAD

I was wandering the back streets of Palo Alto on New Year's Eve of 1964 with a friend, and we heard banjo music coming from the back of the music store, Dana Morgan Music. We knew it had to be Garcia. He was a banjo and guitar teacher there, so we knocked on the door and he invited us in. He was waiting for his students to come by, and we apprised him of the fact that it was New Year's Eve and they probably weren't going to show.

OCTOBER '66

15 *The Black Panther Party is launched in Oakland, California, by activists Huey Newton and Bobby Seale.*

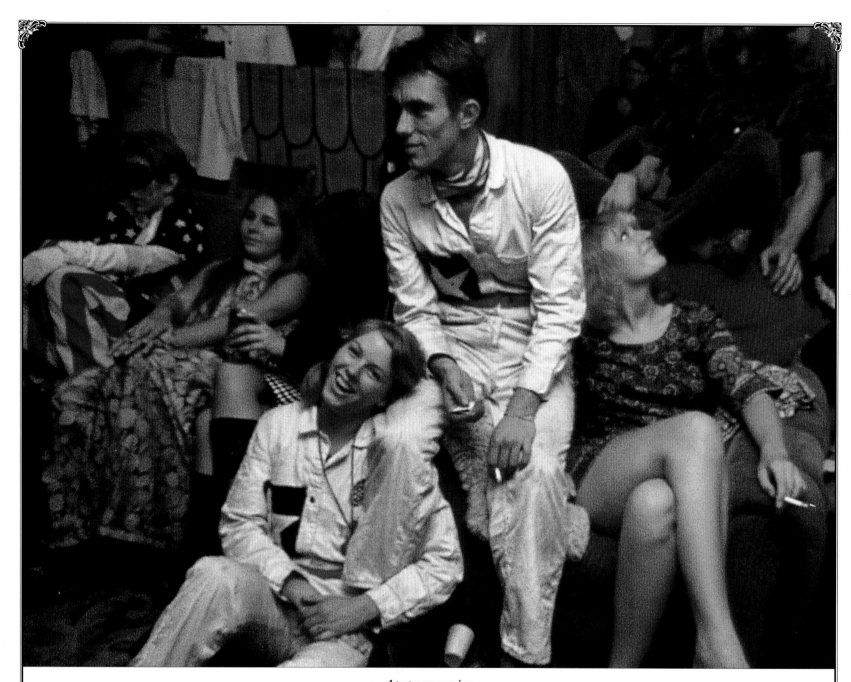

On January 8, 1966, the Merry Pranksters put on a colossal Acid Test at the Fillmore Auditorium, in San Francisco's black ghetto. They had put down a deposit on the hall two days earlier, ignoring the landlord's earnest warning that there would be no way to publicize an event in that short a time. The Pranksters just smiled mysteriously. About twenty-four hundred people showed up.

The Fillmore was a huge dance floor with a balcony running along two sides. The Pranksters wired it up with so much electronic equipment —

A poster announcing the Acid Test Graduation, which was to be held at Winterland in San Francisco on Halloween 1966 (opposite). In actuality, the event had to be moved at the last minute, though the spirits of the graduating class nonetheless remained high (above).

including the TV Portapaks they were going to carry around — that the floor was littered with electronic boxes and skeins of electric cable. The whole place actually gave off a low, buzzing hum.

The show started in the usual fashion with Kesey's Psychedelic Symphonette playing random sequences of notes at one end of the floor. Down at the other end, the Warlocks, who had recently changed their name to the Grateful Dead, were simultaneously playing rock & roll built around the expansive noodlings of guitarist Jerry Garcia.

NOVEMBER '66

8 Ronald Reagan is elected governor of California. He promises to crack down on student war-protesters at Berkeley and to enforce anti-obscenity laws. One week later, the Psychedelic Shop in San Francisco is raided for allegedly selling obscene literature. The offending publication is a poetry collection called The Love Book, by Lenore Kandel.

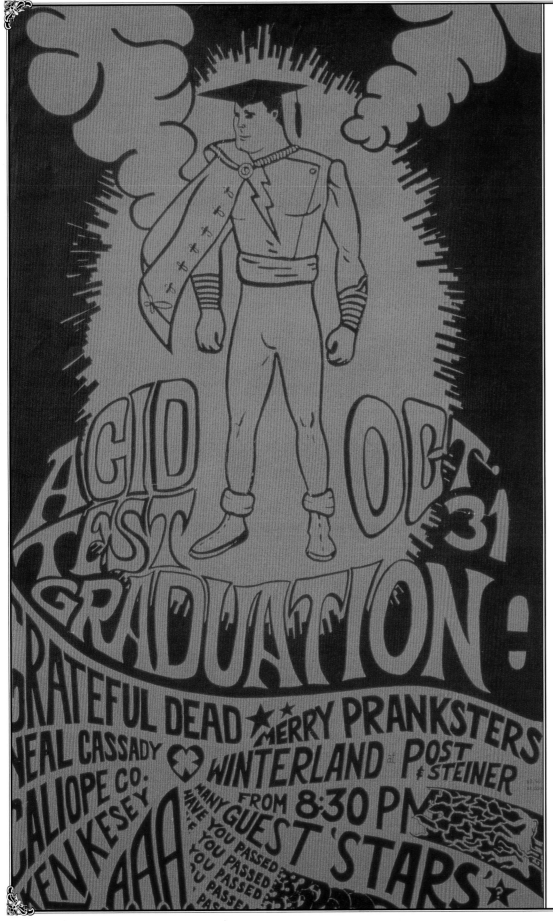

In the middle of the floor stood a baby bathtub full of Kool-Aid spiked with LSD.

From then on, the evening was psychedelic chaos. Pranksters wore comic-book superhero costumes and wandered around doing everything they could to make the trip weirder. Phrases that read like excerpts from a Kesey novel-in-progress were projected onto the walls. Perhaps this whole event was a Kesey novel, set in some kind of space-age madhouse.

Because of city regulations, the Acid Test was required to end at 2:00 a.m., and the police showed up to make sure the curfew was observed. "Who's in charge?" they demanded. Hilarious. Everything had been totally out of control for hours.

The police went around pulling plugs and turning off switches. The Pranksters went around after them turning everything back on again. When the lights went off, the crowd cheered. When they went back on, they cheered again. A group of people on the floor had found a ladder and were climbing toward the police, chanting, "Hug the heat! Hug the heat!" just as Kesey's lawyers arrived to smooth everything over.

Neal Cassady, one of the original beatniks, was there that night. He had been hanging around with the Merry Pranksters for some time. Habitually wired on amphetamines, he would usually be talking a motormouthed stream of consciousness while juggling a hammer to deal with his speed-induced restlessness. But here, staring down from the Fillmore balcony at all the stoned people crawling through mountains of electronic equipment and giant sculptures, he seemed downright placid.

NOVEMBER '66

9 John Lennon meets Yoko Ono at Indica Gallery during a private preview of her show "Unfinished Paintings and Objects."

21 The first sex-change operation at an American hospital is performed at Johns Hopkins University in Baltimore.

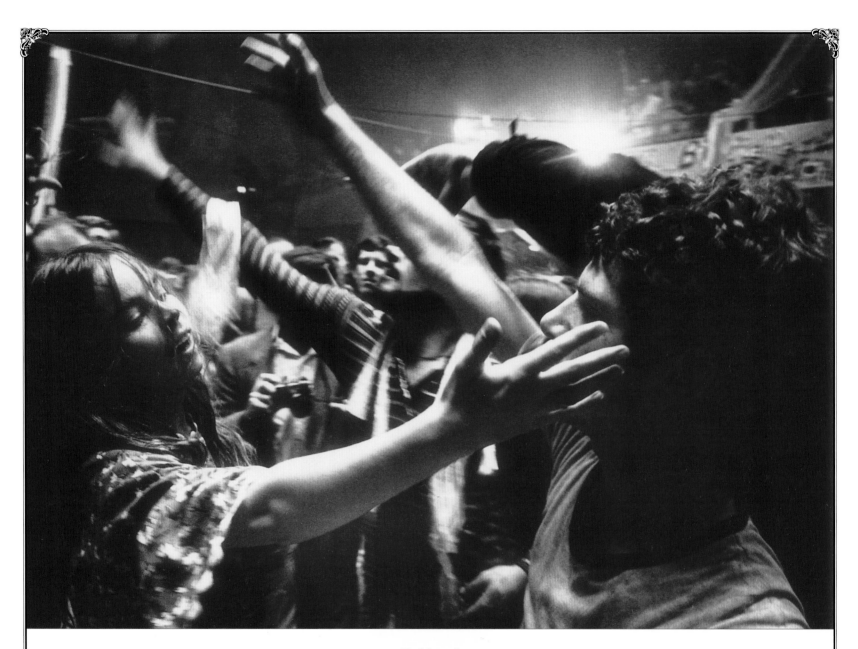

The event that followed the Fillmore Acid Test was boldly named the Trips Festival. It aimed at incorporating everything that had been part of these public gatherings into whatever else might fit. Stewart Brand had rented Longshoremen's Hall from January 21-23, 1966.

The Trips Festival poster read: *the general tone of things has moved from the self-conscious Happening to a more JUBILANT occasion where the audience PARTICIPATES because it's more fun to do so than not. Maybe this is the ROCK REVOLUTION.*

Not just maybe. From the first night, the LSD party engulfed the cabaret theater skits and

Gleeful anarchy reigns at the Trips Festival (above and following pages), a three-night psychedelic happening at Longshoremen's Hall in 1966. A poster for the festival (opposite, left) and a column by **San Francisco Chronicle** *music journalist Ralph J. Gleason (opposite, right) mark it as an event to remember— that is, if you could.*

slides of American Indians. A band called the Loading Zone was hurried onstage to handle the vast, undirected energy that pulsed through the hall. The second night was supposed to feature avant-garde films, a light show and the music of Big Brother and the Holding Company, fresh from their first gig. But the Grateful Dead swept everybody offstage and the event turned into another thundering Acid Test, complete with flashing strobe lights and fluorescing colors while Kesey's messages were projected on the wall in the unparalleled chaos (one such message: "Anybody who knows he is God, go up onstage"). When the event closed down at 2:00

DECEMBER '66

2 6 **Time unveils its annual Man of the Year. It is not an individual but the Younger Generation.**

One Wild Night-- A Trips Festival

Ralph J. Gleas[on]

IN THE OPENING pages of that modern classic, "[The] Circus of Dr. Lao" (available now in a Bantam pap[er]back) Dr. Lao's circus is [describe]d as having a midw[ay] conquests, resurrected supermen of antiquity." "replete with sideshows wherein were curious being[s] the netherworld on display, macabre trophies of anc[ient]

Dr. Lao would have been right at home at the Tr[ips] Festival this weekend: the variety, imagination, deg[ree] of exoticism and just plain freaky far-outness of thousands who thronged the Longshore Hall defies d[es]cription.

Hastening to get this report to you, I have had [to] skip Sunday night's affair but I can tell you what w[ent] on at the other two. Friday night: Nothing. A bus[t, a] bore, a fake, a fraud, a bum trip. One of the frustra[ted] customers got on stage halfway through the dull ev[en]ing and said, unselfconsciously, into the micropho[ne] "this is a bore even on acid." A little while later, [a] guy behind me said to his partner, "Let's go out in [the] car and listen to the radio." It seemed like a bri[ght] idea.

★ ★ ★

DESPITE THE PROMISE of unspeakable deligh[ts] all that happened Friday was a series of dull st[atic] events from the Open Theater (which may be succes[sful] there, but are nowhere in a large hall), some slide[s,] pictures of Indians and some free form, multi-colo[red] flicks. At one point I went over and looked into the [In]dian teepee that was set up on the floor. There was [a]

a.m., there was still a line outside. This was nothing new to producer Bill Graham, who had been desperately running around all night with his clipboard, trying to keep the vast, polymorphous event organized.

The third night, which hadn't been entirely planned, automatically became another Acid Test and dance with the Grateful Dead, the video cameras, the giant sculptures and the rest. In the roaring chaos, an Olympic trampolinist who wore a mask to preserve his amateur status dove from the balcony into a trampoline under stroboscopic light.

Well over 6,000 people had attended the Trips Festival. It was the only place to be that weekend. A band named the Mystery Trend, who hadn't been paying attention, booked a theater on Saturday. Only three people showed up.

JANUARY

1 4 *A Gathering of the Tribes for a Human Be-In is held in Golden Gate Park in San Francisco. Described as "a union of love and activism" by its planners, the Human Be-In draws a peaceful crowd of thousands. Performers include Quicksilver Messenger Service, the Grateful Dead and Big Brother and the Holding Company.*

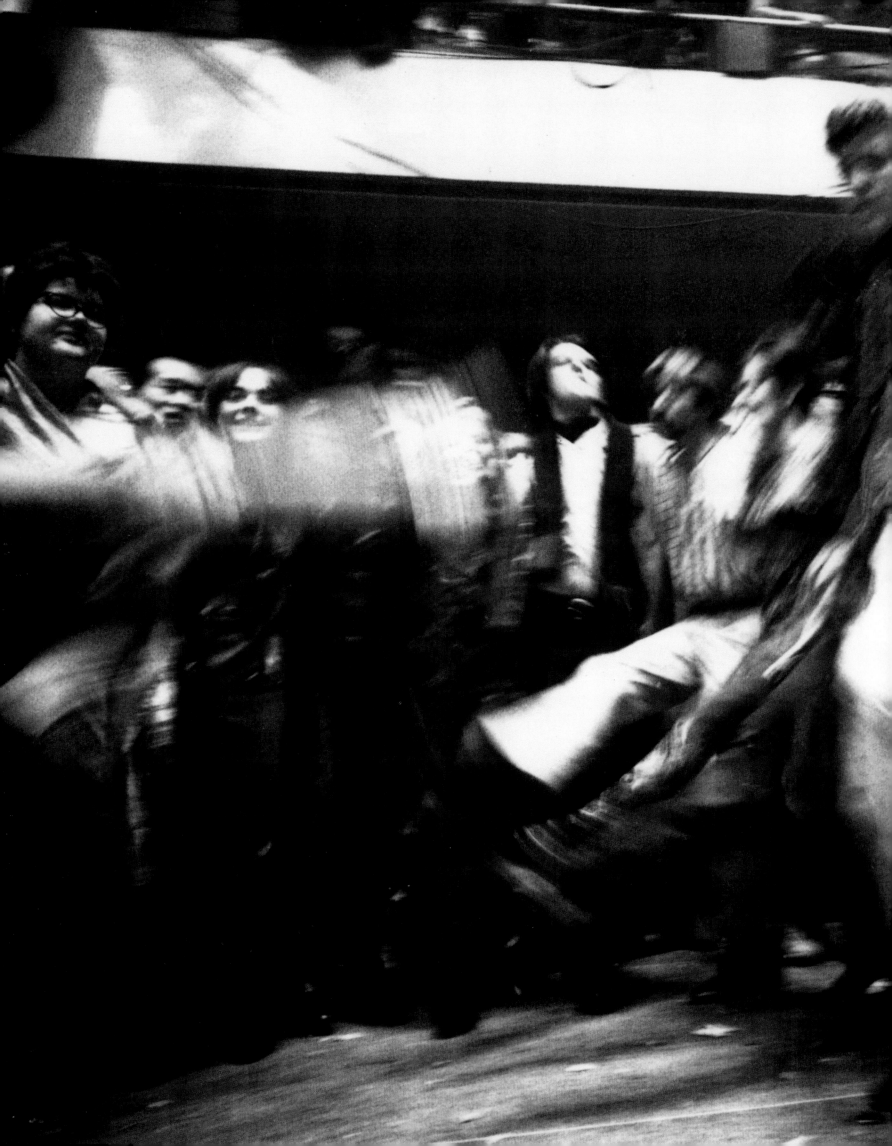

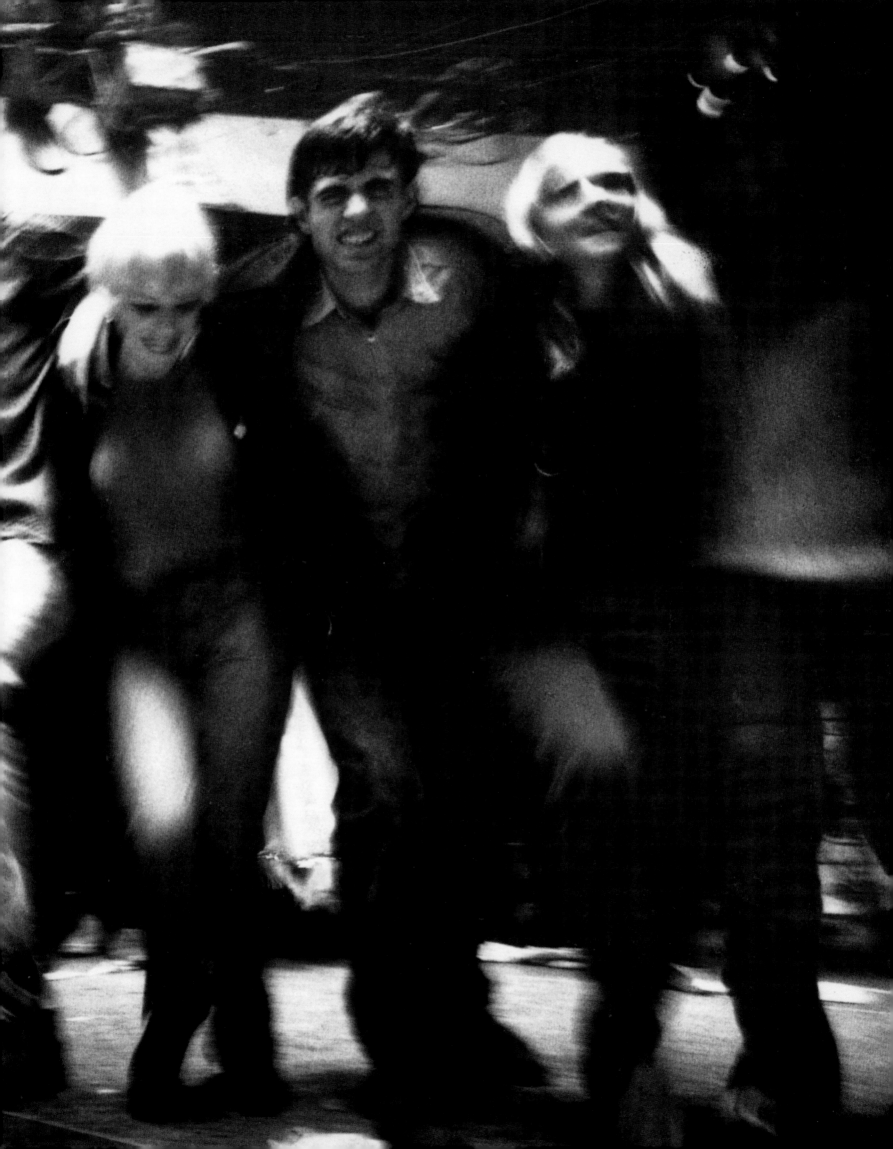

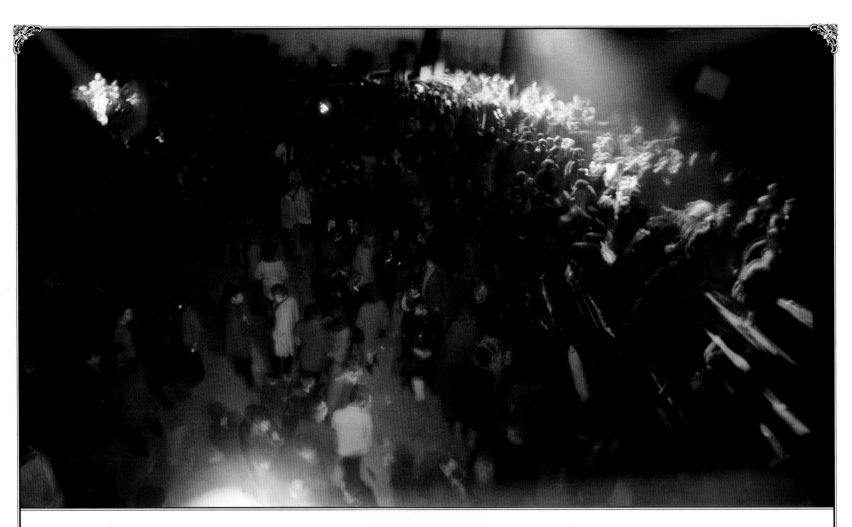

INTERNATIONAL TIMES

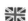

Pink Floyd played their first gig before a large crowd on October 11, 1966. The occasion was the launch party for *International Times* (*IT* for short), which became Europe's first underground newspaper. Inspired by the Albert Hall poetry reading, John "Hoppy" Hopkins and I were attempting to reach the new audience we had seen there. After publishing several poetry anthologies, an album and a newsletter, we had decided that an alternative newspaper was called for. *IT* was modeled on the *Village Voice*, the *East Village Other* and the *L.A. Free Press*. We began in the basement of Indica Books, which had by then separated from the gallery and moved to Southampton Row.

Congregants at the Roundhouse (above), the rail yard turned concert arena where such events as the 1966 launch party for **International Times** *took place. Soft Machine, who were co-equals with Pink Floyd on London's underground scene at mid-decade, perform at an* **IT** *benefit at the Roundhouse in 1966 (opposite).*

The newspaper's launch party was held at the Roundhouse, an old engine shed that had stood empty for fifteen years. There were only two toilets, and it was freezing cold, a fact that encouraged people to dance. A large bowl of sugar cubes greeted everyone at the entrance. Though the cubes weren't spiked, plenty of people behaved as if they were. Some brought their own lysergically fortified sugar cubes. People wore silver-foil headdresses and masks, refraction lenses, eighteenth-century military uniforms, bondage gear and glitter. Paul McCartney dressed as an Arab. Marianne Faithfull won a prize for barest costume: a nun's habit that did not quite cover her bottom. There were stalls and vendors, and the London Filmmaker's Co-Op gave an all-night film show featuring underground favorites.

Soft Machine had played at both the Spontaneous Underground and the London Free School, but the crowd of 2,500 at the Roundhouse

JANUARY '67

15 *The Rolling Stones perform their controversial new single,* "Let's Spend the Night Together," *on the Ed Sullivan Show, amending the lyrics at Sullivan's insistence to* "Let's spend some time together."

The Roundhouse was this huge place near Chalk Farm, a great old engine railway turning-place. That, in fact, was more important than UFO. That's where it all started. The burgeoning psychedelic scene in England started there. It was huge and freezing.

In concert, the Soft Machine were pioneering the nonstop set where all the numbers were linked. My particular corner of that was one repetitive song we had called "We Did It Again," which sometimes we would do for half an hour or more. There were a lot of improvisational things. Long solos. As soon as the ideas came up, we were throwing them at the audience.

It would probably be quite boring now, if you were to listen to it, but at the time it was quite fun because the people were so stoned that that was the thing to do.✴

JANUARY '67

2 4 *San Francisco police chief Thomas Cahill coins the term "the Love Generation" to describe the denizens of the Haight-Ashbury.*

2 7 *The U.S., the U.S.S.R. and fifty-eight other nations sign a treaty banning nuclear weapons in outer space.*

INTERNATIONAL TIMES FIRST
ALL-NIGHT RAVE

POP OP COSTUME MASQUE DRAG BALL ET AL

STRIP TRIP/HAPPENINGS/MOVIES
SOFT MACHINE/PINK FLOYD STEEL BAND

SUR PRIZE FOR SHORTEST-BAREST

ROUND HOUSE (OPP CHALK FARM TUBE)
SAT 15 OCTOBER 11 PM ONWARDS
5 SHILLINGS IN ADVANCE 10 SHILLINGS DOOR

BRING YOUR OWN POISON

An **International Times** *concert flier (left) touts a familiar double bill: Pink Floyd and Soft Machine. A ticket to an event at the Roundhouse (bottom right) is all hearts and flowers. Mike Lesser, a performance artist (opposite), parties naked at an* **International Times** *benefit concert in 1966. Lesser, who orchestrated a lot of happenings, is caught in the messy act of body painting. In the foreground, an enormous mound of jelly (Jell-O) continues to set, promising untold fun. You can get* **IT** *if you really want: a sign for* **International Times** *(page 76) and an actual cover from Britain's first underground paper (page 77), which mixed international politics with pop culture.*

Soft Machine took its name from the Burroughs novel of the same name. Their lineup was always very flexible, and a variety of modern-jazz musicians often sat in with them.

The Roundhouse gig was Soft Machine's first as a quartet. Daevid Allen recalled: "Yoko Ono came onstage and created a giant happening by getting everybody to touch each other in the dark, right in the middle of the set. We also brought a motorcycle onstage and put a microphone against the cylinder head."

It was the first time most of the audience had seen a light show, and many stood openmouthed. The Floyd brought their set to a dramatic climax by blowing out the fuses, which plunged the building into darkness. In its review, the Sunday London *Times* noted that "a pop group called the Pink Floyd played throbbing music while a series of bizarre-colored shapes flashed on a huge screen behind them. Someone had made a mountain of jelly, and another person had parked his motorbike in the middle of the room. All apparently very psychedelic."

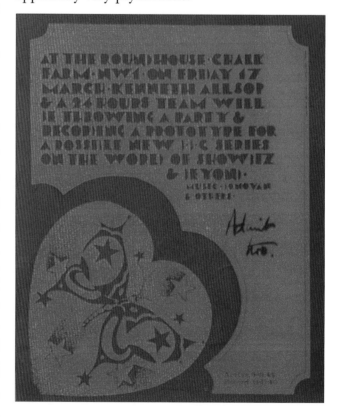

was by far the largest the band had ever seen. Robert Wyatt and Mike Ratledge met at school in Canterbury, where they shared an interest in avant-garde jazz. They were joined by Kevin Ayers and Australian poet Daevid Allen, who already had an impressive résumé at age twenty-one, having read in Paris with William Burroughs and recorded with avant-garde musician Terry Riley.

The first issue of Oz, a colorful paper started by Australian immigrants drawn to London's underground scene, is published.

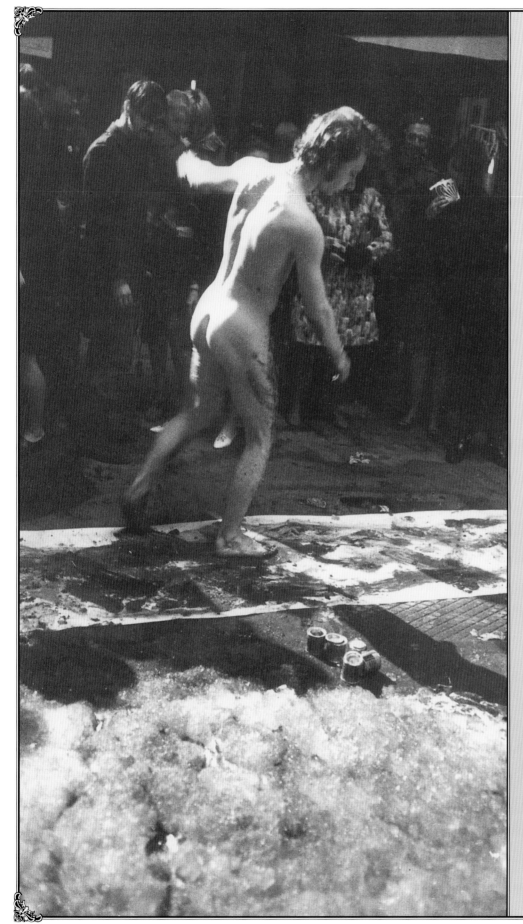

In 1965, I got offered a job opening Elektra Records' office in London and took it. One of the first people I met was John "Hoppy" Hopkins. By 1966, I'd left Elektra and was managing the Incredible String Band. Hoppy and I had become part of the London Free School. Pink Floyd played a benefit concert for it at a church hall in Notting Hill. They and the Soft Machine also played at the *International Times* launch at the Roundhouse in October 1966. That was really the kind of template for everything that came afterwards. It was a great event. It was kind of the debut of the London underground scene.

It was also the first week of *IT*'s existence, which meant Hoppy was plunging himself fully into the underground and giving up his job as a working photographer. The early weeks of *IT* didn't generate a lot of cash. We were both in a position where we needed a source of income, so we started talking about the idea of putting on a show like the *IT* launch and charging admission. We looked for a place to do it, and Hoppy found this Irish dancehall in the West End called the Blarney club. We had the first UFO club event there on December 23, 1966. Basically, for the first two and a half months, it was Pink Floyd and the Soft Machine alternating. That was the beginning of the meteoric nine-month career of the UFO club.✳

4 *Buffalo Springfield's "For What It's Worth," a song inspired by the Sunset Strip riots in L.A., is released. Stephen Stills' lyrics address the increasingly violent generational divide in American society: "Stop! Hey, what's that sound? Everybody look what's going down."*

you can get

here

PETER JENNER Co-MANAGER OF PINK FLOYD AND Co-FOUNDER OF THE LONDON FREE SCHOOL

We were all young hippie dopers, and we were based in West London, around Notting Hill. We used to meet at Hoppy's. Hoppy [John Hopkins] was absolutely central to the organization of the early events of the London underground. He also seemed to know where you could get some dope. He was a nuclear physicist turned photographer. I was a lecturer at the London School of Economics in economics and sociology.

Then there was Joe Berke, an American psychologist who was involved with R.D. Laing. Race was an important issue, and Michael X [a black activist] was involved, which gave us a whole view on that aspect.

In this context, Barry Miles started the *International Times,* which was to be an information vehicle for the London Free School. It was all about enlightenment and freeing your head from all the old hang-ups and old-fashioned shit. The Free School was a wonderfully nice idea, as we all wanted to connect traditional disciplines in a relevant "modern" manner.✱

12 *DJ Larry Miller debuts the first underground-radio show on KMPX-FM in San Francisco. Eschewing the Top Forty playlists in favor of album cuts, Miller's show runs from midnight to 6:00 a.m., Monday through Saturday.*

1 2 *Keith Richards' home Redlands, in West Wittering, Sussex, is raided by authorities looking for drugs after an alleged tip-off from the tabloid News of the World.*

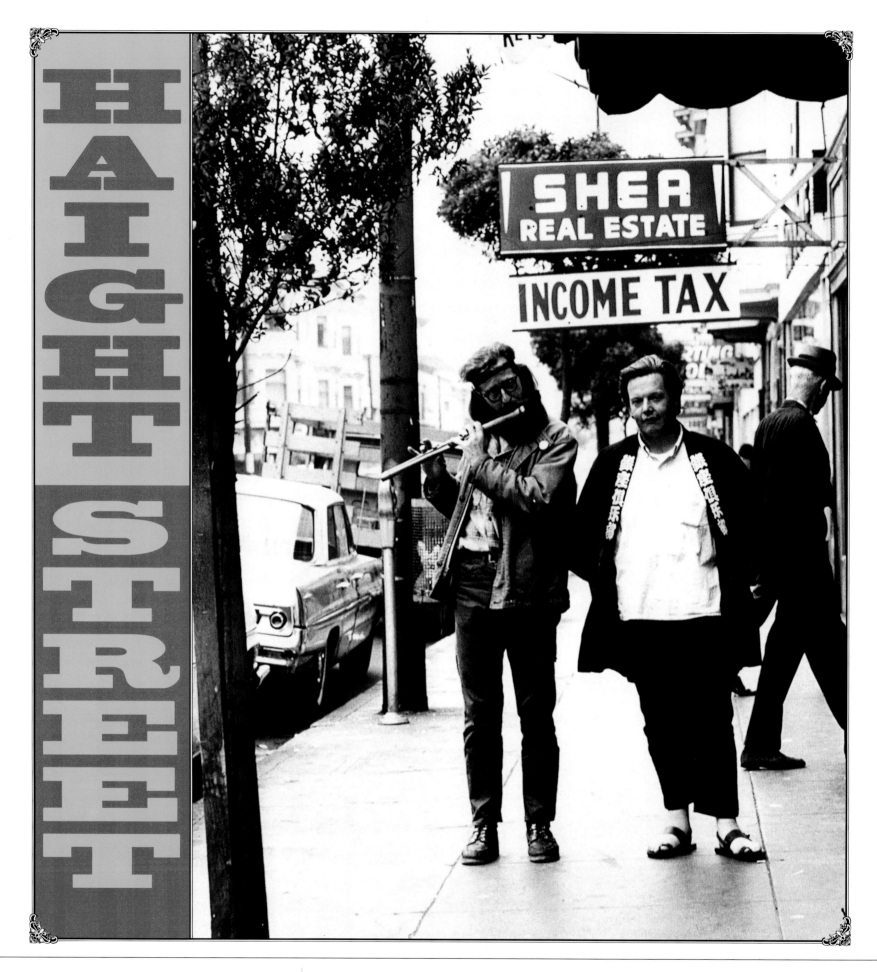

HAIGHT STREET

SHEA REAL ESTATE

INCOME TAX

MARCH '67

9 *The offices of International Times are raided by policemen bearing warrants issued under the Obscene Publications Act.*

1 6 *Scientists claim that taking LSD may cause chromosome damage.*

I WANT TO TAKE YOU HIGHER

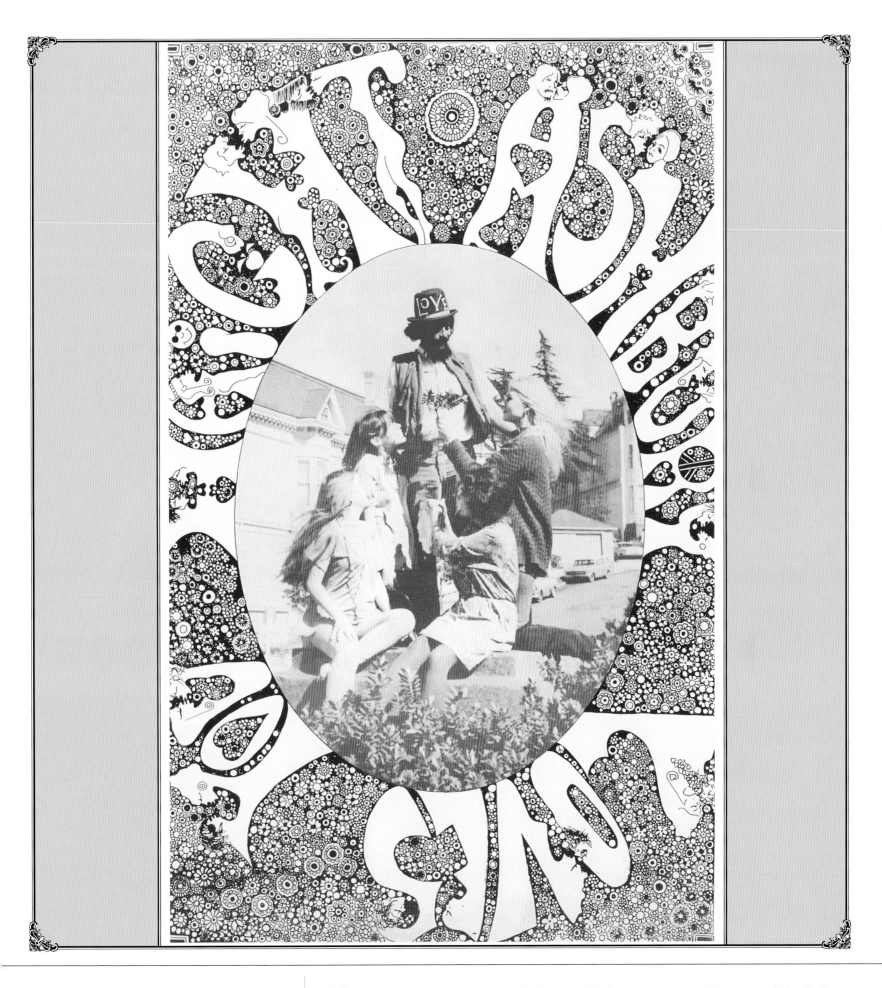

25 *New album releases by the Doors (their eponymous debut, which includes "Light My Fire" and "The End") and Jefferson Airplane (Surrealistic Pillow, featuring "White Rabbit" and "Somebody to Love") enter the U.S. charts.*

THE FLOWERING OF THE HAIGHT

o hippies, the real news in 1966 was occurring on the rock & roll front. In January the Beatles' "We Can Work It Out" could be heard as a love song or a plea for peace on earth. The original cover of their June collection of recent hits, *'Yesterday'... and Today,* showed the lovable Mop Tops dressed in bloodstained butchers' aprons, holding butcher knives and doll parts. ("Was this their commentary on the war?" we all wondered.) The record company recalled the album and pasted a more tasteful cover over it, but hippies discovered that you could steam the new jacket off, revealing the "butcher cover" in all its defiant glory.

Bob Dylan's contribution was "Rainy Day Women #12 and 35," in which he laughingly led a good-time chorus of the words "everybody must get stoned." And then in August, the Beatles released *Revolver,* their most daring album yet. Some of the songs, such as "Got to Get You Into My Life," were psychodramas about conflicted love like the ones on Dylan's recent *Blonde on Blonde.* "Good Day Sunshine" seemed to evoke the exhaustion and exhil-

A flutist and friend stroll Haight Street in 1966 while a poster showing members of the Love Generation in a sylvan setting proclaims **Haight-Ashbury Loves You** *(previous pages). Hippies bide their time on the famous corner of Haight and Ashbury (left) in 1966. Meanwhile, across the bridge in Berkeley, the more politicized student body held antiwar demonstrations and events like the Public Smoke-In (below). Witness the curious college kid in button-down shirt and tie. Brothers Ron and Jay Thelin mull over the concept of hip capitalism on the steps outside their Psychedelic Shop, a mainstay in the cultural life of the Haight-Ashbury, in 1967 (opposite).*

aration of the morning after an acid trip. And the lyrics for "Tomorrow Never Knows" were actually quotes from Timothy Leary's adaptation of the Tibetan Book of the Dead, explicitly intended as a road map to an LSD experience.

Well, there you had it. Everybody seemed to be coming into the open about LSD and marijuana, and yet lightning did not strike. Sure, the Beatles got in trouble on the eve of their tour to promote *Revolver,* but not for the drug references — it was because John Lennon had told a reporter that Christianity was doomed. Dylan had taken a certain amount of flak for "Rainy Day Women," but he had cleverly left everything ambiguous. The main result was that a lot of policemen became convinced that "rainy day women" was a secret code name for marijuana cigarettes. What a goof.

The Trips Festival handbill mentioned a store called the Psychedelic Shop at 1535 Haight St. As a result of the events of the preceding months, the psychedelic rock community had become aware of itself and began gravitating, as people put it, to the Haight-Ashbury district. The rest of the city was aware of the Haight-Ashbury, if at all, as the area around the east end of Golden Gate Park where the Panhandle extended for about eight blocks. It had been fashionable around the turn of the century but had been running downhill ever since.

2 6 **Inspired by San Francisco's Human Be-In, similar events draw massive crowds to parks in New York and Los Angeles.**

3 0 **The cover of Sgt. Pepper's Lonely Hearts Club Band is shot at photographer Michael Cooper's studio.**

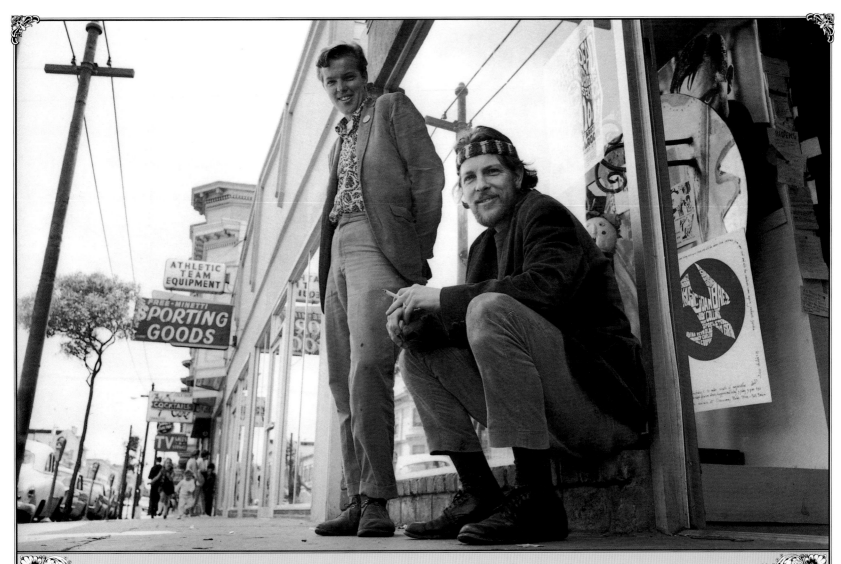

"The street people were adopting a new culture. Hallucinogens were everywhere, so everybody was really high. It was a community that was just buzzing with new energy. It was like an anthill, a very creative, wondrous anthill trying to come into existence on the edge of the world."∗

4 Dr. Martin Luther King Jr. urges all draft-age American men, regardless of color, to boycott the Vietnam War by declaring themselves conscientious objectors.

To an acidhead, it was ideal, with the park nearby and lots of groovy old Victorian houses with trippy art nouveau decorations. Its only problem was a lack of a hangout. There was no point in hanging out in the fashion boutique Mnasidika, the only hip shop on the street. People were so desperate for places to congregate that they went to a greasy 24-hour doughnut shop where the jukebox had Rolling Stones. For a while, the laundromat on Haight Street was a social scene.

But they could certainly socialize at the

As at Alice's Restaurant, you could get anything you wanted at the Psychedelic Shop (above), at 1535 Haight St. The Thelin brothers, dropouts from a rental business at Lake Tahoe, stocked the Psych Shop with books, records and magazines. Later, they installed a meditation room.

Psych Shop. It stocked everything a psychedelic explorer might be interested in: writings about psychedelic drugs; scriptures of Asian religions and books about American Indian spirituality; beads, bells, incense, pungent patchouli oil, feathers and quaint jewelry; records of rock & roll and sitar music; paisley fabrics, rolling papers, hash pipes and stash boxes. A couple of months earlier, people might have been afraid to step into a place called the Psychedelic Shop, but now it seemed ideally suited to the community.

5 The Gray Line Bus Company adds a two-hour "San Francisco Haight-Ashbury District 'Hippie Hop' Tour" to its roster of bus tours. It is promoted as "the only foreign tour within the continental limits of the United States."

I WANT TO TAKE YOU HIGHER

Windows in the neighborhood displayed wind chimes, paisley fabrics and Mexican Indian wooden crosses strung with brightly colored yarn that were known as "god's eyes." People in the Haight-Ashbury called their neighborhood "loose," meaning it offered the kind of hassle-free openness as at one of the psychedelic rock dances. By fall, occupants of an apartment on Shrader Street were selling buttons that read *Good Ol' Grateful Dead*. If they weren't home, you would just open the unlocked door, take the buttons and leave your money.

The Haight was fast becoming the capital for Bay Area hippies. Because it was centrally located, it became the main marijuana market of the whole area. Hippies who started out selling just enough grass to pay for their own stash found so many customers that they graduated to selling enough to pay the rent and then ended up with more money than they had ever imagined. So they dressed more and more extravagantly and furnished their apartments whimsically with pillows and colorful goods from around the world.

GRACE SLICK
SINGER FOR JEFFERSON AIRPLANE

That song "San Francisco (Be Sure to Wear Flowers in Your Hair)," by Scott McKenzie, was corny and cute. We weren't quite that cute, and it struck us funny. Donovan came over to play the Fillmore West at one point, and I think he brought his father with him. He was dressed in this long, East Indian–looking arrangement and was throwing flowers into the crowd. And we're going, "Oh, Lord in heaven." Because we were kind of scruffy, most of us. We'd get up onstage and play, and we didn't even bother to dress up very much. Once in a while, Janis would get a Louisiana-mama outfit or I would wear an L.A.P.D. uniform or something like that. But the way we were was not the way they saw us. The interpretation was just a little too cute and a little too commercial. But we were amused by it. We just thought, "Okay, if that's the way you see it, go ahead." ✳

APRIL '67

7 **The Grateful Dead's eponymous first album is released. That evening, former Top Forty DJ Tom Donahue debuts his underground rock show on KMPX-FM.**

17 **Doctors at the University of California Medical Center report that exposure to loud rock music can irreparably damage hearing.**

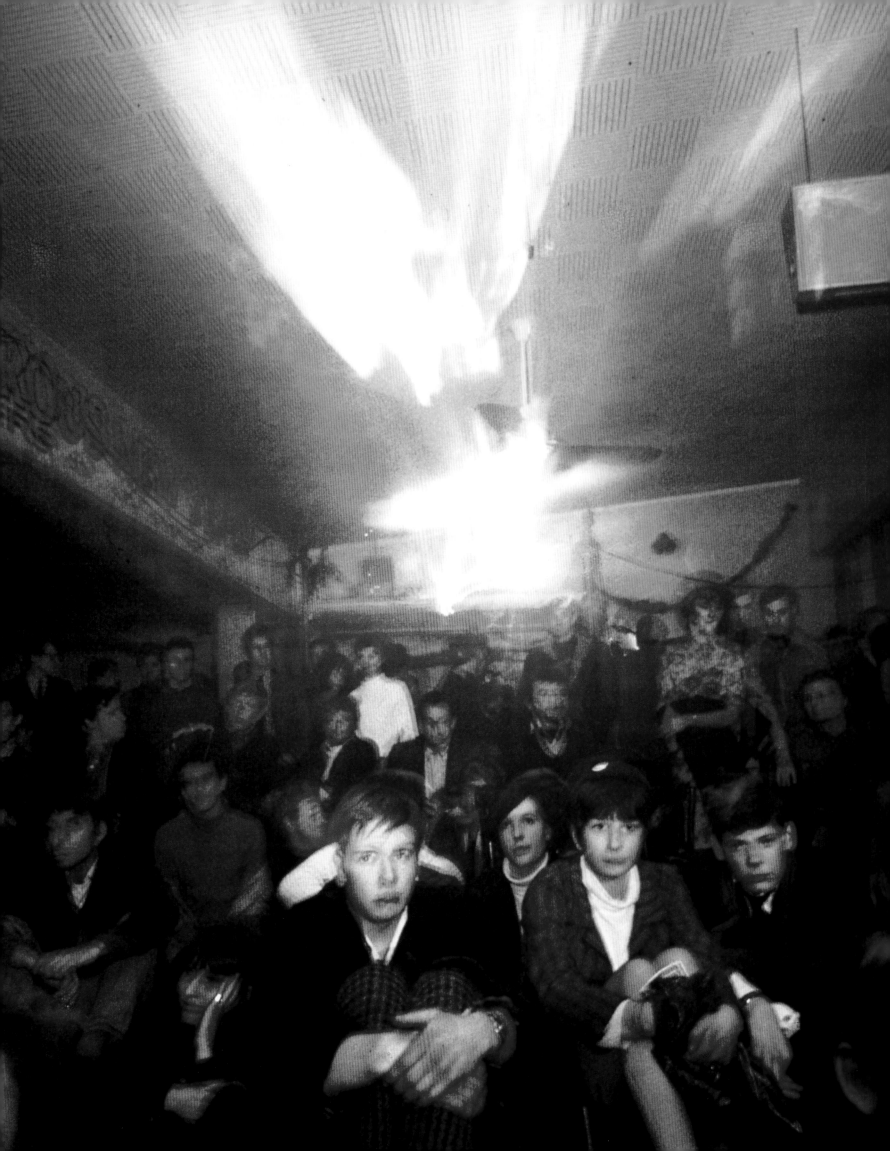

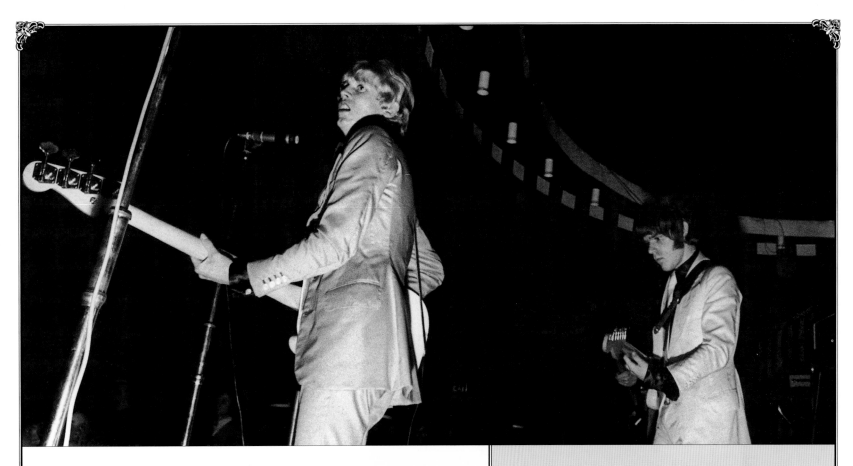

UFO Is Born

International Times lived up to its name by providing reports from around the world. The biweekly paper ran writings by the Living Theatre, William Burroughs and Bertrand Russell. *IT* quickly ran into financial difficulties. Noting that the London Free School had solved many of its financial problems by holding benefit concerts, Hoppy decided that *IT* should itself get involved in music as a fundraising strategy. He located the Blarney club, an Irish dancehall in the basement at 31 Tottenham Court Rd. Joe Boyd, who managed and produced the Incredible String Band, became the musical director at UFO (pronounced *you-foe*). Hoppy did everything else. Thus was the UFO club born. *IT* initially booked two evenings, December 23 and 30, 1966, intending to continue only if those were a success. They were, and Pink Floyd and Soft Machine became the house bands.

A somewhat sedentary crowd cools its heels at the UFO club (opposite). Bassist Ace Kefford and guitarist Roy Wood of the Move excite an audience at London's Marquee club in 1966 (above). "We went to London with the absolute intention of becoming famous and doing whatever it took to do that," recalls Move drummer Bev Bevan. "We really did jump on several bandwagons, and I guess the psychedelic flower-power one was one of them. We weren't true believers."

BEV BEVAN DRUMMER FOR THE MOVE

The Move formed in 1966 and got into this work mode where we were working seven nights a week. We very rarely had a night off, and quite often we'd do "doubles" — do one show and pack up the gear and do another. We got into this real heavy work mode from 1966-68, touring Britain night after night. In 1967, the UFO was king of the clubs but all the others around the country were very similar. They all had those oil slides on the walls and people lying down more than anything else, just generally stoned or at least believing they were. Half of them were smoking bananas or something. It was all very unreal.✱

2 2 *Pink Floyd's first single, "Arnold Layne," an eccentric number about a transvestite, enters the British charts.*

2 7 *Carl Wilson of the Beach Boys is indicted for failing to appear for his draft induction.*

JOHN "HOPPY" HOPKINS

CO-FOUNDER OF THE UFO CLUB

UFO was done from the heart with a purpose, which was to have a good time. We decided to run UFO all night, and it was a piece of all-night culture suddenly flashing into being that really made it popular. People would stay till it was light outside. You could stay out of your head all night.

The thing about UFO is that it wasn't sort of one music all night and the music would stop between tracks, which is unheard of now. The bands would do two sets, and there would just be gaps where people would talk to each other. Records would be played from time to time, but then someone might decide to do a little poetry. In the culture as a whole, people didn't listen to just one sort of music. You'd find people listening to avant-garde jazz, blues and serious music like John Cage.✳

Loaves of psychedelic bread (left) rise for the occasion: an International Times *happening. The face of a girl at the UFO club is caught in the glimmer and glow of a psychedelic light show (right). On page 88, three members of the psychedelic pop group Tomorrow study some of the groovy poster art making the rounds in '67. "It was a very atmospheric time," recalls guitarist Steve Howe (later of Yes), "because the sound of things was all so new." Arthur Brown (shown grimacing on page 89) was another UFO club regular. He set the world alight with "Fire" in the summer of 1968.*

APRIL '67

29 *The 14-Hour Technicolour Dream, a concert and fund-raiser for* International Times, *is held at London's Alexandra Palace.*

10 *Brian Jones of the Rolling Stones is arrested at his home on drug possession charges.*

Going into the UFO club when you were on the bill made you feel great. You walked in that place, and it's packed with people. Everybody's diving around. It was very exciting. You'd get in your dressing room and change your clothes in front of like twenty people. You'd get onstage and you're sweating, the place is almost on fire, you can't see, it's deafening, there's feedback. It was a mass happening, day after day, week after week. You were part of something; you felt like you belonged somewhere.

The whole movement was about a change in attitude from aggression to peace. This was part of the message, but sometimes you had to release that aggressive energy. It was a very euphoric time. With regard to Tomorrow, I remember the power of what we got going there. It was a good club for us with a simple stage. Basically, we were a very bold sort of group. What happened was the group discovered a kind of release, a kind of meditation, a kind of higher state of mind, and we were all right there together. We used to play, and it would kind of implode. We'd stop, people would go mad, and we'd go, "God, where were we?" The songs were an escape into improvisation and then back to the song to finish.

There are nights that I remember well. One I remember was when Arthur Brown was on the stage. He always used to have this hat he set alight. Well, this night he set alight the curtains, and the place almost burned down. Also, Jimi Hendrix played with us one night in the UFO. In the show, Junior (John Wood) would put down his bass and dance around. This night I was improvising, and Twink (John Adler) was doing things on the drums to keep the rhythm going without it being just a backbeat. Suddenly, this figure appeared onstage. We all knew who it was 'cause we'd seen him a lot. Hendrix picked up the bass, and we went somewhere. For the life of me, I don't know where it was. We were just improvising. He started playing away, and I wasn't ever sure we were in the same key. But we were somehow doing something that was electrifying.✻

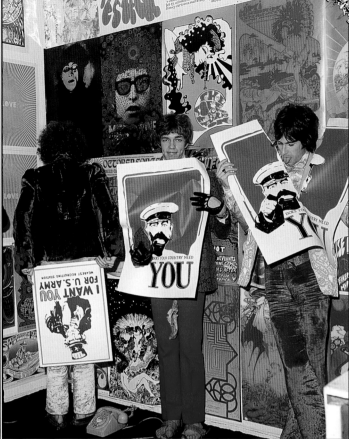

The club had a large, polished wooden dance floor complete with a mirror ball and a smaller area off to the side for food. Alcohol was not served. The shows got going around 10:00 p.m., and by 5:00 a.m. people would lay curled up on the floor in the corners while psychedelic lights flickered on them. From a control tower in the center, surrounded by light-show equipment, records were played and Hoppy read poetry and made announcements. Every wall had a light show, which required multiple operators. The principal light-show artist was Mark Boyle, who had been presenting light shows as art events since 1963.

In addition to live music, avant-garde films were shown and poetry readings held. The club was initially more important as a social gathering place than for the music, which was almost incidental. People scored drugs from a fat German dealer named Manfred, ordered frilly shirts and velvet trousers from underground tailors and were schooled on macrobiotics at the food counter.

Regulars included Paul McCartney and

MAY '67

12 Pink Floyd stages a multimedia concert billed as "Games for May" at the Queen Elizabeth Hall. The group's then-leader, Syd Barrett, writes the classic "See Emily Play" for the occasion.

Pete Townshend. Townshend's girlfriend, Karen Astley, was featured on the first UFO poster, the words "Nite Tripper" painted on a close-up of her face. It was at UFO that Townshend first heard Arthur Brown, whom he signed to Track Records. Brown was an amazing dancer with a tall, skeletal frame, a skull-like face accentuated by face paint, and a thin beard. He did what was known in music hall parlance as "Egyptian dancing," a jerky, sideways movement with all limbs at right angles. He frequently wore a long robe or dress. For his signature song, "Fire," he made an entrance with his headdress in flames.

UFO audiences were notoriously fickle. They booed the Move, a great band that had come down from Birmingham, but loved Tomorrow, particularly when drummer John "Twink" Adler wriggled atop the amps like a snake while reaching down to beat his drums. Tomorrow also featured guitarist Steve Howe, later of Yes. Another UFO favorite was Giant Sun Trolley, a free-form jazz group. The two records that best defined the underground scene were "My White Bicycle," by Tomorrow, and "Granny Takes a Trip," by the Purple Gang. The latter group performed only once at UFO before its masked leader, Peter "Lucifer" Walker, departed to become initiated as a warlock.

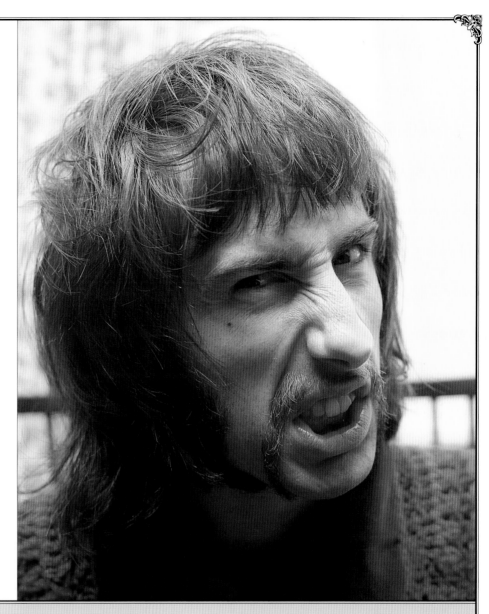

ARTHUR BROWN

Onstage, I'd wear a flaming helmet and a silver mirror mask, which I would at a certain point tear off. Underneath was black-and-white death-mask makeup. At one of the gigs I had an all-white suit that I could set on fire. There were black capes and a huge saffron robe. When I took off the saffron robe, there was a woman's dress underneath, and I would do this woman's part for a while, delivering doggerel rhymes and insults and whatever. Then that would come off and beneath it would be a black velvet suit.

There was another huge robe in the next sequence. Whenever I stretched my arms, it would make a huge semicircle revealing this vast area painted with ultraviolet designs. We'd shine the ultraviolet lamp on it, and there would be oranges and reds and very beautiful colors. With that robe, I wore a sun god's helmet.

Another thing I had was a twelve-foot hypodermic, in the middle of which I used to stand while a fan blew in these white flakes that filled it up slowly. We had a huge brain that the road manager used to wear. Its eyes came out on stalks, and he would run up and down the aisles hitting people with his eyes.

Sometimes I would be brought in crucified on a cross. Sometimes I'd roll on in a womb or egg. Sometimes I'd come in on a crane or come up through the floor. I remember swinging in on a rope from the Roundhouse ceiling. I sat in a little cupola on top of the roof and swung down a hundred feet or so. A lot of those people were on acid, so when they saw this figure flying down with flames coming out of his head, they thought God was coming.✳

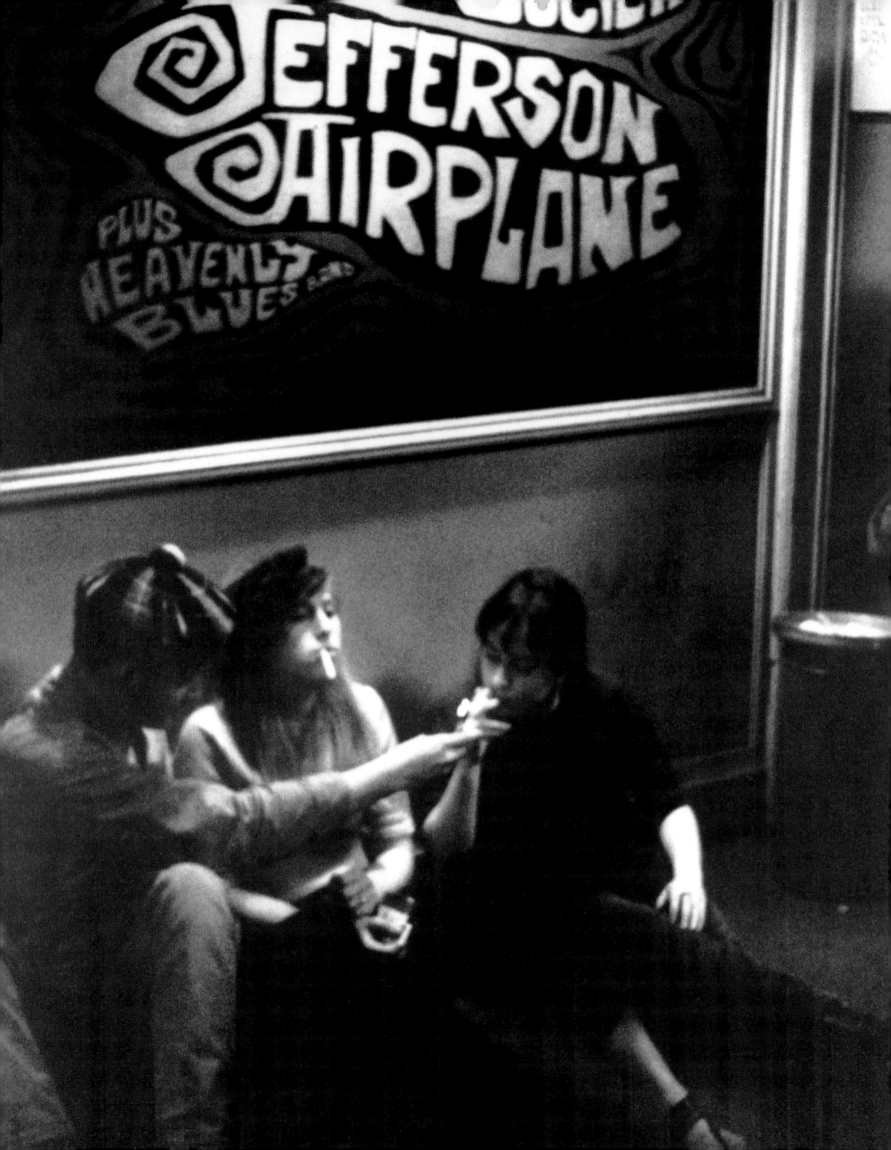

THE BALLROOMS

In the wake of the Trips Festival, rock concerts started being held all over the Bay Area on weekend nights. Acid rock quickly killed off the folk craze. Even the North Beach folk clubs started booking rock bands.

Both Ken Kesey (now a fugitive from the law on two marijuana charges) and the original Family Dog people had left for Mexico, so Big Brother manager Chet Helms started putting on Family Dog dances at the Fillmore Auditorium in February 1966, alternating weekends for a while with Bill Graham, who had already leased the Fillmore for three years. In April, Helms found his own hall, the Avalon Ballroom. They had the two best halls in town, each with good acoustics and a capacity of about a thousand.

GARY DUNCAN
GUITARIST FOR QUICKSILVER MESSENGER SERVICE

As far as the musical scene, the Avalon Ballroom was the place to be. It was a lot cooler place than the Fillmore. Chet Helms was more instrumental in the beginning for creating the atmosphere. Bill Graham didn't come along till a while after that. I'd have to say honestly that the real scene was at the Avalon. But because Helms and the Family Dog were in direct competition with Graham, it was just a matter of time before he froze 'em out.

Graham was a businessman. He put San Francisco on the map, and he brought a lot of big talent to San Francisco. If you look at it from that respect, he had a lot to do with making rock & roll concerts a common thing. But as far as adding to the music scene from a musician's standpoint, he was detrimental in a lot of ways. For instance, if you came to San Francisco and played for anybody else in town, like if you did a show for Chet, you'd never work for Bill.

The Avalon was just a lot looser. We'd play the Avalon at least twice a month, sometimes more. So did the Grateful Dead and the Airplane. Our managers fought pretty hard for us to play both halls, because Bill didn't want us playing for Chet. We used to play at the Avalon and, in between sets, go over and jam with the Dead at the Fillmore. So for a few years there, it was a really good scene as far as interchange among musicians.

You had to be there. If you can imagine 2,000 people in a smoke-filled dancehall, high on every possible kind of drug you can imagine, writhing as one with a light show so that you could barely see and just incredibly loud music and then wandering up the stairwells, and people would be laying there too stoned to walk. I mean, the Avalon was where you went if you really wanted to get into the scene.✱

22 It is reported that John Lennon has given his Rolls-Royce a psychedelic paint job over the protests of its manufacturer.

Fillmore impresario Bill Graham (preceding page) gazes down from his poster-filled office in 1967. A scene from the second-floor Fillmore Auditorium lobby (page 90), where freaks light up below a chalkboard poster. A long line down the block attests to the popularity of whatever band was playing Graham's Fillmore West, formerly the Carousel Ballroom (left). Groups that performed on the Fillmore's final night included Santana (below), Creedence Clearwater Revival and Tower of Power, and the evening ended with a "San Francisco Musician Jam."

Each hall had its own style. Graham, a former efficiency expert, ran a smooth, professional operation where musicians always appeared onstage on time. With his wispy blond beard and long hair, Helms was clearly a hippie himself, and he walked around the Avalon in richly embroidered coats, savoring the spiritual tone of the dance. At Graham's dances, there was always a spotlight on the singer; at the Avalon, the stage was dark so you could concentrate on watching the light show, if indeed you were watching anything at all. Helms had an Englishman announce the acts in a fashionable Beatles-like accent; Graham barked announcements himself in his unfashionable Brooklynese.

Still, the experience was much the same at either hall. You walked onto a darkened dance floor full of astonished, conspiratorial glee. People danced anything from the Frug and the Twist to expressionistic writhing and free-form twirling, in the dark or under stroboscopic lights that might hit a hypnotic alpha rhythm as they turned the dancers into a series of flashing snapshots.

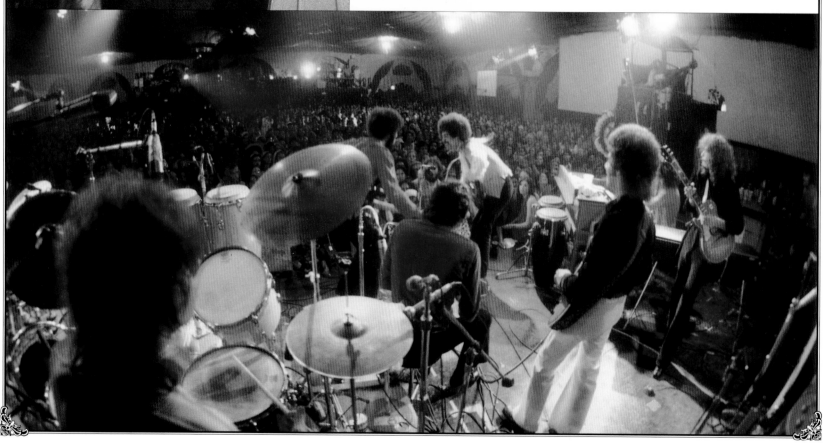

J U N E ' 6 7

1 Sgt. Pepper's Lonely Hearts Club Band *by the Beatles is released in Britain. It is released in America on June 2. The advanced production techniques, thematic content and psychedelic sounds of Sgt. Pepper will influence rock music for years to come.*

There was a little club called the Matrix, on Fillmore Street, where we worked out a lot of material. As a matter of fact, even after I left Steve Miller and started my own band, I played in the Matrix a number of times. That was just a favorite room for Steve's band and players.

The Avalon, though, was the really special place. It just had the right vibe. It was a real musician's place. I think Chet Helms' approach made it all so comfortable and relaxed. Something about the room — it was the right size and the right vibe. ✳

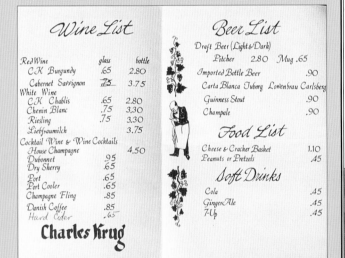

A 1967 poster for the Chambers Brothers at the Matrix, designed by Victor Moscoso (right). Jefferson Airplane blaze new trails in electrified folk-rock at the Matrix (below) in 1966. Vocalist Marty Balin renovated and opened the Matrix in August 1965; prior to that, the small club at 3138 Fillmore St. had been called the Honeybucket. A menu from the Matrix (left) included beer and wine, though the stimulants of choice among the clientele were more likely to be pot and acid.

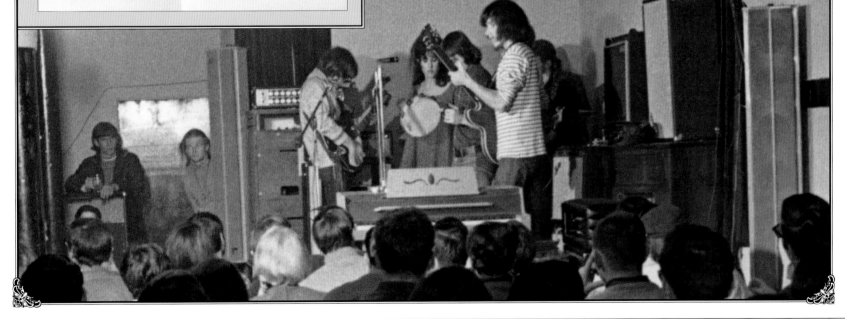

5 Moby Grape, *the debut album by the high-energy San Francisco–based quintet, is released. As a publicity gimmick, Columbia Records simultaneously releases five different singles taken from the album.*

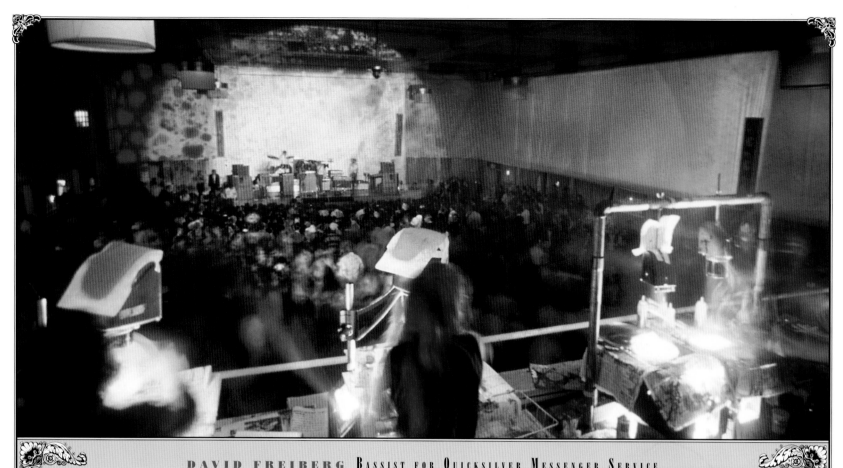

DAVID FREIBERG BASSIST FOR QUICKSILVER MESSENGER SERVICE

"The Fillmore was fine. Winterland was nice, too. It was all good, but the Avalon really had a good vibe. It was like playing in your living room there."*

Somewhere in each hall there would be an ultraviolet light, so people would bring Day-Glo paints and make fluorescent designs on the floor or each other's bodies. At the Avalon, a puppeteer would hang puppets from the balcony and have them dance with the girls. People would bring quaint things to the dances — whistles, feathers, curious pebbles they had found — and hand them out to blow each other's minds. If they didn't have the more ecstatic costumes that had appeared at the first dances, people at least threw on their most colorful shirt and

Big Brother and the Holding Company in concert at the Fillmore in 1967, engulfed by a psychedelic light show. Fillmore overseer Bill Graham "did pay attention to detail, wanted people to have a good time and had a good staff of people," says Big Brother's bassist, Peter Albin.

a string of beads, maybe a button with some mysterious message such as *Alice designs her face on my mind* or *Owsley is righteous.*

While the dance floor was dark, the walls were blazing with light. The light-show artists stationed on the balconies had found ways to cover three whole walls of a dancehall with brilliant, flowing colored lights, like abstract paintings changing from moment to moment. Alternating with the liquid projections might be kaleidoscope patterns, or slides of faces, flowers or mandalas. Sometimes there were

JUNE '67

5 - 1 0 *Israel launches the Six Day War in the Middle East, quadrupling its land holdings by the time a UN cease-fire takes effect on June 10. The war commences with a surprise attack by Israel upon the air forces of the U.A.R., Jordan and Syria.*

films. At the Fillmore, movies showed dancers from the previous weekend, triple-exposed on the same film at different angles, as if they were dancing through each other in free-fall.

The thing that gathered everybody in the first place was the music, though an outsider wouldn't have been able to see why. Clearly the musicians were former folkies, to judge by their nonprofessional attitudes. They seemed to take forever to tune up, and a guitar solo might go on for forty-five minutes in a wandering, staggering sort of improvisation. When feedback howled from musicians' loudspeakers, they seemed to enjoy it.

Anybody could tell Big Brother's new singer, Janis Joplin, had an extraordinary voice —raw, passionate, stunningly overwrought—but she certainly didn't look like a star, as far as talent scouts could tell.

Light-show artist Bill Ham launched the LSD (Light, Sound, Dimension) Theater in 1968 (above). The venture lasted only a few months. Ham, always a head of his time, was a light-show pioneer, having taking a kinetic light sculpture to the Red Dog Saloon back in 1965. His magical light box, which he built with Bob Cohen, changed colors to the sound of the music being played.

She made her own funky jewelry out of chicken bones.

An outsider couldn't know that the musicians were speaking to the deepest concerns of the dancers. Not just the tribulations of love, transcendentally poignant though that could seem on LSD, or even the fear of nuclear destruction, which resonated in songs like the Grateful Dead's "Morning Dew" or Quicksilver's "Pride of Man." After all, folk musicians had already done all that. Their bizarre-sounding songs dealt with issues of psychedelic exploration: how to deal with emotional changes in that vulnerable state, where you stood in the universe, what life and death really meant. LSD raised questions about the nature of ultimate reality and tantalizingly half-suggested answers. It seemed that a radiant solution to every problem, personal or philosophical, was just around some indescribable corner. By singing about

8 *Procol Harum's inscrutable "A Whiter Shade of Pale" tops the British singles chart, signaling that the underground has gone mainstream.*

9 *Jefferson Airplane's Surrealistic Pillow peaks at #3, making it the most commercially successful record by a San Francisco band to date.*

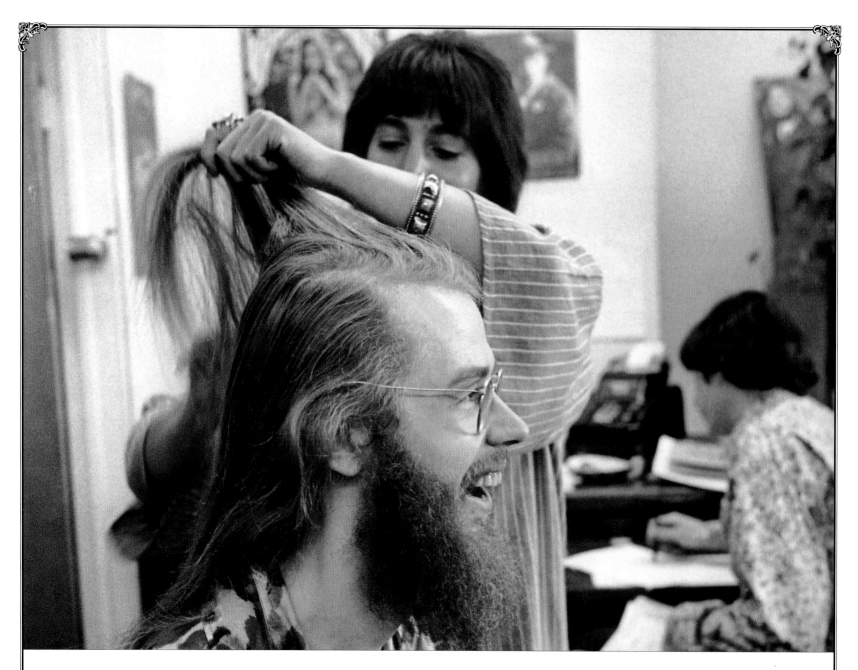

the situation, the musicians proclaimed themselves brothers in the quest. People even imagined that the musicians themselves might have part of the answers.

It was astonishing, if you thought about it. Every weekend, thousands of people were having spectacular cosmic visions, experiencing overwhelming emotional rollercoaster rides, in a public place. It started to seem as if the whole world revolved around what was happening at the dances. Sometimes the Fillmore or the Avalon felt like a pulsing, organic spaceship that might escape the world of war and racial conflict outside by the power of the collective

Chet Helms, who headed up the Family Dog and booked the Avalon Ballroom, gets groomed for success in 1967 (above). The Family Dog family (opposite) gather in a vacant lot on Pine Street, with the beatific Helms standing atop a van.

energy of hundreds of people celebrating life as they tried to solve the riddle of LSD.

The dances were advertised by vividly colored, if hard-to-read, posters that showed astonishing creativity in suggesting the psychedelic experience. Technically, they were merely advertising material, but people immediately began collecting them. One day Bill Graham finished putting up posters on Telegraph Avenue in Berkeley and discovered they had been taken down almost as soon as they went up. Soon afterward he started giving posters away to everyone who came to a dance.

JUNE '67 **1 0** ***Country Joe and the Fish debut on the album charts with Electric Music for the Mind and Body, a musical primer on the psychedelic experience.***

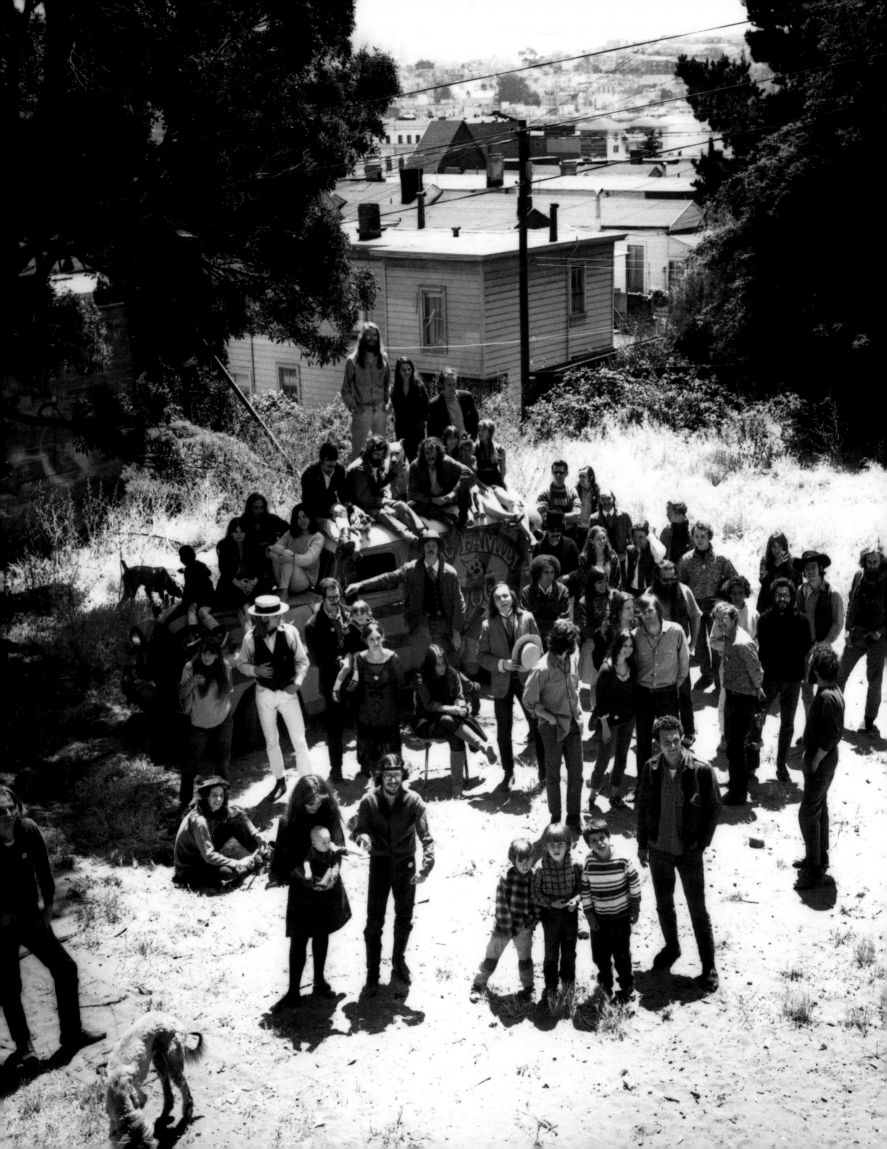

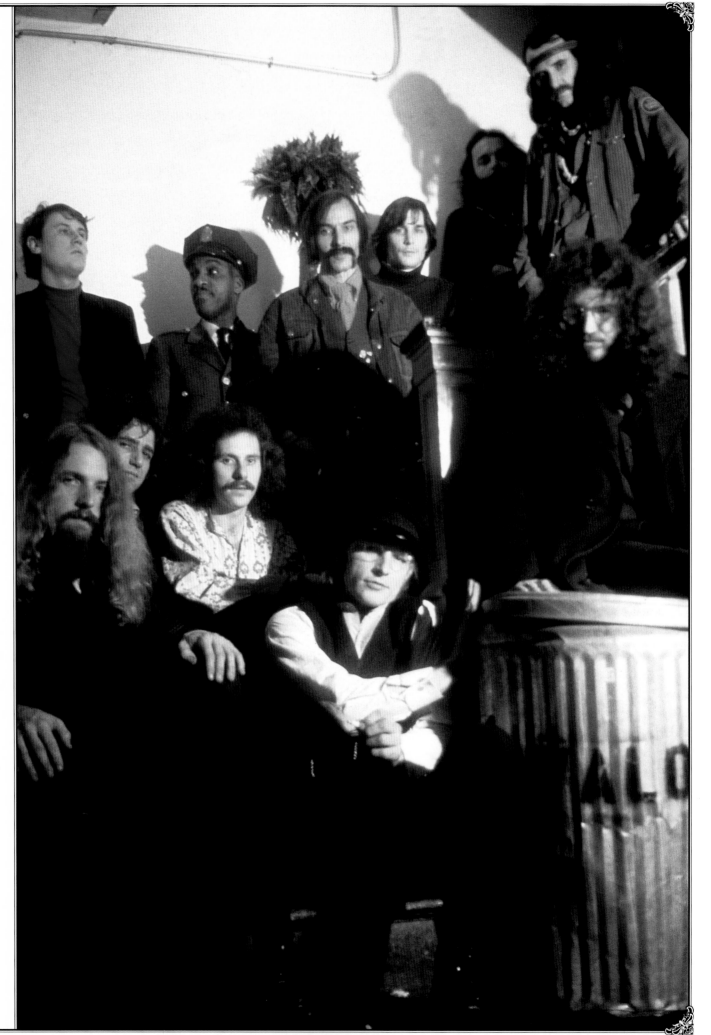

The cream of San Francisco artists, as photographed backstage at the Avalon in 1967. Clockwise from bottom left: Rick Griffin, Satty, an Avalon security guard, Victor Moscoso, Wes Wilson, unknown, Alton Kelley, Stanley "Mouse" Miller, George Hunter, unknown, Art Fried.

Posters were the main avenue for advertising events. It was all happening at a neighborhood level, where you knew the musicians and the people in the audience. Within seven days of having done a piece, I'd get feedback about a poster from people who were at the dance and from the musicians.

were four, six, eight posters coming out each weekend.

Whatever you're doing that's hot is going to be seen in a week by competitors and, likewise, the same with you. I could see what Wes Wilson and Mouse and Kelley and later Rick Griffin were doing the moment they went up. There were no secrets, just individual personalities.

vibrating edge. After all, musicians were turning their amps all the way up so that you'd be deaf for a week, and it was cool. I would just turn the color up as high as I could so I would blind you: "Whoa! What's that?"

The joint was jumping. The surf was up. The air was electric with things happening. You could actually walk into

I would just turn the color up as high as I could so I would blind you: "Whoa! What's that?"

I could immediately put the feedback into the next poster.

All the artists were doing this. We're watching each other's work. We're competing with each other. Wes Wilson would do a poster for Bill Graham. I might do a poster for Family Dog. Somebody would do a poster for California Hall. Somebody else would do one for the Straight Theater. So there

You could take whatever you wanted from anybody. The thing to do, though, was to chew it up, digest it and spit it out as your own. You had to add your own twist; otherwise it was just taking. And we weren't into taking; we were into creating.

Something was happening. You'd use as many vibrating colors as you possibly could. You'd make every edge a

a room and say, "Hey, let's start a rock & roll band," and seriously launch yourself into rock & roll. That's what these guys did. They were garage bands. And what happened was they became famous garage bands, because they were at the right place at the right time. So was I, and so were a whole bunch of other people.✱

16 - 18 *The Monterey International Pop Festival kicks off the Summer of Love with three days and nights of music. The festival serves to launch the careers of Jimi Hendrix and Janis Joplin, and unforgettable performances are given by the Who, Otis Redding and others. Monterey Pop will forever stand as a high-water mark in the annals of the Sixties counterculture.*

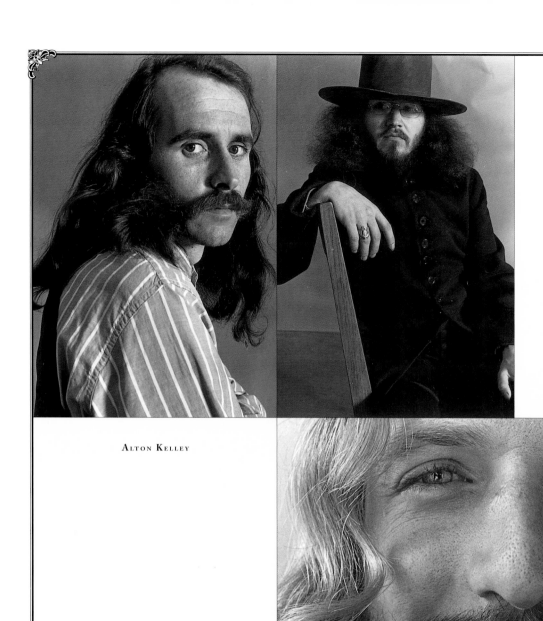

STANLEY MILLER
[MOUSE]

RICK GRIFFIN

ALTON KELLEY

WES WILSON

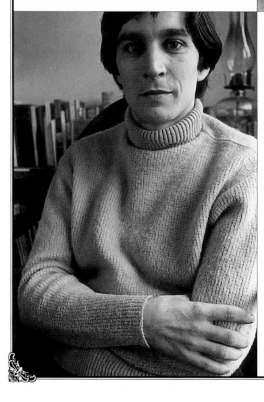

VICTOR MOSCOSO

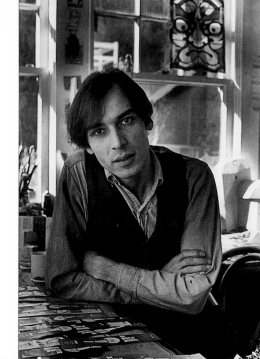

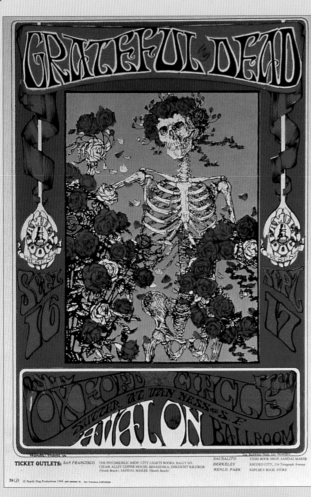

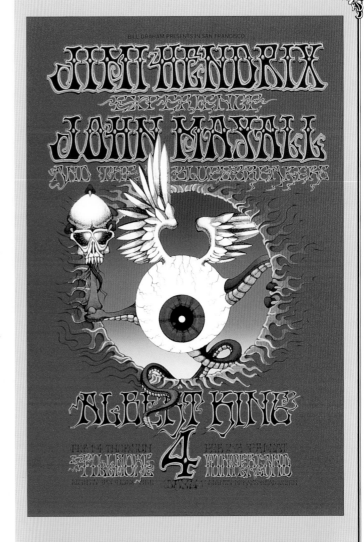

Individual portraits of the most important poster artists on the San Francisco scene (opposite). Some of their finest work is displayed on this page. Proceeding clockwise from top left, these four posters were designed by Stanley Mouse and Alton Kelley (Grateful Dead), Rick Griffin (Jimi Hendrix and John Mayall), Victor Moscoso (Blue Cheer, Lee Michaels), and Wes Wilson (Jefferson Airplane et al.). "Our studios were all open to each other," says Moscoso. "After all, what we were doing was going up on the walls all over town. You're taking your best shot, and anybody can turn around and do riffs on them within six days, so what's the secret?"

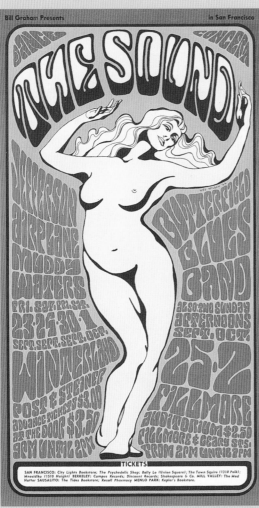

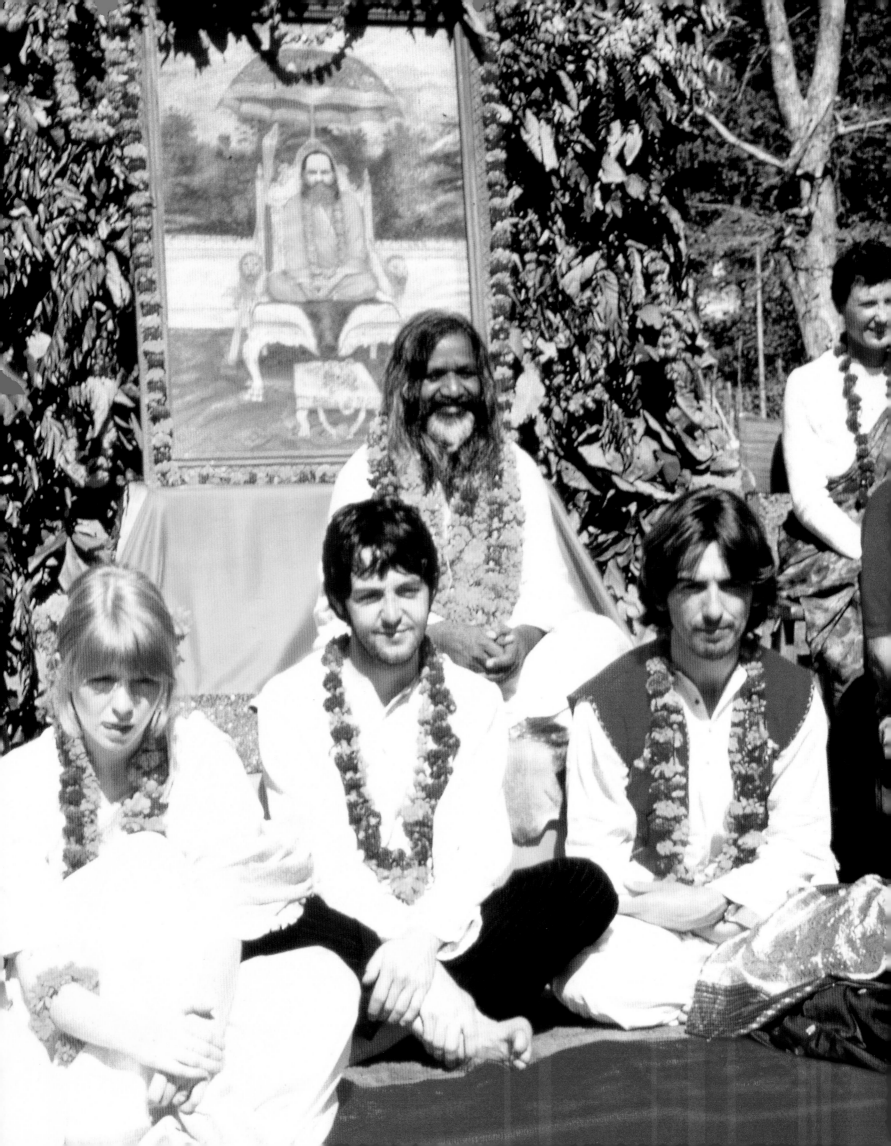

The seeds planted in 1965 and 1966 continued bearing fruit in 1967, as the underground scene exploded in all directions. The musical high point was the June release of the Beatles' psychedelic masterwork, *Sgt. Pepper's Lonely Hearts Club Band.* The Rolling Stones followed suit, releasing the trippy colossus *Their Satanic Majesties Request.* All the while, there were love-ins, hippie weddings and pot rallies in Hyde Park. *International Times'* 14-Hour Technicolour Dream was the largest and most memorable underground event of all.

By the end of the year, the Beatles had undertaken their *Magical Mystery Tour* and were preparing to hang out with the Maharishi Mahesh Yogi in India. Graham Nash went psychedelic and soon quit the Hollies. Rock bands everywhere adopted underground-sounding names. Zoot Money's Big Roll Band, for instance, became Dantalian's Chariot. Incidentally, the guitarist for both groups was Andy Somers, who later amended his surname to Summers and became a new-wave figurehead with the Police.

In a development similar to that occurring in San Francisco, the London scene became characterized by its psychedelic posters. Artist Michael English designed the first UFO posters, using Day-Glo pink and blobby, post-art-nouveau lettering. He soon teamed up with Nigel Waymouth, and their first collaborative work — a giant pair of pink lips announcing the UFO Festival — was in the same style. They signed it *Hapshash and the Coloured Coat,* which derived from a misspelling of the Egyptian queen Hatshepsut. They were published by Osiris Visions, a UFO offshoot run by Joe Boyd.

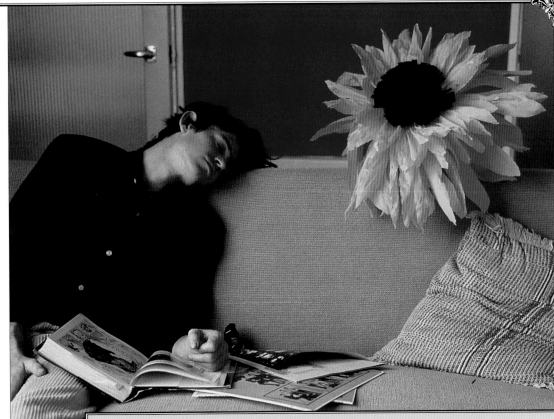

NIGEL WAYMOUTH BRITISH POSTER ARTIST

We were primarily graphic artists. Hapshash and the Coloured Coat was Michael English and myself doing posters for all sorts of clubs and pop things. The equivalent was Stanley Mouse and Rick Griffin in San Francisco. The difference was that we used a slightly different technique of printing. Our posters were silk-screened, so each one is unique and has its own idiosyncrasies. They actually stand up incredibly well in size and color and boldness today.

Our concept was to plaster the streets of London with this very brightly colored and beautiful poster-work at a time when most of the posters in the streets were rather drab and wordy. You had concert bills put up for the Marquee club or whatever, just announcing Manfred Mann in bold letters. What we tried to do was zap them, as we said, with color and chaos to the eyes so that people would be attracted to this blast. It was a precursor to graffiti, in a way. It's sort of between pop art and graffiti. We were trying to push the boundaries of the visual aspect of pop.✳

JUNE '67 19 *Paul McCartney publicly admits that he has taken LSD.*

By now, stories were reaching London about the rainbow printing being done in California. When applied to silk-screen printing, the results were fantastic. Hapshash and the Coloured Coat quickly developed techniques that allowed them to "rainbow" each screen from silver to gold or green to yellow. The process was expensive and labor-intensive, but the intensity of color could not be achieved any other way. Today these graphic works are exhibited in museums around the world.

Michael McInnerney also worked for Osiris (he later did the sleeve for the Who's *Tommy*), as did Martin Sharp, an Australian artist working as a designer for *Oz* magazine. Sharp was a regular at the Speakeasy, one of the new late-night clubs

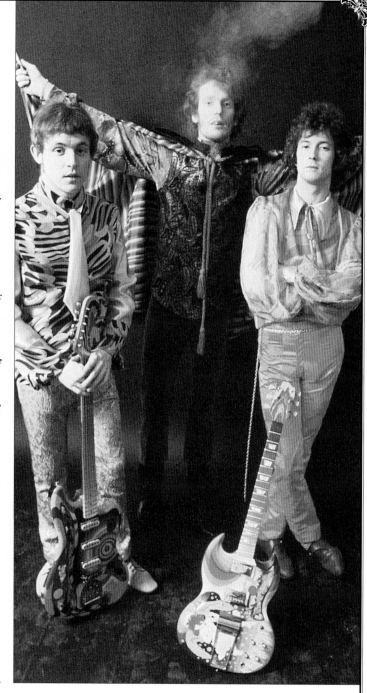

Members of the Beatles and their entourage, including Jane Asher, Paul McCartney and George Harrison (page 102, from left), receive instruction in transcendental meditation from their guru, Maharishi Mahesh Yogi. Australian artist Martin Sharp, who contributed memorable psychedelic artwork to Cream's Disraeli Gears *and* Wheels of Fire *albums, nods off beside a giant sunflower upon arriving in London from the land of Oz in 1966 (previous page). The rock trio Cream (right), comprising Eric Clapton, Ginger Baker and Jack Bruce (from left), explored psychedelic rock from a foundation of blues and jazz. British poster artists Nigel Waymouth (opposite, center) and Michael English (seated), who worked under the name Hapshash and the Coloured Coat, are surrounded by their psychedelic handiwork. The third figure is Guy Stevens, who produced their concept album* Hapshash and the Coloured Coat Featuring the Human Host and the Heavy Metal Kids.

PETE BROWN SINGER, POET AND LYRICIST

I wrote two-thirds of the lyrics for Cream's "Sunshine of Your Love." The hook is [Eric] Clapton's, and I don't like it. As much as I'm grateful to it for earning me lots of money over the years, I would never have written a line like "sunshine of your love." It started with Jack and I. We were writing all night. There wasn't much time to write when Cream was on the road all the time, so whenever Jack came back from touring for a couple of days we would get together and do what we could. We'd both have some ideas and put them together. We'd work for as long as we could till we dropped.

We were working all night, and it was like five or six o'clock in the morning when Jack said, "What about this?" He grabbed his bass and played the riff. I said, "Oh, yeah," and I was writing how it's getting near dawn when lights close their tired eyes. I just did it, and it didn't take too long, as I recall. And that's the song that's paid for lots of my life, of course.✱

that catered to the burgeoning rock aristocracy. There he met Eric Clapton, whose group Cream had debuted in July 1966. Sharp announced that he had written some song lyrics and read them aloud. "That's great," Clapton responded. "I've just written some music." Sharp's words and Clapton's music became "Tales of Brave Ulysses," featured on Cream's second album, *Disraeli Gears,* for which Sharp designed an ultrapsychedelic cover.

21 *The summer solstice is celebrated with a concert in Golden Gate Park using a P.A. "borrowed" from the Monterey Pop Festival by the Grateful Dead. Bands that perform include the Dead, Big Brother and Quicksilver.*

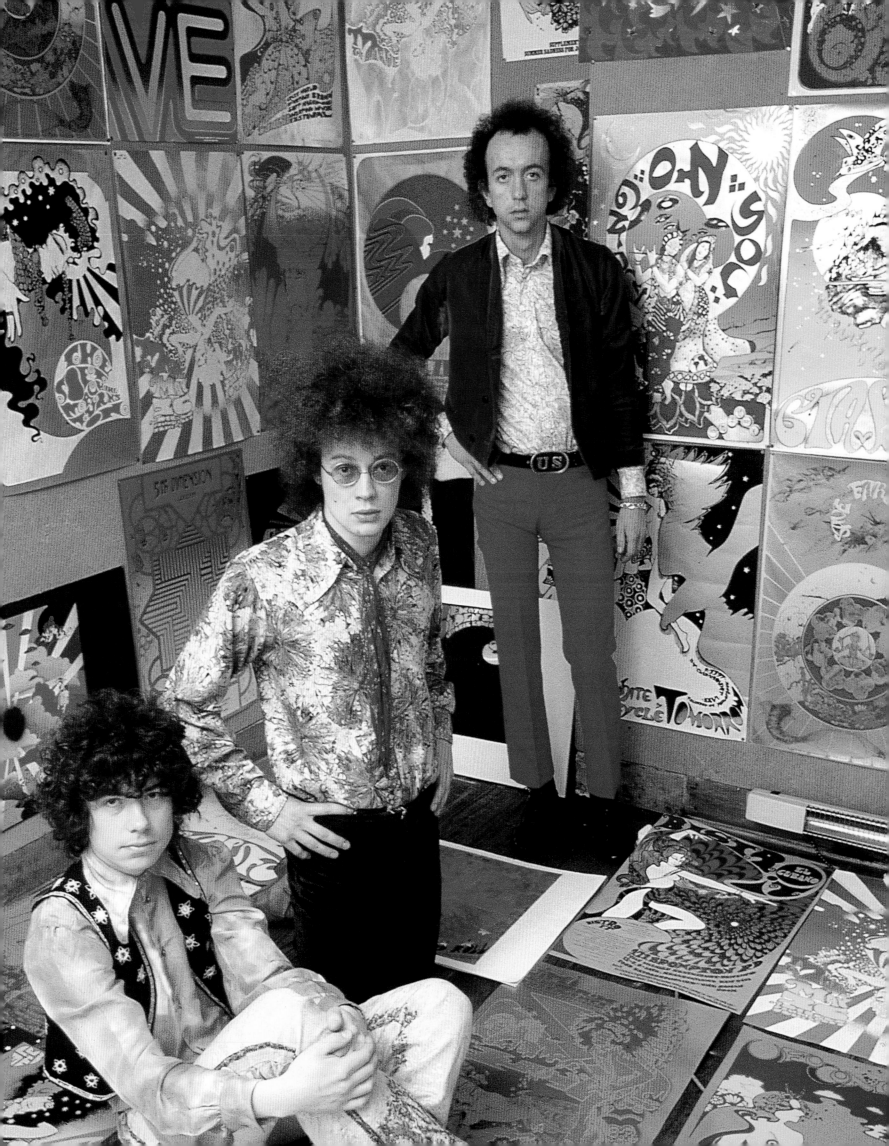

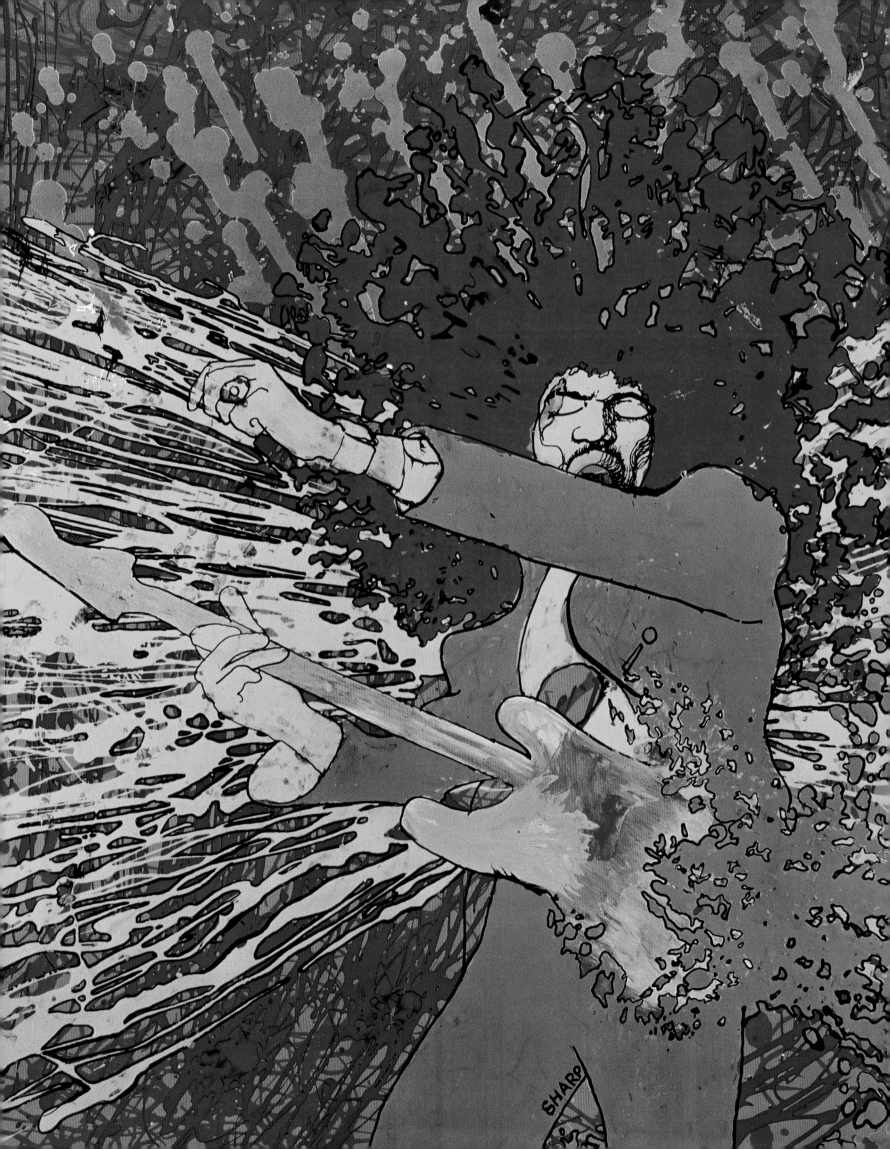

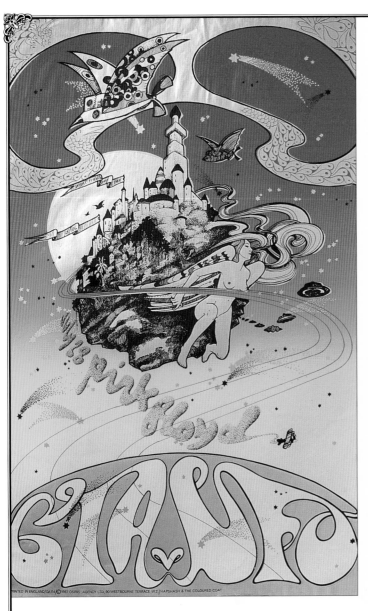

A poster of Jimi Hendrix (opposite) in all his acid-blazing glory, designed by Martin Sharp. A Pink Floyd concert at the UFO club is the subject of the poster at left. The visual imagery complements the mind-melting spaciness of the Floyd, whose concert showstopper was titled "Interstellar Overdrive."

halfway around the world to investigate. Curious Aussies included editor Richard Neville, feminist Germaine Greer and photographer Robert Whitaker, who was in the Beatles' inner circle. (It was Whitaker who shot the notorious "butcher cover" used for the American release of *'Yesterday'... and Today.*) The Aussie crowd was involved in the English edition of *Oz*, a magazine Neville had previously published in Sydney.

The first U.K. edition of *Oz* came out in February 1967. It included a photo-collage attack on the London underground, Indica, *IT,* Ginsberg and the Beats. Despite this satirical beginning, *Oz* went completely underground by its fourth issue, which came with a gold foldout cover by Hapshash and the Coloured Coat. From then on, *Oz* was the magazine for hippies. Issue no. 5 consisted of a gigantic poster collage entitled "Plant a Flower Child," featuring a pair of identical teenage twin girls naked in a field of flowers. *Oz* was unique among underground papers in that it was a full-color glossy publication. Because it was published monthly, *Oz* didn't carry listings. Neither did it organize events like *IT* did. Its great value lay in its truly innovative graphics.

The two got along so well that they shared a flat on Kings Road, in Chelsea. There was a great deal of acid around, and it was easy to get spiked at Sharp's studio. The effect on Clapton was dramatic: He grew his hair and had it permed into an immense Afro. The guitarist took to buying hippie clothes and painted his guitar in psychedelic paisley patterns. Sharp was also responsible for the sleeve of Cream's third album, *Wheels of Fire.* His most memorable work was an enormous, exploding image of Jimi Hendrix. At one time, this poster could be found in virtually every student pad in London.

By 1966, news of Swinging London had reached Australia, prompting a large number to travel

NIGEL WAYMOUTH
BRITISH POSTER ARTIST

We felt like we were illustrating an ideal. We were trying to give a visual concept of what we were experiencing, which was like hallucinations. Not literally LSD hallucinations, but the ragbag of things that assault one visually. So one week we'd be doing a poster that was very heavily visually illustrative in a sort of nursery-rhyme way or a childlike way, using images from turn-of-the-century illustrators. The next week we'd be quite boldly doing almost op-art things. It was a mix of things. ✻

2 4 *"San Francisco (Be Sure to Wear Flowers in Your Hair)" is the #6 single in the nation. Purporting to tell of the cultural revolution in the Haight-Ashbury, it was actually written by an L.A. songwriter—John Phillips, of the Mamas and the Papas—and sung by the choirboy-voiced Scott McKenzie, also from L.A.*

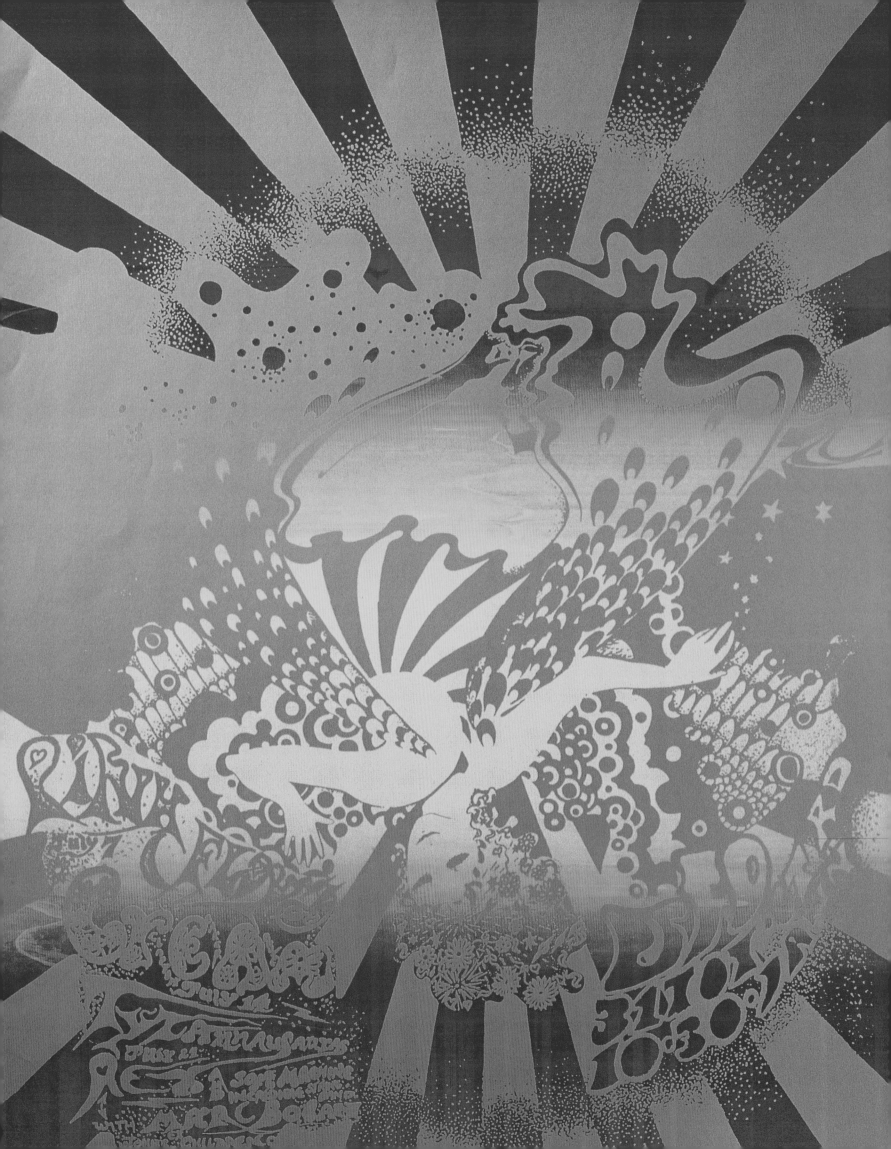

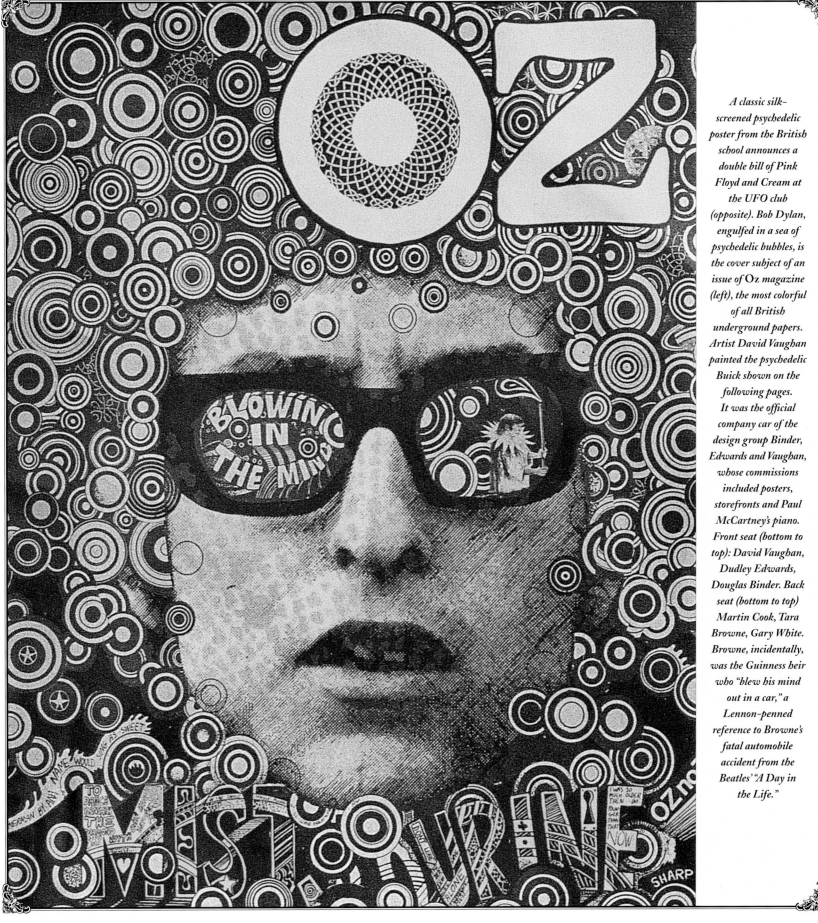

A classic silk-screened psychedelic poster from the British school announces a double bill of Pink Floyd and Cream at the UFO club (opposite). Bob Dylan, engulfed in a sea of psychedelic bubbles, is the cover subject of an issue of Oz magazine (left), the most colorful of all British underground papers. Artist David Vaughan painted the psychedelic Buick shown on the following pages. It was the official company car of the design group Binder, Edwards and Vaughan, whose commissions included posters, storefronts and Paul McCartney's piano. Front seat (bottom to top): David Vaughan, Dudley Edwards, Douglas Binder. Back seat (bottom to top) Martin Cook, Tara Browne, Gary White. Browne, incidentally, was the Guinness heir who "blew his mind out in a car," a Lennon-penned reference to Browne's fatal automobile accident from the Beatles' "A Day in the Life."

J U N E ' 6 7

2 5 **World champion boxer Muhammad Ali (formerly Cassius Clay) is sentenced to five years in prison for refusing to serve in the army. Two months earlier, he had been stripped of his boxing title for refusing induction.**

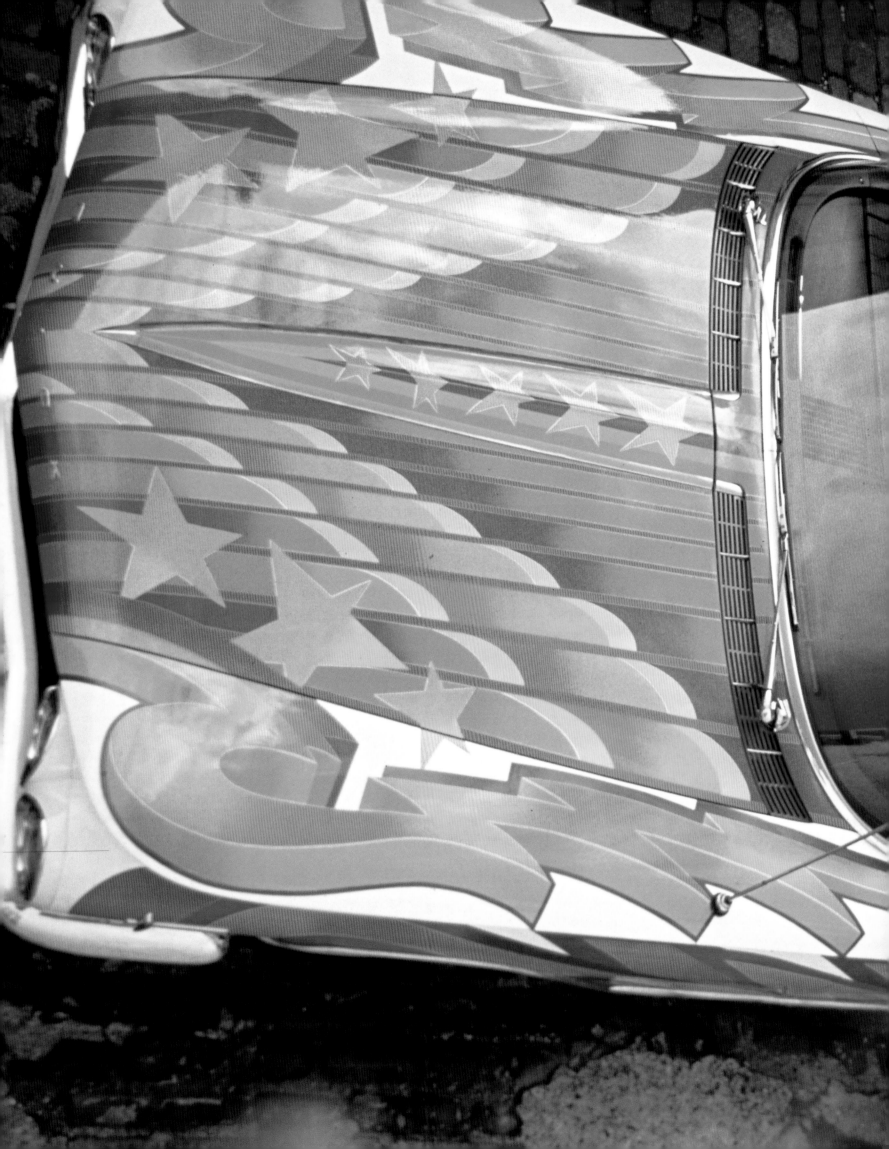

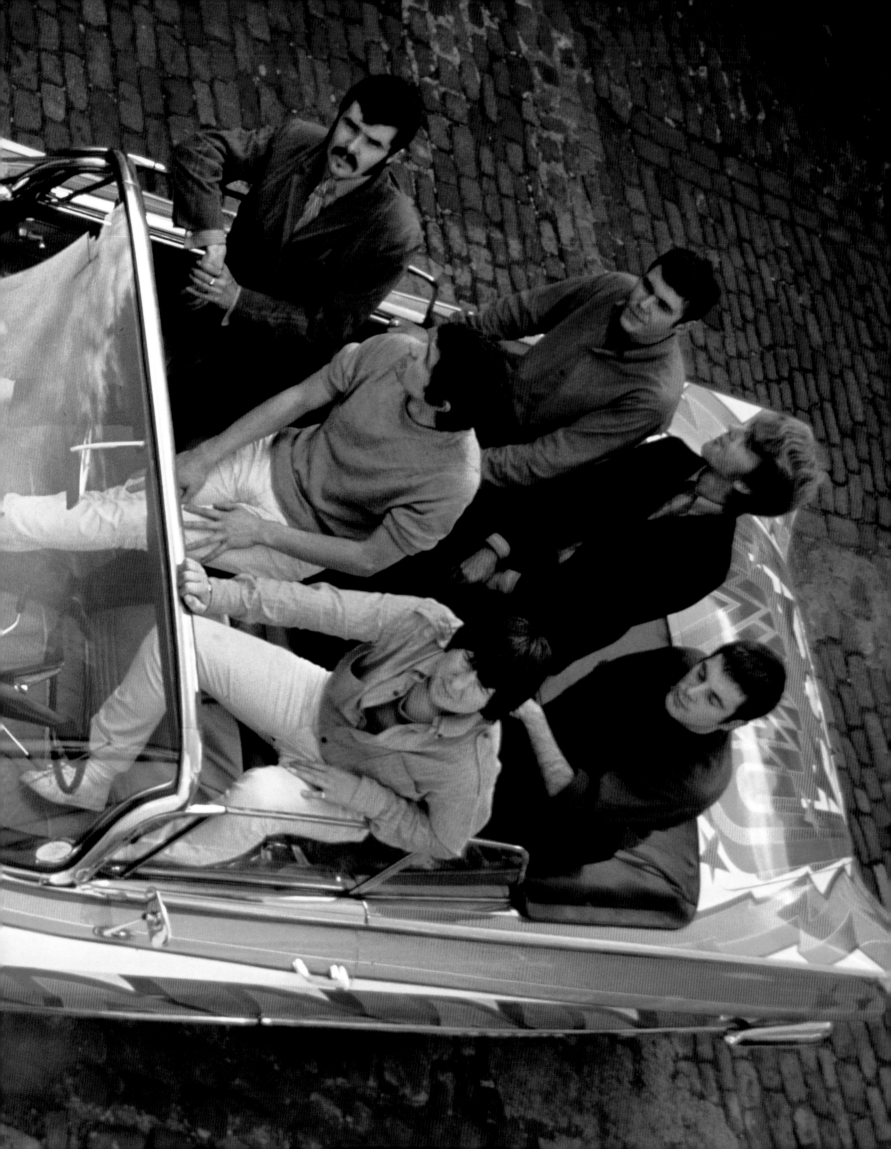

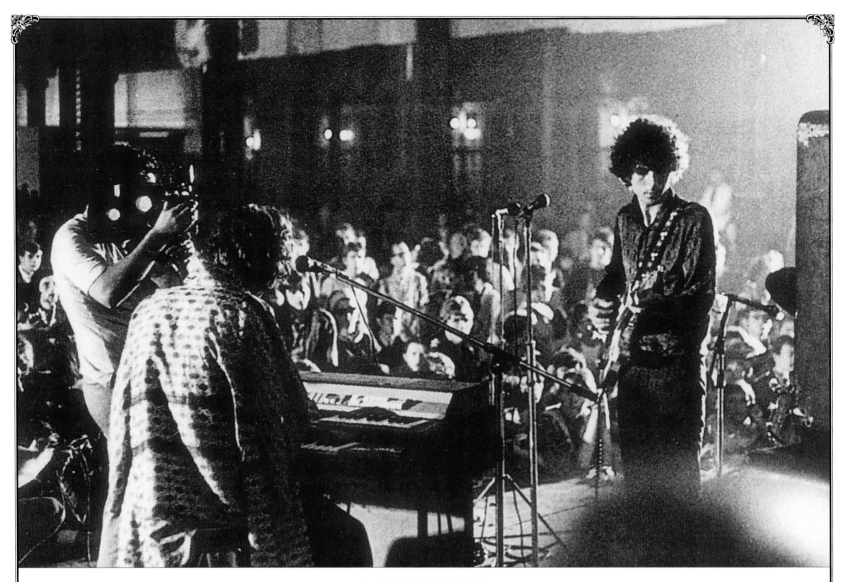

On March 9, *IT* was served with a warrant issued under the government's Obscene Publications Act. It was a published comment from black American comedian Dick Gregory —"I say, 'Fuck white folks' "— that got the paper busted. Twelve plainclothes police confiscated every scrap of paper in the office, including telephone directories, files, correspondence and back issues. Even the editor's personal address book was seized. It was a classic piece of police-state intimidation. A large police truck transferred everything to New Scotland Yard, where it was kept in a locked cage for three months while detectives rifled through it before returning it without bringing charges.

The next day at the UFO club, news items and articles intended for *IT* were read aloud while

Pink Floyd perform at the 14-Hour Technicolour Dream (above), the multimedia rock festival held at the Alexandra Palace in 1967 as a benefit for **International Times.** *Keyboardist Rick Wright (seated, at left) and guitarist/singer Syd Barrett are visible in this picture.*

illustrations were projected onto a screen. Thus, the magazine was "published," albeit in an audio-visual format. If the establishment intended to kill the underground, they only succeeded in driving it aboveground.

Before the bust, a monster concert and happening had been planned to raise funds for *IT*. In the wake of the bust, musicians clamored to offer their services to the 14-Hour Technicolour Dream. They included Alexis Korner, the Creation, the Crazy World of Arthur Brown, Pink Floyd, Soft Machine, Graham Bond, the Move and the Pretty Things. Michael McInnerney designed a beautiful rainbow poster for the event. At dusk on April 29, rockets burst over the London skyline, summoning the freaks from their lairs.

2 9 Mick Jagger and Keith Richards are given sentences of three months and one year, respectively, after having been found guilty two days earlier on drug charges —Jagger for possession of four amphetamines, and Richards for allowing hashish to be smoked on his premises.

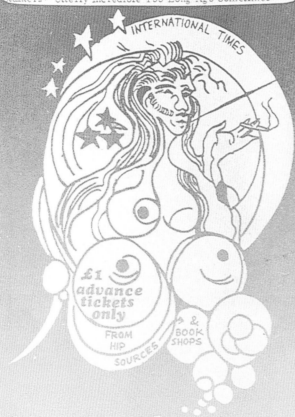

14 Hour TECHNICOLOR DREAM
8pm Saturday APRIL 29 onwards
ALEXANDRA PALACE N22

Alexis Korner* Alex Harvey* Creation* Charlie Browns Clowns* Champion Jack Dupree* Denny Laine* Gary Farr* Graham Bond* Ginger Johnson* Jacobs Ladder Construction Co* Move* One One Seven* Pink Floyd* Poetry Band* Purple Gang* Pretty Things* Pete Townshend Poison Bellows* Soft Machine* Sun Trolley* Social Deviants Stalkers* Utterly Incredible Too Long Ago Sometimes

INTERNATIONAL TIMES

£1 advance tickets only FROM HIP SOURCES & BOOK SHOPS

Shouting at People* Young Tradition* Lincoln Folk Group* Noel Murphy* Dave Russell* Christopher Logue* Barry Fantoni* Ron Geesin* Mike Horovitz* Alex Trocchi* Mike Kemshall* Yoko Ono* Binder Edwards & Vaughn* 26 Kingly St* Robert Randall* love from Allen Ginsberg* Simon Vinkenoog* Jean Jacques Lebel* Andy Warhol* The Mothers of Invention* The Velvet Underground* and famous popstars who cant be mentioned for contractual reasons* guess who*

A flier for the 14-Hour Technicolour Dream (left); a handbill for Pink Floyd's "Games For May" concert (right), held at the Queen Elizabeth Hall on May 12, 1967; and the sheet music for "See Emily Play," the 1967 Pink Floyd single that reached #6 on the British chart during the Summer of Love (below right). On the following pages, percussionists and audience members mingle in a scene from the 14-Hour Technicolour Dream.

JOE BOYD PRODUCER OF PINK FLOYD'S FIRST SINGLE, "ARNOLD LAYNE"

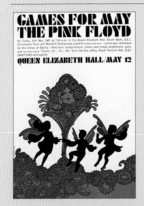

GAMES FOR MAY
THE PINK FLOYD

QUEEN ELIZABETH HALL/MAY 12

Syd Barrett was great. I liked working with Syd a lot. He was a constant source of great melodies. Sadly, there's a long-lost tape I had from him of tunes, other songs he had written.

When I saw them in February of '67, he was still Syd: bright-eyed, impish and full of charming, attractive energy. When they came back in June, it was just like somebody had turned off the lights. Nobody home. That night, he stopped playing in the middle of the set and just stood there. He took an awful lot of acid that spring, I believe.✳

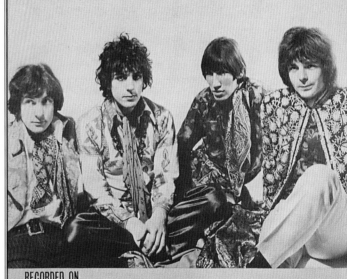

SEE EMILY PLAY

Words & Music by SYD BARRETT

RECORDED ON COLUMBIA RECORDS BY PINK FLOYD

ESSEX MUSIC LTD 3s. 0d.

The Arts Lab, a gathering place for creative types across the spectrum of the arts, opens up in London. Its arrival is marked with these words: "If you like films, poetry, environments, paintings, sculpture, music, food, plays, happenings, People Show, warm flesh, soft floors, happiness, better things through chemistry, or what was once called art, then you should probably join the Arts Lab at once."

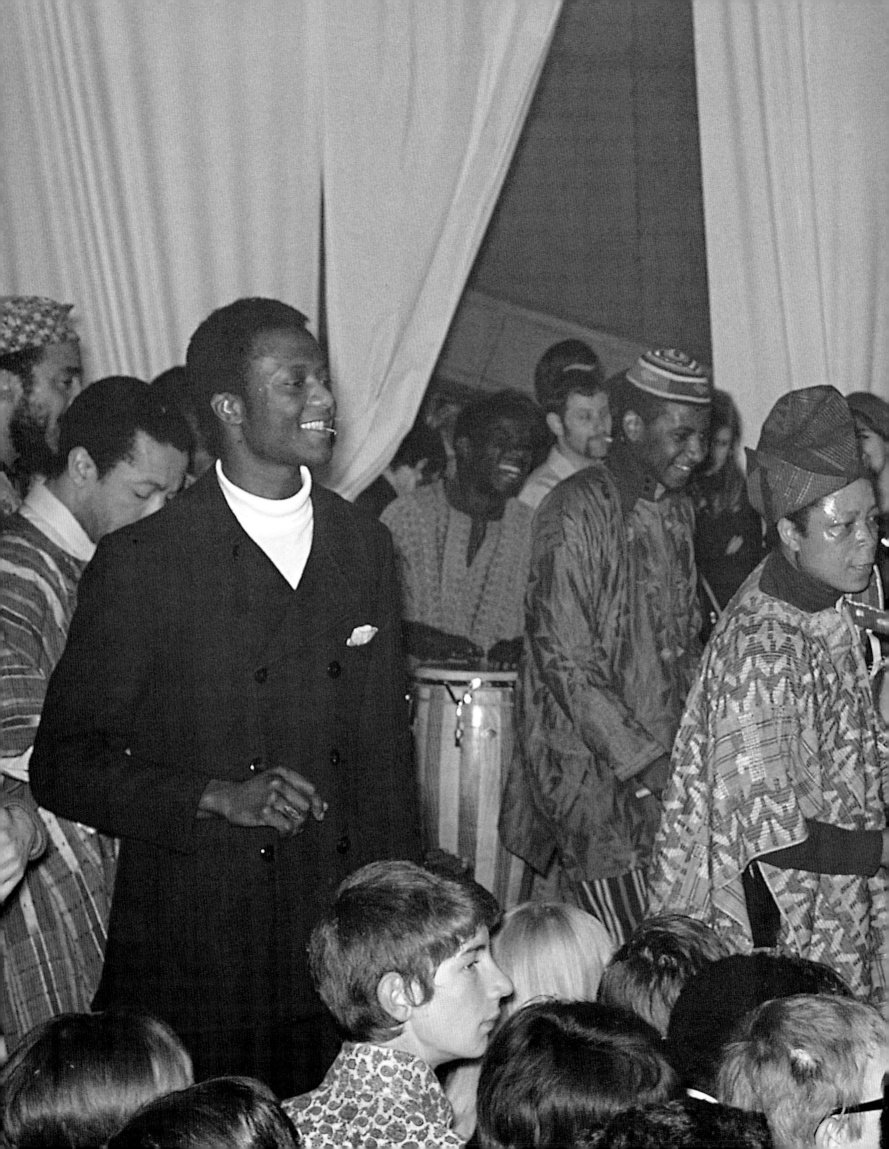

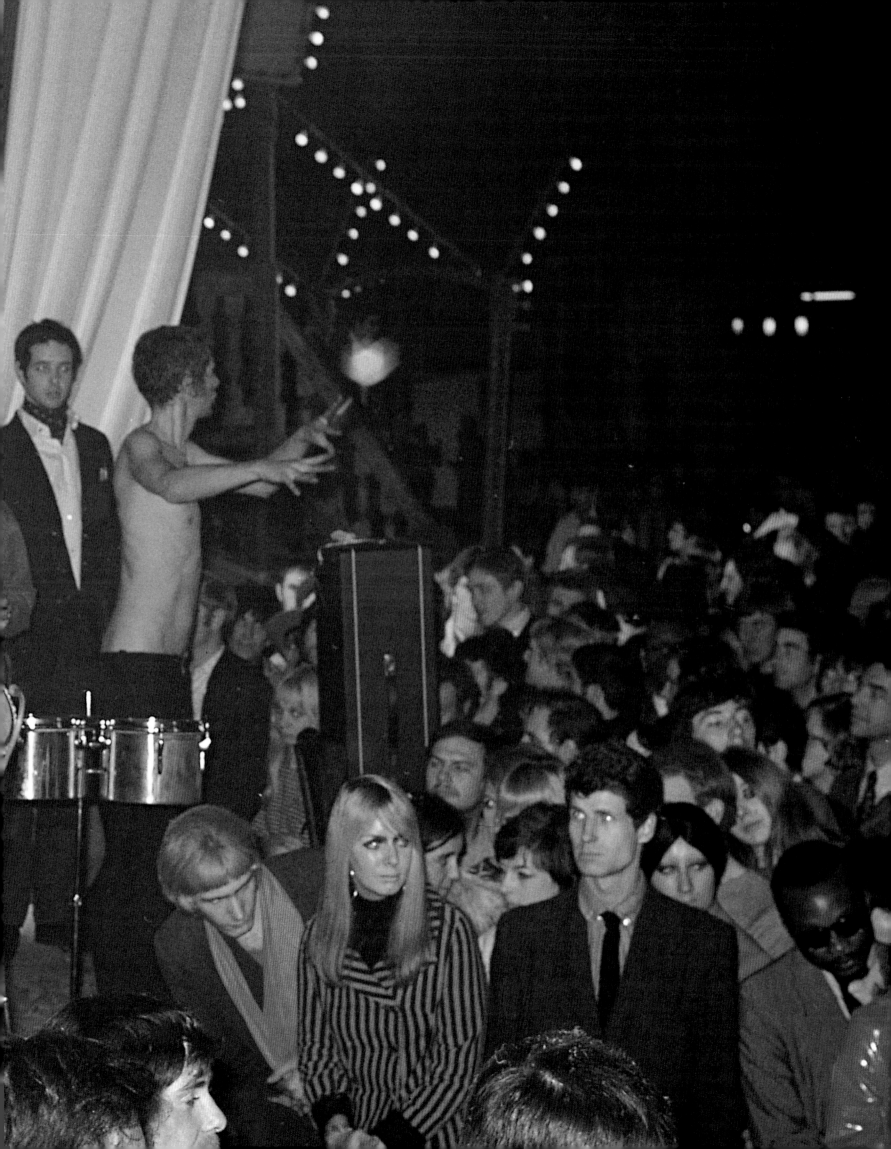

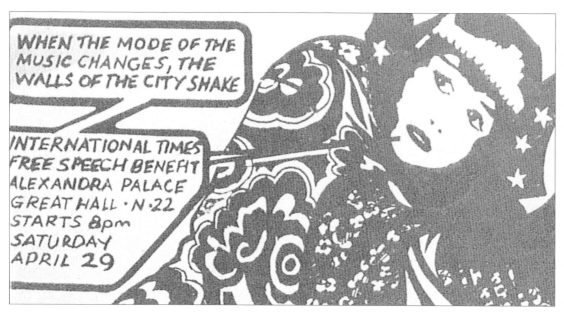

WHEN THE MODE OF THE MUSIC CHANGES, THE WALLS OF THE CITY SHAKE

INTERNATIONAL TIMES FREE SPEECH BENEFIT ALEXANDRA PALACE GREAT HALL · N·22 STARTS 8pm SATURDAY APRIL 29

already met at Ono's show "Unfinished Paintings and Objects," at Indica Gallery.

Ten thousand people attended the 14-Hour Technicolour Dream. It was the largest underground gathering in London to date, the very climax of underground activity. Ally Pally was like an enormously enlarged UFO club, and it felt familiar and comfortable. This was partly due to the lineup of UFO regulars: Arthur Brown (who gave an incendiary performance as "the God of Hellfire"), Soft Machine and Pink Floyd. The latter group arrived around 3:30 a.m., having returned from Holland by ferry after playing a gig that evening. They were exhausted, and both manager Pete Jenner and Barrett were tripping. By this time, Barrett was in the throes of acid psychosis, having lived for a year in a flat in which everything was spiked. The band went on as the first fingers of dawn entered the enormous rose window of Alexandra Palace. The throbbing bass line of "Interstellar Overdrive" galvanized the crowd into a final burst of energy.

Alexandra Palace (or "Ally Pally") was a huge Victorian pleasure palace of metal and glass set in the middle of a park high on Muswell Hill, overlooking London. Inside, the impression was that of a giant cathedral, a vast space filled with light. A fairground helter-skelter [slide] at one end offered free rides, and a fiberglass igloo for smoking banana skins — which was that month's craze — had been erected. The palace was so large that there were stages at both ends, with poetry or folksinging on one and rock music on the other. In the middle was probably the biggest sound and lighting system ever erected in Britain. From a platform high above the floor, Hoppy and his crew ran the event. Mick Farren's Social Deviants opened the show and were followed by forty or so groups.

John Lennon and John Dunbar were tripping when they saw a clip about the event on the news. Lennon's chauffeur was summoned, and they set off for Muswell Hill. One of the events that Lennon saw was a happening organized by Yoko Ono in which a young woman's clothes were cut off, one small piece at a time, by audience members. Lennon and Ono had

A ticket (above) from the 14-Hour Technicolour Dream.

John Lennon's psychedelic Rolls-Royce (below); even the cars were tripping in the Summer of Love.

Yoko Ono (opposite) at her one-woman show entitled "Unfinished Paintings and Objects."

1 **William Rees-Mogg, editor of the London Times, publishes a reasoned editorial entitled Who Breaks a Butterfly on a Wheel? condemning the sentences given Jagger and Richards. Rees-Mogg argues: "There must remain a suspicion in this case that Mr. Jagger received a more severe sentence than would have been thought proper for any purely anonymous young man."**

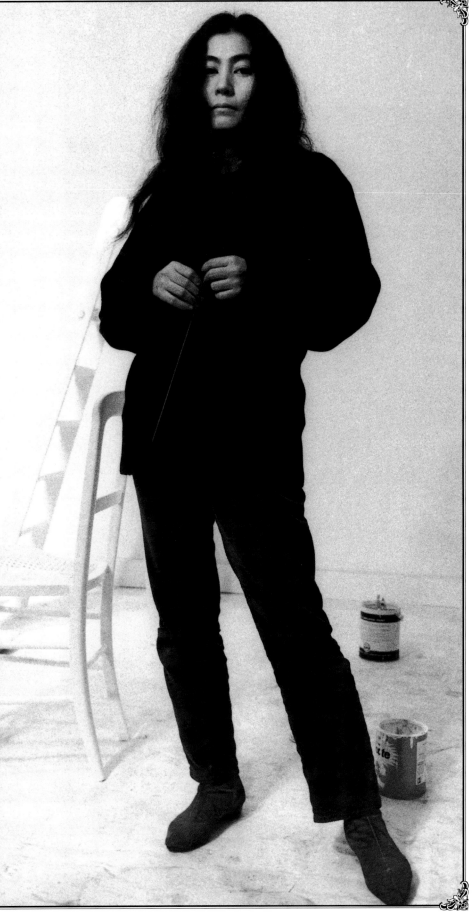

JOE BOYD Co-founder of the UFO Club

In addition to music, we had a lot of events at UFO. We always had theater groups like the People Show, an alternative theater group from London that's still going. We had avant-garde jazz. We had situationist kind of events. And Yoko Ono used to do things. UFO was her main recruiting center for the *Bottoms* film. She filmed a series of people's behinds.

Yoko also used to come down and do events, one of which I remember very vividly. She asked for a stepladder and a contact microphone with a long lead. She glued the microphone to one blade of a pair of scissors, and then she brought in this very beautiful girl who was wearing a paper dress. At the right time in the middle of the evening, when the place was completely jammed, Yoko put the stepladder in the middle of the room and had the scissors plugged into an amp in the middle of the stage. She put the girl up on the stepladder and cut the dress right off the girl with the noise of the scissors being hugely amplified through the amp. ✳

7 **Time** *magazine runs a cover story called* The Hippies: Philosophy of a Sub-Culture.

1 2 *Race riots leave 26 dead and 1,500 injured in Newark, New Jersey.*

THE BE-IN

O n October 6, 1966, LSD became illegal. Would the psychedelic community respond with protest demonstrations? The editors of the *Oracle*, a recently founded Haight-Ashbury newspaper, proposed a gathering that would not confront the violence of the world with threats but with a confident manifestation of the psychedelic lifestyle. Big Brother and the Dead would play in the Panhandle on the very day LSD became illegal. *Bring the color gold*, read a leaflet advertising the Love Pageant Rally; *bring photos of personal saints and gurus and heroes of the underground... bring...children...flowers...flutes...drums... feathers...bands...beads...banners...flags... incense...chimes...gongs...cymbals...symbols.*

It was so obvious: a psychedelic-rock gathering in the bosom of nature to bear witness to a faith in psychedelics — which had come to seem like the only hope for saving the world from nuclear destruction — and to sense the existence of the psychedelic community and its inevitable spread. This was taking the whole thing to a new level. Seven or eight hundred people came, along with reporters and TV cameras.

The following week, a group of Mime Troupe actors calling themselves the Diggers passed out a flier reading: *Bring a bowl and spoon to the Panhandle at Ashbury Street 4 p.m. 4 p.m. 4 p.m. Free food everyday. Free food. It's free because it's yours.* To get your food, you had to step through a 13-foot wooden square, painted yellow, that was called the Frame of Reference. This caught everybody's attention. In recent weeks, there had been signs that the local economy of the Haight-Ashbury was no longer accommodating the growing number of newcomers. Now there were kids on Haight Street panhandling for spare change. The hip merchants, who had now organized themselves as the Haight Independent Proprietors (HIP), worried that this would bring a police crackdown.

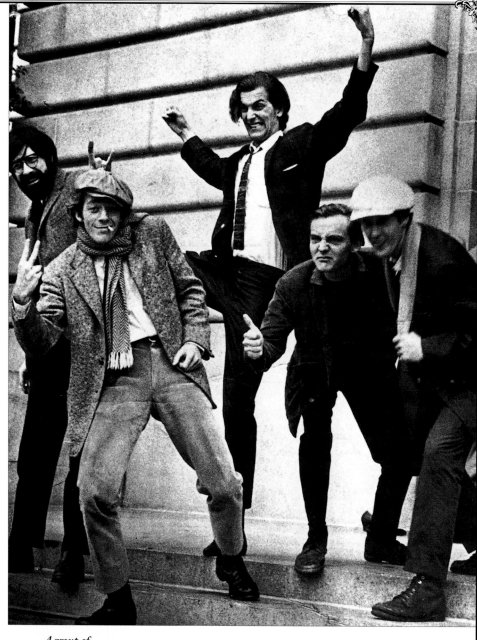

A group of Diggers raises a ruckus on the steps of San Francisco's city hall (above) after being cleared in court of charges of creating a public nuisance: Robert La Mortacella, Emmett Grogan, Kent Minault, Peter Berg and Brooks Butcher (from left). Dancers celebrate at a weekend gathering in the Panhandle (opposite).

They had started having meetings to consider taking steps, like setting up some kind of hippie job co-op.

But the Diggers offered another solution: paying no attention to the straight world and its ways, obtaining food by scrounging and outright theft and giving it to anybody who wanted it — "because it's yours." They also had a "free store" where secondhand clothes were there for the taking. Teenagers all over the Bay Area learned about it almost immediately. If you ran away from home, the story went, you could go to the Haight, and the Diggers would take care of you.

JULY '67

16 *A "legalize pot" rally is held in London's Hyde Park.*

22 *The Beatles' anthemic "All You Need Is Love" goes to #1 in the U.K. On June 25, the group performed the song in a TV studio for a worldwide satellite broadcast.*

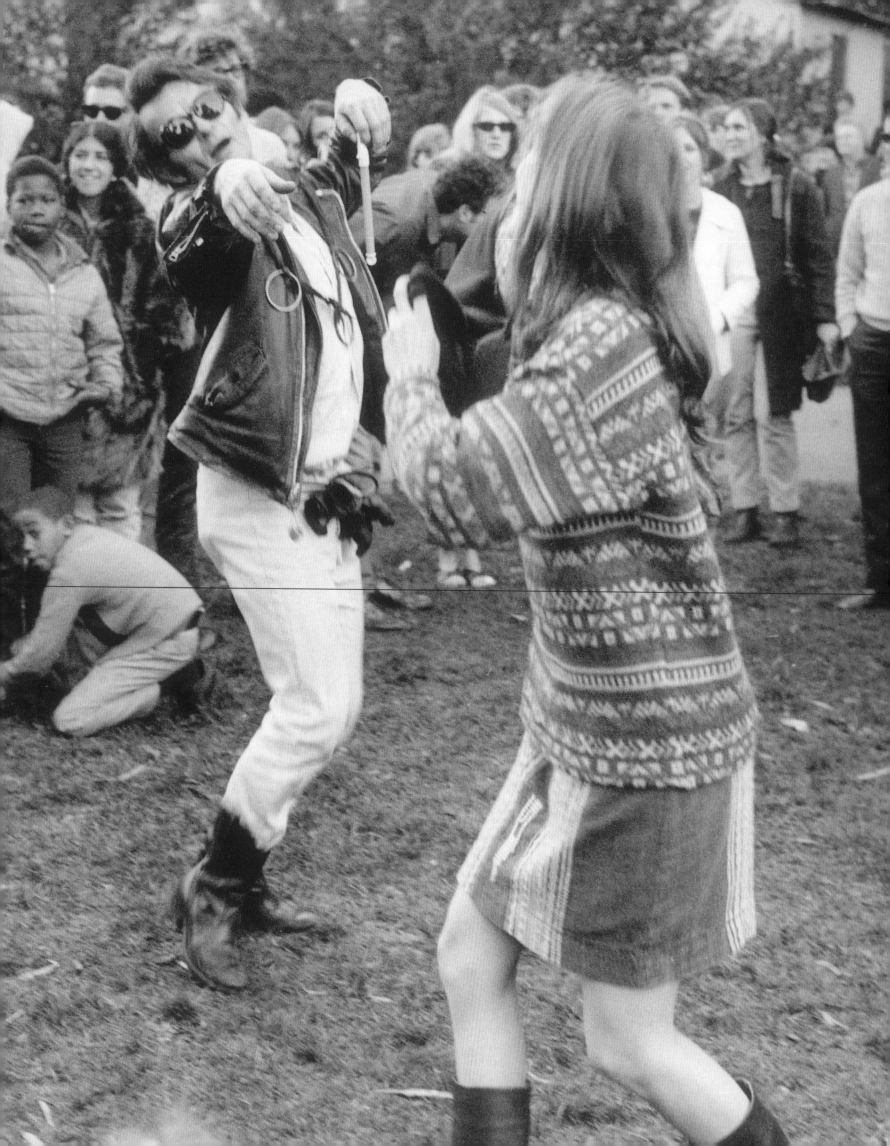

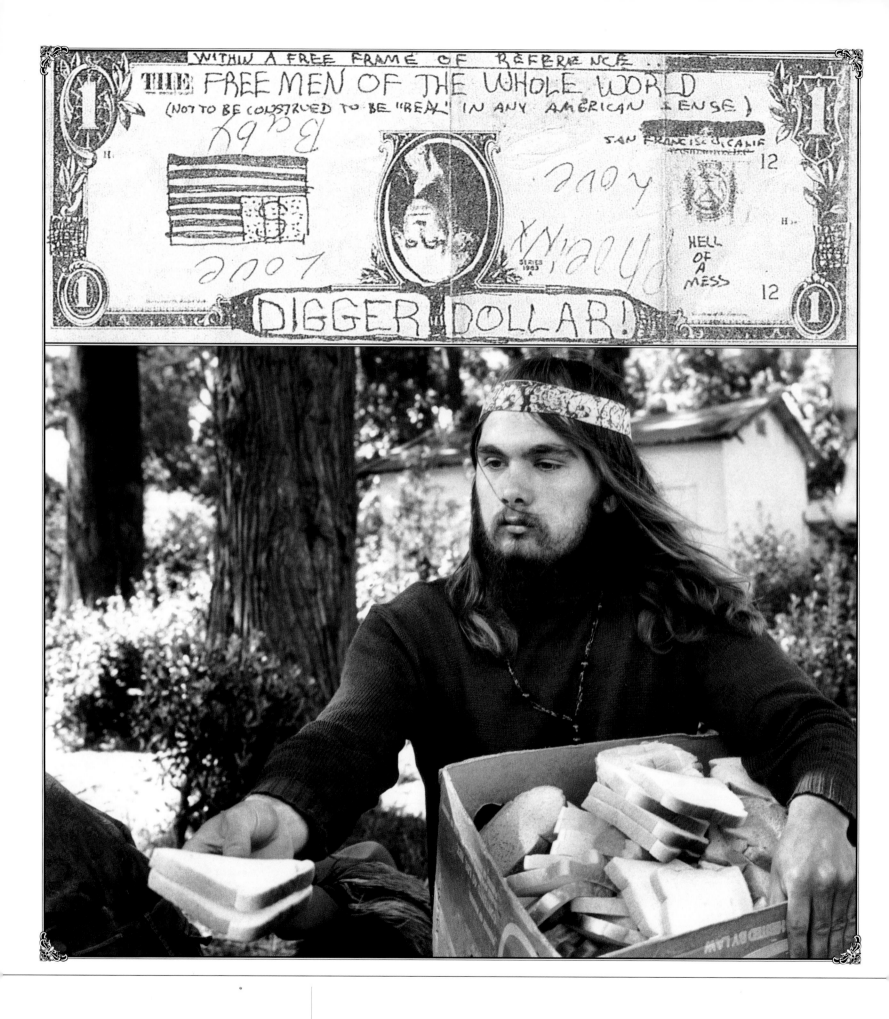

Bring a bowl & a spoon to the Panhandle at Ashbury Street. Free food every day.

2 3 - 2 7 *A week's worth of rioting and destruction in Detroit claims 43 lives. The riots leave 2,000 injured and 5,000 homeless while causing an estimated $400 million in property damage. President Johnson calls in the National Guard and federal paratroopers.*

2 4 A full-page ad in the London Times urges the legalization of marijuana in Britain. It is signed by all four Beatles, as well as by many other celebrities and notable figures.

RESTRICTED
STREET

TRUCKS LIMITED
TO ONE BLOCK
FOR PICKUP OR
DELIVERY ONLY

*Crowds swarm
in the Panhandle
during the
Summer of Love
as a national
media frenzy turns
the spotlight on
the Haight-
Ashbury (left).*

*A close-up of
a typical Panhandle
scene (previous
page), with dancers,
drummers and
beatific observers all
digging the vibe.*

*A Digger
hands out sandwiches
in the Panhandle
(page 120); above
him, a "Digger dollar,"
good for free
food, at least.*

JULY '67

29 *"Light My Fire," by the Doors,
is the top-selling single in America.*

29 - 30 *Pink Floyd takes
part in an all-night "International
Love-In" at London's Alexandra
Palace.*

And now there was word of the biggest event yet, scheduled for January 14, 1967. It was called a Gathering of the Tribes for a Human Be-In.

It was announced all over the Bay Area by posters, one of which was the cover of the latest *Oracle.* The underground paper had quickly shed most elements of convention and by now mostly published poetry, interviews and essays, such as the one on the "new science": astrology, acupuncture and homeopathic medicine. Like the dance posters that had subordinated their text to striking design, the pages of the *Oracle* were becoming primarily visual phenomena. Column widths were altered to produce slanting patterns on the page. Some pages were printed entirely in orange or purple ink.

The Be-In was not scheduled to begin until 1:00 p.m., but people had been arriving at Golden

Astrologer, writer, philosopher and presidential grandson Gavin Arthur in his apartment (above). He was asked to determine the best day for the Human Be-In, choosing January 14, 1967. Astrologically, he claimed, it was a favorable day for positive communications to promote the common good.

Gate Park since early morning, moving in ever-growing trickles through the greenery, past romantic structures named Storybook Fountain and Portals of the Past. You could sense acidheads from all over making their way here, wearing the beaming, conspiratorial, amazed Be-In smile and personal adornments suggesting cosmic glory and the spontaneous bounty of nature.

Finally, all roads converged on the Polo Field. It became a sea of people. There were ten or twenty thousand — who could tell? — spread out on the grass in a dense tapestry of human bodies. What were they there for? From time to time, people on a little stage at one end of the field apparently claimed to tell them. There was talk of a union of psychedelic San Francisco and radical activist Berkeley, an idea that had been floating around for a while.

JULY '67 31 **Mick Jagger's and Keith Richards' sentences are remanded by an appeals court that found the earlier court-ruling in error.**

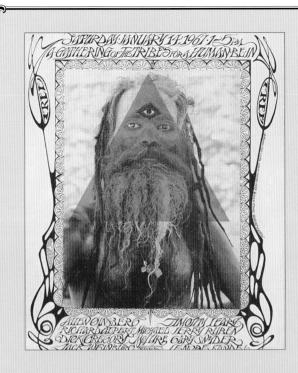

ALLEN GINSBERG

It was just gangs of friends getting together. Gary Snyder and I circumambulated the meadow in Golden Gate Park, doing Hindu and Buddhist mantras to purify the ground. Suzuki Roshi, the great Zen master, was seated on the platform in meditation most of the afternoon unbeknownst to most people, who didn't recognize him. The new bands, like Quicksilver and the Grateful Dead, were playing on the platform. It was a big poetry time, so Gary Snyder and Michael McClure and I read poems. Leary was allowed the same time as the poets, fifteen minutes. There was a psychedelic element there, too. We recruited the formerly hostile Hell's Angels to be the guardians. They weren't very good at it, but at least it neutralized them. Then at the end, we said, "Let's have kitchen yoga," which is to clean up the park as you leave. So we left the park cleaner than when we came, which was kind of astounding.✱

Posters announce the Human Be-In, promoted as a Gathering of the Tribes. According to David Freiberg of Quicksilver Messenger Service, who played at the Be-In, "It was a big deal. You looked around, and there were 20,000 to 100,000 people, depending on whose count you believed. It seemed like a lot of freaks in one place at one time. We realized we weren't alone."

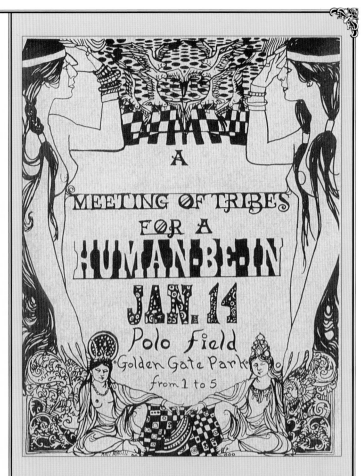

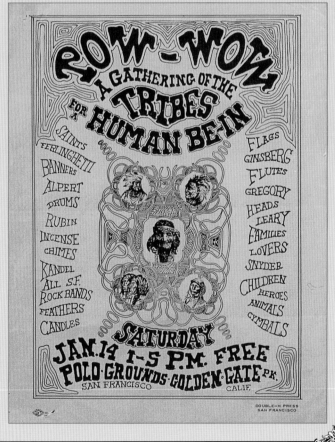

8 *Beatle George Harrison pays a visit to the Haight-Ashbury, strolling down Haight St. while strumming a guitar. He sings "Baby You're a Rich Man" as a crowd trails him.*

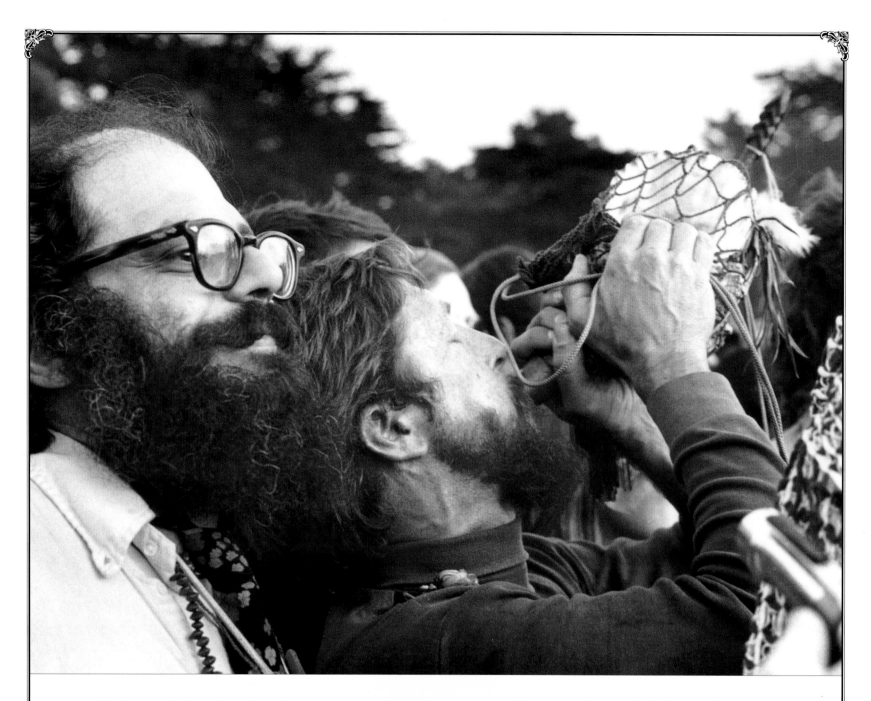

But it was obvious that the real reason was simply to be-in — that is, to be in a place declaring your right to be, just as civil rights demonstrators had been sitting-in at Southern lunch counters to declare their right to be seated. In any case, it was hard to hear the speakers over the crummy P.A. (its generator was guarded by Hell's Angels). People did sing along with poet Gary Snyder when he chanted the mantra of Maitreya, the coming god of love, and with Allen Ginsberg when he chanted the mantra of Shiva, the hashish-smoking god of yoga.

Allen Ginsberg and Gary Snyder (above) at the Human Be-In. Snyder is shown blowing into a conch shell, the ritual instrument of a sect of Japanese Buddhists, to celebrate the start of the event.

They sang along with Jefferson Airplane on "Let's Get Together," and some danced to the Grateful Dead's music, though it was odd to be dancing in the sun after all those months in murky dance-halls. A chant went up: "We are all one."

Finally, as the afternoon was waning, a parachutist appeared from the sky. The rumor instantly went around that it was Owsley, the LSD chemist. And then people began wandering back home or to their cars, many of which had been parked hours ago at some pretty stoned angles.

AUGUST '67

9 "San Francisco (Be Sure to Wear Flowers in Your Hair)," by Scott McKenzie, reaches #1 in Britain.

14 Britain's "pirate" radio stations, a popular alternative to BBC programming, are closed down by the government.

Those who stayed picked up trash reverently on the Polo Field and ended up at Ocean Beach chanting with Ginsberg as the sun set.

It had been exhilarating. Hopes and dreams that had scarcely seemed utterable now looked like distinct possibilities and maybe even the only way to survive in an age of nuclear threat. The press had been astonished, too. Berkeley demonstrations they could understand, as there was always an insistent catalog of demands. But this huge gathering had been utterly mysterious. Reporters suddenly discovered a line in a Bob Dylan song that seemed to sum it up: "You know something's happening but you don't know what it is. Do you, Mr. Jones?"

Ron Thelin, co-owner of the Psychedelic Shop, and poet Lenore Kandel at the Human Be-In (above). Kandel's poetry collection The Love Book had been seized during an obscenity bust at the Psychedelic Shop two months earlier. Kandel read from The Love Book at the Be-In. Another participant was Timothy Leary (following pages), seated onstage while Quicksilver plays.

VICTOR MOSCOSO
SAN FRANCISCO POSTER ARTIST

There was a period of time in 1965 and '66 when I thought the millennium had come. A benevolent virus had descended and happened to hit San Francisco and was spreading out. Pretty soon everybody was going to live by the golden rule and treat everybody the way they wanted to be treated. And the lion shall lay down with the lamb, etc. I really thought the millennium had come, and for about six months in San Francisco, it had.✻

AUGUST '67

19 *"All You Need Is Love," by the Beatles, is the #1 song in America.*

29 *The rock trio Cream makes its San Francisco debut, playing six sold-out nights at the Fillmore.*

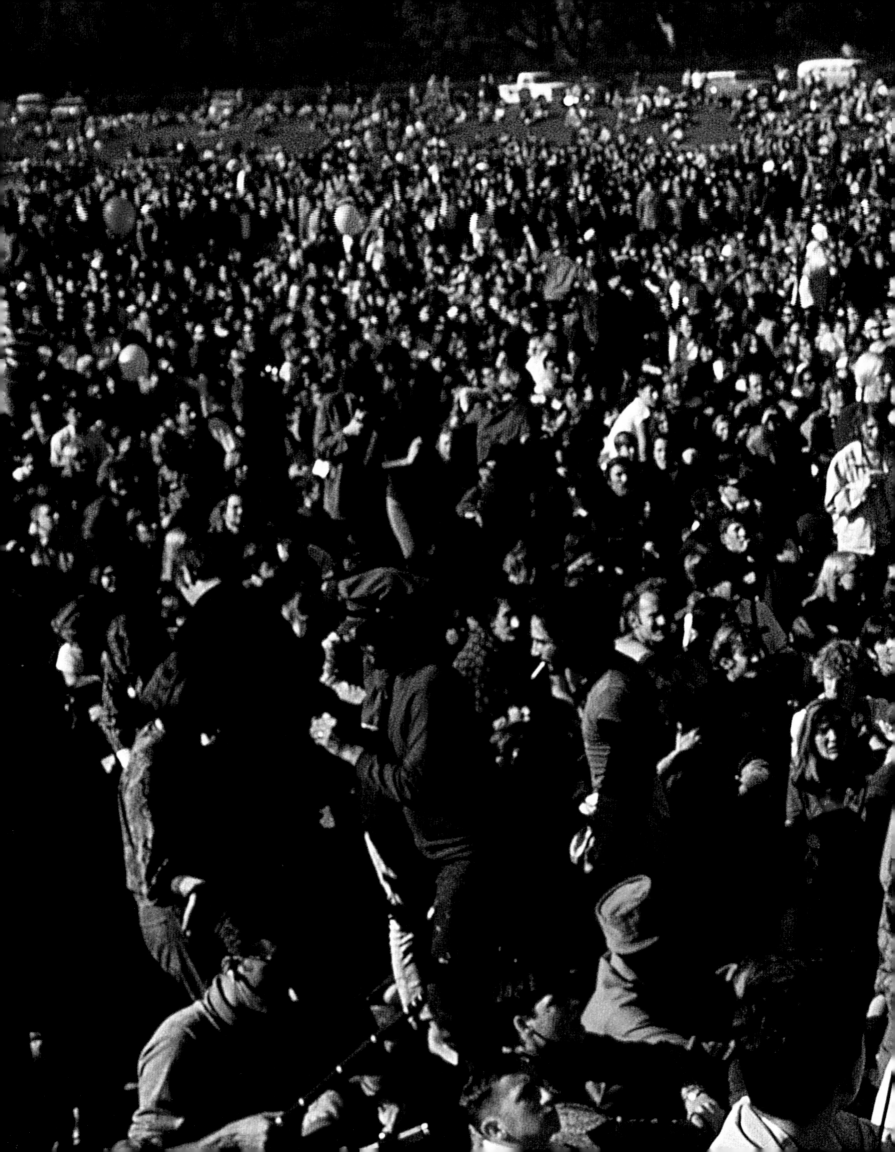

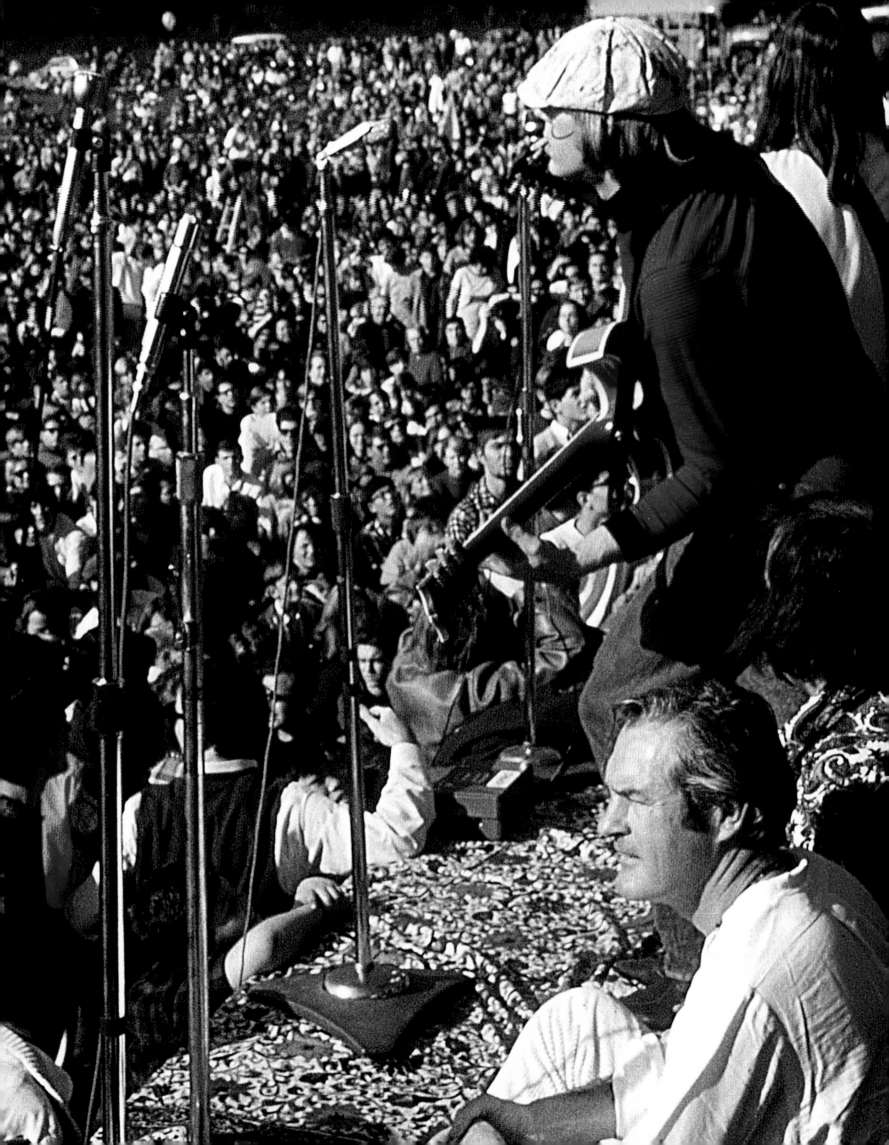

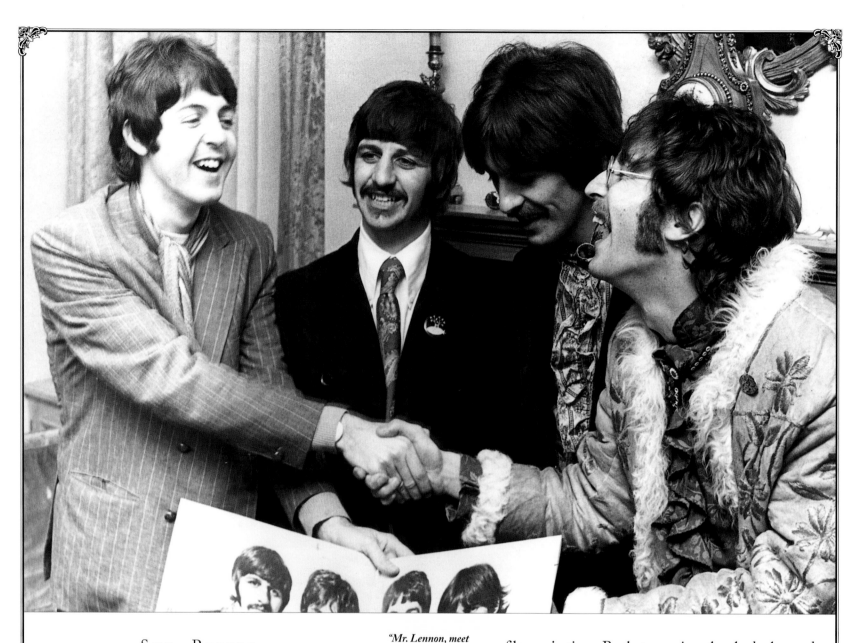

"Mr. Lennon, meet Mr. McCartney." The Beatles share a moment of levity at the launch party for Sgt. Pepper's Lonely Hearts Club Band. *Reviewers such as the* Village Voice's *Tom Phillips proclaimed* Sgt. Pepper *"the most ambitious and successful record album ever issued." It was also an album inspired, in McCartney's words, by "drugs — pot and acid." The lid was now off Pandora's box.*

S GT. P E P P E R

Pink Floyd's first large solo concert was put on by a classical music promoter at the prestigious Queen Elizabeth Hall in the South Bank arts complex. Called "Games For May," the concert featured the first use of a quadraphonic P.A. system in Britain. Gigantic speakers enabled sounds to move around the hall in a circle. A roadie threw huge bunches of daffodils to the audience, and millions of bubbles drifted through the air, reflecting the moving-liquid light show and film projections. By that morning, they had rehearsed the light show but not the music. "When it came to the performance in the evening, we had no idea what we were going to do," Roger Waters recalled. "We just took a lot of props onstage with us and improvised." Barrett wrote a song for the event, "Games For May," which was later changed to "See Emily Play." One of the trippiest tunes from the Summer of Love, it became a Top Ten single for the band in July 1967.

Record companies responded to all the new music by launching underground labels such as Vertigo, Direction, Harvest, Fly and Deram. One hallmark of a true arty underground band was its refusal to release singles. The best example of this

S EPTEMBER ' 6 7

3 0 *John Lennon and George Harrison appear with the maharishi on the David Frost Show.*

The collage
for the cover of
Sgt. Pepper's Lonely
Hearts Club Band
(below left),
photographed at
a Chelsea studio by
Michael Cooper,
included seventy figures.
Inside the album
came a sheet of badges
and cutouts (above
left). The front of the
building housing
Apple, the Beatles'
boutique on London's
Baker St. (right),
was painted with
psychedelic fantasies
by a Dutch foursome
who called themselves
the Fool. Jenny Boyd,
whose sister Pattie
had married
George Harrison in
1966, serves customers
at Apple Boutique
on opening day in
December 1967
(below).

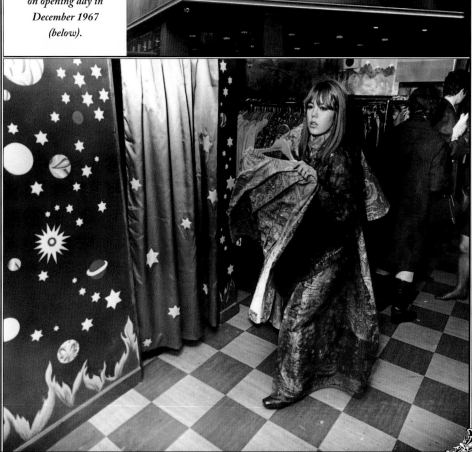

SUE HALL
ART STUDENT AND UFO CLUB REGULAR

The impact of *Sgt. Pepper* was absolutely dramatic. I remember it very well, because it coincided with the availability in this country of good stereo headphones. Before that, you couldn't get headphones; they would have been a high-priced studio artifact. Suddenly they were available for a few dollars. So I remember listening to *Sgt. Pepper* on headphones and feeling as though I had taken acid when I hadn't taken any.✱

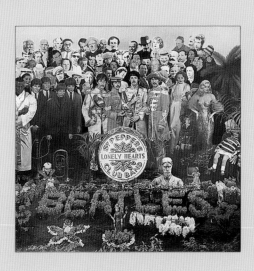

2 The Grateful Dead's communal house at 710 Ashbury St. is raided. Three band members (Bob Weir, Phil Lesh and Ron "Pigpen" McKernan) are charged with marijuana possession.

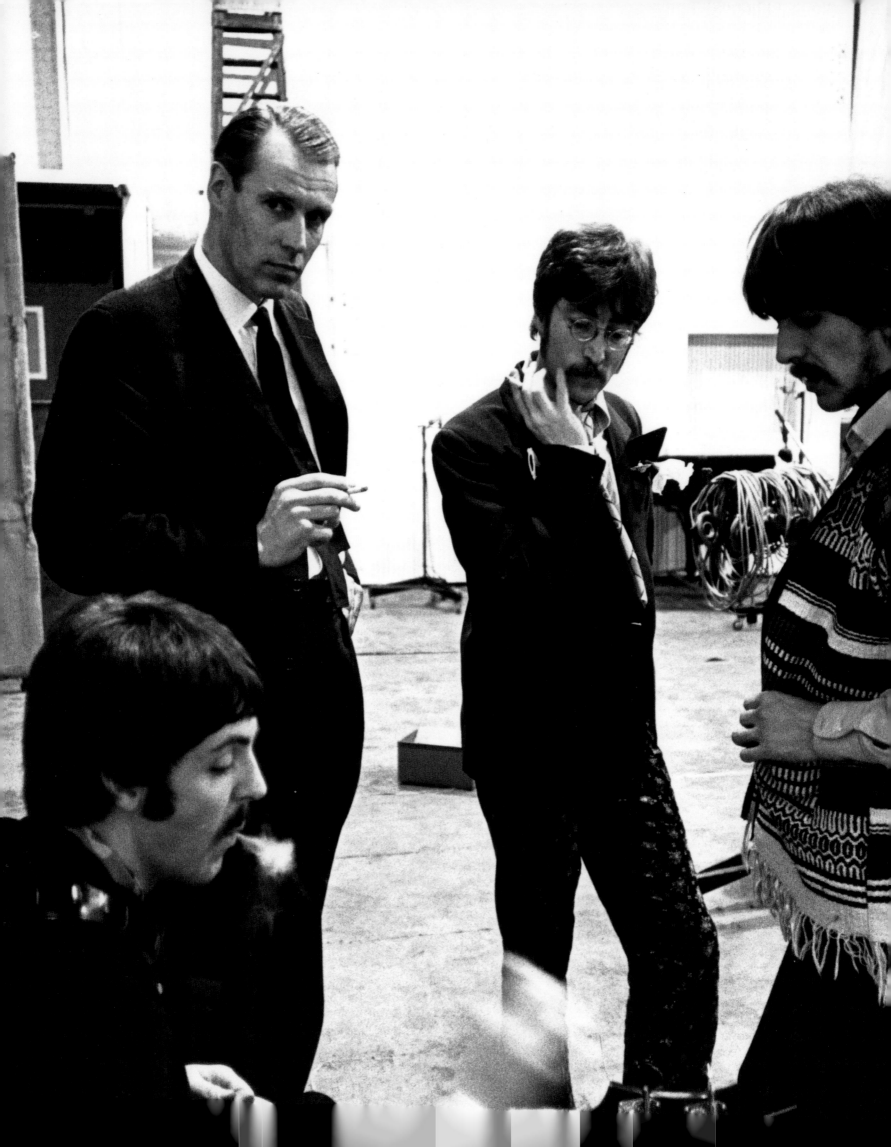

conviction was *Sgt. Pepper's Lonely Hearts Club Band*, from which the Beatles forbade even one single to be issued.

Sgt. Pepper was very much McCartney's album. Lennon's marriage to Cynthia was on the rocks, but he did not want to inflict his own childhood experience upon his son, Julian, by walking out. So instead Lennon stayed at home and took drugs. He hardly ever saw his family and rarely went to London except for recording sessions. He later told me, "I was still in a real big depression during *Pepper*. Paul was feeling full of confidence, but I wasn't. I was going through murder." However bad he felt, John made a significant contribution to the album, which is regarded by many as rock's loftiest pinnacle.

During its recording, the Beatles discouraged studio visitors. Most of the time it was just them and their roadies, Mal Evans and Neil Aspinall.

Three mustachioed Beatles — Paul, John and George (opposite, from left) — and their neatly attired producer, George Martin, at a recording session for Sgt. Pepper *in 1967.*

The Dutch designers known as the Fool (right) recorded a best-forgotten album (below). They also designed clothing for the Beatles' Apple Boutique.

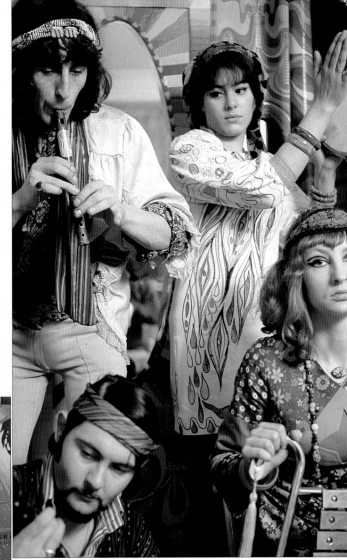

Evans was expected to do the impossible. At 2:00 a.m. Lennon might mutter, "Socks, Mal," and Evans would lumber off, returning in an hour with dozens of pairs of colored socks. It was also Evans' job to roll joints, which he did hidden from producer George Martin's view, behind the sound baffles surrounding Ringo Starr's drum kit. The Beatles would sometimes sneak off for a smoke to a room that housed the building's air conditioning unit. While working on a TV documentary about the making of *Sgt. Pepper*, Martin asked McCartney, "Do you know what caused *Pepper*?" McCartney replied, "In one word, drugs. Pot." Martin protested, "No, no. You weren't on it all the time." "Yes, we were. *Sgt. Pepper* was a drug album."

3 *Folk-music legend Woody Guthrie succumbs to Huntington's chorea at age fifty-five.*

I opened a boutique in London at the end of '65, beginning of '66 called Granny Takes a Trip. It was a rebellion against conventional outfits. Why can't things be more androgynous? Why can't men wear flowered jackets with their long hair? Why can't we wear velvet as a kind of aesthetic thing? Why does fashion have to be *haute couture*? Why does it have to be so rigid? You can wear whatever your fantasy takes you. So we'd make clothes accordingly.

Granny's was the first boutique to sell clothes for men and women side by side on the rail. It was a situation where anybody could wander in, dress up and walk out with these bright, colorful clothes. Of course, groups loved it. They would come in and get kitted up for their tours or record covers or whatever they were doing. Lennon would come in after-hours, as would Keith Richards and the Stones.

The front of the shop was very visual. Originally, we had an art nouveau kind of thing, and then we had this huge painted face of Jean Harlow. Then we had a phase of American Indians, with two very fierce-looking characters glaring out at you with tomahawks. Finally, my partner had a 1947 Dodge that collapsed. It was parked outside, and one day I said, "It's too nice a car to go to the scrap heap. Let's cut it in half. We'll have the front half coming out of the shop." So it sort of came crashing out of the shop. It looked good, and people went wild. It was the first shop to have a car bursting out of its front window.✳

6 A ceremony billed as the "Death of Hippie" is held on the first anniversary of the legislation making LSD illegal. Hippie paraphernalia and media emblems are burned. A mock funeral procession down Haight Street follows. A banner reads: Death of Hippie Freebie, i.e., Birth of the Free Man.

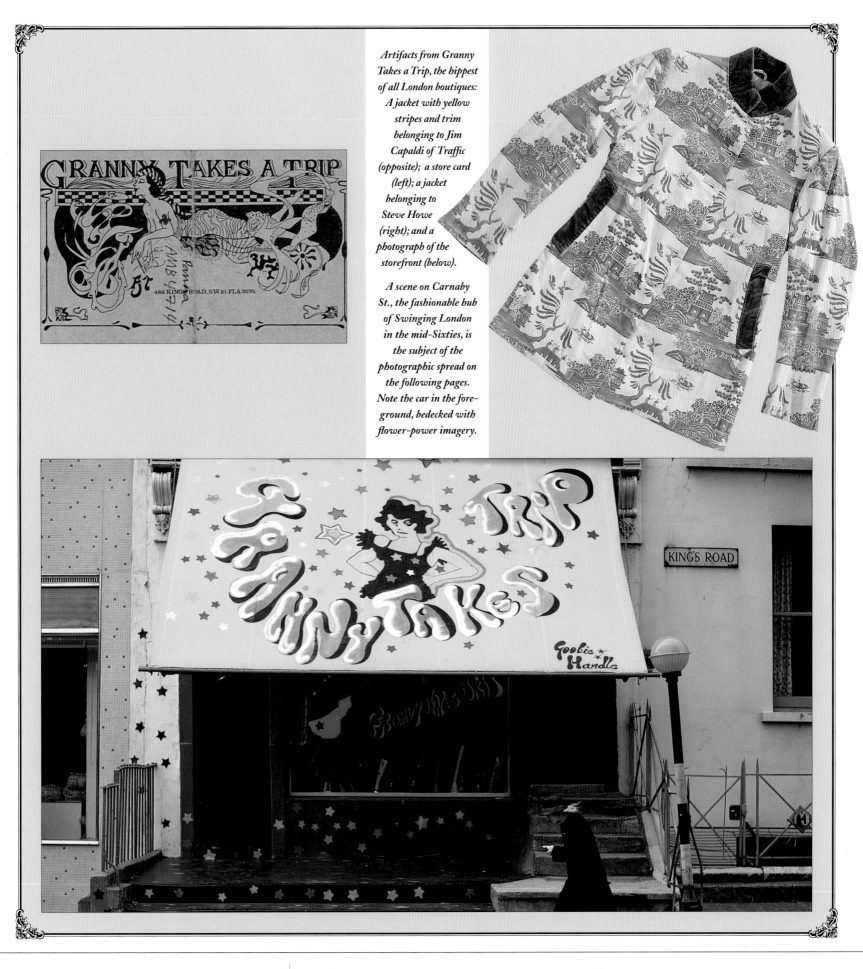

Artifacts from Granny Takes a Trip, the hippest of all London boutiques: A jacket with yellow stripes and trim belonging to Jim Capaldi of Traffic (opposite); a store card (left); a jacket belonging to Steve Howe (right); and a photograph of the storefront (below).

A scene on Carnaby St., the fashionable hub of Swinging London in the mid-Sixties, is the subject of the photographic spread on the following pages. Note the car in the foreground, bedecked with flower-power imagery.

15 The UFO club closes after the building's landlord is pressured by authorities. Melody Maker headline asks: Who Killed Flower Power?

19 America's first underground news provider, the Liberation News Service, is launched.

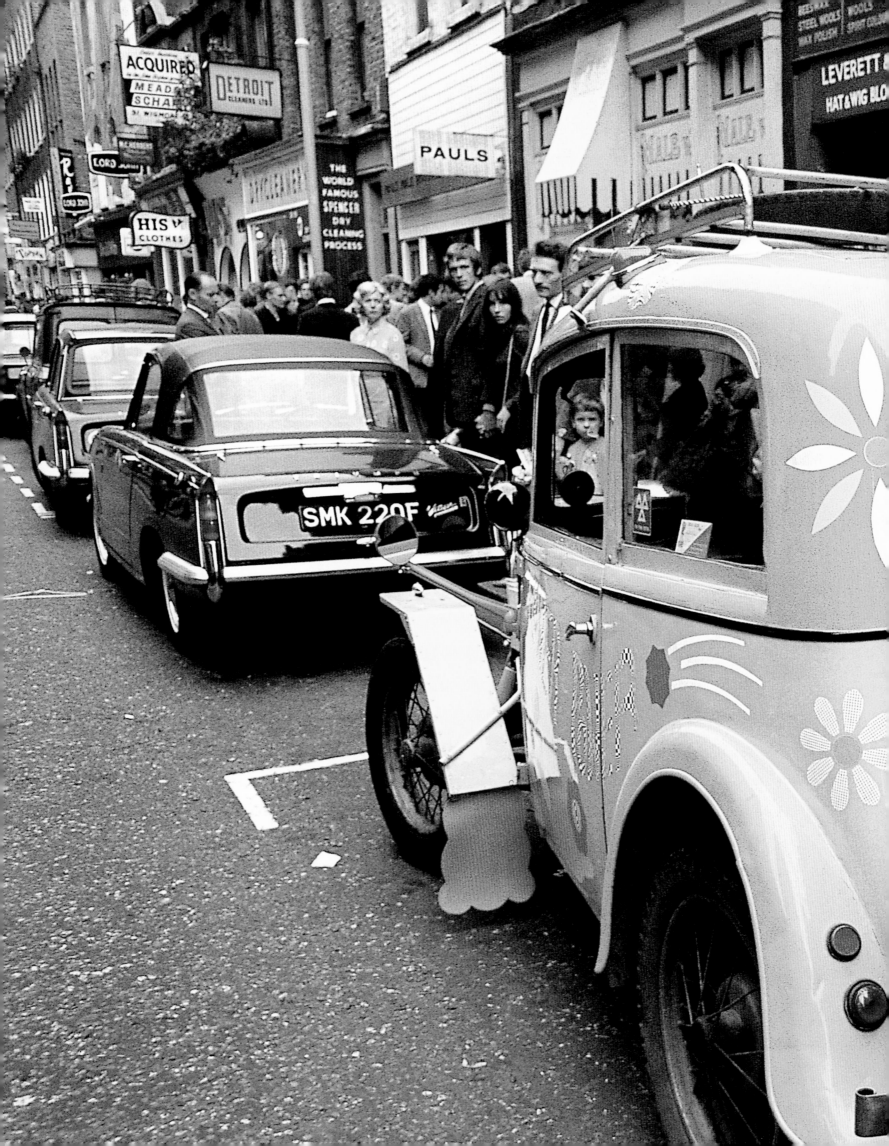

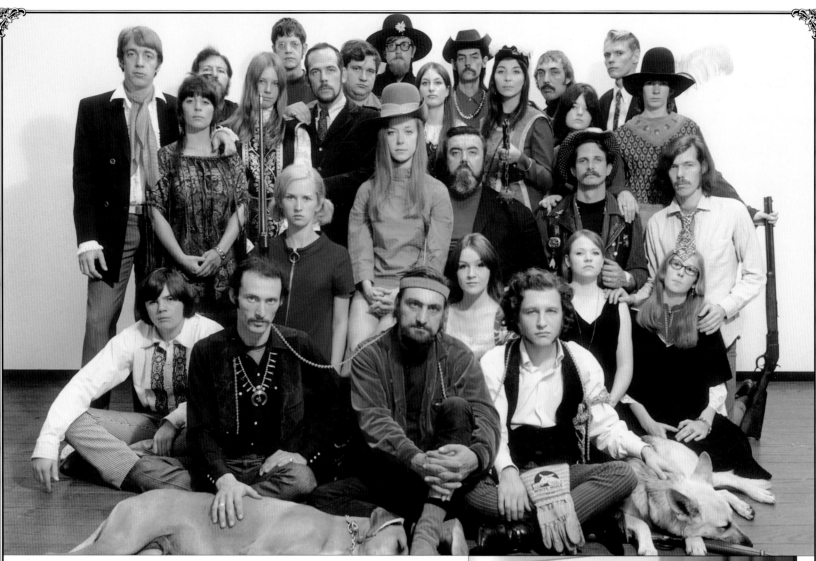

THE MEDIA

A new issue of the *Oracle* that appeared in '67 exploded with color. The editors had invented a technique of putting several different colors of ink in the printing press, separated in the ink fountain by wooden barriers. The inks flowed into each other on the printing roller, turning the text into a dazzling rainbow of colors. It was the most gorgeous, bewilderingly unreadable thing yet.

Color began to explode on hippie clothing as never before. A Mime Troupe actress taught a crafts class on a technique known as tie-dying, where fabrics were knotted in various ways and

The staff of KMPX-FM, San Francisco's first underground rock station (above). Notables include Howard Hesseman (top left), a member of the political comedy group the Committee and later the star of WKRP in Cincinnati; Larry Miller (back row, second from right), the first DJ to play album tracks; and Tom Donahue (center, seated). Allen Cohen (right) founded the San Francisco **Oracle,** *a colorful underground newspaper.*

2 1 **Two days of antiwar protests in Washington draw 55,000 demonstrators; 647 are arrested while attempting to "exorcise" the Pentagon. President Johnson responds with an October 31 speech reinforcing America's commitment to South Vietnam.**

Ralph Gleason was the first one to really write about the San Francisco bands, and Tom Donahue was playing it on the radio on KSAN. So we had simultaneous openings here. Even though it was late at night, for the first time this music was being aired— twenty-, thirty-, forty-minute cuts. You could hear Quicksilver. You could hear us.

Gleason was realizing this was more than just a fad. Something was going on that was spawning this energy, and here it was in town. Gleason was writing these stunning observations on what the scene was like. He was writing about the ritual that was happening in real time. And he was respected.

Then there was Bill Graham. Graham was the only guy that could rent the place, because he was the only straight guy around, and he was respected. He got the permit. No one else would give anybody the permit. Who would give us the permit? Bill was the straight guy. So Donahue played a certain role, and so did Gleason and Graham.✳

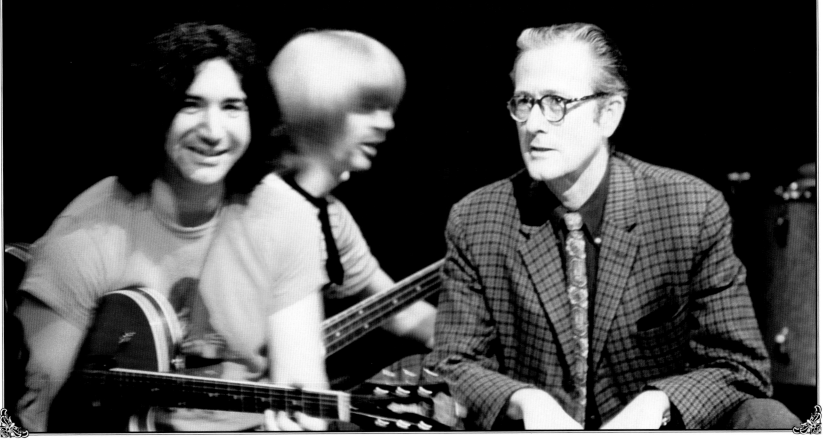

9 Rolling Stone, a San Francisco magazine founded by Jann Wenner, publishes its first issue. It will quickly become the premier chronicle of rock music and youth culture.

then dipped in dye. The folds not exposed to the dye made for spectacular sunburst patterns.

Any weekend that spring, Haight Street was eye-popping. The sidewalks overflowed with a dense crush of hippies in paisley and beads and with nervous, gawking tourists. Dope dealers muttered, "Acid, speed, lids?" to the passing throng. Vendors hawked underground papers, including the *Oracle*, in whose ever-more-dazzling pages the message (if you could make it out) turned out to be: Please don't come to the Haight — do your thing where you are or move to the country. Some people passed out the latest mimeographed poem or screed or, more surreptitiously, Owsley's latest acid. The Psychedelic Shop stuck a couple of theater seats in its front window for anybody who wanted to watch the passing show.

There were plans to start a hippie legal defense organization, to move to the California woods or the holy Indian lands of New Mexico, to put a spell on the Pentagon, to raise organic vegetables. There were plans to go to Tibet, organize vast dope deals, meditate until the Buddha of Love appeared, start rock bands, spread the word. People put themselves on the line for the psychedelic revolution. Choosing to live in a tree in Golden Gate Park showed a sober awareness that this present moment was the fullness of time prophesied in scriptures. The Haight was a stew so big and wild that when people hit it off with strangers, they didn't bother to arrange to meet again but just said, "I'll

In 1967, Jann Wenner (previous page, top) launched **Rolling Stone**, *the San Francisco–based magazine that provided definitively hip coverage of rock music, youth culture, politics and more. Grateful Dead members Jerry Garcia and Phil Lesh (previous page, bottom from left) chat with esteemed music journalist Ralph J. Gleason.*

Underground DJ Tom Donahue, on the air (below) and in a poster for the roots-rock concert at the Avalon Ballroom (right), was a Top Forty émigré who embodied the album-oriented format.

A girl peddles the **Oracle** *on the streets of Haight-Ashbury (opposite).*

★ ANYONE CAN BE A STAR ★

see you." If it was meant to happen, it would. The Haight had become the focus of the entire country.

Scores of journalists and sociologists studied it, while religious groups proselytized it. Ironically, the old economic foundation of the community was drying up with the annual summer shortage of marijuana, and the place was getting so crowded you might not even want to take LSD on Haight Street. Fortunately, there was rock & roll. Rock bands often played free in the Panhandle, and the Fillmore Auditorium held dances six nights a week all through the summer.

N O V E M B E R ' 6 7

2 0 *The population of the United States reaches 200 million.*

2 5 *"Incense and Peppermints," by the Strawberry Alarm Clock, reaches #1, offering further proof that psychedelic music has gone mainstream.*

ROLLING STONE

MFP

NOVEMBER 9, 1967
VOL. I, NO. 1

OUR PRICE:
TWENTY-FIVE CENTS

Recognize Private Gripeweed? He's actually John Lennon in Richard Lester's new film, How I Won the War. An illustrated special preview of the movie begins on page 16.

IN THIS ISSUE:

DONOVAN: An incredible Rolling Stone Interview, with this manchild of magic Page 14

GRATEFUL DEAD: A photographic look at a rock and roll group after a dope bust Page 8

BYRD IS FLIPPED: Jim McGuinn kicks out David CrosbyPage 4

RALPH GLEASON: The color bar on American televisionPage 11

Tom Rounds Quits KFRC

Tom Rounds, KFRC Program Director, has resigned. No immediate date has been set for his departure from the station. Rounds quit to assume the direction of Charlatan Productions, an L.A. based film company experimenting in the contemporary pop film.

Rounds spent seven years as Program Director of KPOI in Hawaii before coming to San Francisco in 1966. He successfully effected the tight format which made KFRC the number one station in San Francisco.

Les Turpin, former program director of KGB in San Diego will replace Tom Rounds at KFRC. Turpin has spent the last year as a consultant in the Drake-Chenault programming service.

The new appointment could mean a tightening up of programming policies. Rounds liberalization of KFRC's play-list may well become more restricted.

THE HIGH COST OF MUSIC AND LOVE: WHERE'S THE MONEY FROM MONTEREY?

BY MICHAEL LYDON

A weekend of "music, love, and flowers" can be done for a song (plus cost) or can be done at a cost (plus songs). The Mon- anyone: to a unit of the New York City Youth Board which will set up classes for many ghetto children to learn music on guitars donated by Fender. Paul Simon, a Festival governor, will personally over see the pro- large sums. This has meant, for instance, that the John Edwards Memorial Foundation, a folk music archive at the University of California at Los Angeles, had its small request overlooked.

In ironic fact, what happened at the Festival and its financial

Airplane high, but no new LP release

Jefferson Airplane has been taking more than a month to record their new album for RCA Victor. In a recording period of five weeks only five sides have been completed. No definite release date has been set.

Their usual recording schedule

DECEMBER '67

Their Satanic Majesties Request, an ultrapsychedelic retort to Sgt. Pepper, is released by the Rolling Stones. Its 3-D cover depicts the Stones as wizards and shamans, and the music explores the outer limits of psychedelia in songs such as "2,000 Lights Years from Home" and "She's a Rainbow."

Issue #1 of
Rolling Stone, *dated November 9, 1967, featured John Lennon on the cover in a still from the film* **How I Won the War** *(opposite). Artist R. Crumb is caught in the act of drawing a mural on a wall in the Mission District of San Francisco in 1966 (below). Also pictured are San Francisco's "comix" artists (left), and the cover of a book by S. Clay Wilson (right).*

DRAWINGS BY
S. CLAY WILSON
2.00

PRINTED IN SAN FRANCISCO BY THE SAN FRANCISCO GRAPHIC ARTS
SOCIETY FOR S. CLAY WILSON IN A LIMITED EDITION OF 1000.
PUBLISHED BY THE SAN FRANCISCO COMIC BOOK CO. MARCH 1969.
ALL RIGHTS RESERVED.

9 Cream's second album, Disraeli Gears, enters the U.S. album charts. It is a psychedelic tour de force, from its mind-bending cover art (by British artist Martin Sharp) to the trio's mind-altering music on such songs as "Tales of Brave Ulysses" and "Sunshine of Your Love."

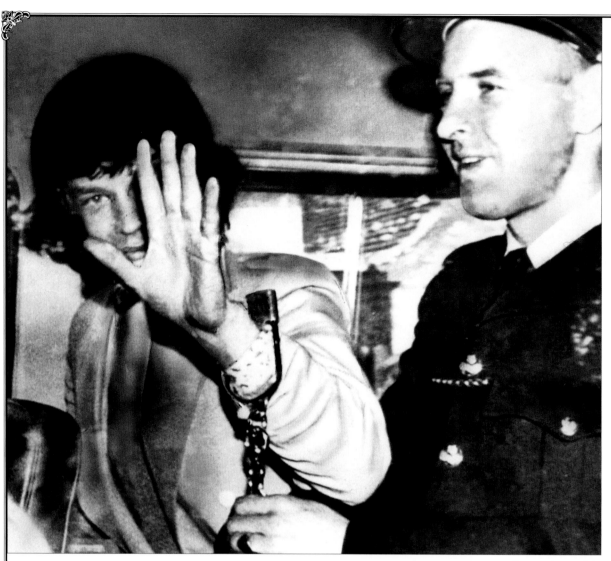

was busted by police acting on a tip. Though *News of the World* denied it, one of their reporters informed me off the record that the paper had a man in the Stones camp. This person, a Canadian, had suddenly appeared with some dynamite acid and suggested a party to try it out. Richards, who vaguely remembered meeting him in New York, went along with the idea and invited a number of friends to his house for the weekend. Jagger, Marianne Faithfull, Robert Fraser and various others drifted down. It is thought that the police waited until George and Pattie Harrison left before raiding the house. At that point, the Beatles were still untouchable.

A policewoman tackled Fraser as he ran into the garden, finding twenty packs of heroin on him. Jagger had four amphetamine tablets, legally obtained in Italy. Apart from Fraser's heroin, the only drugs found on the premises were in the pockets of the mysterious supplier, who was carrying some hash and a bag of grass. The police pointedly ignored his briefcase. Because of the grass, Richards was told he would be charged with allowing his premises to be used for drugs. *News of the World* ran an article headlined *Drug Squad Raid Pop Stars' Party*. On May 10, 1967, Jagger, Richards and Fraser appeared in court to be remanded on bail. To make a clean sweep of all three leading Stones, police then raided Brian Jones' flat in London and arrested him for possession of pot. In a gesture of solidarity with the beleaguered Stones, the Who recorded a single of Stones songs ("The Last Time" b/w "Under My Thumb").

BUSTED

By early 1967, dozens of people had been busted. Michael Hollingshead found that many who had visited him at the World Psychedelic Center were now living alongside him in prison. Mick Jagger and Keith Richards were among them, but only for one night.

On February 5, 1967, *News of the World* published an article alleging that Jagger had taken acid at the Moody Blues' house. Jagger was outraged and announced he was suing the paper for libel. This focused attention upon the group, who were leading far from blameless lives. The next week Keith Richards

Mick Jagger is handcuffed after being found guilty of drug possession in London on June 28, 1967 (above). Demonstrators carry picket signs at a "legalize pot" rally in the Picadilly section of London in 1967 (opposite). John "Hoppy" Hopkins, whose own drug bust would became a cause célèbre among the London underground, is on the left playing the flute.

DECEMBER '67

10 Soul singer Otis Redding and four members of his band, the Bar-Kays, are killed when their plane crashes into a frozen lake in Wisconsin.

26 The Beatles' Magical Mystery Tour, an hour-long psychedelic travelogue, is aired on British television to generally negative reviews.

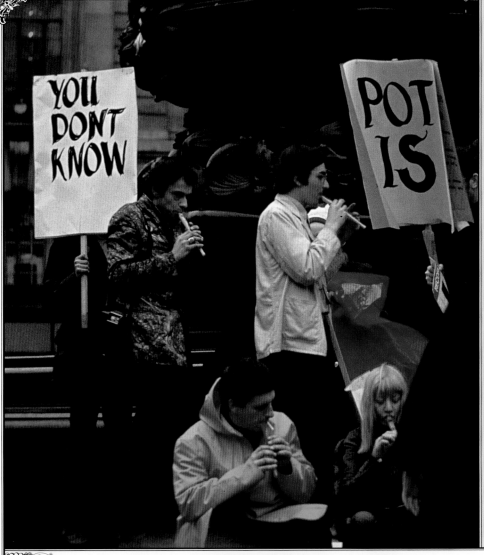

This girl Stacy used to visit me, and she'd wear practically nothing for prison visits. The rest of the convicts, their eyes would pop out and their sides would start shaking as she dropped a piece of hash into the coffee and carelessly slid it across the table to me. She was so outrageous that her visits did me a lot of good.

As far as prison goes, time stops. It's like the clock stops when you walk into prison. You're not really aware of the weather. It goes from summer to winter, but inside the prison it's more gray and you don't notice it so much. I went in when it was high summer, and I came out when it was cold winter. For me, it was like six months of gray, neither winter nor summer. Nothing colored, everything gray. It was an eerie experience. Certainly not one I prefer to repeat.✳

"Who Breaks a Butterfly on a Wheel?"

FEBRUARY

15 *The Beatles depart for Rishikesh, India, to take an advanced training course in transcendental meditation with the maharishi. They will remain one to two months, writing much of the material for The Beatles, better known as the White Album, including John Lennon's indictment of their guru, "Sexy Sadie."*

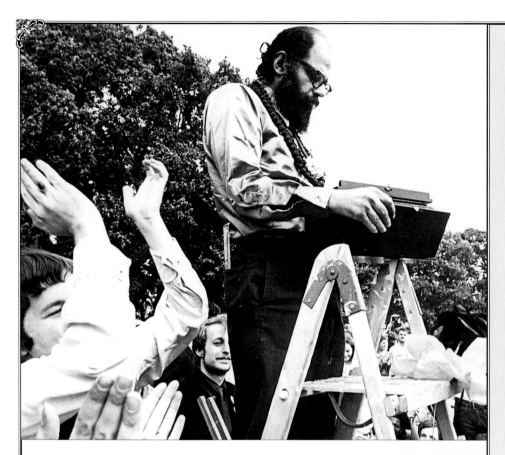

While the first couple of months were epitomized by Pink Floyd and the Soft Machine, the spring of 1967 was epitomized by Tomorrow and Arthur Brown. Tomorrow were, I think, the best group we had at the UFO club. Steve Howe and Twink were great.

One of the most memorable moments at UFO occurred after the Stones' bust. It was probably the act that signaled the demise of UFO, unfortunately. We felt that the *News of the World* had been responsible for the bust, so we decided to attack. All the papers were in Fleet Street, which was not too far from UFO — a ten- or fifteen-minute walk. At 2:00 a.m. when the trucks were starting to leave the newspaper buildings to deliver the Sunday papers, we emptied the club. We announced that the club was moving to the *News of the World* building.

Tomorrow was playing that night, and Twink acted as the Pied Piper, leading everyone in this march through the West End down to the *News of the World* building. We surrounded the loading bay and sat down in the street to prevent their trucks from going out with the paper. The police came with German shepherds, and eventually we were dispersed. Everybody then marched back to the club, and Tomorrow did the greatest set I've ever seen. Twink was crawling through the audience murmuring, "Revolution, revolution," while Steve Howe played a wonderful solo. ✳

The trials of Jagger, Richards and Fraser began on June 27. Four days later, Judge Block pronounced his sentences, which were draconian. Richards was given a year in prison. Jagger was given three months for possession of legally acquired amphetamines. Fraser was sentenced to six months.

It was as if the establishment had declared war on young people. That night, a spontaneous demonstration erupted outside the hated *News of the World*. Police dogs were turned on the demonstrators. People were crushed, and six were arrested. What made the demonstration a uniquely underground event was its timing: the middle of the night, when all the Fleet Street newspapers were being put to bed. No one but young people would demonstrate at 2:00 a.m.

Jagger and Richards appealed and were released on bail the next day, which happened to be a UFO club night. At midnight, a thousand people left the club and made their way down Tottenham Court Road to the Eros statue in Piccadilly Circus, where hundreds more had assembled from other

Allen Ginsberg reads from on high at the "legalize pot" rally in Hyde Park in July 1967 (above). Told by police that he couldn't play music without a license, Ginsberg chanted.

A copy of the famous "legalize pot" ad (opposite), signed by all four Beatles, that ran in the London Times *July 24, 1967.*

16 *Otis Redding's mellow soul classic, "(Sittin' On) The Dock of the Bay," becomes his first #1 single, albeit posthumously.*

the law against marijuana is immoral in principle and unworkable in practice

The signatories to this petition suggest to the Home Secretary that he implement a five point programme of cannabis law reform:

THE GOVERNMENT SHOULD PERMIT AND ENCOURAGE RESEARCH INTO ALL ASPECTS OF CANNABIS USE, INCLUDING ITS MEDICAL APPLICATIONS.

ALLOWING THE SMOKING OF CANNABIS ON PRIVATE PREMISES SHOULD NO LONGER CONSTITUTE AN OFFENCE.

CANNABIS SHOULD BE TAKEN OFF THE DANGEROUS DRUGS LIST AND CONTROLLED, RATHER THAN PRO-HIBITED, BY A NEW AD HOC INSTRUMENT.

POSSESSION OF CANNABIS SHOULD EITHER BE LEGALLY PERMITTED OR AT MOST BE CONSIDERED A MISDEMEANOUR, PUNISHABLE BY A FINE OF NOT MORE THAN £10 FOR A FIRST OFFENCE AND NOT MORE THAN £25 FOR ANY SUBSEQUENT OFFENCE.

ALL PERSONS NOW IMPRISONED FOR POSSESSION OF CANNABIS OR FOR ALLOWING CANNABIS TO BE SMOKED ON PRIVATE PREMISES SHOULD HAVE THEIR SENTENCES COMMUTED.

Jonathan Aitken
Tariq Ali
David Bailey
Humphry Berkeley
Anthony Blond
Derek Boshier
Sidney Briskin
Peter Brook
Dr. David Cooper
Dr. Francis Crick, F.R.S.
David Dimbleby
Tom Driberg, M.P.
Dr. Ian Dunbar
Brian Epstein
Dr. Aaron Esterson
Peter Fryer
John Furnival
Tony Garnett
Clive Goodwin
Graham Greene
Richard Hamilton

Dr. R. D. Laing
Dr. Calvin Mark Lee
John Lennon, M.B.E.
Dr. D. M. Lewis
Paul McCartney, M.B.E.
David McEwen
Alasdair MacIntyre
Dr. O. D. Macrae-Gibson
Tom Maschler
Michael Abdul Malik
George Melly
Dr. Jonathan Miller
Adrian Mitchell
Dr. Ann Mully
P. H. Nowell-Smith
Dr. Christopher Pallis
John Piper
Patrick Procktor
John Pudney
Alastair Reid
L. Jeffrey Selznick

"All laws which can be violated without doing anyone any injury are laughed at. Nay, so far are they from doing anything to control the desires and passions of man that, on the contrary, they direct and incite men's thoughts toward those very objects; for we always strive toward what is forbidden and desire the things we are not allowed to have. And men of leisure are never deficient in the ingenuity needed to enable them to outwit laws framed to regulate things which cannot be entirely forbidden. . . . He who tries to determine everything by law will foment crime rather than lessen it."—Spinoza

The herb Cannabis sativa, known as 'Marihuana' or 'Hashish', is prohibited under the Dangerous Drugs Act (1965). The maximum penalty for smoking cannabis is years' imprisonment and a fine of £1,000. Yet informed medical opinion supports the view that cannabis is the least harmful of pleasure-giving drugs and is, in particular, far less harmful than alcohol. Cannabis is non-addictive, and prosecutions for disorderly behaviour under its influence are unknown.

The use of cannabis is increasing, and the rate of increase is accelerating. Cannabis smoking is widespread in the universities, and the custom has been taken up by writers, teachers, doctors, business-men, musicians, scientists, and priests. Such persons do not fit the stereotype of the unemployed criminal dope fiend. Smoking the herb also forms a traditional part of the social and religious life of hundreds of thousands of immigrants to Britain.

A leading article in The Lancet (9 November, 1963) has suggested that it is "worth considering . . . giving cannabis the same status as alcohol by legalizing its import and consumption . . . Besides the undoubted attraction of reducing, for once, the number of crimes that a member of our society can commit, and of allowing the wider spread of something that can give pleasure, a greater revenue would certainly come to the State from taxation than from fines. . . . Additional gains might be the reduction of inter-racial tension, as well as that between generations."

The main justification for the prohibition of cannabis has been the contention that its use leads to heroin addiction. This contention does not seem to be supported by any documented evidence, and has been specifically refuted by several authoritative studies. It is almost certainly correct to state that the risk to cannabis smokers of becoming heroin addicts is far less than the risk to drinkers of becoming alcoholics.

Cannabis is usually taken by normal persons for the purpose of enhancing sensory experience. Heroin is taken almost exclusively by weak and disturbed individuals for the purpose of withdrawing from reality. By prohibiting cannabis Parliament has created a black market

at a moment of national anxiety". In recent months the persecution of cannabis smokers has been intensified. Much larger fines and increasing proportion of unreasonable prison sentences suggest that the crime at issue is not so much drug abuse as heresy.

The prohibition of cannabis has brought the law into disrepute and has demoralized police officers faced with the necessity of enforcing an unjust law. Uncounted thousands of frightened persons have been arbitrarily classified as criminals and threatened with arrest, victimization and loss of livelihood. Many of them have been exposed to public contempt in the courts, insulted by uninformed magistrates and sent to suffer in prison. They have been hunted down with Alsatian dogs, stopped on the street at random and improperly searched. The National Council for Civil Liberties has called attention to instances where drugs have apparently been 'planted' on suspected cannabis smokers. Chief Constables have appealed to the public to inform on their neighbours and children. Yet despite these gross impositions and the threat to civil liberties which they pose the police freely admit that they have been unable to prevent the spread of cannabis smoking.

Abuse of opiates, amphetamines and barbiturates has become a serious national problem, but very little can be done about it so long as the prohibition of cannabis remains in force. The police do not have the resources or the manpower to deal with both cannabis and the dangerous drugs at the same time. Furthermore prohibition provides a potential breeding ground for many forms of drug abuse and gangsterism. Similar legislation in America in the 'twenties brought the sale of both alcohol and heroin under the control of an immensely powerful criminal conspiracy which still thrives today. We in Britain must not lose sight of the parallel.

MEDICAL OPINION

"There are no lasting ill-effects from the acute use of marihuana and no fatalities have ever been recorded. . . . The causal relationship between these two events (marihuana smoking and heroin addiction) has never been substantiated. In spite of the once heated interchanges among members of the medical profession and between the medical profession and law enforcement officers there seems to be a growing agreement within the medical community, at least, that marihuana does not directly cause criminal behaviour, juvenile delinquency, sexual excitement, or addiction."

Dr. J. H. Jaffe, in The Pharmacological Basis of Therapeutics, L. Goodman and A. Gillman, Eds., 3rd Ed. 1965

"Certain specific myths require objective confrontation since otherwise they recurrently confuse the issue, and incidentally divert the energy and attention of police and customs and immigration authorities in directions which have very little to do with facts and much more to do with prejudiced beliefs. The relative innocence of marijuana by comparison with alcohol is one such fact, its social denial a comparable myth."

Dr. David Stafford-Clark, Director of Psychological Medicine, Guy's Hospital. The Times, 12 April, 1967

"Marijuana is not a drug of addiction and is, medically speaking, far less harmful than alcohol or tobacco . . . It is generally smoked in the company of others and its chief effect seems to be an enhanced appre-

3 1 As his aggressive policy in Vietnam becomes increasingly unpopular with the U.S. electorate, President Johnson makes the surprise announcement that he will not run for re-election

MARCH '68

clubs. The crowd marched toward the *News of the World* building. The police set loose their dogs, and one demonstrator was badly bitten. Demonstrations were again held the next night, and numerous participants were arrested and beaten by police.

Many felt justice was not served. The editor of the London *Times*, William Rees-Mogg, wrote an editorial entitled *Who Breaks a Butterfly On a Wheel?* In it, he condemned the harshness of the verdict and sentences. Almost every national newspaper followed his lead, leaving *News of the World* sidelined. Drugs were now a matter of public discussion.

John "Hoppy" Hopkins had been busted on December 30, 1966, and was sentenced on June 1, 1967, to nine months for possession of a small quantity of pot. He lectured the court, saying that pot was harmless and laws should be changed. The judge disagreed, saying, "I have just heard what your views are on the possession of cannabis and the smoking of it. This is not a matter I can overlook. You are a pest to society."

An emergency meeting of Hoppy's friends was called in the back room at Indica Bookshop. Steve Abrams, founder of the drug research organization SOMA (Society of Mental Awareness), thought the best way to get the law changed was to influence the deliberations of the government's Subcommittee on Hallucinogens. To bring the issue of soft drugs and the law into public debate, Abrams proposed running a full-page advertisement in the London *Times*. The idea won unanimous approval. The next day, Abrams and I visited Paul McCartney, who said that all four Beatles would sign the ad and pay for it. As we left, he gave Abrams a copy of *Sgt. Pepper*. Abrams later said, "Unless my memory is playing tricks, McCartney thrust a copy of *Sgt. Pepper* into my hands and said, 'Listen to this through headphones on acid.'"

*A brooding shot of the Rolling Stones (below) by Michael Cooper, who photographed the covers for both the Stones' **Their Satanic Majesties Request** and the Beatles' **Sgt. Pepper's Lonely Hearts Club Band**.*

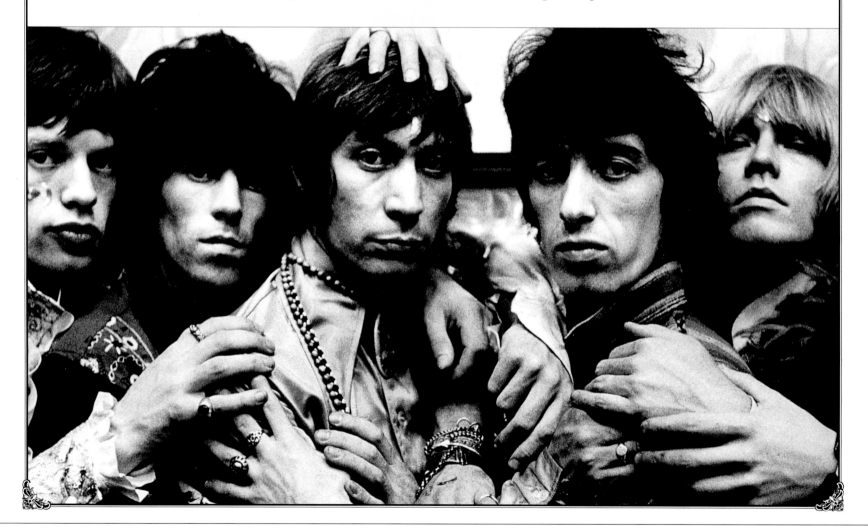

4 Dr. Martin Luther King Jr. is assassinated by James Earl Ray on the balcony of a motel in Memphis, Tennessee, triggering two weeks of riots and looting across America. In Chicago, Mayor Richard Daley orders police to "shoot to kill" arsonists.

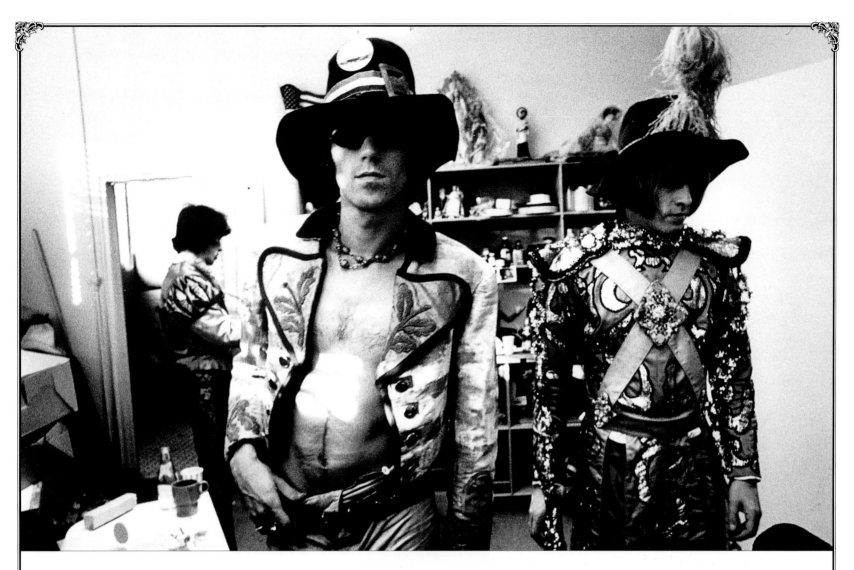

The movement to change the law on marijuana led to mass demonstrations. Allen Ginsberg was the principal speaker at a pot rally in Hyde Park on July 16. He was cornered by Walter Cronkite before reaching the stand. When Allen unpacked his harmonium and began chanting, a policeman informed him that musical instruments were forbidden in the royal parks. Ginsberg put it away and gave the policeman his flower before continuing his mantra. The policeman blushed and left with the flower.

The "legalize pot" ad was published in the London *Times* on Monday, July 24, further fueling the debate. It was signed by sixty-five leading names in British society, including the Beatles, Francis Crick (the Nobel laureate scientist who co-discovered DNA) and novelist Graham Greene. The media reacted with outrage, and MPs raised the issue in the House

Rolling Stones Bill Wyman, Keith Richards and Brian Jones (above) in their costumes from the album **Their Satanic Majesties Request.** *They helped design the album, whose cover featured a 3-D card glued to the front jacket depicting the group as sorcerers in a psychedelic wonderland, with Mick Jagger attired in a wizard's robe. It was one of the most striking album covers of the Sixties.*

of Commons. A week after its publication, however, Keith Richards' conviction was dismissed on appeal, and Jagger's sentence was reduced to a conditional discharge. The ad may well have influenced the appeal court's decision.

Meanwhile, the Subcommittee on Hallucinogens' report underwent a stormy passage through Parliament, but eventually its recommendations were implemented. On February 1, 1970, the *Sunday Mirror* headline read: *Drug Law Shock: Penalties for Pot Smokers To Be Cut.* The situation in Britain today is such that sentences like those handed Richards are virtually unknown, unless the accused has been dealing large quantities of drugs. The 1967 advertisement had repercussions that no one who attended the original meeting in the back room of Indica Bookshop could have dreamed possible.

3 *Leftist student protesters in France attempt to topple the government of Charles de Gaulle. A month's worth of civil disobedience, police brutality and economic strikes attract the attention of the world. Order will not be restored by the military until the month's end. The violent quashing of the protesters serves notice that only so much resistance will be tolerated by the establishment.*

The biggest musical gathering yet was held down the coast in Monterey. On June 16, the first night of the Monterey International Pop Festival, there were already thirty thousand people at the Monterey County Fairgrounds, even though the stadium could only hold seventy-five hundred. The football field and the home economics building at the local college were quickly put at the disposal of the crowds. By Saturday afternoon, attendance was estimated at anywhere between fifty-five thou-

A blissed-out crowd digs the scene at the Monterey International Pop Festival (below). "Monterey was exciting because none of us had really seen each other," recalls Grace Slick of Jefferson Airplane. "I hadn't seen everybody there, except the San Francisco bands, because we'd been pretty much working."

sand and ninety thousand people. Campers covered every square foot of the football field and the fairground, including the parking lot. They were entertained by all-day jam sessions with Steve Miller, the Dead, Country Joe and other bands.

The feeling of a great coalescence was in the air, partly because Monterey Pop was a joint venture between Los Angeles and San Francisco, whose respective psychedelic scenes had ignored each other. L.A. had produced some of the first hip bands: the Byrds, the Mamas and the Papas (whose leader, John Phillips, was one of the festival's organizers), the Mothers of Invention. Others continued to rise from that scene, such as Canned Heat and

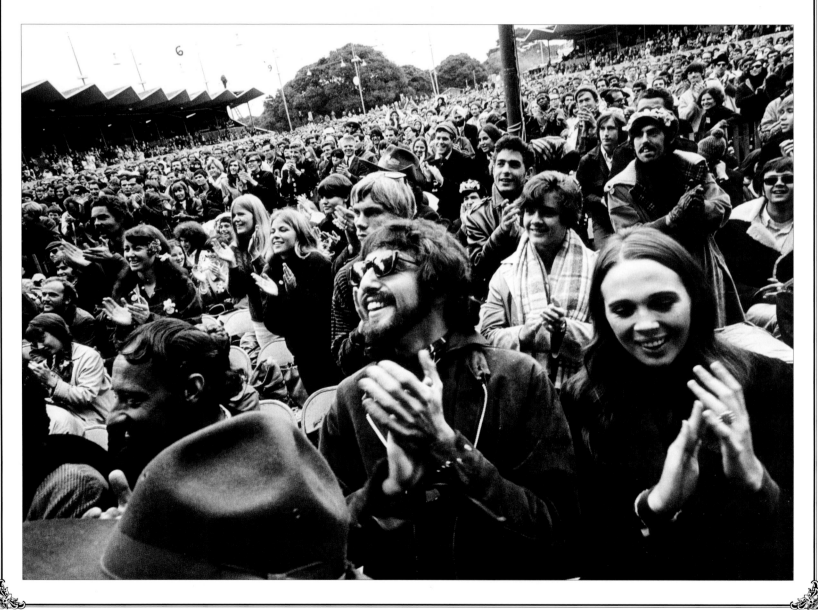

5 While celebrating a presidential primary victory in California, Senator Robert F. Kennedy is shot by a Jordanian immigrant named Sirhan Sirhan. Kennedy dies the next day.

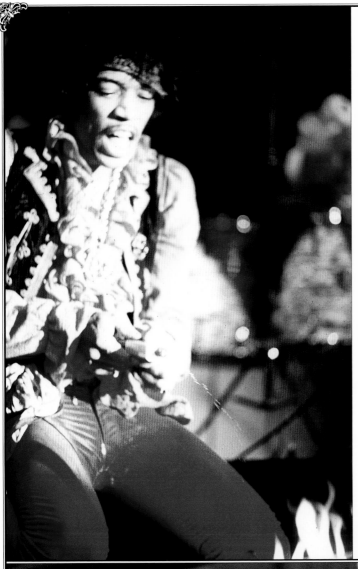

Hendrix in the process of setting fire to his guitar at the close of his incendiary set at Monterey Pop (left). Opposites attract: Indian musical legend Ravi Shankar and San Francisco acid king Owsley Stanley (below) hanging out at the festival. Shankar's performance on Sunday afternoon drew one of the largest ovations at the three-day event. "I explained to the audience that this is not pop or rock music," Shankar recounted twenty-five years later. "It has to be heard with a feeling of respect and discipline."

GARY DUNCAN
GUITARIST FOR QUICKSILVER MESSENGER SERVICE

The Monterey Pop Festival was wonderful. That was the best one of those particular kinds of shows that I ever saw, and I played a lot of outdoor festivals. I think it was just a matter of luck and timing. It just came off as a really nice thing.

We played at Monterey, but we didn't get recorded. They wanted everybody to completely sign away all rights to anything, and our manager didn't want to do it. So we didn't get in the movie. In hindsight it probably would have been better just to go ahead and do it.

We didn't play very well. I was nervous. There was a lot of pressure, and they had a schedule that was just click-click-click. You were on for a certain period of time and had to be ready, then they were shuffling stuff off and getting ready for the next act. It was our first experience at one of those major shows, and it was pretty scary.

After the festival ended the last night, they had a big jam session over in this other building. Jack Casady and Jorma Kaukonen were playing real loud. Hendrix walked in, looked over at me and said hey, and I said hey to him. Then he reached in his pocket, took out this little candy tin, popped the lid and offered me some acid. He had about twenty hits in there, so I took about five and he took the rest. He swallowed them all, I swallowed mine, and we stood there for about fifteen minutes. Then he started smiling at me and I smiled at him, and we went over and played for about two or three hours. That was fun. Somebody should've gotten that on tape. ✳

2 0 *Iron Butterfly's* **In-A-Gadda-Da-Vida** *enters the album charts. The seventeen-minute title track becomes a mainstay of underground radio, and the album sells several million copies and eventually reaches #1.*

JULY '68

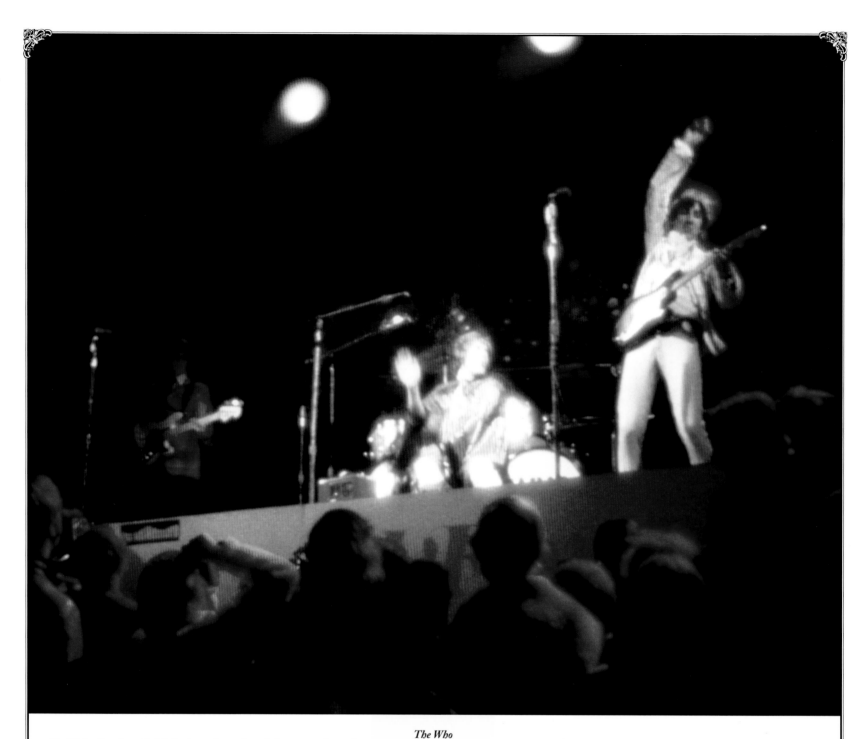

Buffalo Springfield (who played at Monterey) and Love and the Doors (who didn't). Based on the film documentary *Monterey Pop*, San Francisco's contribution would seem slighter than it was in reality. That is because such Haight-Ashbury regulars as the Grateful Dead and Quicksilver Messenger Service refused to sign a last-minute contract donating all rights to the festival and therefore weren't included in the movie.

The Who smashed their instruments onstage at Monterey Pop as the finale to their Sunday-night set (above). Jimi Hendrix (with back to camera opposite) and Rolling Stone Brian Jones meet on the fairgrounds.

At last, it was clear that the distant rock gods of England were on the same trip as the American acidheads. The Stones, under indictment for drug possession charges, couldn't perform, but a beaming Brian Jones strolled the festival grounds and introduced the Jimi Hendrix Experience, who were making their debut in the U.S. The Beatles sent a message that was printed in the program: *Love to Monterey from Sgt. Pepper's Lonely Hearts Club Band.*

JULY '68

26 The Rolling Stones' Beggars Banquet, considered by many to be their best work, is withdrawn from release by Decca, due to a controversial "toilet" cover. The album, eventually released in December, includes "Street Fighting Man," a hard-hitting anthem of solidarity with youthful protesters, and "Sympathy for the Devil," a dark and daunting Stones classic.

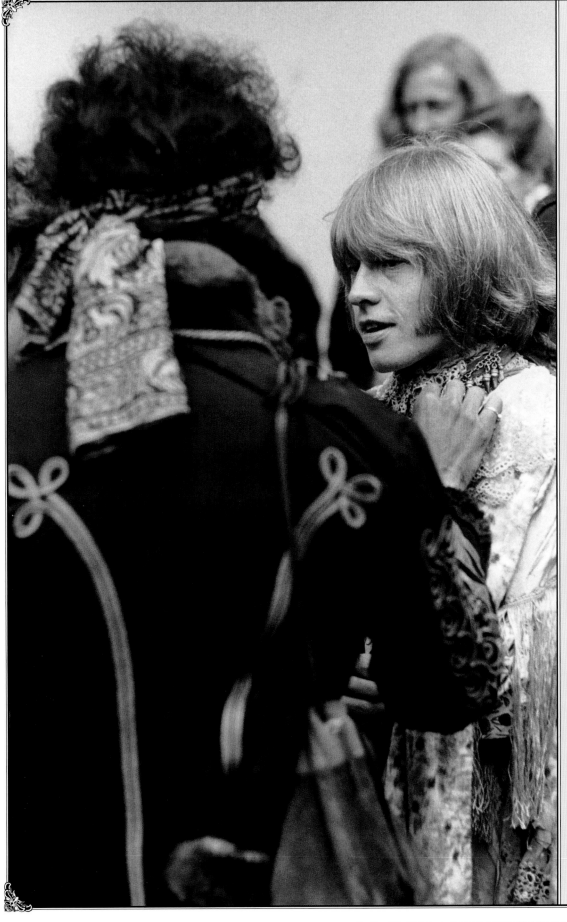

A big thing happened when the English bands performed at the Monterey Pop Festival. It was a wake-up call to those San Francisco and L.A. bands. It was a real awakening. To see the power of Jimi Hendrix and the Who — what those guys were doing was leaps and bounds ahead of anything anybody was doing in San Francisco. The San Francisco guys really became more professional and serious, seeing that those kinds of careers were possible for themselves. With some organization and the right recording contracts, they saw that a real career could happen.

So when I got to San Francisco in the autumn of '67, many of these bands were starting to get their recording contracts right and started to take some direction. Bands were no longer so local so often. They were beginning to do national tours. They started going out, and ballrooms started appearing across the country. You could really string together a serious national tour. The scene really started to become less localized. The guys weren't around town so much anymore. Everybody was spreading out at that point.✳

AUGUST '68

10 *Cream's double album* Wheels of Fire, *half of which was recorded live at the Fillmore West in San Francisco, tops the U.S. album charts. Simultaneously, the Band's* Music from Big Pink *makes its chart debut, heralding the arrival of a more roots-oriented movement in rock music.*

BUFFALO SPRINGFIELD

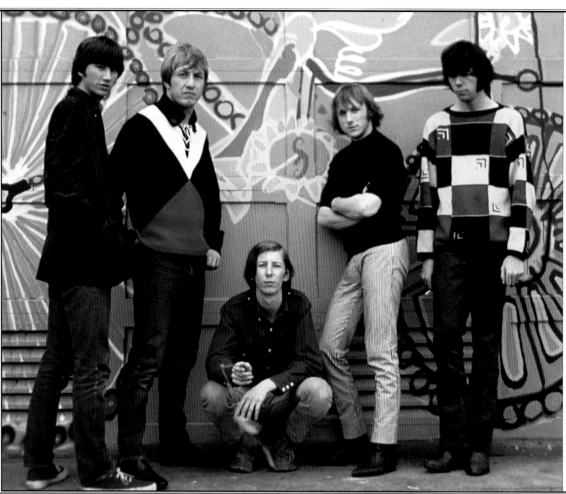

Buffalo Springfield (left), whose 1967 hit "For What It's Worth" was inspired by clashes between police and youthful protesters on L.A.'s Sunset Strip. From left: Richie Furay, Dewey Martin, Bruce Palmer, Stephen Stills, Neil Young.

Also shown are circular posters for the Kaleidoscope, an L.A. club (below).

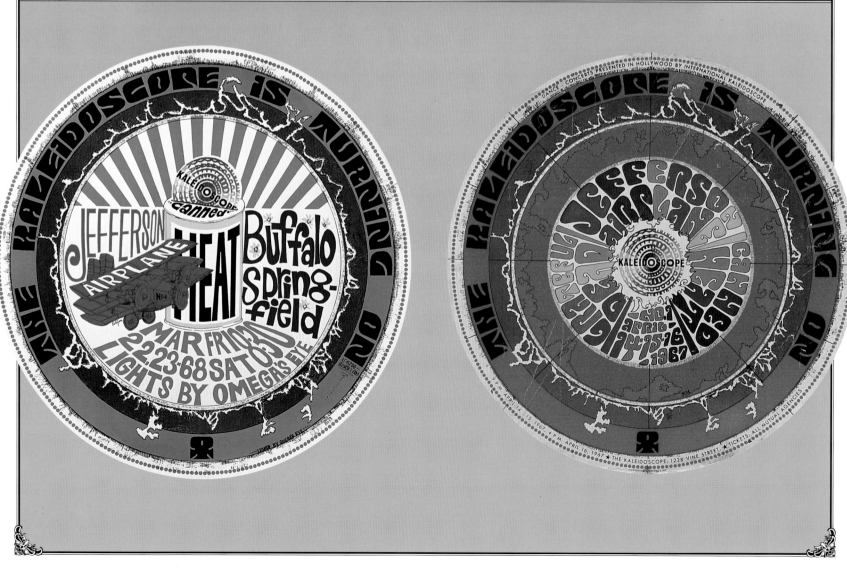

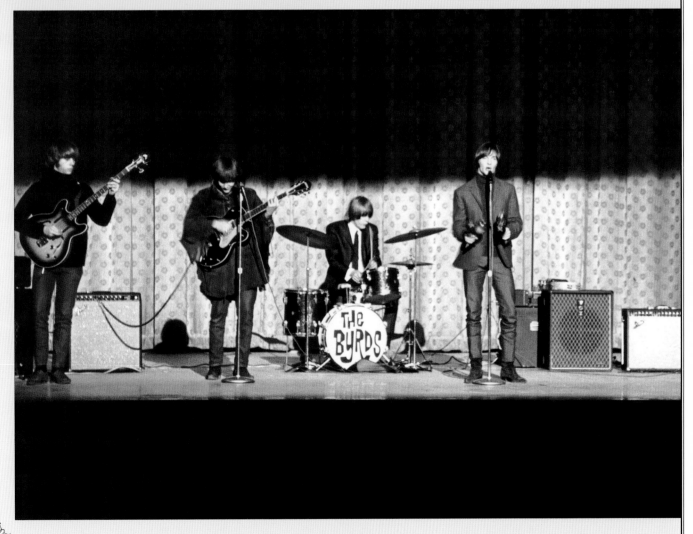

Two of L.A.'s finest bands: the Doors (above) and the Byrds (below). The Doors' "Light My Fire" went to #1 on the U.S. charts at the height of the Summer of Love in July 1967. Of the Byrds, leader Roger McGuinn reflects, "We were coming from folk music, which in our estimation had reached an end, so we wanted to get into something new. The Beatles and all the British groups had come along with a fresh sound we wanted to get into." Ironically, the Byrds themselves influenced the generation of British bands that formed in the mid-Sixties as part of the London underground scene.

Psychedelic music exploded onto the scene in 1967. The Incredible String Band approached the movement from a peculiarly British folk-rock perspective. This resourceful and largely acoustic duo consisting of Mike Heron and Robin Williamson was beloved by the underground crowd, though they rarely played at the UFO club and generally kept their distance from the scene. Other quasi-psychedelic bands, such as Procol Harum, used the underground as a point of departure, getting their start at UFO but quickly moving on to bigger things.

Without question, the most exciting band to emerge was the Jimi Hendrix Experience. Hendrix had been playing the Café Wha? in New York City when he was discovered by Chas Chandler. Formerly the Animals' bass player, Chandler became Hendrix's manager and brought him to London. With Mitch Mitchell on drums and Noel Redding on bass, the Jimi Hendrix Experience was born. Chandler signed them to Track, and their first single, "Hey Joe," reached #6 on the U.K. charts in February 1967.

The Incredible String Band (below) in concert at Fillmore East, with founding member Robin Williamson in the middle and partner Mike Heron not visible. According to Heron, "We were very much a part of the emerging underground in London. We used to play a lot of instruments to color our songs." Some of the heaviest hitters on the British music scene in a candid and unsmiling moment (opposite, from left): Eric Burdon (of the Animals), British blues legend John Mayall, Jimi Hendrix, Steve Winwood (of Traffic) and Carl Wayne (of the Move).

We were from Scotland but went down to London where we realized that everyone was kind of interested in what we did. We met Graham Nash, Eric Clapton and various musicians. It was a very open kind of era. The barriers were really down then, and I don't think they have been since. Everything is very categorized now.

At these overnight things at the UFO, there were all kinds of music. You had Middle European music and Indian music and classical music. Then there was Pink Floyd and the blues bands. Nowadays, people won't go and see Pink Floyd and a blues band in the same club. They'd have it on different nights.

It was nice for us, because we'd come out of a purist folk scene, which was a bit restricting. Suddenly to be invited into the psychedelic culture — a whole new era with all differnt kinds of things — was very exciting. ✱

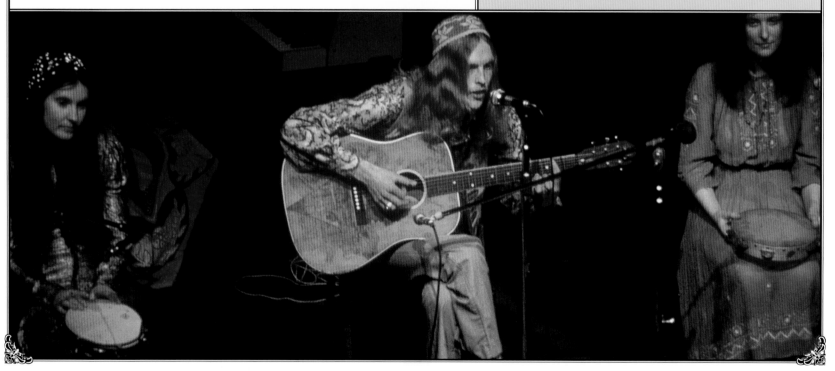

17 "Fire," by the Crazy World of Arthur Brown, hits #1 in Britain and remains there for fourteen weeks.

26 - 29 The Democratic national convention in Chicago becomes a stage for violent confrontation between police and protesters.

Overnight, Hendrix became a star. He dressed in silk, old lace, elaborate hand-painted jackets and scarves. His look was made for television, and his appearances on *Top of the Pops* and *Ready Steady Go!* ensured that his second single, "Purple Haze," went even higher, reaching #3.

Almost from the moment he set foot in London, Hendrix was surrounded by beautiful women and drug dealers, and he enjoyed every minute of it. In 1967 he released *Are You Experienced?*, one of the seminal psychedelic rock albums. He took huge amounts of acid and spent time in clubs like the Bag O'Nails and the Speakeasy, where he would get up and jam with whoever was playing. Hendrix epitomized the trendy, fashionable Chelsea scene.

In July 1967, Jim Haynes, a director of *International Times*, opened his Arts Lab at 182 Drury Lane, dedicating it to "films, poetry, environments, paintings, sculpture, music, plays, happenings, People

Teasing and primping their hair, the Jimi Hendrix Experience—drummer Mitch Mitchell, bassist Noel Redding and guitarist/singer Hendrix—prepare to take the stage in 1968. An early draft of Hendrix's "Purple Haze" (right) was titled "Purple Haze – Jesus Saves."

Show, warm flesh, soft floors, happiness and better things through chemistry." The cinema was a room filled with mattresses and a projector. The smell of dirty feet was overwhelming, but the films were interesting and the sexual tension palpable. The Arts Lab became an underground gathering place, open all day every day, making underground ideas available to a wide group of people. David Bowie played there with his mime duo and was so impressed that he opened an arts lab of his own. In fact, dozens of arts labs opened all over the country in the next few years.

The UFO club outgrew its old location and in September 1967 moved to the newly restored Roundhouse. The atmosphere did not travel with it,

1 2 Cheap Thrills, by Big Brother and the Holding Company, tops the album charts. It features a distinctive cartoon cover by artist R. Crumb and contains classic performances by vocalist Janis Joplin on such songs as "Piece of My Heart."

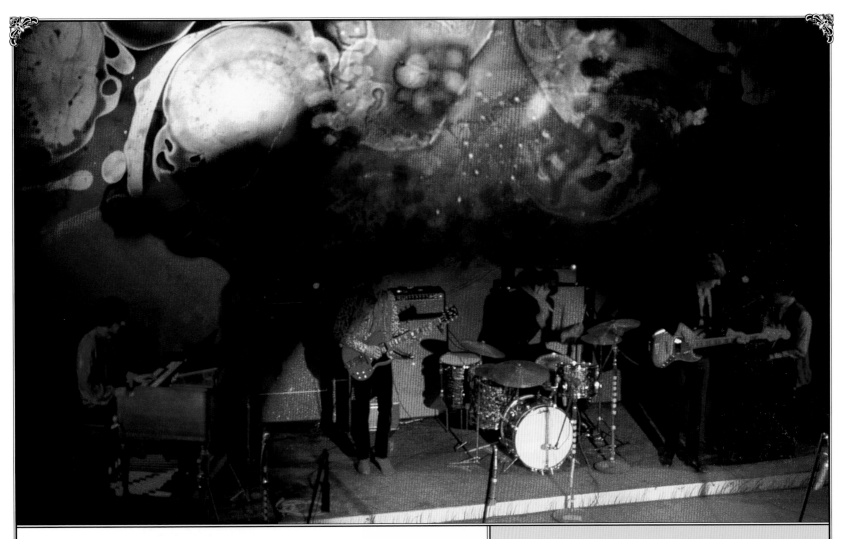

however. Higher overhead meant that bigger groups were booked to draw larger crowds; it became just another music venue. The old crowd was diluted by newcomers. The community spirit was gone, and on October 6, 1967, UFO closed down.

The first new venue to cash in on the hippie scene was the Electric Garden, in Covent Garden. It opened on May 24 and closed the same night, after owner Brian Waldman tried to stop a Yoko Ono performance and beat up her husband Tony Cox. The police were summoned, and performers and audience alike walked out. Electric Garden was changed to Middle Earth and new management brought in. The club developed a regular clientele and a genuine atmosphere. To many who missed the UFO Club, Middle Earth was the very epitome of the underground. It did hire the same bands, poets and performers, but some things just cannot be repeated.

Procol Harum in concert at the Fillmore East in 1968. "Procol Harum started off with Keith Reid and myself writing songs in late 1966," recalls singer/keyboardist Gary Brooker. "Then we thought about a band. We'd always liked that five-man lineup: blues guitar, bass, drums, organ and piano, which gave it plenty of scope. The strength of the thing was that we felt we were doing something different to what the general trends were."

GARY BROOKER
SINGER AND KEYBOARDIST WITH PROCOL HARUM

I can't believe that anybody who makes a point of delving into lyrics could seriously look at the words to "A Whiter Shade of Pale" and not understand what they mean. Certainly, the words of that song in a literal sense seem to describe two people being at what sounds like a party to me. As soon as they meet each other, the person telling the story becomes totally engrossed with the girl. It was all about seeing something that had a great effect on you. These things were all in there to be read. But it wasn't a drug song, as such.✳

NOVEMBER '68

5 *Richard Milhous Nixon is narrowly elected president over the Democratic contender, Hubert Humphrey.*

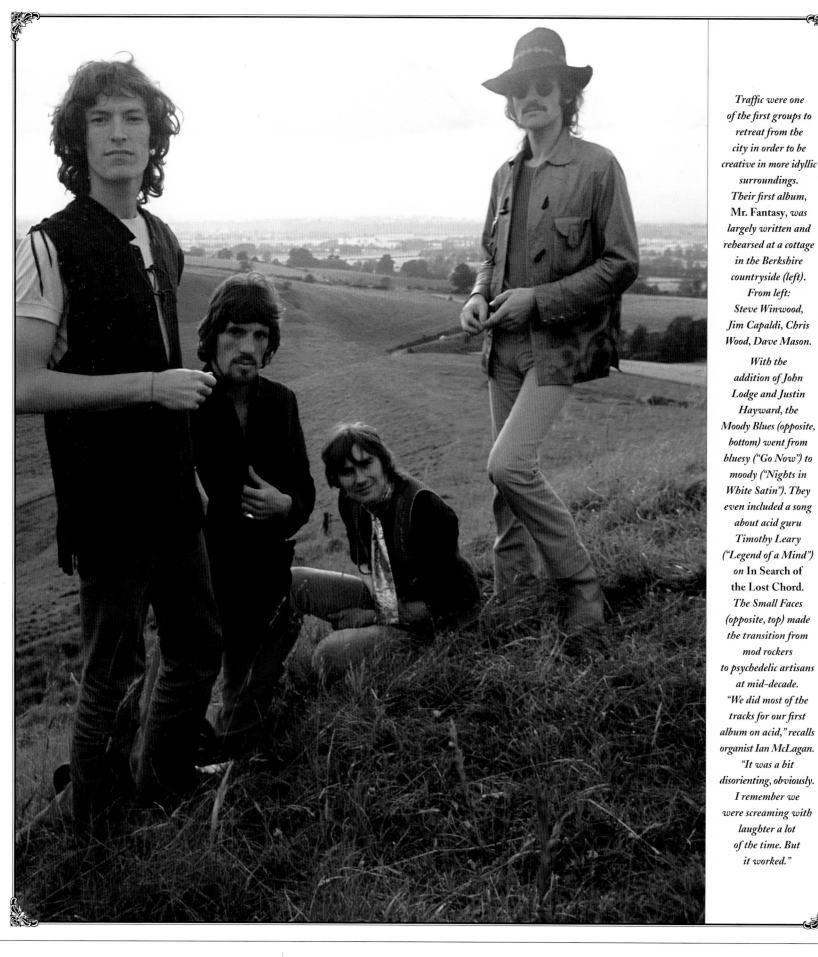

Traffic were one of the first groups to retreat from the city in order to be creative in more idyllic surroundings. Their first album, Mr. Fantasy, was largely written and rehearsed at a cottage in the Berkshire countryside (left). From left: Steve Winwood, Jim Capaldi, Chris Wood, Dave Mason.

With the addition of John Lodge and Justin Hayward, the Moody Blues (opposite, bottom) went from bluesy ("Go Now") to moody ("Nights in White Satin"). They even included a song about acid guru Timothy Leary ("Legend of a Mind") on In Search of the Lost Chord. The Small Faces (opposite, top) made the transition from mod rockers to psychedelic artisans at mid-decade. "We did most of the tracks for our first album on acid," recalls organist Ian McLagan. "It was a bit disorienting, obviously. I remember we were screaming with laughter a lot of the time. But it worked."

NOVEMBER '68

16 *Jimi Hendrix's double album,* Electric Ladyland, *tops the U.S. album charts. Hendrix scores a Top Forty hit with "Crosstown Traffic" and an underground radio classic with "All Along the Watchtower," an electrified recasting of a Bob Dylan song from* John Wesley Harding.

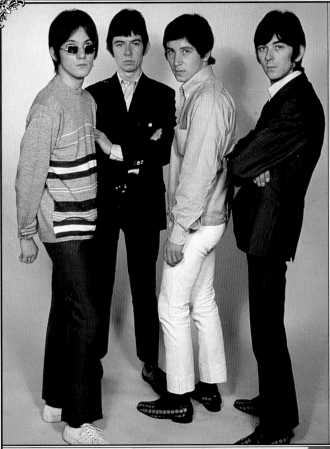

IAN McLAGAN KEYBOARDIST FOR THE SMALL FACES

There was a park in the East End that people called Itchycoo Park, even though that wasn't the actual name. There were a lot of nettles, and if you took a shortcut through the park you'd invariably get stung by the nettles. I don't know why it was Itchycoo, but the "itchy" part was obvious. It was known as that by everybody in the area.

That phasing sound on the record was suggested by our second engineer, who'd been on a Beatles session some weeks before. We were looking for some psychedelic effect. He said, "Well, I saw the Beatles do this," so he got two machines going, and we used that effect. I believe we were the third artists to use phasing, after the Beatles and Timi Yuro.

We found it very difficult to put songs like "Itchycoo Park" on the stage. Instead of being a bit of a thrash band, which we were in the early days, we couldn't do stuff like phasing onstage. It was not possible in 1967! We went out and did a tour of Australia, opening for the Who, and we died, really. ✳

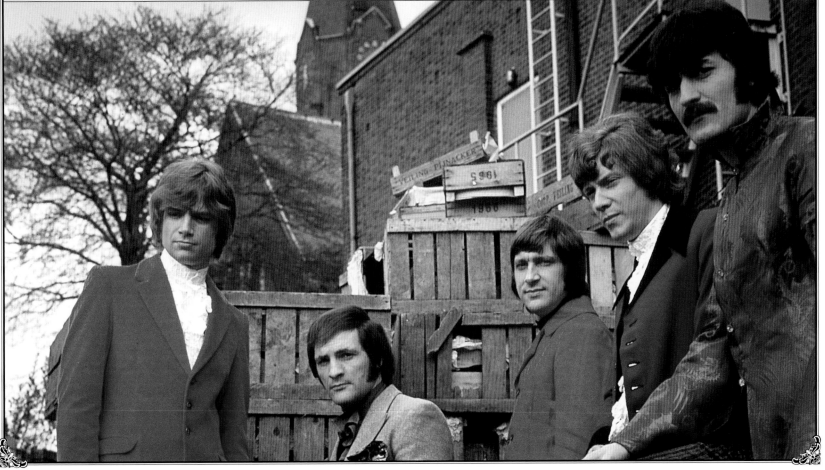

NOVEMBER '68

25 The Beatles, *a double album more commonly known as the White Album, is released in the U.S.*

26 *Cream play their farewell concert at London's Royal Albert Hall.*

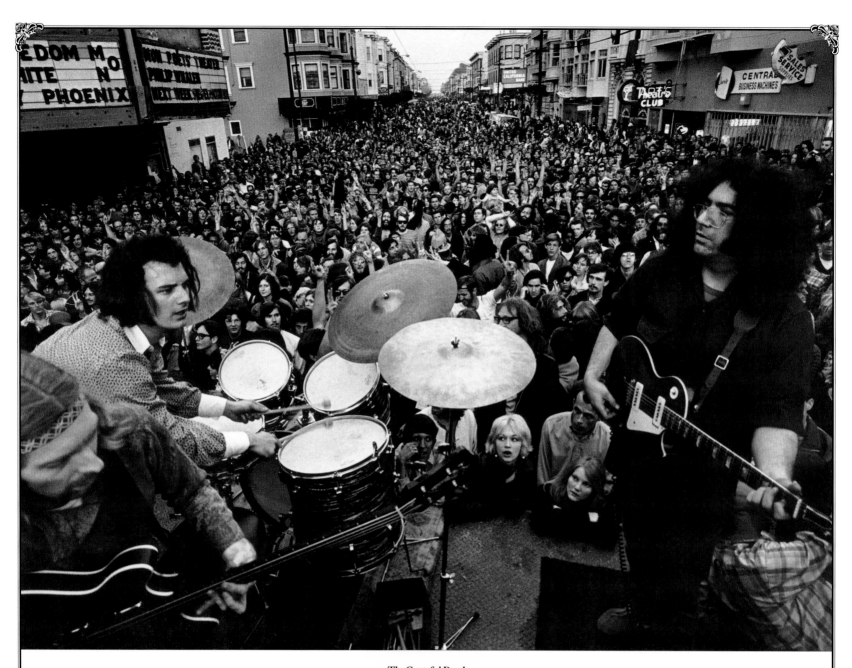

THE HAIGHT EXPLODES

n June 21, three days after Monterey, an event called the Summer Solstice was held. It was another Be-In–like gathering at Golden Gate Park. This time, however, there were no speakers. It was the official beginning of the Summer of Love.

The summer of '67 was much like the spring, only on a bigger scale. Probably one hundred thousand people moved to the Haight that

The Grateful Dead performing on Haight Street (above and opposite), with group members Phil Lesh, Bill Kreutzmann and Jerry Garcia visible. "The Grateful Dead had a lot of sides," says drummer Mickey Hart. "It was able to seduce you. It was able to scare the shit out of you. It could rattle your bones. It could let you see God."

summer, swamping nearly all the institutions that had come into being the preceding year. The Diggers weren't providing free food any longer — they had moved on to other projects months before: street theater provocations, working with the Black Panthers, moving to New Mexico. The Job Co-Op couldn't provide many jobs other than those selling underground papers and basically became an underground paper distributor. The HIP merchants were too busy trying to run their stores in the mob scene of Haight Street to have meetings.

1969

JANUARY

3 1 A major oil spill off the coast of California fouls the beaches of Santa Barbara. Public outrage serves to galvanize the embryonic environmental movement.

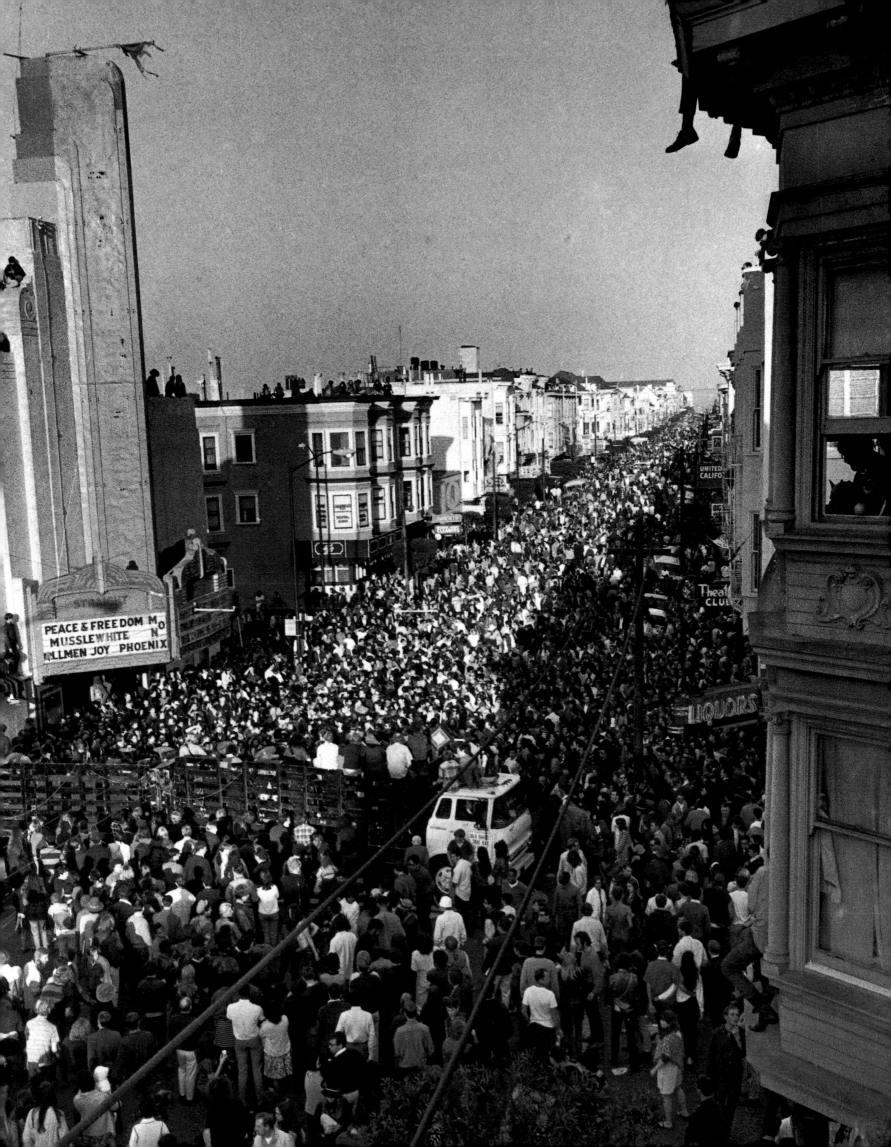

FUNERAL NOTICE

HIPPIE

*In the
Haight Ashbury District
of this city,
Hippie, devoted son
of
Mass Media*

Friends are invited
to attend services
beginning at sunrise,
October 6, 1967
at
Buena Vista Park.

It was actually amazing that the surging mob of newcomers didn't destroy everything. The reason was that older hippies who hadn't yet moved to the country were getting hold of them as soon as they arrived and shunting them off to crash pads in other parts of town or to rural communes. The institutions that worked well were new ones like the Haight-Ashbury Legal Organization, which defended busted hippies, and the Haight Free Clinic, which provided first aid and medical assistance. Meanwhile, the dancehalls roared on all summer.

Though the expectation of a great psychedelic breakthrough persisted, the Haight itself had begun to show signs of heavy wear. Furthermore, it was obvious that many who came to the Haight that summer weren't as loving and enlightened as those who had preceded them. There were hustlers and phonies in the mix, even violent criminals like future cult leader Charles Manson. In September the HIP merchants, Diggers and other hippie leaders who hadn't left town decided that the community had been exploited by commercialization and shallow media coverage. They tried to save the phenomenon by holding a ceremony called "the Death of Hippie." It was a mock funeral at which a casket filled with hippie paraphernalia was solemnly set afire. The real hippies, the organizers told the assembled press, were now wise to the media and would henceforth be known as "free men."

Some people made the distinction, and it became conventional to apologize for using the word "hippie," but otherwise the ceremony made no difference. Whether in the form envisioned or not, the lifestyle pioneered in San Francisco was spreading across the nation.

Inside the Haight-Ashbury Free Medical Clinic (previous pages). Pallbearers in the funeral procession for "the Death of Hippie" ceremony through the Haight-Ashbury on October 6, 1967 (right). A sea of lost faces: the runaway board at the Haight-Ashbury police station in 1967 (following pages). George Harrison and wife Pattie visited the Haight-Ashbury in August 1967, and though he beamed at the time (page 170), it was actually a highly disillusioning experience that ultimately led him to renounce drugs. A converted U.S. mail truck (page 171, top) claims to carry a different kind of cargo. Page 171, below, a group of freaks hangs out in front of the Drogstore [sic] Café at the busy intersection of Haight and Masonic Streets.

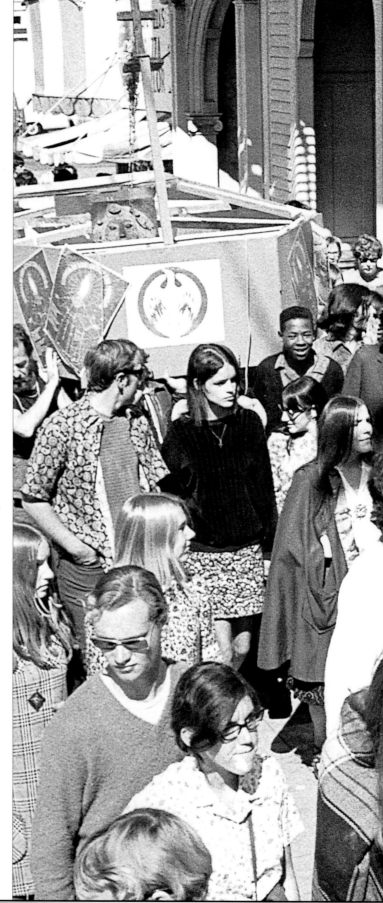

7 **Governor Ronald Reagan asks the California state legislature to "drive criminal anarchists and latter-day fascists off the campus."**

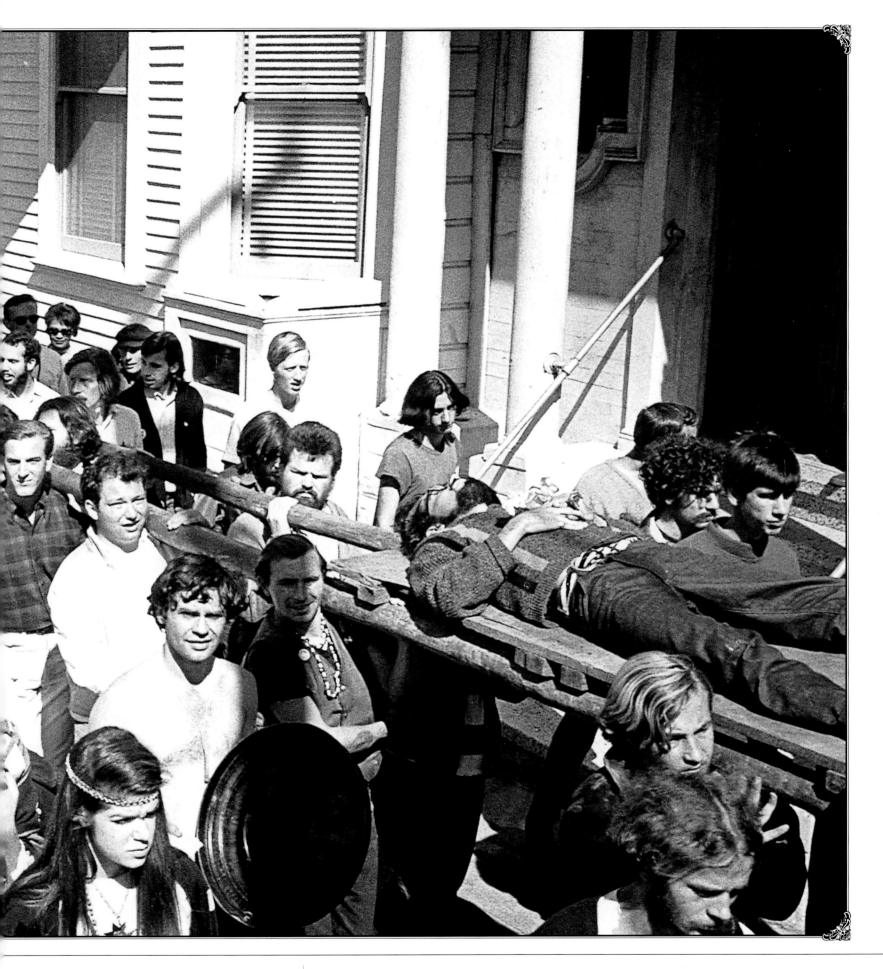

12 *Paul McCartney and Linda Eastman are married in London.*

20 *John Lennon and Yoko Ono marry in Gibraltar, celebrating their union with a week-long "bed-in" at the Amsterdam Hilton.*

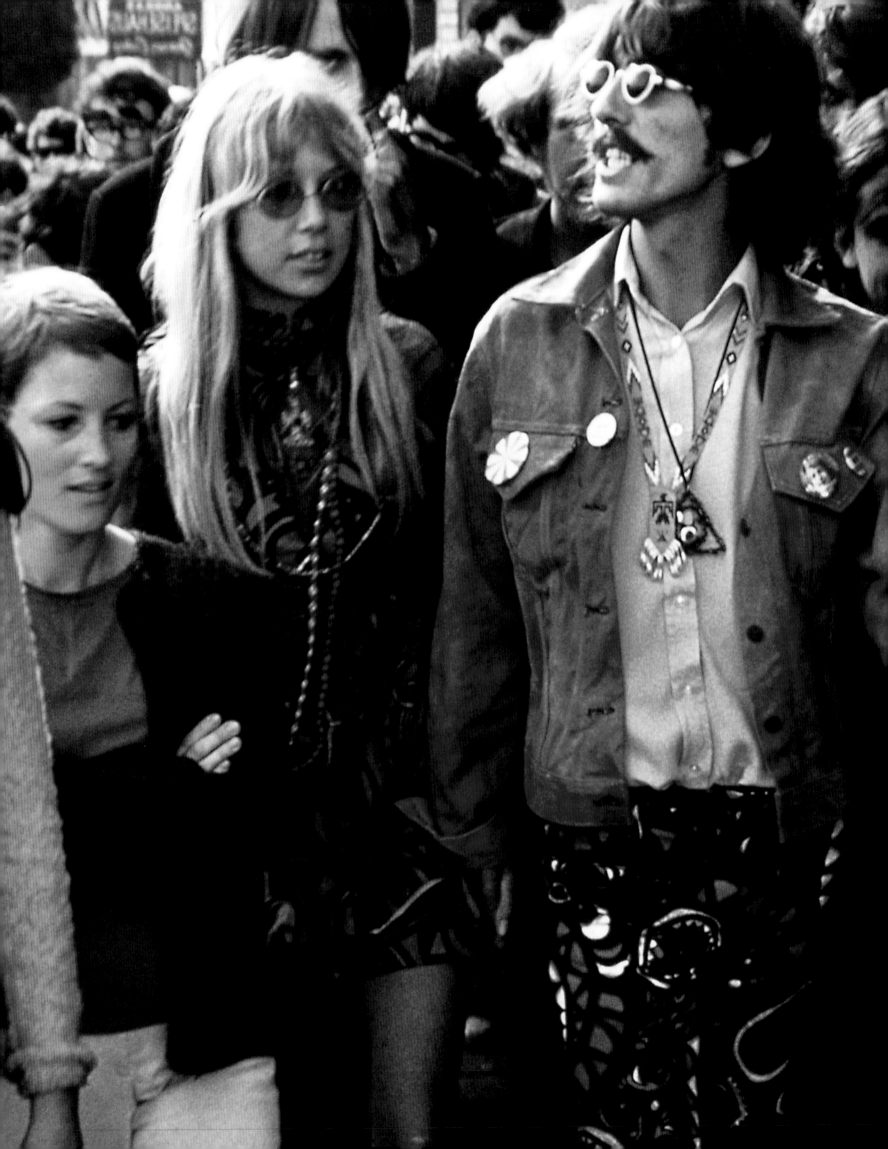

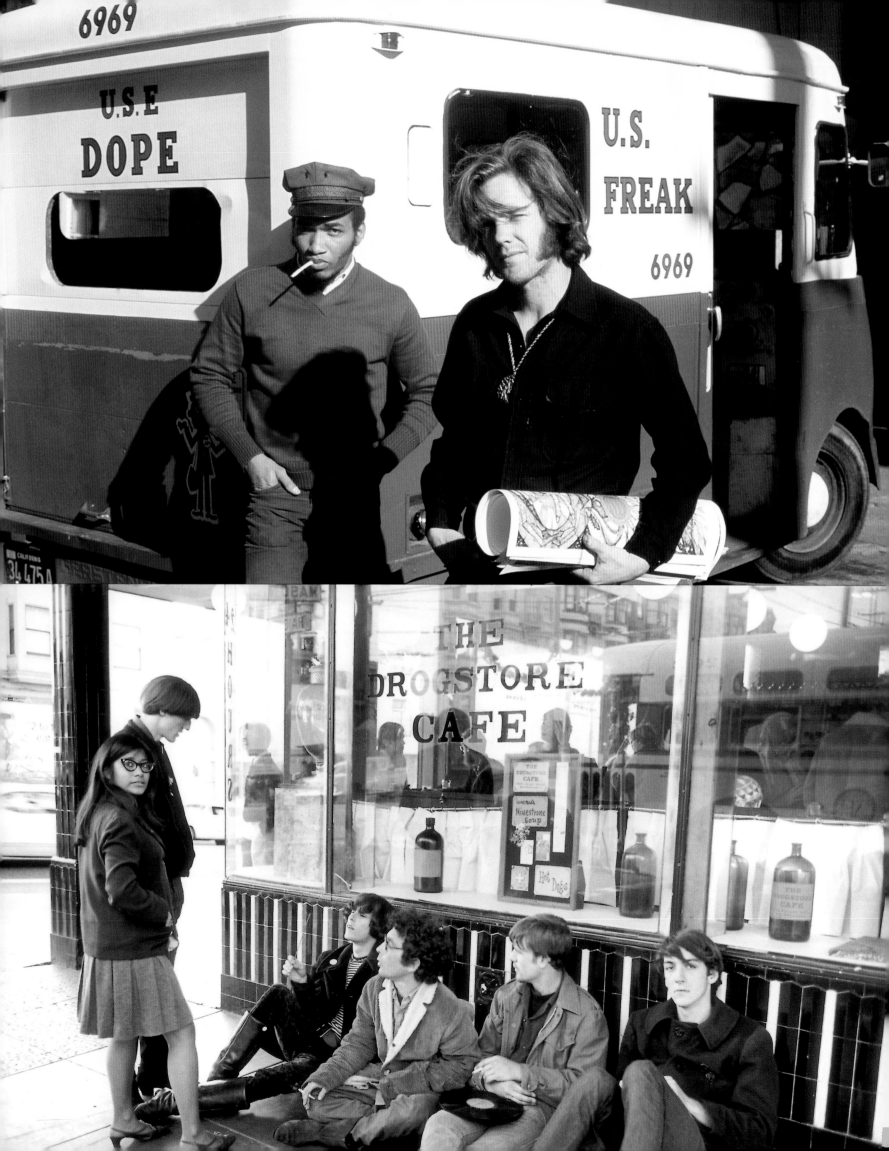

MOBY GRAPE

Moby Grape in concert at Fillmore East (right). Their debut album, **Moby Grape,** *ranks with the best albums released by a San Francisco band. It includes the classic psychedelic rocker "Omaha," penned by guitarist/singer Skip Spence. Fellow band member Peter Lewis recalls Spence, who later was beset with drug problems, as "a guy who gave everything he had in 1967 and '68. Really, he was trying to turn himself inside out to do this energy trip he wanted to do. He was on fire onstage."*

APRIL '69 *The number of U.S. troops in Vietnam reaches 543,000, a wartime peak.*

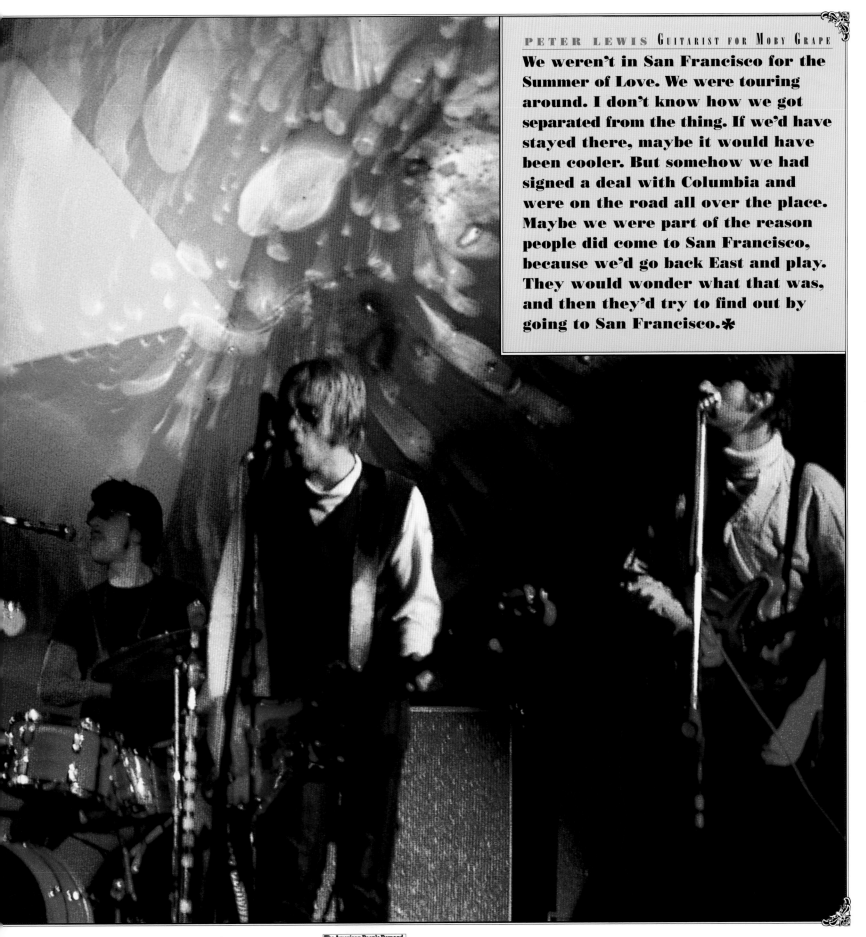

We weren't in San Francisco for the Summer of Love. We were touring around. I don't know how we got separated from the thing. If we'd have stayed there, maybe it would have been cooler. But somehow we had signed a deal with Columbia and were on the road all over the place. Maybe we were part of the reason people did come to San Francisco, because we'd go back East and play. They would wonder what that was, and then they'd try to find out by going to San Francisco.✻

The American People Demand-
OUT NOW
March Against the War-
Sat., May, 13
Assemble: Embarcadero Plaza
-11:30 A.M.
Rally: Civic Center Plaza
-1:00 P.M.

MAY '69

15 *Ongoing protest over People's Park in Berkeley, California, turns violent when gun-wielding police fatally wound one demonstrator.*

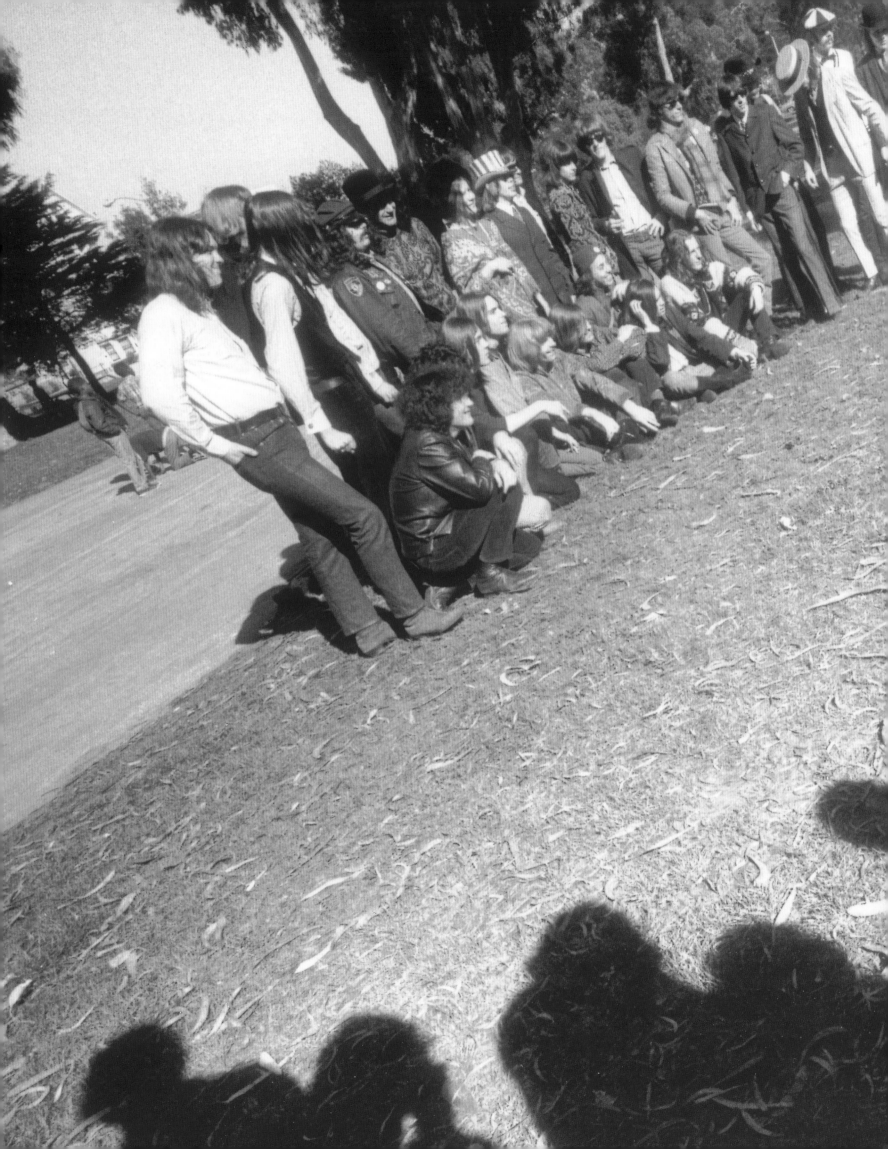

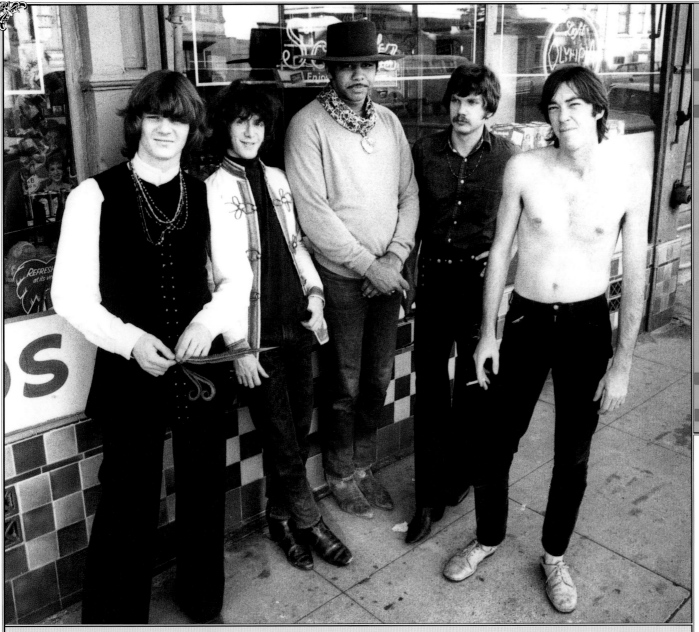

The Steve Miller Band (left), which featured guitarists/singers Miller (left) and Boz Scaggs (right), took the unusual step for a San Francisco band of traveling to London to record their first album, Children of the Future.

The members of San Francisco's five top bands — Quicksilver Messenger Service, the Grateful Dead, Big Brother and the Holding Company, Jefferson Airplane and the Charlatans — pose for a family portrait (opposite), circa 1967.

BOZ SCAGGS

The scene in San Francisco was well established when I walked into it late in 1967. I moved out to join the Steve Miller Band, who were very much a part of the scene. They were popular guys who moved easily in and out of the ideas and scenes going on there. They had a communal house, and all the guys in the band lived there. I was given a small room. People were coming and going all day and night. San Francisco was very tribal in the sense that everyone had their own house or communal thing and everybody knew everybody. There were a lot of people around from that summer, which I guess you'd call the apex of the whole scene.

I describe it as having missed the Summer of Love but arriving at the Autumn of Mild Discontent.✳

JUNE '69

7 The Who's rock opera Tommy, a mystical parable about a deaf, dumb and blind boy's quest for enlightenment, enters the U.S. album charts. The double album is largely composed by guitarist Pete Townshend.

THINGS TURN POLITICAL

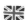

By 1968 the underground was fragmenting. The student riots in Paris that May drew many of the *IT* staff to France. Anti-Vietnam War demonstrations were held outside the U.S. embassy in Grosvenor Square, and mounted police charged the protesters. The underground splintered into warring factions, with outside groups trying to wrest control of *IT* and half a dozen concert promoters battling to become Britain's answer to Bill Graham. Meanwhile, rock groups proliferated. Any night of the week you could see the likes of Traffic, Family, Fairport Convention, the Jeff Beck Group, the Moody Blues and Tyrannosaurus Rex.

However, a perceptible change came over the scene as the underground split into two distinct communities: political radicals such as White Panthers

A demonstration against the Vietnam War proceeds down Bond Street (above), with Joan Baez and Donovan at the forefront.

and militant squatters, and pot-smoking vegetarian hippies, who retreated to communes in Wales. In London, the Summer of Love was over.

The last glimpse of the spirit of the underground came with the Rolling Stones' free concert in Hyde Park on July 5, 1969. Organized by Pete Jenner's Blackhill Enterprises, the lineup featured the Third Ear Band, Pete Brown's Battered Ornaments and King Crimson, climaxing with a memorable performance from the Stones.

The event was dedicated to the memory of Brian Jones, who had died two days previously. Jagger said, "I want to make it so that Brian's send-off from the world is filled with as much happiness as possible." He began the Stones' set with a reading from Shelley's "Adonaîs." It was a beautiful sunny day that attracted an audience of half a million, the largest gathering in Britain since V-E Day. There was no violence, just good vibes — as if it were still 1967.

Another antiwar demonstration, in Grosvenor Square (left, top), resulted in a violent clash between police and protesters.

John Lennon and Yoko Ono try more peaceable tactics, taking to their bed during a visit to Canada for eight days in 1969 (left, bottom). During their "bed-in," Lennon wrote and recorded his first non-Beatles single, "Give Peace a Chance," installing a recording deck in his hotel room and enlisting visitors such as Timothy Leary and Dick Gregory to clap and chant along.

The Rolling Stones' free concert for a crowd of 500,000 at Hyde Park, on July 5, 1969, was dedicated to the recently deceased Brian Jones (following pages). The performance began with a eulogy by Mick Jagger, who quoted from Shelley's "Adonais."

JULY '69

16 *The first manned mission to the moon, Apollo 11,*
is launched from Cape Canaveral in Florida.

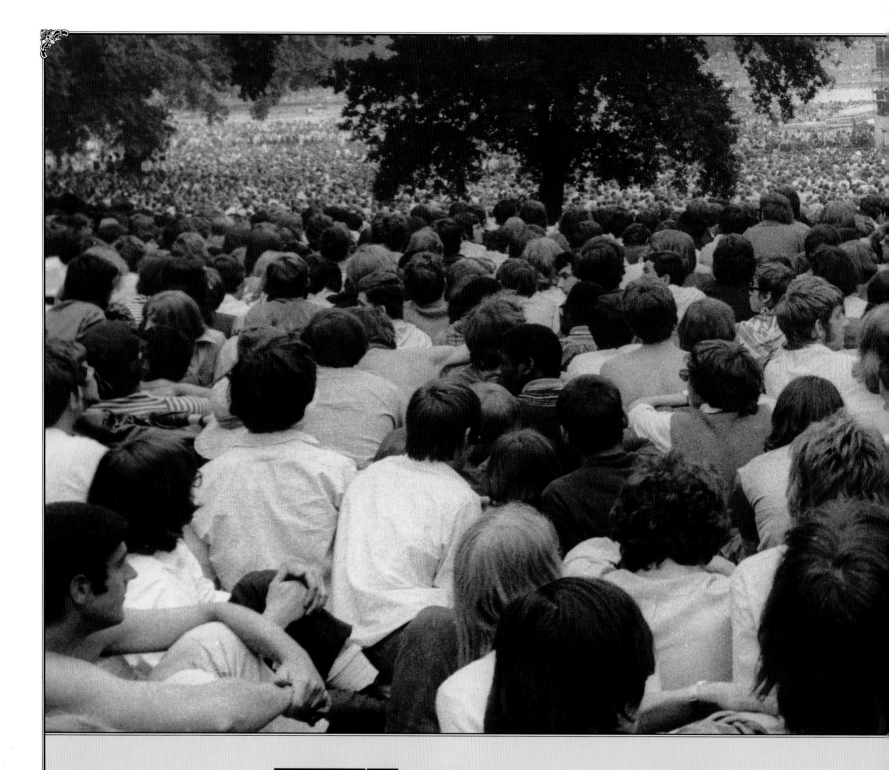

There was just good vibes still

20 **Astronaut Neil Armstrong, commander of Apollo 11, becomes the first person to walk on the moon. It is, in his words, "one small step for a man, one giant leap for mankind."**

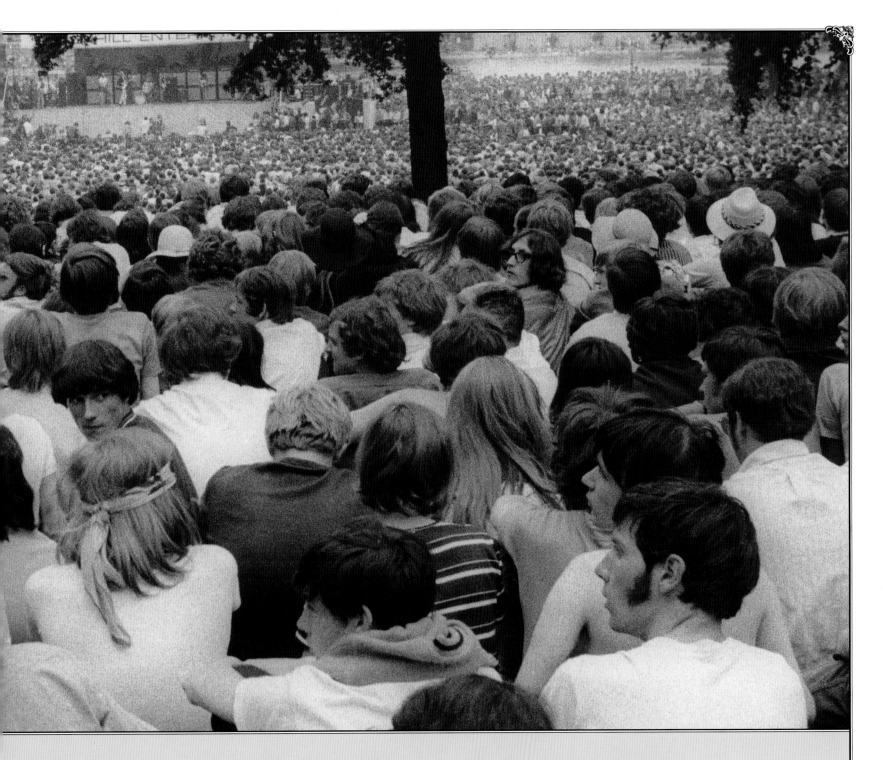

no violence, - as if it were 1967.

9 *Five people, including actress Sharon Tate, are murdered by members of the Manson Family under orders from its leader, Charles Manson.*

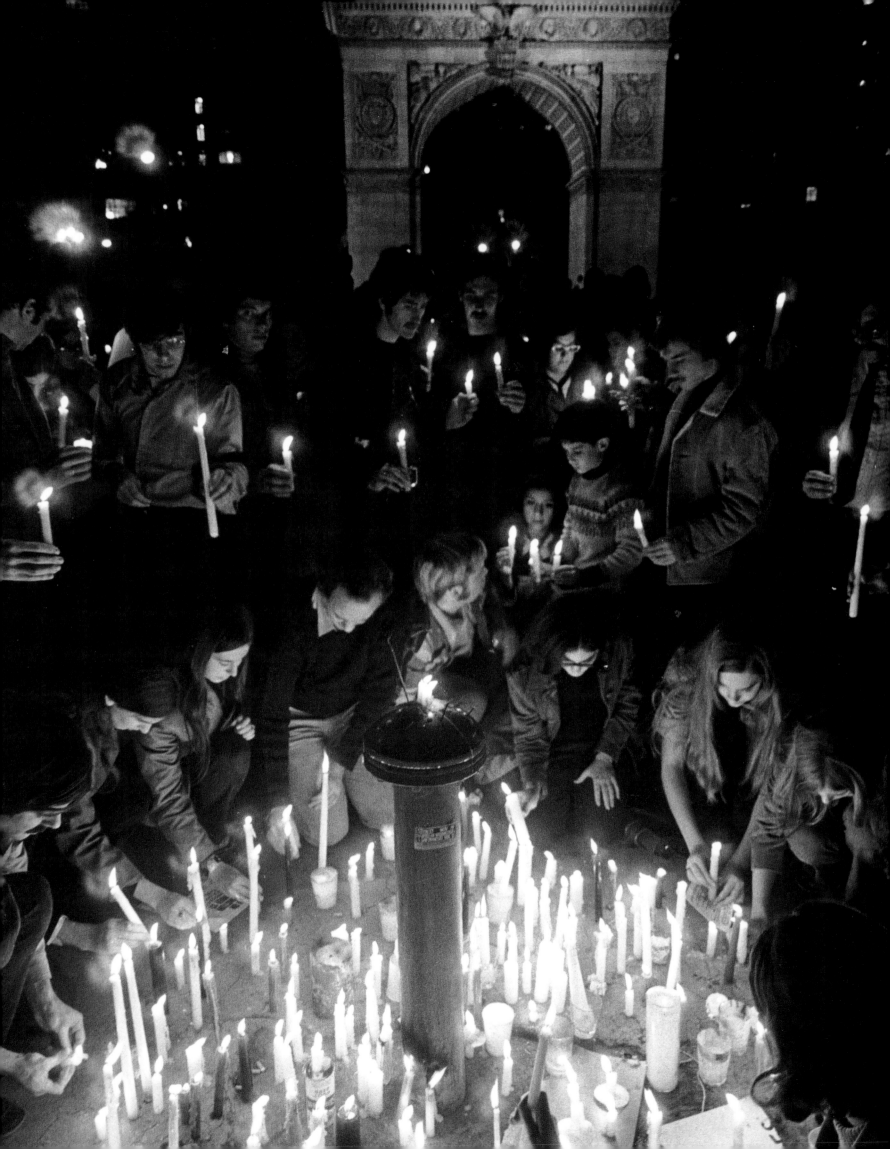

By The Time We Got To Woodstock

There was yet another Haight-Ashbury invasion during the summer of 1968, and the Fillmore and Avalon Ballrooms again presented dance concerts nearly every night. Nobody was calling it the Summer of Love however, or any kind of special summer at all. Events and musical changes weren't coming as quickly as they had the year before, but the hippie movement itself was still growing — and encountering resistance. The only political issue everybody really cared about in the Haight was the Vietnam War. Hippies provided a high proportion of the marchers in the peace demonstrations of 1968. In May, the editors of the *Oracle* organized an "exorcism" of the Pentagon, attempting to levitate the nation's military headquarters. In '68 and '69, the whole nation grew deeply and violently divided over the issue.

"Everywhere I hear the sound of marching, charging feet . . ." Those words, from "Street Fighting Man," by the Rolling Stones, describe the temperament of the late Sixties as antiwar sentiment reached fever pitch. In New York City, a candlelight peace ceremony took place near the Washington Square arch in Greenwich Village (opposite).

In San Francisco, demonstrators marched down Market Street (below), bearing banners, placards and peace signs. A handbill (right) announces another antiwar gathering.

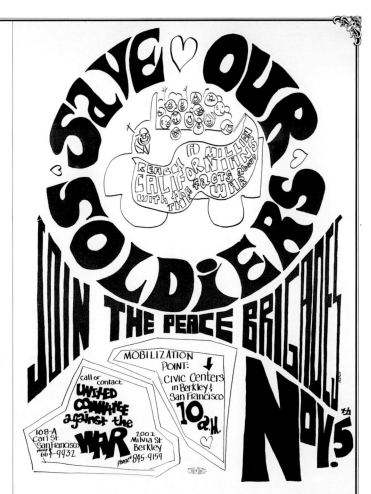

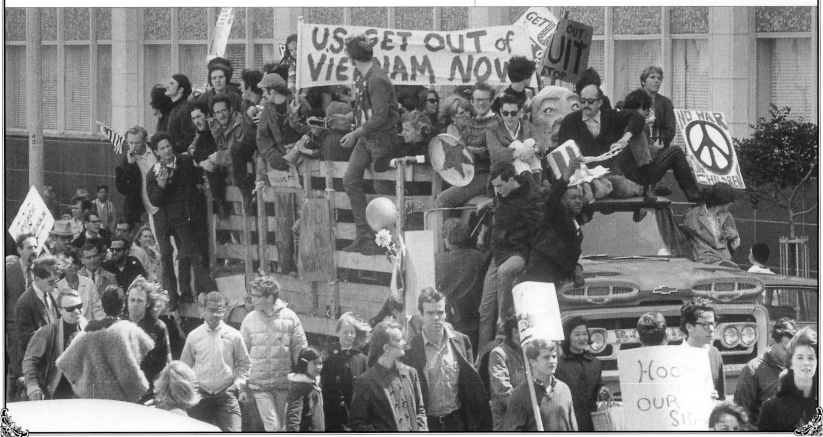

AUGUST '69

15 - 17 *The Woodstock Music and Art Fair attracts 450,000 people to Bethel, New York, for three days of "peace, love and music." It is the zenith of countercultural gatherings. Fittingly, many of the San Francisco bands are prominently featured.*

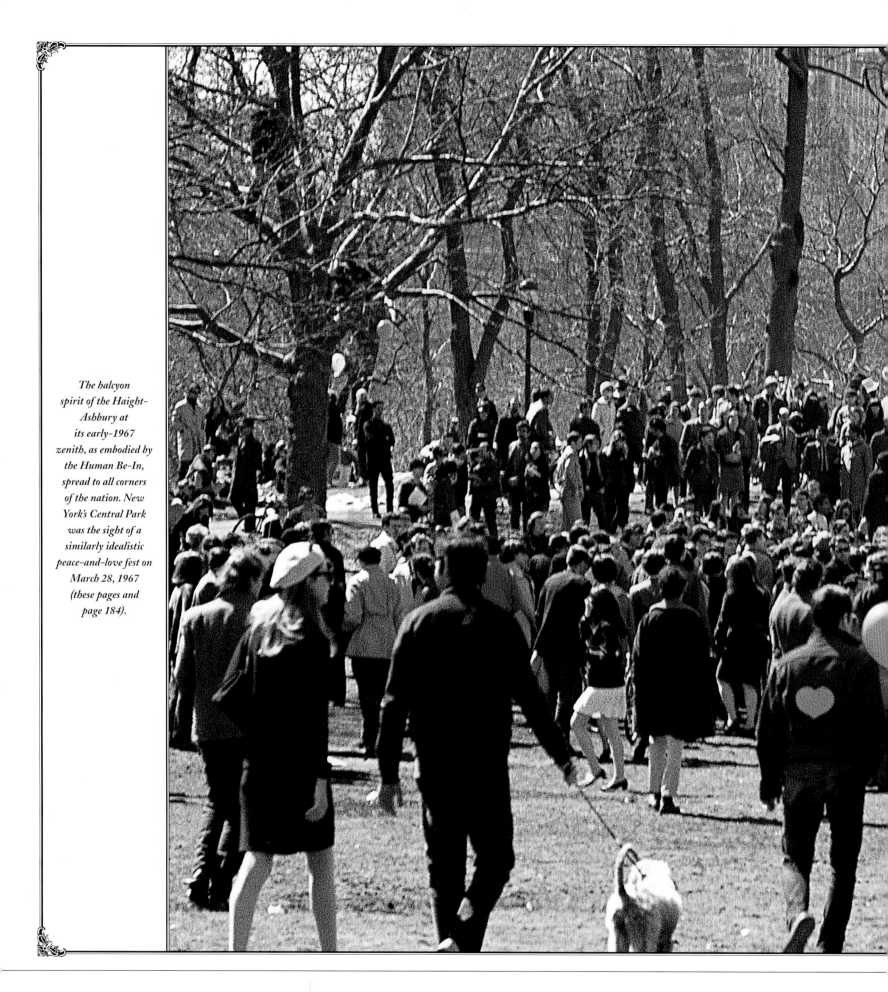

The halcyon spirit of the Haight-Ashbury at its early-1967 zenith, as embodied by the Human Be-In, spread to all corners of the nation. New York's Central Park was the sight of a similarly idealistic peace-and-love fest on March 28, 1967 (these pages and page 184).

13 *Having triumphed at Woodstock with their fiery, percussive Latin rock, the San Francisco-based Santana enters the album charts with their debut album, which includes the popular tracks "Evil Ways" and "Soul Sacrifice."*

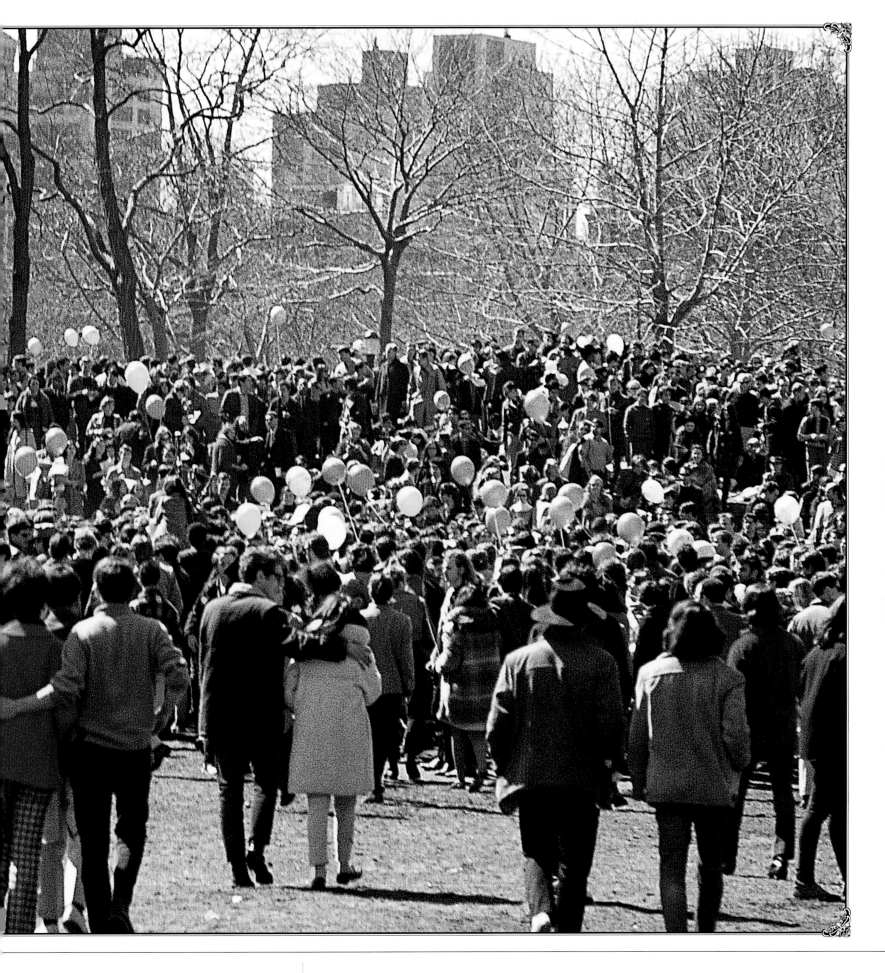

2 3 *Rumors that Paul McCartney is dead begin to surface as DJs and fans piece together apparent clues dropped in Beatles songs and on album jackets about his decapitation in a car crash.*

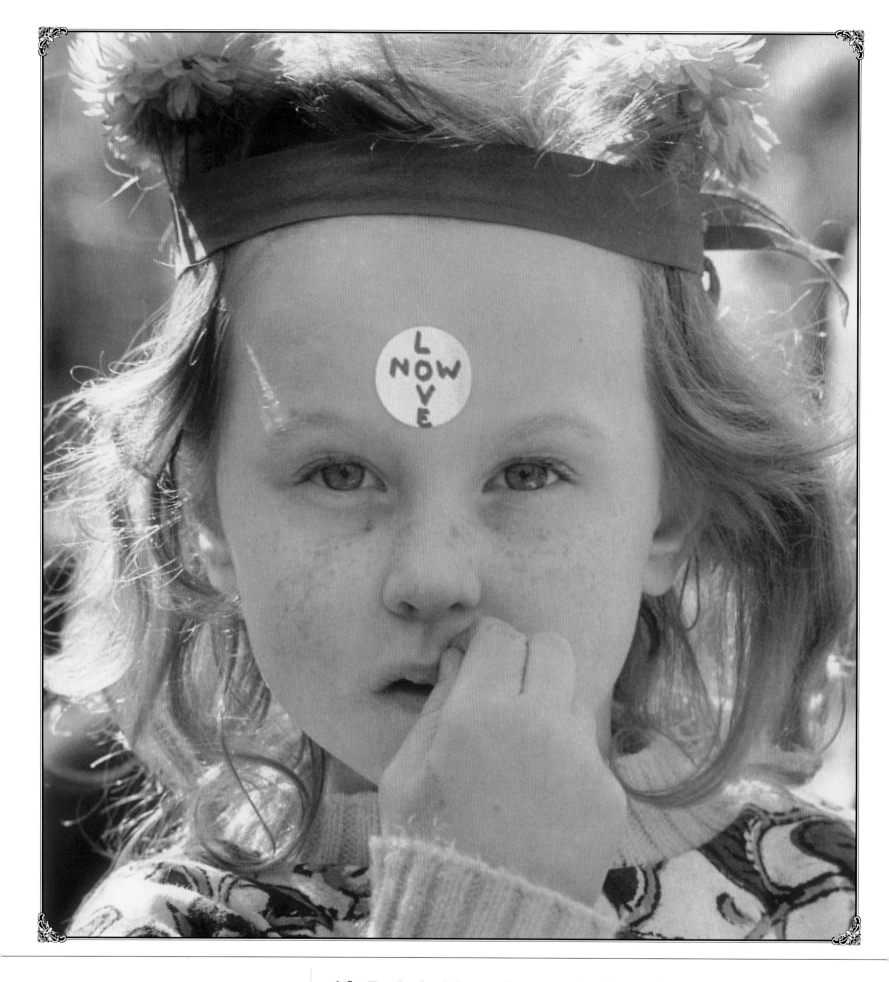

1 5 **Hundreds of thousands turn out for Moratorium Day events in a massive nationwide protest against the Vietnam War. More than a quarter of a million gather in Washington D.C. for the largest antiwar rally ever.**

In 1969, as the political climate darkened and confrontations grew more violent, rock fans all across the country sensed a need for the sorts of gatherings that had brought solidarity and self-identity to the Haight-Ashbury: the first dances, the Trips Festival, the Love Pageant, the Be-Ins, and Monterey Pop. Thus, the summer of '69 became the summer of pop festivals. At least forty were scheduled around the United States and Canada.

The biggest affirmation took place August 15-17 in the tiny town of Bethel in upstate New York. An estimated four hundred and fifty thousand attended the Woodstock Music and Art Fair, making it temporarily the third-largest city in New York. Jefferson Airplane, the Grateful Dead, Janis Joplin (now a solo artist) and Country Joe and the Fish were prominent, along with newer San Francisco bands such as Santana, Creedence Clearwater Revival

At an October 1967 antiwar rally in Washington D.C., a peaceful protester inserts a flower into a rifle belonging to a National Guardsman (below).

The highlight of the day's protest was an Allen Ginsberg−led attempt to "exorcise" the Pentagon.

and Sly and the Family Stone. San Francisco itself was no longer the undisputed capital of the youth movement. The ripples that had begun in the Haight had by now spread across the nation and even the world. Bells, beads, sandals, Indian fringe and feathers, and turquoise jewelry — to say nothing of the much-imitated San Francisco dance posters — were staples of head shops everywhere. Psychedelic mysticism, astrology, Indian lore and pacifism were becoming familiar across the country, as was the hippies' communal way of living. Even nonhippie men began growing long hair. It no longer seemed odd for adults to listen to rock & roll.

As 1969 dissolved into 1970, we realized half a decade had passed since the seeds for a revolution in music, politics, art, fashion and lifestyles were first sown in San Francisco. It had been a long, long summer of love.

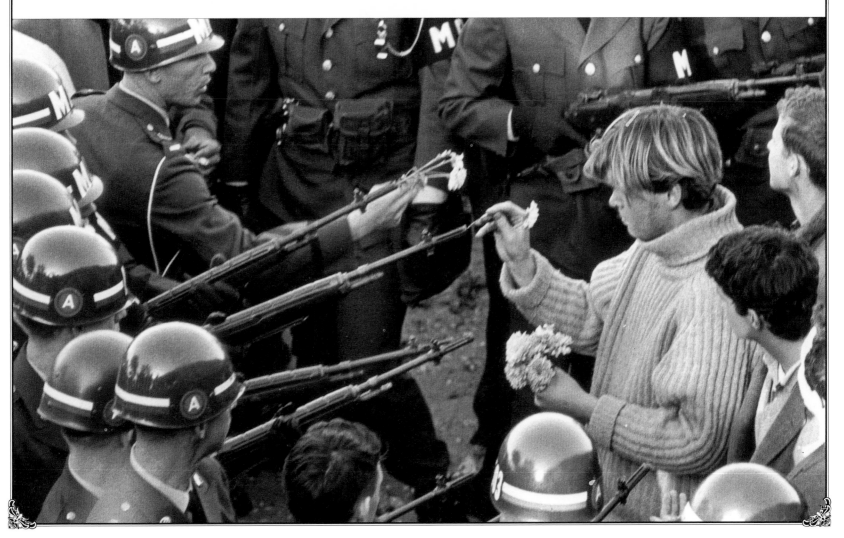

2 1 *Beat Generation writer Jack Kerouac dies of a stomach hemorrhage in St. Petersburg, Florida. Unsympathetic to the hippies who followed in his footsteps, Kerouac made this observation on his one and only acid trip: "Walking on water wasn't built in a day."*

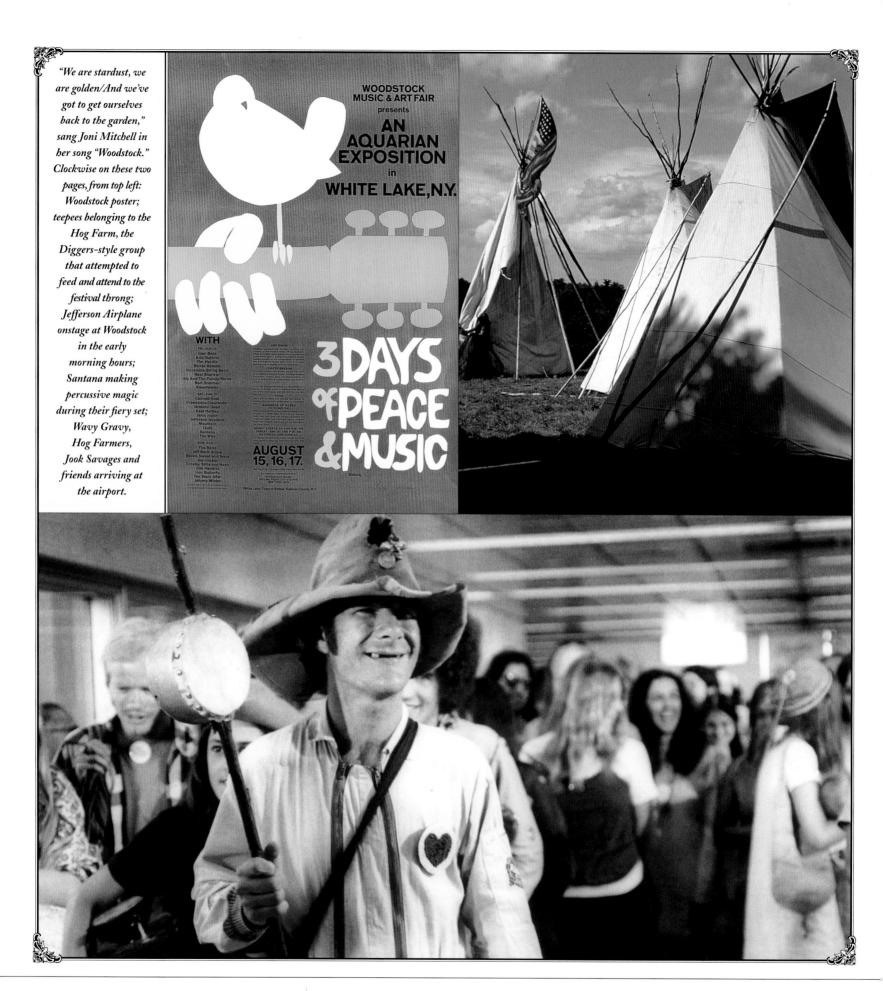

"We are stardust, we are golden/And we've got to get ourselves back to the garden," sang Joni Mitchell in her song "Woodstock." Clockwise on these two pages, from top left: Woodstock poster; teepees belonging to the Hog Farm, the Diggers-style group that attempted to feed and attend to the festival throng; Jefferson Airplane onstage at Woodstock in the early morning hours; Santana making percussive magic during their fiery set; Wavy Gravy, Hog Farmers, Jook Savages and friends arriving at the airport.

1 "Okie from Muskogee," a hippie-bashing song by country music legend Merle Haggard, moves from country to pop charts.

1 4 Dow Chemical Co. agrees to stop manufacturing napalm, a chemical used by U.S. troops in Vietnam.

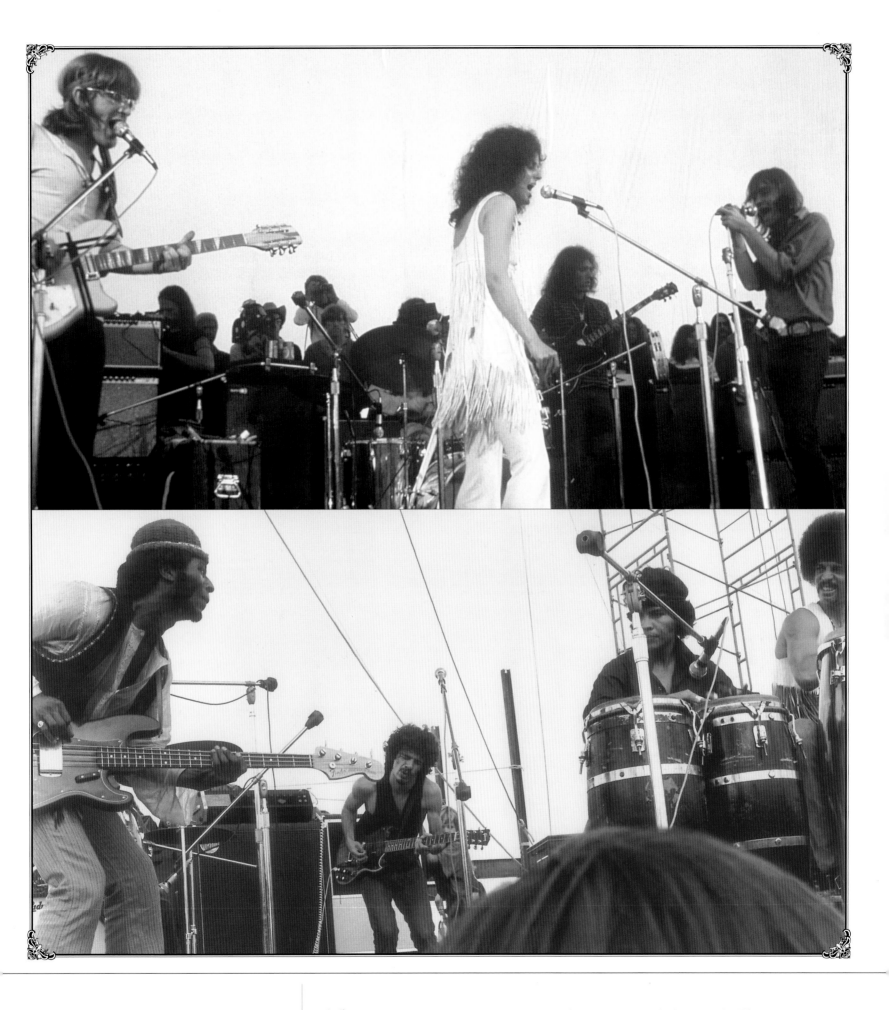

2 5 *As a gesture of protest for Britain's support of the war in Vietnam, John Lennon returns his MBE to Queen Elizabeth.*

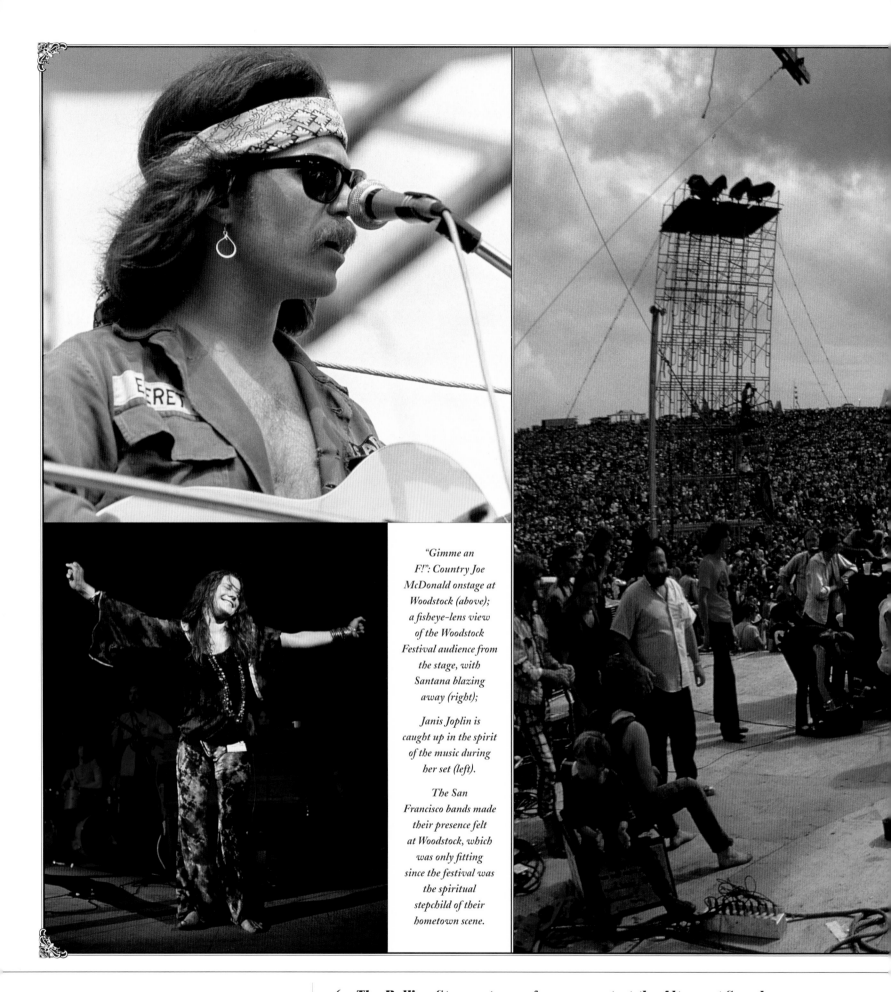

"Gimme an F!": Country Joe McDonald onstage at Woodstock (above); a fisheye-lens view of the Woodstock Festival audience from the stage, with Santana blazing away (right);

Janis Joplin is caught up in the spirit of the music during her set (left).

The San Francisco bands made their presence felt at Woodstock, which was only fitting since the festival was the spiritual stepchild of their hometown scene.

6 *The Rolling Stones stage a free concert at the Altamont Speedway, outside San Francisco. The festival atmosphere is marred by drug overdoses, violence from the Hell's Angels and the stabbing death of a concertgoer during the Stones' performance.*

I WANT TO TAKE YOU HIGHER

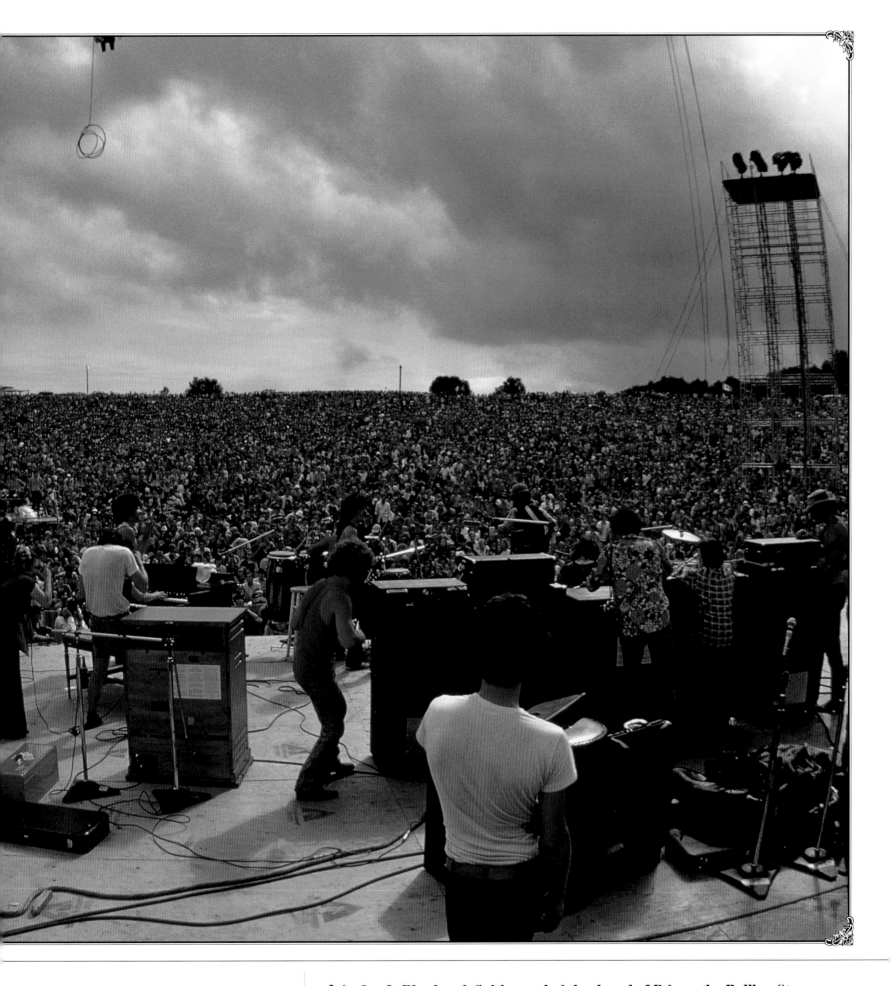

26 Let It Bleed, a definitive end-of-the-decade LP from the Rolling Stones, enters the charts. It includes the Stones classics "Gimme Shelter" and "You Can't Always Get What You Want."

THE PSYCHEDELIC 100

THIS LIST OF 100 SONGS is designed as a chronological overview of the classic psychedelic period, defined as lasting from 1965 to 1969. Despite the fact that there was considerable interaction between the U.S. and the U.K. during that time — much more so than today — it seems easier to chart the two countries separately. The story of each movement is told through the records. *The Psychedelic 100* is not simply an exercise in personal taste: You should find most of the major artists and songs represented. Just to keep things interesting, however, there are a few obvious hits that have been passed over for equally interesting obscurities, for example, "It's All Too Much" instead of "All You Need Is Love." *Bearing in mind* that the kitsch of each pop period can be as interesting as the true path, I've also decided to include psych-exploitation over borderline genre-busters: Tommy James instead of the Velvet Underground, Iron Butterfly over the Mothers of Invention. The one hundred are arranged chronologically, not in order of preference; unless marked otherwise, the date given is the release date. *Above all, the list is designed to be played* and indeed fits perfectly onto four C90 cassettes or DATs, with the breaks between sides occurring at the 27th, 50th, 77th and 100th songs. Dive deep into one of the most exciting pop moments of all time, and remember—you have nothing to lose but your mind.

JON SAVAGE

PSYCHEDELIA U.S.

1. EIGHT MILES HIGH *(1st edition)*
The Byrds
Recorded: December 22, 1965

Seven weeks after recording the simple folker "He Was a Friend of Mine," the Byrds blasted into hyperspace with this version of "Eight Miles High," the first aural reproduction of the LSD rush: Gene Clark's queasy lyric and Roger McGuinn's Coltrane/Shankar improvisations made the airplane flight the central pop metaphor for LSD's trip into the otherworld. Recorded at RCA Studios, this first, wilder version went unreleased for nearly twenty-five years.

2. ALABAMA BOUND
The Charlatans
Recorded: spring 1966

The first San Francisco psych group was a concept dreamed up by singer/autoharpist George Hunter: swells dressed in clothes that matched the Edwardian mansions of the Haight. An LSD-drenched, summer '65 season at the Red Dog Saloon in Nevada added the Wild West into the mix: guns, dogs, country blues. Good-timey rather than messianic, the Charlatans' tour de force was "Alabama Bound," where they stretched out Jelly Roll Morton's tune of loss and dislocation into a new American symphony of sweet, shimmering guitars.

3. VISIONS OF JOHANNA
Bob Dylan
Recorded: May 26, 1966

As early as 1963's "Lay Down Your Weary Tune," Dylan was exploring the egoless

surrender to the universe that would characterize the first, benign phase of psychedelia. From 1965 on, his gnomic, gnostic utterances laid down the parameters for what would follow, as the Beatles, the Byrds and the Rolling Stones fell under his spell. Dylan issued disclaimers—"I never have and never will write a drug song . . . It's just vulgar," he exclaimed on the last night of his 1966 world tour—but this "Visions of Johanna," taken from the night before, has the infinitesimal focus of acid-time compression.

4 BLUES FROM AN AIRPLANE
Jefferson Airplane
May 1966

Jefferson Airplane were the first S.F. rock group to sign with a major label, for the then unheard-of advance of $25,000. "Blues From an Airplane" features first singer Signe Toly Anderson and is a good example of the turf they'd make their own: drug epiphanies translated into romantic story lines. "I'm sure of how I can be the man I feel," Marty Balin cries, parading a loneliness topped off with soaring folk harmonies and acidic lead guitar.

5 SECTION 43
Country Joe and the Fish
August 1966

In late '65, Berkeley activists Country Joe and the Fish released the first version of their infamous anti-Vietnam tune "I-Feel-Like-I'm-Fixin'-to-Die Rag." This seven-minute instrumental from their second self-produced EP has a fragile, first-time innocence. Dominated by David Cohen's reedy organ, "Section 43" is all fog, space and possibility—a perfect representation of the Bay Area at that time.

6 SOMEONE TO LOVE
The Great Society
Summer 1966

"Someone to Love" is one of the few accurate representations of the San Francisco Sound as it happened: teenage angst deliciously amplified to cosmic proportions, with that ballroom echo and wild, distorted guitar. The group's ambition outstripped their ability—producer Sly Stone quit the studio in disgust after fifty takes—but that's what makes them resonate still. Grace Slick took the song with her to Jefferson Airplane, who retitled it "Somebody to Love." It went Top Five in May 1967.

7 ELECTRICITY
Captain Beefheart and the Magic Band
Recorded: summer 1966

Don Van Vliet unveiled his new look at the Avalon Ballroom in summer 1966. As Gene Sculatti writes in *San Franciscan Nights*, "The real Captain Beefheart stood up in pre-new-wave plastic wraparound sunglasses, tassle-topped Shriner's fez and a braided bandleader's corset right out of *The Music Man*. With killer drumming, horror movie theremin and slide guitar (played by Ry Cooder) that went straight to the third eye, "Electricity" surfed on the metallic pulse of the new era: "Go into bright/Find a light and know/That friends don't mind just how you grow."

8 FOOLISH WOMAN
Oxford Circle
Autumn 1966

From Sacramento, Oxford Circle recorded right on the garage/psych cusp. Their only 45, "Foolish Woman," begins with a punk Them-style rant that, after a minute or so, runs out of spleen. There is a pause before some backwards guitar, then they're off into the stratosphere, speeding into feedback drones. A quick restatement of the basic theme, and they're cut dead—from misogyny to transcendence and back again, all within 2'30".

9 ROLLER COASTER
13th Floor Elevators
Autumn 1966

One of the first psychedelic groups to hit nationally (with "You're Gonna Miss Me"), these Texans made frequent visits to the Bay Area in the second half of 1966. Beginning quietly, "Roller Coaster" soon peaks into unabashed proselytism: "You've got to open up your mind/And let everything come through/After the trip your life opens up/You start doing what you want to do." Driven by Roky Erickson's unearthly shrieks, the Elevators take you through every stage of the journey—eight hours compressed into 5'05".

10 FEEL THE MUSIC
Vejtables
Autumn 1966

In 1965, the Vejtables followed their Autumn labelmates, the Beau Brummels, onto the national charts with the Beatlesque "I Still Love You." A year and two female drummers later, they regrouped for an attempt at mind expansion. The requisite ego-loss is rendered by two ragalike breaks, as the guitarist wanders up and down the frets in sitar simulation. In the high register, finger cymbals; at the end, a cymbal clash; and the band is gone in a puff of smoke.

11 PSYCHOTIC REACTION
The Count Five
September 1966

Included as much for its title and its contemporaneity, "Psychotic Reaction" was justly celebrated by Lenny Kaye in his groundbreaking *Nuggets* collection—which, in 1972, excavated '60s punk for the next generation to plunder. A Top Five hit, "Psychotic Reaction" was the Yardbirds' "I'm a Man" as played by five gawky teens from San Jose—a punker so perfect as to inspire the Lester Bangs rant that titled his book *Psychotic Reactions and Carburetor Dung*.

12 CHILDREN OF THE SUN
The Misunderstood
Recorded: autumn 1966

Another Yardbirds cop, perhaps the finest ever, as this Riverside, California, group—transplanted to the U.K.—go stratospheric with this toughened-up rewrite of "Shapes of Things." Dominated by Glenn Ross "Fernando" Campbell's searing slide guitar, "Children of the Sun" rocks so hard you wonder how the Misunderstood could top it, and they didn't. Like Icarus, they quickly fell to earth, draft dodgers hounded by the army and the FBI.

13 FEATHERED FISH
Sons of Adam
Autumn 1966

A total punk/psych classic, with a massive, fuzzed stop-start riff, high harmonies and wacko lyrics by none other than Love's Arthur Lee. Like, uh: "I don't know/There I go." All that we know about Sons of Adam is that they were an L.A. group affiliated with Love. Impressed by their rendition of this ferocious tune, Lee pinched drummer Mike Stuart for Love's upcoming *Da Capo* album.

14 7 AND 7 IS
Love
September 1966

A hyperspeed slice of acid-amped teen angst. Sample lyric: "When I was a boy I thought about the time I'd be a man/I'd sit inside a

bottle and pretend that I was in a can/In my lonely room I'd slip my mind in an ice cream cone/You can throw me if you wanna 'cos I'm a bone." At the break, Arthur Lee counts it down: "One, two, three, four!" and then Love's only Top Forty hit explodes in your face, leaving a fragment of the blues in its wake.

15 GOOD VIBRATIONS
The Beach Boys
October 1966

Recorded over six months, the final version of "Good Vibrations" is a masterpiece of editing. Brian Wilson's pocket symphony begins with a deceptive simplicity, all solo voice and modulation organ, but twists and turns into a full-blown theremin psych-out. It reached #1 in December 1966; for a brief moment the Beach Boys were ahead of the Beatles. And yes, it was the first time you heard the phrase.

16 FRANTIC DESOLATION
Sopwith Camel
Early 1967

Named to reflect the obsessions of the moment (Edwardiana, flight), S.F. art-schoolers Sopwith Camel are best known for their Top Thirty hit, "Hello Hello," which rode the Lovin' Spoonful's sweet jug-band style for one last time in January 1967. Since having a hit was uncool, the Camel were consigned to the outer darkness — an injustice, as this unexpected slice of desperation makes clear. The eloquent fuzz solo is as pure a distillation of San Francisco as you will ever hear.

17 THE CRYSTAL SHIP
The Doors
January 1967

Always the most understated and thus persuasive song from the group's infamous first album. With images of parting, madness, surrender and death, the Doors set sail for

uncharted waters and took their audience along with them. Just so you didn't forget that they came from L.A., the West Coast's media center, Jim Morrison came up with some great soundbites: "I'd rather fly"; "another flashing chance at bliss"; "deliver me from reasons why."

18 MR. FARMER
The Seeds
March 1967

L.A.'s finest for a season, the Seeds straddled the punk/psych divide until they went over the edge in late '67. As the notes to their third album, *Future*, say, "leading the way once more back past the dragons through the crooked forest to the fairy castle surrounded by flowers and flower children playing in the sun." This 45 was the follow-up to "Pushin' Too Hard" and, although drenched in the same cheesy organ, is more psych in its imagery and subject matter: "Mr. Farmer, let me water your crops." Now what were those "little green things"?

19 KEEP YOUR MIND OPEN
Kaleidoscope
April 1967

All the more impressive for its restraint, this ballad was one of the first antiwar songs from within the emerging counterculture. Berkeley's Kaleidoscope were the first to fully integrate non-Western music and pop. Here, an exotic, hothouse mood (wind chimes, Near Eastern instrumentals) is slowly undermined by gunfire swells — the *Realpolitik* behind psychedelia.

20 GET ME TO THE WORLD ON TIME
The Electric Prunes
April 1967

"Get Me to the World on Time" was the follow-up to the Electric Prunes' #11 hit "I Had Too Much to Dream (Last Night)" and, like all great follow-ups, tightened the mesh. In this case, that meant snotty vocals, mind-melting lyrics shrouding a basic teenage horniness, a killer Bo Diddley beat and a whole battery of effects meant to induce freaking out: fuzz, wah-wah, reverb. "Here I go go go," the band gibbers on the fade, as the guitarist shoots for the stars. Top Thirty U.S., deservedly.

21 JOHNNY WAS A GOOD BOY
Mystery Trend
May 1967

One of the first wave of S.F. groups, Mystery Trend took their name from a mis-heard line in Dylan's "Like a Rolling Stone." This tough punker — sped up in the cut — was their only 45. Announcing itself with breaking glass, it told a story that has since become all too familiar: "the boy next door," good with kids and animals, who makes front-page news with something so unmentionable

that the group doesn't dare to name it. Great but twisted and, unsurprisingly, not a hit.

22 OMAHA
Moby Grape
May 1967

The received wisdom that hippies were about peace and love is exploded by records like this. Backwards guitars come at you like

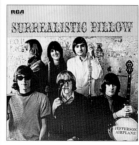

hammer blows, the dual-octave riff starts, and they're off. "Omaha" is nothing if not intense, a jammed-up collision of flashing guitars and ragged voices that taps the crazy, aggressive energy of a moment turning in on itself. A Skip Spence song from what is undoubtedly the finest first-wave S.F. album, *Moby Grape*, and a Top Thirty hit in July 1967.

23 I'M FIVE YEARS AHEAD OF MY TIME
Third Bardo
Summer 1967

New York's Third Bardo took their name from the Tibetan Book of the Dead and recorded this lunging come-on with lyrics so perfectly pretentious that they bear printing in detail: "It may seem like I'm coming on strong/But I know just where it's at for me/I'm through caring 'bout that right or wrong/I've unlocked the door to life's mystery!" Just step inside my mind . . .

24 WHITE RABBIT
Jefferson Airplane
June 1967

Alice in Wonderland set to a bolero beat, this is Grace Slick's record. She brought it from the Great Society, and it is her sardonic, precise vocal that gives the moral authority to the kiss-off: "When logic and proportion have fallen sloppy dead/And the White Knight is talking backwards/And the Red Queen is off with her head/Remember what the Dormouse said: Feed Your Head! Feed Your Head!" Explicit drug propaganda and one of the oddest records ever to reach the U.S. Top Ten.

25 HALLUCINATIONS
Tim Buckley
June 1967

To the mass media, the point of psychedelia was love. In fact, psychotropic drugs only serve to augment what is already there, and what comes across as strongly as the utopian propaganda of this period is an overwhelming sadness. Buried in an album subtly dominated by Vietnam, Buckley's "Hallucinations" are not paisley patterns but lyrical, disturbing paradigms of how loss fucks your head up.

26 ARE YOU GONNA BE THERE? (AT THE LOVE-IN)
Chocolate Watchband
June 1967

From the South Bay, the Watchband is best known for its performance in the AIP film *Riot on Sunset Strip* (rushed out to exploit the December 1966 Sunset Strip riots), which they enlivened with a perfect Yardbirds rip-off, "Don't Need Your Lovin'." "Are You Gonna Be There?" is another mod R&B record, written for a film called *The Love-Ins*: all crunch and sneer, an outsider's view of a culture curdling into conformity.

27 BALL AND CHAIN
Big Brother and the Holding Company
June 1967

Like most first-wave S.F. groups, Big Brother didn't have much of an idea about making records. Their first album was a bunch of demos, their second a major label botch job. This live cut from the Monterey festival is the one that made them superstars. Not a second too long at 8'07", it captures the group at the height of its powers and hints at its future demise — the loser script that Janis Joplin would be required not only to sing but to live out.

28 ANXIOUS COLOR
Painted Faces
Summer 1967

Nothing is known about the Painted Faces except that they came from Fort Myers, Florida, and that they released three singles. This was their first: a marvelous encapsulation of how LSD hit nonmetropolitan America. As the group takes you through all the styles it's learned up to this point — frat rock, Brit beat, punk — it offers the definitive summing up of the acid experience in the title phrase.

29 MAGIC HOLLOW
The Beau Brummels
August 1967

The Beau Brummels' January '65 hit, "Laugh, Laugh," was the first creative American response to the British Invasion. It also helped to finance Autumn Records, the label where Sly Stone attempted to produce first-wave S.F. groups like the Great Society and the Charlatans. Although in at the ground level of the S.F. boom, the group was too minor-key for the full thunder of psychedelia as it became defined. This song, from their *Triangle* album, all harpsichord and chimes, hints at the secret sadness that lay beneath the wonder.

30 BROKEN ARROW
Buffalo Springfield
Autumn 1967

In March 1967, Buffalo Springfield went Top Ten with "For What It's Worth," written after the Sunset Strip riots. The group then began to disintegrate, recording its second album on the run. Neil Young explored his ambivalence to fame in this six-minute epic (which begins with drummer Dewey Martin's fake soul Xerox of Young's "Mr. Soul," recorded live without its author). With an ambition typical of the period, Young then vaults into American Indian mythology and thus the core reason for the shadowy absence that's always present in America: the exterminated native race.

31 INCENSE AND PEPPERMINTS
Strawberry Alarm Clock
October 1967

NutraSweet psychedelia, "Incense and Peppermints" went to #1 in the U.S. in November 1967, six months after it was first released locally on the West Coast, which tells you something about the time lag involved in hitting the mass market. By the winter, of course, the song's uncritical acceptance of the hippie ethos was passé. For all that, it is addictive as a sugar hit, with soft harmonies and an irresistible melody.

32 THE RED TELEPHONE
Love
November 1967

What was so great about Love was that they were nasty hippies. No one was more perfectly cast as Nero than Arthur Lee, "sitting on the hillside, watching all the people die." *Forever Changes* cuts through the pacific pieties of 1967 with an astringent viciousness, sweetened only by Lee's crooning vocals and David Angel's lush orchestration. "The Red Telephone" is a masterpiece of melodic bile, one source of which is made apparent in the song's famous fade, when a noxious Uncle Tom voice offers: "All God's chillun gotta have their freedom."

33 CHANGE IS NOW
The Byrds
January 1968

Although they had recorded some of the best examples of the genre before there was one, the Byrds were not part of the psychedelic hierarchy. Just to show everyone, they pieced together this droning masterpiece of acid lift-off. Propelled by Chris Hillman's pumping bass, "Change Is Now" moves through a country chorus before entering serious third-eye territory with a multidubbed, backwards-guitar symphony. By now, when Roger McGuinn sings "dance to the day when fear is gone," you've joined him.

34 (SITTIN' ON) THE DOCK OF THE BAY
Otis Redding
January 1968

For a brief moment, worlds collided as white psychedelia impacted on black dance music. Inspired by *Sgt. Pepper* and the S.F. scene, Otis Redding recorded this ambient ballad of loss, travel and time (replete with sea atmospherics and sea gull noises from Steve Cropper's guitar), which, after his death in an airplane accident, went to #1 on both sides of the Atlantic. In that process, what had been reflective became unbearably poignant; what had been a pause became a full stop.

35 A QUESTION OF TEMPERATURE
The Balloon Farm
March 1968

A throwback to the cheerful certainties of 1966 punk, this Top Forty hit features one of the best "Huhs" on record — no small achievement — and some neat catch phrases: "Cool disposition hanging by a thread"; "Nonstop elevator going to the top." Lust reduced to pathology, the tension (and psych quotient) is kept up by trebly, fuzzed guitar and what sounds like very early Moog synthesizer squiggles.

36 DANCE TO THE MUSIC
Sly and the Family Stone
March 1968

Waiting to launch his own vision, Sly Stone witnessed the birth pangs of the new era as

house producer at Autumn Records. He took that ambition and applied it, with incredible glee, to a reconstruction of black music. "Dance to the Music," the Family Stone's first Top Ten hit, breaks up jazz, doo-wop, soul and Tamla into a wholly new thing. In this psychedelic funk, you can hear everything that came after, from Funkadelic through today's rap.

37 PRIDE OF MAN
Quicksilver Messenger Service
May 1968

The San Franciscan bidding frenzy wasn't always to the benefit of the musicians, many of whom had fractious relationships with record companies who had no understanding of what they'd bought. Quicksilver held out, signed late and delivered a carefully arranged debut. This opener has unusually confident vocals and stinging lead guitar by John Cipollina, as metallic as that acid taste in your mouth, which backs up the lyric's biblical curse.

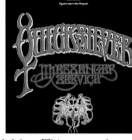

38 THAT'S IT FOR THE OTHER ONE
The Grateful Dead
Summer 1968

The Dead were always the furthest out, but you couldn't hear how until 1968's *Anthem of the Sun,* recorded at concerts and studios around the country over a six-month period. From the time when musicians talked about taping air, this twelve-minute sequence mixes the thunder of the Dead in full flight with Phil Lesh's *musique concrète* and some gorgeous guitar melody about seven minutes in, which by itself justifies Jerry Garcia's reputation. A tour de force of editing and cross-fading, it carries the ambience of the moment like nothing else.

39 IN-A-GADDA-DA-VIDA
Iron Butterfly
September 1968

Along with Blue Cheer and Vanilla Fudge, Iron Butterfly epitomized the moment that the lightness of psychedelia became heavy rock, a process later industrialized by Led Zeppelin. A corruption of "in the garden of Eden," this was the title track of Iron Butterfly's second

album, which stayed on the charts for nearly three years and became one of the first million-sellers of the new era. With its Mafioso title, ponderous solos, moronic riff and ludicrously deep vocals, "In-a-Gadda-Da-Vida" shows that the ridiculous can be a lot of fun.

40 MAGIC CARPET RIDE
Steppenwolf
October 1968

More psychedelic schlock, this time from exiled Canadians who hitched the S.F. ride with an existentialist name and a style that they named in their first hit "Born to Be Wild": heavy metal thunder. This follow-up (#3 U.S. in November) is even better, with its dogfight intro, definitive rock riff, Hammond organ break and spooky premonition of '70s pleasure-babble: "Fantasy will set you free."

41 SONG FOR OUR ANCESTORS
The Steve Miller Band
November 1968

Steve Miller would have been successful in whichever period he came to prominence, and he was, with hits in the '70s and the '80s. For several albums in the late '60s, however, this rock pro had his game raised by the scene of which he was a part. Opening the Steve Miller Band's second, and best, album, *Sailor,* "Song for Our Ancestors" is Country Joe's "Section 43," two years and a lot of record company investment later: all creeping fog and bay atmosphere, with a depth of field that we would now describe as ambient.

42 MACHINES
Lothar and the Hand People
November 1968

Investing heavily in the new rock, the major labels deep-trawled longhaired groups from across America. Among the quacks, false messiahs and journeymen thus given exposure were genuine oddities like this New York group. The opening cut on their first album, "Machines" should have been covered by Gary Numan in the late '70s. Its synth blasts and automaton percussion just beg for robot dancing.

43 CRIMSON AND CLOVER
Tommy James and the Shondells
December 1968

Bubblegum pushed by spacey lyrics and an overdose of reverb into the last great psychedelic

#1. Formerly best known for pulp classics "I Think We're Alone Now," "Hanky Panky" and "Mony Mony," James made his move in summer 1968, when he advised Democratic presidential candidate Hubert Humphrey on youth affairs. "Crimson and Clover" was the first time the group had artistic freedom, and they really hit it; for all its transparent dopiness, the song still shimmers in its own time.

44 WILLIAM
White Lightning
Early 1969

Impossibly intense and vicious, this is Love's "7 and 7 Is" several hundred trips later. Built around a monstrous treble/fuzz riff, "William" is both a perfect psych put-down — "how can you be happy with a symbol for your goal?"— and an encapsulation of the moment when the movement imploded. "You think you're making music but it's twisted out of key," they sneer, then rip off a distorto-solo of which Kurt Cobain would be envious.

45 DREAM WITHIN A DREAM
Spirit
January 1969

Bookended by Ed Cassidy and Randy California, a forty-year-old jazz drummer and a teenage guitar prodigy who had worked with Jimi Hendrix, Spirit had a generosity of talent that made for the most enduring records of that era. From the album *The Family That Plays Together,* "Dream Within a Dream" coils and uncoils like a desert rattlesnake while retaining a truly psychedelic sense of wonder: "And oh my soul like some newborn baby cries."

46 WAR IN PEACE
Alexander "Skip" Spence
February 1969

Skip Spence had lived out the breakdown of the psychedelic age, from the first Jefferson Airplane through Moby Grape and LSD psychosis to an enforced hospitalization in New York's Bellevue Hospital. Recording by himself in Nashville, Spence took on the multiple cracked personae of the street singer who grabs you by the sleeve. Poised between ineptitude and infinite delicacy, "War in Peace" resolves the tensions of its title into, as Greil Marcus writes, "a final version of the San Franciscan Sound, all scattered, but still gleaming."

47 DARKNESS, DARKNESS
The Youngbloods
Spring 1969

From the same New York folk/blues scene as the Lovin' Spoonful, the Youngbloods moved to San Francisco and went Top Five in 1969 with the dippy "Get Together," a snatch of which is parodied in Nirvana's "Territorial Pissings." Recorded decades before the hippies' children would return to haunt them, "Darkness, Darkness" is the Youngbloods' masterpiece, a full recognition of the shadow absent from the rest of their work, given a total authenticity by one of San Francisco's great guitar solos.

48 ELECTRIC SAILOR
Kak
Summer 1969

A real S.F. obscurity, Kak's only album disappeared as quickly as it came. If you dig deep, however, you'll find connections with the Oxford Circle and Blue Cheer, which makes sense. "Electric Sailor" has 1969's ponderousness, but the mood is playfully acid-fried. Their celebration of a hippy everykid, "with his coffee-colored T-shirt and striped bell pants," is bisected by a yattering, bending guitar solo that pushes through into another dimension. Like they say, "You've got to smile if you're from space."

49 MOUNTAINS OF THE MOON
The Grateful Dead
June 1969

Even more so than "Dark Star," which is full of life and movement, this is the Dead at their moment of fullest outreach. Trapped within their palindrome, the band barely stirred throughout *Aoxomoxoa*: "Mountains of the Moon" is all harpsichord and celestial harmonies, harnessing this wasted entropy to a science-fiction scenario of weightlessness and mythical heroism worthy of Philip K. Dick. From here on in, the rest was a slow retreat.

50 THE STAR-SPANGLED BANNER
Jimi Hendrix
Recorded: August 18, 1969

A blast of reality from a collective delusion. Playing to a half-asleep audience, in his blackest, most American phase, Hendrix redrew the psychic map of his own country with a solo that has everything and nothing: the rage of the black American Indian, the hallucinatory terror of the Vietnam War, the end of the hippie dream at the very moment when it seemed to have won.

❊ PSYCHEDELIA U.K. ❊

1 TOMORROW NEVER KNOWS
The Beatles
Recorded: April 1966

"Tomorrow Never Knows" takes you right into the maelstrom: shamanistic drums compressed and limited to the max; guitars fuzzed and played backwards; tape loops from five different sources all topped by John Lennon's mutated voice, artificially double-tracked, then fed through a whirling Leslie speaker so that he'd sound "like the Dalai Lama singing from the highest mountaintop." The final cut on a #1 album in the U.S. and U.K., it immediately impacted on pop culture.

2 PAINT IT, BLACK
The Rolling Stones
May 1966

The first million-selling single (#1 U.S. and U.K.) to open up the ethnic sonorities of what would become psychedelia. Typical for the Rolling Stones in this careening, nihilistic phase, "Paint It, Black" is a total downer: "I wanna see the sun blotted out from the sky." Psychotic overtones were provided by Near Eastern humming, inward-looking lyrics and the internationally televised sight of Brian Jones, crosslegged and priestly, playing the sitar.

3 MAKING TIME
Creation
July 1966

Built around massive R&B bass riffs and heavy, slashing Who-inspired chords, this stomper falls right on the Mod/psych cusp. Best known for the wild break, where guitarist Eddie Phillips sends the harmonics flying with a violin bow (a device later popularized by Jimmy Page), "Making Time" explodes with frustration: "Makes you sick!" they sneer, and you remember that, yes, the Sex Pistols played Creation songs early on.

4 SEASON OF THE WITCH
Donovan
August 1966

A masterpiece of controlled menace, "Season of the Witch" captures the nascent psychedelic culture with its follies ("Beatniks out to make it rich"), possibilities ("When I look in my window, so many different people to be") and paranoia, always returning to the ominous refrain, "You've got to pick up every stitch," which states an essential acid fact: LSD was not an escape but a reckoning.

5 HAPPENINGS TEN YEARS TIME AGO
The Yardbirds
November 1966

When asked what they were about in summer 1966, the Yardbirds replied, "Images in sound," a claim they'd soon back up with this, their finest moment. Lyrically, "Happenings" is the standard mixed-up confusion, but the song cracks open in the break, where Jeff Beck and Jimmy Page convert their ego battles into sensory overload: sirens, low-flying jets, seismic disturbance.

6 I FEEL FREE
Cream
December 1966

Beginning with a cappella vocals, "I Feel Free" explodes into life with an electric Clapton guitar figure, and then they're off: fast high-hat drumming, repeated high-register piano notes, a succinct Clapton solo and a hyperventilating Jack Bruce vocal. Psych lyrics: "I can drive down the road and my eyes don't see/Though my mind wants to cry out loud/ Though my mind wants to cry out loud."

7 STRAWBERRY FIELDS FOREVER
The Beatles
February 1967

When this first came on radio in early 1967, it sounded like nothing else, with its

wracked vocal, out- of-tune brass section and queasy strings. There was a good reason: The final "Strawberry Fields" edited together two quite distinct versions. Despite the fact that they were in different tempos and different keys, the intimate original was sped up and the heavily scored manic second version slowed down, giving a disoriented sheen to Lennon's trip back into his tortured childhood and orphaned adolescence.

8 INTERSTELLAR OVERDRIVE
Pink Floyd
Recorded: February 1967

This 16'46" interplanetary voyage is the finest extant example of Syd Barrett's improvisation: intuitive, free of longueurs, surprisingly delicate. As Chris Cutler writes in *File Under: Pop*: "Barrett took the guitar into a new realm; he introduced a whole range of new techniques but, most important, an inspired and risky approach to performance. He unlocked the electric guitar to a degree beyond anything that had come out of rock until that time."

9 MY FRIEND JACK
Smoke
February 1967

Early U.K. psych-exploitation. "My Friend Jack" begins with a total reverb OD before making its statement of intent in the first line: "My friend Jack eats sugar lumps." Points are awarded for the effete vocals and mystical lyrics, but everything comes down to the reverb, which slashes and shimmers throughout.

10 GREEN CIRCLES
The Small Faces
Recorded: spring 1967

"Green Circles" was the Small Faces' first major psych-out, a gentle tune that is dominated by high-register tack piano and mystical lyrics — "And with the rain/The stranger came/His eyes were filled with love" — before the final rave-up, where the sound is squeezed by a primitive form of stereo panning. "Circles" seems to have been the most popular English metaphor for LSD disorientation during 1966 and 1967.

11 DAYS OF PEARLY SPENCER
David McWilliams
Spring 1967

A heavily produced folk-rock song, "Days of Pearly Spencer" couldn't have been made in any other year. It's something to do with the strings that swirl into the chorus with McWilliams' compressed voice, and the detailed yet distanced underdog lyrics: "Iron trees smother the air/Withering they stand and stare/Through eyes that neither know nor care/Where the grass has gone."

12 IN YOUR TOWER
The Poets
March 1967

Glasgow's finest, the Poets were on a dying curve when they cut this storming 45 in early 1967. Built around a flute riff and distorted raga (i.e. detuned) guitar, "In Your Tower" is total fairy-tale medievalism and a fabulous document of how LSD impacted on the styles of the time, although I blame the Rolling Stones and "Lady Jane" myself.

13 I CAN HEAR THE GRASS GROW
The Move
April 1967

A big U.K. hit, "I Can Hear the Grass Grow" has everything: a killer riff, the usual complex Move production, percussive "yip yip" background vocals, Beach Boys harmonies, weird electronic alarm noises and mind-melting lyrics: "My head's attracted to a magnetic wave of sound/With the streams of colored circles making their way around." In the final verse, some acid one-upmanship: "If you can't smell what you've found/Then I know that you're not my kind."

14 ARE YOU EXPERIENCED?
The Jimi Hendrix Experience
May 1967

Opening with backwards beats that leap forward sixteen years to the scratches of hip-hop, "Are You Experienced?" moves through a basic come-on to something much sweeter and infinitely cosmic: "Trumpets and violins I can hear in the distance/I think they're calling our names/Maybe now you can't hear them, but you will (ha ha)/If you just take hold of my hand." A great anthem, pinned to the back of your brain by martial drums, repeated high piano notes and the definitive backwards guitar solo.

15 NIGHT OF THE LONG GRASS
The Troggs
May 1967

Coming off four caveman Top Ten hits —

the U.K. equivalent of U.S. punk — the Troggs dipped with the formulaic "Give It to Me." Their next 45, "Night of the Long Grass," brilliantly adapted their two-chord trick to the new era. Wind noises segue into high female harmonies and whispered choruses of evanescent desire and loss. Major psych move: "With lips apart I thought that you were going to call my name/Instead the kiss that followed was enough to melt my brain."

16 PAPER SUN
Traffic
May 1967

The first 45 by Steve Winwood's second group, "Paper Sun" went #5 U.K. in early summer 1967. The P.R. about Traffic was that they went to get their heads together in the countryside (among the "Berkshire Poppies"), and

"Paper Sun," with its sinuous sitar, buzzing saxophone and Swinging London burnout lyric, has the expected looseness stiffened by a bitter, bleak undertow that stays on the tongue long after the period trappings have faded.

17 MIDSUMMER NIGHT'S SCENE
John's Children
Summer 1967

"There's a face disfigured with love": a real oddity from a group that epitomized the Brit pop tendency to foppish violence. This 45 was scheduled as the follow-up to the banned Marc Bolan song, "Desdemona," and stakes out its currency with the repeated phrase "petals and flowers." This idiot mantra recurs through a string-breaking, freak-out solo, before Bolan crashes in with a vocal that tears the song to shreds — his final act with the group.

18 IT'S ALL TOO MUCH
The Beatles
Recorded: May/June 1967

An unusually sloppy Beatles recording, with an unnamed curse and overamped guitar leading into mad brass and handclaps so luscious that they sound like the chewing of a thousand cows. The George Harrison lyrics are the usual domesticated U.K. acid fare: "Show me that I'm everywhere then get me home for tea"— but all that is subsumed within aural pleasure as the Beatles relax into the first of their long fades, a few baroque flourishes, a snatch of the Merseys' "Sorrow," then everything merges into the acid haze.

19 — COLOURS OF MY MIND
The Attack
June 1967

More detuned raga guitar and raging male hormones cloaked by pseudoprofound lyrics: "My eyes are green and yellow because they're the roving kind." The Attack span the journey between the basic punk/R&B and prog rock that bookend this period. "Colours of My Mind" comes from that moment when groups tried to have hits with lyrics like "Living is a habit thrust upon mankind." Nevertheless, they rock.

20 — ITCHYCOO PARK
The Small Faces
August 1967

One of the few U.K. psych records to make the U.S. Top Twenty, "Itchycoo Park" is a surprisingly simple production, making the most of acoustic guitar, Hammond organ and Steve Marriott's white-soul voice. The sentiments could easily curdle — "I feel inclined to blow my mind" — but are given total authority by a gorgeous melody and phased cymbals that take the roof off your head, so that by the time Marriott yells "It's all too beautiful" at the song's fade, you've believed him.

21 — THE STARS THAT PLAY WITH LAUGHING SAM'S DICE
The Jimi Hendrix Experience
August 1967

Tucked away on the flip of Hendrix's fourth single, "Burning of the Midnight Lamp," was this demented aural simulation of LSD's stronger cousin STP. A quick wah-wah liftoff, then let MC Jimi be your guide: "The Milky Way express is floating. All aboard! I promise each and every one of you won't be bored . . . Oh, I'd like to say there will be no throwing cigarette butts out the window . . . Thank you . . . Now to the right you'll see Saturn. Outassight. And if you look to the left you'll see Mars . . ."

22 — MATILDA MOTHER
Pink Floyd
August 1967

"Matilda Mother" is a perfect evocation of childhood wonder, sung by a child to his mother as she reads him stories at bedtime. The verse carries the written fairy tale, "A thousand misty riders climb/Up high, once upon a time," alternating with the child's point of view in the chorus: "Why d'you have to leave me there/Hanging there in my infant air, waiting!" In retrospect, such empathy masked real disturbance, but how could anyone know that heady, first-time summer?

23 — WE LOVE YOU
The Rolling Stones
August 1967

The song of the *cause célèbre*. A few days after their July 31 release on appeal, Mick Jagger and Keith Richards went in with the other Rolling Stones and two Beatles —Lennon and McCartney— to record this glorious "fuck you" masquerading as a Summer of Love anthem. "We Love You" sounded fabulous on the radio in high summer of '67 with its monster piano riff and Mellotron arabesques hanging in the air. It was only later that you noticed the heavy walking of the prison warden at the song's start or the sarcastic hostility of the lyrics.

24 — RELAX
The Who
Recorded: August 1967

Despite their single in support of Jagger and Richards, despite their appearance at Monterey, the Who hardly embraced the new era: Their big hit from this period, "I Can See for Miles," is a furious explosion. Buried deep within their hymn to pirate radio and pop commerce, "Relax" is one of the Who's sweetest songs, a trip guide enhanced by a golden, droning feedback glow: "Settle your affairs and take your time/'cos everything in the world is yours and mine."

25 — FLIGHT FROM ASHIYA
Kaleidoscope
September 1967

Another take on the flight motif, pop made as only the Brits knew how: a folkish tune, thrumming bass line, fey vocals, romantic sadness. London's Kaleidoscope master the basic requirements of the time — the emphasized word "high," the visions of childhood, the high (spaceship) concept— but make them their own with a curious, quavering chorus that carries a hint of psychedelia's end, far from anywhere that you could call home: "Nobody knows where we are."

26 — DEFECTING GREY
The Pretty Things
Autumn 1967

An album's worth of ideas compressed in one side of a single, "Defecting Grey" moves through several stages: a pulsing, bass-heavy intro; sitar-dominated verses ("sitting alone on a bench with you"); raveup choruses with heavy rock guitar; a lyrical middle eight bars; a music-hall finale; and a wistful psych-out fade. Even with all this, the Pretty Things didn't get the girl, a far cry from their days as R&B Neanderthals.

27 — FROM THE UNDERWORLD
The Herd
September 1967

The story of Orpheus and Eurydice faithfully rewritten for the teen market and goosed up with a classic 1967 overproduction: funeral bells, thundering brass, high-register piano, fuzz guitar and that awful Rickenbacker bass you heard everywhere that year. Mythological kitsch of the highest order: "What was the sudden will to destroy the love and the joy?"

28 — MICHAEL ANGELO
The 23rd Turnoff
September 1967

The Turnoff were named after the Liverpool exit on the M6 highway, Junction 23. This melancholic celebration of the Renaissance artist was underscored by phased strings, "Penny Lane" trumpets and Jimmy Campbell's Scouse vocals. Like many other long-lost groups, the Turnoff wrote their own script: "How can it be that a man such as me/Who cares not for money and fame/Shouldn't be rich with God's natural gifts/To have something to show at the end of life's game."

29 — KING MIDAS IN REVERSE
The Hollies
October 1967

Manchester's finest, the Hollies hadn't ignored the trend toward odd noises and inventive story lines, but hits like "Stop Stop Stop" kept the weirdness firmly within the everyday. "King Midas in Reverse" was their Summer of Love move into biblical allusion, with full orchestration, slurred exotic vocals and gratifyingly pretentious lyrics. The idea, of course, was that our hero turns everything not into gold but into dust: "I'll break you and destroy you given time."

30 DREAM MAGAZINE
Svensk
Autumn 1967

Svensk run the Who's "Pictures of Lily" concept — boy falls in love with image of woman, is devastated when he realizes that it's not real — into unhealthy obsession: "Saw her picture in a dream magazine/Sweetest girl I've ever seen/In wide angle she's so fine/In telephoto she is mine." The domination of the thundering church organ shows the immediate influence of the U.K. Summer of Love hit, Procol Harum's "A Whiter Shade of Pale."

31 IMPOSTERS OF LIFE'S MAGAZINE
The Idle Race
October 1967

Before late-period ELO, Jeff Lynne had five years of making great records with the Move, early ELO and the Idle Race. "Imposters" is their first 45, a compressed production typical of the period, with storming riffs, sped up wah-wah guitars, strings and the rest. What begins in media, however, ends in acid riddles: "Touch your friend's girl. Will he mind?/Will his mind will it? Will your friends think?/In their thoughts they're with you/Are they?"

32 SAN FRANCISCAN NIGHTS
Eric Burdon and the Animals
October 1967

"San Franciscan Nights" was the most effective of all the records that exploited Haight-Ashbury that summer with its sweet melody and evocative lyrics, part of the folk memory of 1967. It debuted at Monterey in June and was a U.K. Top Ten by November, by which time this beatific vision of Haight-Ashbury was already in the past.

33 LOVE IS ALL AROUND
The Troggs
October 1967

Continuing the journey they'd begun with "Night of the Long Grass," the Troggs scored with this Summer of Love anthem disguised as a romantic ballad. Underpinned by cellos and violins, Reg Presley makes fidelity sound like LSD liftoff: "I feel it in my fingers/I feel it in my toes/Love is all around me/And so the feeling grows." As the strings blend with the ether at the fade, Presley waxes wistfully cosmic. Their last big hit (#5 U.K.; #7 U.S.), and a fitting epitaph.

34 VACUUM CLEANER
Tintern Abbey
November 1967

Tintern Abbey, fashionably named after Arthurian legend, made this one defining 45. A simple yet ambient production, "Vacuum Cleaner" is driven by flashing cymbals and David MacTavish's awe-struck voice. The lyrics celebrate a surrender made physical by the droning, feedbacked guitar break: "Fix me up with your sweet dose/Now I'm feeling like a ghost." The group disappeared into thin air, leaving behind this perfect testament.

35 MADMAN RUNNING THROUGH THE FIELDS
Dantalian's Chariot
Autumn 1967

All the hard-drinking loons from the mid-'60s club scene fell like ninepins to acid and none harder than Zoot Money, who folded his Big Roll Band and got seriously psyched with a mythological name and this complex 45 dominated by backwards cymbals and high-pitched drone. R. D. Laing move: "If reason's gone/How do I live on?/Because I know/Which way I must go." Note also the guitar on the great spacey fade, thanks to future Policeman Andy Summers.

36 KITES
Simon Dupree and the Big Sound
November 1967

A Top Ten U.K. hit in December 1967, "Kites" is pure exotic kitsch, a straightforward love ballad embellished with the trappings of the time: gongs, woodblocks, wind sounds, flight metaphors, a Chinese rap and, dominating throughout, the Mellotron. Simon Dupree and the Big Sound affected to despise this atmospheric performance. Just shows how much rock groups know, as it was by far the best thing they ever did.

37 I AM THE WALRUS
The Beatles
November 1967

In late '67 "I Am the Walrus" sounded like nothing on Earth, all bizarre effects and gobbledegook lyrics. Beginning with the two notes of a police siren, "I Am the Walrus" is another classic Beatles overproduction, featuring violins, cellos and horns, the sixteen-strong Mike Sammes Singers — who whoop and mutter nightmarish

backing vocals — and the infamous sweep across the Medium Wave on the fade. All this only serves to cloak a reversion into primal, psychosexual muck — as Lennon repeats throughout: "I'm crying."

38 REVOLUTION
Tomorrow
December 1967

Another LP compressed onto a 45, "Revolution" is the second single from one of '67's big hypes. Tomorrow featured future Pretty Thing John "Twink" Adler, future Yes guitarist Steve Howe and Keith West, whose autumn solo hit, "Excerpt from a Teenage Opera," stalled the group. "Revolution" is absurdly committed to the flower-child ethic, paranoid and gloriously overproduced. This being England, however, revolution was more ameliorist than in the U.S. Tomorrow's program? Simple: "All we want is peace to blow our minds."

39 IT'S ALRIGHT MA, IT'S ONLY WITCHCRAFT
Fairport Convention
Early 1968

"It's Alright Ma" begins with a manifesto: "Looking through the window to see which way the wind blows/It seems as though a hurricane is due today/Sunny on the outside, stormy on the inside/Stormy weather's best for making hay." A jazzy shuffle breaks into a boogie, then the group explodes like they've been let out of a cage, with soaring harmonies and acid guitar from Richard Thompson. The source of this freedom? The sound that he found on the 'Frisco way.

40 PICTURES OF MATCHSTICK MEN
Status Quo
January 1968

Driven by a monster moronic riff, phased and wah-wahed to slice out of your transistor, "Pictures" carries its obsessive nonsense with a certain good humor: "When I look up to the sky/I see your eyes, a funny kind of yellow." Top Ten U.K. in February, it occasioned classic TV appearances with the Quo in full 1968 regalia: paisley tunics, frills, center hair partings

and the astonished grins of five people who couldn't believe their luck.

41 THE OTHERSIDE
The Apple
Early 1968

Another shamanistic gem from two unlikely sources: produced by future Elton John guitarist Caleb Quaye, released by Kinks/Troggs manager Larry Page. This mournful message from the underworld is the Apple's moment: "If you see me and I'm coming from the otherside/Don't be sad because I'll be going with the rising tide/The seeds are sown, the soil has blown my love so far away/To a land where spirits climb halfway to the sky."

42 FASTER THAN LIGHT
The Mirror
May 1968

Some late acid omnipotence from this Bath group, who appeared nude in their publicity photos. The flip of their only single, "Faster Than Light" is the sort of record that might have got wider exposure if the pirate radio stations had still been broadcasting: mod pop with an acid sheen, bisected by a transistor-friendly, totally phased drum break that lived up to the title's promise.

43 RAINBOW CHASER
Nirvana
May 1968

Another celebration of the shaman who "travels on a cloud," backed by a phased orchestra that rips through the speakers like a jet fighter: "Many miles to go/How many bridges do we cross?/Winter rain and snow/Over mountains high and low." Nirvana had a great streak of elaborate pop-psych 45s in 1967–68. "Rainbow Chaser" was the third and their only Top Forty hit. It epitomizes the freedom that the Seattle group of the same name would half-mock, half-ache for twenty-five years later.

44 COLD TURKEY
Big Boy Pete
May 1968

The Plastic Ono Band 45, this is a total one-of-a-kind. Set to a vicious, off-kilter Stax beat, peppered with electronic whirrings and alarms, "Cold Turkey" expands on the drug-equals-love addiction theme with total panache, before being brought to a close by a fuzz explosion that makes everything else pretty redundant.

45 ME MY FRIEND
Family
June 1968

More acid omnipotence from Leicester's finest and another kitchen-sink production (trumpets, Mellotron, stereo panning, phasing), this time by Traffic's Dave Mason. Some great vocals from Roger Chapman, some suitably fried lyrics — "Me my friend/I have seen many lands, me my friend/I have been far and wide/I have sailed many a tide/I have rode many a ride" — all adding to a precious classic. The first single from one of the period's most enduring albums, *Music in a Doll's House*.

46 JUGBAND BLUES
Pink Floyd
September 1968

Possibly the bleakest record ever made, as Syd Barrett withdraws from the group that he created and which was no longer his: "It's awfully considerate of you to think of me here/And I'm most obliged to you for making it clear that I'm not here." The song slowly lurches into a Salvation Army band break and a final, shimmering space exploration, before Barrett returns, as if from another song, intoning over an acoustic guitar his judgment on the era whose style he defined: "And what exactly is a dream?/And what exactly is a joke?"

47 FIRE
The Crazy World of Arthur Brown
September 1968

Driven by Vincent Crane's monster organ riff, "Fire" can now sound ludicrous, if only because it was the first to mine the fertile seam of English Gothic. It wasn't so at the time. The charismatic Arthur Brown — with flaming headdress — would shriek and twist in a truly

chilling, demonic performance that burned the song's curses into your brain: "Fire; to destroy all that you've done." A harbinger of riot and disturbance and a massive hit (#1 U.K.; #2 U.S.) in that season of the Chicago Democratic convention.

48 1983 ... (A MERMAN I SHOULD TURN TO BE) MOON, TURN THE TIDES ... GENTLY GENTLY AWAY
The Jimi Hendrix Experience
October 1968

At 14'38", Hendrix's fullest journey into the underworld. The story line is simple: facing Armageddon, Hendrix decides to return with his girlfriend to the sea, the source of all life. By the time we get to "Moon, Turn the Tides," we're in the underwater currents. As Harry Shapiro writes: "At one point the tapes are slowed down and then speeded up again to represent a shoal of fish swimming up to investigate these strange beings that have joined their world. Their curiosity satisfied, they swim away." Mixed in one complete take in an eighteen-hour session.

49 DIAMOND HARD BLUE APPLES OF THE MOON
The Nice
November 1968

Flip the Nice's kitsch version of Leonard Bernstein's "America" and you get this soul-inflected pop/psych gem, which begins and ends with electronic noises that Hendrix wouldn't have been ashamed of. In between you get some delightful, Mellotron-drenched nonsense — about circles, heroes, black cats and, yes, the diamond hard blue apples of the moon — that a year before might have been unremarkable but that in mid-1968 sounded like the penultimate gasp of an endangered species.

50 CAN'T FIND MY WAY HOME
Blind Faith
August 1969

Blind Faith were the first official U.K. super-group, pulling in Eric Clapton and Ginger Baker from Cream, Rick Grech from Family and Steve Winwood from Traffic. Buried in the hype was this lament for a time past, sung by a Winwood adrift on stormy seas: "I'm wasted and I can't find my way home." This isn't an exercise to fill out an album, it's a matter of life and death, an intensity which makes you realize how much the last few years had meant and how much had already been lost.

THE IDEA OF DOING AN EXHIBIT ABOUT THE PSYCHEDELIC ERA first came up during a curatorial meeting in the fall of 1995, shortly after the Rock and Roll Hall of Fame and Museum opened its doors. Jann Wenner, the editor and publisher of Rolling Stone and vice-chairman of the Rock and Roll Hall of Fame, suggested the subject, and Bob Santelli, the Museum's director of education, pointed out that the timing would be ideal — 1997 would be the thirtieth anniversary of the Summer of Love.

Several discussions followed that meeting and in early 1996, I made some preliminary trips to London and San Francisco to investigate the possibility of mounting such an exhibit. During those trips, I received valuable input from numerous people associated with the era. In London, Peter and Sumi Jenner, Joe Boyd, Barry Miles, Mat Snow, Barney Hoskyns, Jon Savage, John Hopkins, Jeff Dexter, Jonathon Green and David Mellor were all helpful. In San Francisco, Joel Selvin, Bonnie Simmons, Chet Helms, Victor Moscoso, Phil Cushway, the staff at Bill Graham Presents, Jerry Abrams, Paul Grushkin, Eric King and Dennis King provided advice, information and assistance.

Paul Kantner, Jorma Kaukonen, Vanessa Lillian, Bill Thompson, Jack Casady, Steve O'Rourke and others took time to meet with me during the 1996 Hall of Fame induction ceremony in New York City, during which both the Jefferson Airplane and Pink Floyd were inducted. Cameron Sears, the manager of the Grateful Dead, and Hal Kant, the group's lawyer, also took time out of their schedules to come to Cleveland to visit the Museum and talk about the project.

In July, a two-day conference was held in Cleveland. Country Joe McDonald, Sarah Lazin, Abe Peck, Chet Helms, Victor Moscoso, Peter and Sumi Jenner, Charles Perry, Jon Savage, Joel Selvin and Craig Inciardi all flew to Cleveland to help develop the blueprint for the exhibition.

It was always our goal to publish a book in conjunction with the exhibit, and a core team developed to carry out that mission. Sarah Lazin, a former colleague of mine at Rolling Stone, agreed to produce the book. Julie Claire Derscheid came aboard as photo editor. Charles Perry, another Rolling Stone alumnus, agreed to write about San Francisco; Barry Miles agreed to write about London. Jon Savage provided the list of 100 top psychedelic records and also helped with photo contacts in the U.K. Parke Puterbaugh, yet another former Rolling Stone colleague, agreed to help edit the book, write the time line and conduct interviews with various musicians and other key figures of the era. Alexander Isley and Kim Okosky created the book's design in record time. This book would not have been possible without the hard work and long hours all of these people put into the project. In particular, Sarah, Parke and Julie deserve special thanks; they have been amazing to work with. And Tanala Osa-Yande, at Sarah Lazin Books, has gone far beyond her job description for everyone involved in the project.

In addition, the staff at the Hall of Fame has been very supportive. Bob Bosak, Bob Santelli, Craig Inciardi, Rachel Schmelzer, Nancy Parrish, Sharon Koller, Tali Bar-Ilan and Lisa Vinciquerra have been helpful throughout various stages of the project.

At Chronicle Books we would like to thank Jack Jensen, Kate Chynoweth and our editor, Jay Schaefer.

Several photographers also deserve a special nod. They were on the scene in the Sixties and have been very helpful to us, both by supplying photographs for this book, but also by providing information and insight: Jim Marshall, Herb Greene, Baron Wolman, Gene Anthony, Bob Seidemann, Lisa Law, Robert Whitaker, Graham Keen and Adam Ritchie.

Other people who deserve thanks include Jacaeber Castor, Jack Cassin, Antonia Cipollina, Bill Belmont, Holly George-Warren, Susan Richardson, Will Rigby, David Cohen, Susie Hudson, Johne Behner, Walter McNamara, Ellen Harmon, George Conger, Denise Sfraga, Jeffrey Wood and Carine Verheyen and the people at Design Photography in Cleveland. Also, extra special thanks to Mary Works for all her help and generosity.

A few people deserve more than a thank you. Jann Wenner has been a source of support and guidance to me for nearly 20 years. Thanks for everything, Jann. Erin Hogan has been my right hand at the Hall of Fame for nearly three years now; I don't know what I would do without her. Ileen Sheppard Gallagher, the Museum's director of exhibitions, has worked closely with me on all of the Museum's exhibitions, and together we make a great team. And Suzan Evans, the executive director of the Hall of Fame, and Bill Hulett, the Museum's CEO, have both been very supportive of this and other curatorial projects.

Finally, I would like to thank my sons, Arthur and Christopher. They are the one constant source of joy in my life.

JAMES HENKE

JAMES HENKE is the chief curator of the Rock and Roll Hall of Fame and Museum. A former music editor and writer at *Rolling Stone*, he is also the co-editor of *The Rolling Stone Album Guide* and *The Rolling Stone Illustrated History of Rock and Roll, Third Edition*.

PARKE PUTERBAUGH is a longtime writer and editor for *Rolling Stone* and several other music publications. He is also a curatorial consultant to the Rock and Roll Hall of Fame and Museum.

CHARLES PERRY is the author of *The Haight-Ashbury: A History*. A contributor to *Rolling Stone* since 1968, he is now on the staff of the *Los Angeles Times*.

BARRY MILES was a key figure in the London underground during the late Sixties, helping found the Indica Bookstore and Gallery, the London Free School and the *International Times*. He has written biographies of Allen Ginsberg and William Burroughs and is working on Paul McCartney's autobiography.

JON SAVAGE is a journalist and the author of several books about rock and roll, including *England's Dreaming: Anarchy, Sex Pistols, Punk Rock and Beyond*.

THE ROCK AND ROLL HALL OF FAME AND MUSEUM was founded in 1983 with the goal of recognizing the artists, composers, producers, disc jockeys and other people responsible for making rock & roll the most popular music of all time. In 1986, the Hall of Fame held its first annual induction ceremony. That same year, Cleveland was chosen as the site for the Rock and Roll Hall of Fame and Museum. Designed by I.M. Pei, the Museum opened to the public on September 1, 1995. Through the use of artifacts, films, interactive computers and photographs, the Museum examines the history of rock & roll, from its roots to the present. For membership information, call 1-800-349-ROCK.

"Street Fighting Man" by Mick Jagger/Keith Richards, ©1969 ABKCO Music Inc. "Woodstock" by Joni Mitchell, ©1970 Siquomb Publishing Co."Ballad of a Thin Man" by Bob Dylan, ©1965 Warner Brothers Inc./©1993 Special Rider Music. "For What It's Worth" by Stephen A. Stills, ©1966 Cotillion Music Inc./Richie Furay Music/Springalo Toones/Ten-East Music. "Blues From an Airplane" by Marty Balin/Alex "Skip" Spence, ©1967 After You Publishing Co. "Electricity" by Don Van Vliet/Bermann, ©1966 Kama Sutra Music. "Roller Coaster" by Tommy Hall/Roky Erickson, ©1966 Tapier Music Corp. "Feathered Fish" by Arthur Lee, ©1966 Grass Roots Music. "7 and 7 Is" by Arthur Lee, ©1966 Grass Roots Music. "The Crystal Ship" by The Doors, ©1967 Doors Music Company. "Mr. Farmer" by Sky Saxon, ©1967 Neil Music Inc. "I'm Five Years Ahead of My Time" by R. Evans/V. Pike, ©1967 Aldor Music/ Longitude Music Inc. "White Rabbit" by Grace Slick, ©1966 Irving Music Inc. "The Red Telephone" by Arthur Lee, ©1967 Trio Music Company. "Change Is Now" by Roger McGuinn/Chris Hillman, ©1967 Tro-Essex Music. "A Question of Temperature" by Michael Thomas Appel/Donald Henny/Edward Paul Schnug, ©1967 Raton Songs Inc. "Magic Carpet Ride" by John Kay/Rushton Moreve, ©1968 Duchess Music. "William" by Tom Caplan/David Struthers/Warren Woodrich, Jr., ©1969 Cotillion Music Inc./Celann Music Co. "Dream Within a Dream" by Jay Ferguson, ©1968 Irving Music Inc./Hollen Beck Music. "Electric Sailor" by Dehner C. Patten/Christopher A. Lockheed/Joseph D. Dannell/Gary L. Yoder, ©1969 Interkak Publishing/Ameba Music Co. "Paint It, Black" by Mick Jagger/Keith Richards, ©1966 Westminster/ABKCO. "Season of the Witch" by Donovan, ©1966 Donovan Ltd. "I Feel Free" by Pete Brown/John Bruce, ©1966 Unichappell-Stigwood Music Sp. "My Friend Jack" by the Smoke, ©1967 Morgan Music. "Green Circles" by Marriott/Lane/O'Sullivan, ©1967 Avakak Songs/ Immediate Music. "Days of Pearly Spencer" by David McWilliams, ©1967 Carlin Music Corp.

"I Can Hear the Grass Grow" by Roy Wood, ©1967 Essex Music. "Are You Experienced?" by Jimi Hendrix, ©1967 Yameta. "Night of the Long Grass" by Reg Presley, ©1967 Dick James Music. "Midsummer Night's Scene" by Marc Bolan, ©1967 Cromwell Music. "It's All Too Much" by George Harrison, ©1967 Northern Songs. "Colours of My Mind" by Shirman, ©1967 Contemporary Music. "Itchycoo Park" by Steve Marriott/Ronnie Lane, ©1967 Avakak/Immediate. "The Stars That Play With Laughing Sam's Dice" by Jimi Hendrix, ©1967 A. Schroeder. "Matilda Mother" by Syd Barrett, ©1967 Magdalene/Essex Music. "Relax" by Pete Townshend, ©1967 Fabulous Music. "Flight From Ashiya" by Peter James Daltrey/Edmund Pumer, ©1967 Flamingo Music. "Defecting Grey" by Phil May/Dick Taylor/Wally Waller, ©1967 Lupus Music. "From the Underworld" by Howard/Blaikley, ©1967 Lynn Music. "Michael Angelo" by Jimmy Campbell, ©1967 Copyright Control. "King Midas in Reverse" by Allan Clarke/Tony Hicks/Graham Nash, ©1967 Gralto Music. "Dream Magazine" by Hopkins/Paul, ©1967 Dick James Music. "Imposters of Life's Magazine" by Jeff Lynne, ©1967 Metric Music. "Love Is All Around" by Reg Presley, ©1967 Dick James Music. "Vacuum Cleaner" by David McTavish, ©1967 Mill Music. "Madman Running Through the Fields" by Dantalion's Chariot (Money/Somers), © 1967 Money Music. "I Am the Walrus" by John Lennon/Paul McCartney, ©1967 Northern Songs. "Revolution" by John Hopkins/Steve Howe, ©1968 Robbins Music. "It's Alright Ma, It's Only Witchcraft" by Ashley Hutchings/Richard Thompson, ©1968 Warlock Music. "Pictures of Matchstick Men" by Francis Rossi, ©1968 Valley Music. "The Otherside" by the Apple (C. Barber), ©1968 Dick James Publishing. "Rainbow Chaser" by Alex Spyropoulos/Patrick Campbell Lyons, ©1968 Blue Mountain Music. "Me My Friend" by John Whitney/Roger Chapman, ©1968 Dukeslodge. "Jugband Blues" by Syd Barrett, ©1968 Essex Music International. "Fire" by Arthur Brown, ©1968 Essex Music. "Can't Find My Way Home" by Steve Winwood, ©1969 Almo Music Ltd.

PHOTOGRAPHY CREDITS

(Endpapers) Baron Wolman; (half title) Gene Anthony; (copyright page) Herb Greene; (Page 12) Mary Works Collection; (15) Gene Anthony; (16) Pictorial Press; (17) Robert Whitaker; (18) Gene Anthony; (19) Gene Anthony; (20) UPI/Corbis-Bettmann; (21) Graham Keen; (22) Larry Keenan; (23) Larry Keenan; (26-27) John Kelly/ Camera Press/Retna; (28) Terry O'Neill/Camera Press/Retna; (29) Graham Keen; (31) Chuck Boyd/Flower Children Ltd.; (32) Erik Weber; (33) Jack Towle/Rusty "Professor Poster" Goldman Archive; (34) Gene Anthony; (36) The Selvin Collection; (37) Jacaeber Castor/Psychedelic Solution; (38) Graham Keen; (39) Robert Whitaker; (40) John Hopkins; (42) Ron Bevirt; (43) photograph from *The Further Inquiry* by Ken Kesey. © 1990 Ron Bevirt, used by permission of Viking Penguin, a division of Penguin Books USA, Inc.; (44) Paul Ryan/Michael Ochs Archives; (45) Paul Ryan/Michael Ochs Archives; (47) Julian Wasser; (48) ©Adam Ritchie; (49 both) Graham Keen; (50) Dick Barnatt/Redferns/Retna; (51) Graham Keen Archive; (54) © Nicholas Blonder; (55) Herb Greene; (56-57) Jim Marshall; (58) Irene Winsby Collection/Peter Anderson; (59) Graham Keen; (60) Graham Keen; (61) Strange Things; (62) Jim Marshall; (64) Gene Anthony; (65 top) Herb Greene; (65 bottom) Gene Anthony; (66) Gene Anthony; (68) Gene Anthony; (70-71) Gene Anthony; (72) ©Adam Ritchie; (73) Graham Keen; (75) Graham Keen; (78) Herb Greene; (80 top) Herb Greene; (80 bottom) Larry Keenan; (81) Herb Greene; (82-83) Gene Anthony; (84) ©Adam Ritchie; (85) Graham Keen; (86 left) ©Adam Ritchie; (86-87) ©Adam Ritchie; (88) Pictorial Press; (89) Pictorial Press; (90) Gene Anthony; (91) Gene Anthony; (92 both) Jim Marshall; (93) Jim Marshall; (94) Pictorial Press; (95) Baron Wolman; (96) Jim Marshall; (97) Herb Greene; (98) Gene Anthony; (100 all) Bob Seidemann; (102) Pictorial Press; (103) Robert Whitaker; (104) Karl Ferris/Pictorial Press; (105) Topham Picture Source/ Image Works; (110-111) ©Adam Ritchie; (112) Strange Things; (114-115) Pictorial Press; (116) Collection of Royal British Columbia Museum/ Manitoba Museum of Man and Nature; (117 left) Graham Keen; (117 right) Iain Macmillan/©1966 Yoko Ono; (118) Bob Campbell/San Francisco Chronicle; (119) Bill Brach; (120) Gene Anthony; (121) Gene Anthony; (122-123) ©1997 Lisa Law; (124) Gene Anthony; (126) Gene Anthony; (127) Gene Anthony; (128-129) Gene Anthony; (130) Pictorial Press; (131 top) London Features; (131 bottom) UPI/Topham/Image Works; (132) Frank Hermann/Camera Press/Retna; (133) ©Adam Ritchie; (135) Image Works; (136-137) John Drysdale/Camera Press/Globe Photos; (138 top) Baron Wolman; (138 bottom) Gene Anthony; (139 top) Baron Wolman; (139 bottom) Ralph J. Gleason Collection/Jazz Casual Productions, Inc.; (140) Michael Ochs Archives; (141) Alain Dister; (143 top) Baron Wolman; (143 bottom) Rusty "Professor Poster" Goldman; (144) Popperfoto/ Archive Photos; (145) ©Adam Ritchie; (146) Popperfoto/Archive Photos; (148) Michael Cooper Archive/Govinda Gallery; (149) Michael Cooper Archive/ Govinda Gallery; (150) Jim Marshall; (151 top) Paul Kagan; (151 bottom) Jim Marshall; (152) ©Jill Gibson/Michael Ochs Archives; (153) Paul Kagan; (154) Henry Diltz; (155 top) Bill Harvey/Elektra Records; (155 bottom) ©1997 Lisa Law; (156) Mike Frankel; (157) London Features; (158) Popperfoto/ Archive Photos; (159) Elliott Landy; (160) Richard Polak/Globe Photos; (161 top) Pictorial Press; (161 bottom) London Features; (162) Jim Marshall; (163) Jim Marshall; (164-165) Alain Dister; (166-167) Popperfoto/ Archive Photos; (168-169) Larry Keenan; (170) Gene Anthony; (171 top) Gene Anthony; (171 bottom) Baron Wolman; (172-173) Elliott Landy; (174) Gene Anthony; (175) Herb Greene; (176) Graham Keen; (177 top) Popperfoto/ Archive Photos; (177 bottom) UPI/Corbis-Bettmann; (178-179) Globe Photos; (180) Charles Gatewood/Image Works; (181) ©1997 Lisa Law; (182-183) Mike Austin/Globe Photos; (184) UPI/Corbis-Bettmann; (185) Bernie Boston; (186 both) ©1997 Lisa Law; (187 top) Mike Frankel; (187 bottom) Archive Photos; (188 top left) Jason Laure/Image Works; (188 bottom left) Henry Diltz/Image Works; (188-189) Jim Marshall; (208) Gene Anthony.

(Title page) Janis Joplin god's eye, gift of *Rolling Stone* magazine; (table of contents) Jimi Hendrix patchwork velvet jacket, gift of James Alan Hendrix, photograph by Tony Festa; (page 13) The Amazing Charlatans at the Red Dog Saloon, Virginia City, Nevada, June 1-15, 1965, design by George Hunter, Michael Ferguson, on deposit from Manny and Skippy Gerrard; (14) Wanted: The Charlatans at Sokol Hall, March 4, 1966, design by Alton Kelley, collection of Philip and Julie Cushway, Artrock; (24 top left) Timothy Leary *Turn On, Tune In, Drop Out,* collection of Scott Kuchta; (24 top right) *LSD: The Consciousness-Expanding Drug* (1966, G.P. Putnam's Sons), edited by David Solomon, introduction by Timothy Leary, collection of Jon Savage; (24 bottom right) Timothy Leary *L.S.D.,* collection of Scott Kuchta; (24 bottom left) Timothy Leary *This Time Around You Can Be Anyone,* collection of Scott Kutcha; (30) Indica letterhead, collection of Barry Miles; (30) brocade jacket, collection of Donovan Leitch, worn by the artist during the late Sixties; (33) The Grateful Dead, Family Dog #33, Avalon Ballroom, November 4 and November 5, 1966, design by Stanley Mouse, Alton Kelley (Mouse Studios), collection of Philip and Julie Cushway, Artrock; (37 top) A Tribute to Dr. Strange: Jefferson Airplane, the Charlatans, Family Dog, Longshoremen's Hall, October 16, 1965, design by Alton Kelley, collection of Jack Cassin; (37 bottom) Port Chicago Vigil Benefit: Country Joe and the Fish, Steve Miller Band, S.F. Mime Troupe, California Hall, Sunday, February 19, 1967, design by Stanley Mouse, on deposit from Manny and Skippy Gerrard; (41 top) Paul McCartney artwork for Indica wrapping paper, 1966, design by Paul McCartney, collection of Barry Miles; (41 bottom) *The Psychedelic Experience* by Timothy Leary, collection of James Henke; (45) *The Acid Test* album, collection of Scott Kuchta; (46) The Acid Test poster, 1965, design by Norman Hartweg, on deposit from Manny and Skippy Gerrard; (51) London Free School flier, March 1966, collection of Barry Miles; (52-53) *International Times* # 30 May 3, 1968, collection of Barry Miles; (54) From the Plains of Quicksilver: QMS, Miller Blues Band, Family Dog #53, Avalon Ballroom, March 22 and March 23, 1967, design by Victor Moscoso, collection of Philip and Julie Cushway, Artrock; (59) Pink Floyd/ Jimi Hendrix Experience/The Move program, collection of Peter and Sumi Jenner; (63) Big Brother and the Holding Company, Selland Arena, Fresno, gift of *Rolling Stone* magazine, photograph by Tony Festa; (67) Acid Test Graduation: Grateful Dead, Merry Pranksters, Winterland, October 31, 1966, design by Gut, collection of Jack Cassin; (69 left) Trips: Grateful Dead, the Loading Zone, Longshoremen's Hall, April 22-April 24, 1966, collection of Jack Cassin; (69 right) "One Wild Night" (Trips festival review), by Ralph J. Gleason, collection of Peter S. Albin; (74 left) *International Times* concert flier (Pink Floyd, Soft Machine), collection of Peter and Sumi Jenner; (74 right) ticket to Roundhouse Chalk Farm, collection of Peter and Sumi Jenner; (76) "You Can Get It Here" in-store flier, collection of Barry Miles; (77) *International Times* #43, November 1, 1968, collection of Barry Miles; (79) Haight-Ashbury Loves You, design by Joseph Gomez, 1967, collection of Jack Cassin; (91) Bill Graham Dance Permit, gift of Bill Graham Presents; (93 top right) The Chambers Brothers, Matrix, March 28 and 30, 1967, design by Victor Moscoso, Neon Rose #12, on deposit from Manny and Skippy Gerrard; (93 left) The Matrix Menu (inside), collection of Jack Cassin; (101 top left) Grateful Dead, Family Dog #26, Avalon Ballroom, September 16-17, 1966, design by Stanley Mouse, Alton Kelley, gift of Philip and Julie Cushway, Artrock, photograph by Tony Festa; (101 top right) Jimi Hendrix Experience, John Mayall, ©1968 Bill Graham #105, Fillmore/Winterland, design by Rick Griffin, gift of Philip and Julie Cushway, Artrock, photograph by Tony Festa; (101 bottom left) The Sound: Jefferson Airplane, Muddy Waters, Butterfield Blues Band, Bill Graham #29, Winterland, September 23, 24, 30, October 1, 1966, Fillmore Auditorium, September 25, October 2, 1966, design by Wes Wilson, collection of Philip and Julie Cushway, Artrock; (101 bottom right) Blue Cheer, Lee Michaels, Family Dog #86, Avalon Ballroom, October 6-8, 1967, design by Victor Moscoso, collection of Philip and Julie Cushway, Artrock; (106) Jimi Hendrix poster, design by Martin Sharp, gift of Philip and Julie Cushway, Artrock; (107) Pink Floyd (Giant/UFO), July 28, collection of Philip and Julie Cushway, Artrock; (108) Pink Floyd, Cream poster UFO Club, July 14, collection of Philip

and Julie Cushway, Artrock; (109) *Oz* with Dylan on cover, collection of Peter and Sumi Jenner; (113 left) 14-Hour Technicolour Dream flier, 1967, collection of Barry Miles; (113 top right) "Games for May" handbill, Queen Elizabeth Hall, May 12, 1967, collection of Peter and Sumi Jenner; (113 bottom right) "See Emily Play" by Pink Floyd, commercial sheet music, 1967, collection of Peter and Sumi Jenner; (116 top) 14-Hour Technicolour Dream ticket, 1967, collection of Barry Miles; (120 top) Digger Dollar, collection of Jack Cassin; (125) Pow-Wow: A Gathering of the Tribes for a Human Be-In, three fliers, design by Stanley Mouse, Alton Kelley, Michael Bowen, Casey Sonnabend, collection of Jack Cassin; (131 bottom left) The Beatles, *Sgt. Pepper's Lonely Hearts Club Band,* collection of Jon Savage; (131 top left) The Beatles, *Sgt. Pepper's Lonely Hearts Club Band* insert, collection of Jon Savage; (133) *The Fool* by the Fool, collection of Jon Savage; (134) Granny Takes a Trip jacket, collection of Jim Capaldi; (135 top left) Granny Takes a Trip card, collection of Barry Miles; (135 top right) Granny Takes a Trip jacket, collection of Steve Howe; (140 top right) Bill Haley, the Drifters, the Flaming Groovies, Family Dog #133, Avalon Ballroom, August 16-18, 1968, design by Wainwright-Hunter, Museum collection; (142) *Rolling Stone* Vol. 1, No. 1 November 9, 1967, Museum collection; (143 top right) S. Clay Wilson comic book, gift of *Rolling Stone* magazine; (147) Times SOMA advertisement for legalization of marijuana, collection of Barry Miles; (154) Kaleidoscope posters, design by Kaleidoscope Graphics, left: Jefferson Airplane, Canned Heat, collection of Julie Cushway, Artrock Buffalo Springfield, right: Grateful Dead, Jefferson Airplane, Canned Heat, printed with permission of John Hartmann, collection of Philip and Julie Cushway, Artrock; (158) lyric draft to "Purple Haze" by Jimi Hendrix, 1966, gift of the Rock and Roll Hall of Fame Foundation, photograph by Tony Festa; (166 top left) Hippie Funeral Notice, October 6, 1967 Buena Vista Park, collection of Jack Cassin; (181) Save Our Soldiers: Join the Peace Brigades, November 5, collection of Jack Cassin; (186) Woodstock poster, design by Arnold Skolnick, gift of Philip and Julie Cushway, Artrock (202) Peter Albin bass, collection of Peter Albin, photograph by Tony Festa.

All artifact photographs unless noted otherwise are by Design Photography, Cleveland, Ohio. All Avalon posters © 1967 Family Dog Productions. Family Dog is the dba of Chester Helms, 771 Bush St., San Francisco, Ca. 94108. Neon Rose poster ©1967 Neon Rose. Neon Rose is a dba of Victor Moscoso.

Album covers pictured in the timeline and in Jon Savage's "Psychedelic 100" are from Strange Things and the collections of Scott Kutcha, Jon Savage, Joel Selvin and James Henke.

Artifacts pictured in the timeline are from the collections of Jack Cassin; Philip and Julie Cushway, Artrock; Peter Howard/ICE; George Hunter, Jon Savage; and on deposit from Manny and Skippy Gerrard.

"THE PSYCHEDELIC 100" by Jon Savage was originally published in a slightly different form as a supplement to *Mojo*, The Music Magazine, issue #6, May 1994. © Jon Savage.

A

Abrams, Steve, 148
Acid Tests, 42, 43, 45, 66–69
Adler, John "Twink," 88, 89, 146
After Bathing at Baxter's, 10, 57
"Alabama Bound," 190
Albert Hall, 16, 17, 18, 50, 72
Albin, Peter, 62, 94
Alexandra Palace (Ally Pally), 112, 116
Allen, Daevid, 74
Amen Corner, 59
AMM, 48, 51
Animals, The, 156, 198
"Anxious Color," 193
Apple, The, 199
Apple Boutique, 131, 133
Are You Experienced? (album), 158
"Are You Experienced?" (song), 196
"Are You Gonna Be There?," 193
"Arnold Layne," 58, 113
Arthur, Gavin, 124
Arts Lab, 158–59
Asher, Jane, 38, 104
Asher, Peter, 21, 28, 30, 38
Aspinall, Neil, 133
Astley, Karen, 89
Attack, The, 197
Avalon Ballroom, 33, 54, 62, 91–94, 96, 98, 140, 181
Ayers, Kevin, 73, 74

B

Baez, Joan, 176
Bag O'Nails, 158
Baker, Ginger, 104
Balin, Marty, 57, 93
"Ball and Chain," 193
Balloon Farm, 193
Barrett, Syd, 58, 59, 60, 112, 113, 116, 130
Battered Ornaments, 176
Beach Boys, 192
Beatles, The, 14, 22, 29, 38, 40, 41, 54, 65, 80, 103, 104, 107, 109, 130, 131, 133, 146, 148, 152, 155, 161, 195–96, 198
Beau Brummels, 193
Berg, Peter, 118
Berke, Joe, 76
Berkeley Barb, 32
Better Books, 17, 18
Bevan, Bev, 85
Big Boy Pete, 199
Big Brother and the Holding Company, 36, 62, 68, 94, 95, 118, 175, 193
Binder, Douglas, 109
Blarney club, 75, 85
Blind Faith, 199
Blue Cheer, 101
Blonde on Blonde, 22, 80
"Blues from an Airplane," 191
Bond, Graham, 50, 112
Bottoms, 117
Boyd, Jenny, 131
Boyd, Joe, 51, 58, 75, 85, 103, 113, 117, 146
Boyle, Mark, 88
Brand, Stewart, 68
Brautigan, Richard, 22
"Broken Arrow," 193

Brooker, Gary, 159
Brown, Arthur, 86, 88, 89, 112, 116, 146, 199
Brown, Joel and Toni, 60
Brown, Pete, 16, 40, 104, 176
Browne, Tara, 109
Bruce, Jack, 104
Buckley, Tim, 193
Buffalo Springfield, 152, 154, 193
Burdon, Eric, 156, 198
Burroughs, William S., 21, 74, 85
Butcher, Brooks, 118
Byrds, The, 14, 59, 60, 61, 150, 155, 190, 193
Byrne, Johnny, 50

C

Cameron, John, 30
Canned Heat, 150
"Can't Find My Way Home," 199
Capaldi, Jim, 135, 160
Captain Beefheart and the Magic Band, 191
Carousel Ballroom, 92
Casady, Jack, 57, 151
Cassady, Neal, 43, 67
Castell, Luria, 33
Chambers Brothers, 93
Chandler, Chas, 156
"Change Is Now," 193
Charlatans, The, 14, 32, 37, 175, 190
Children of the Future, 175
"Children of the Sun," 191
Chocolate Watchband, 193
Cipollina, John, 54, 55
Clapton, Eric, 21, 104, 107, 156
Cohen, Allen, 138
Cohen, Bob, 95
"Cold Turkey," 199
"Colours of My Mind," 197
Committee, The, 55, 138
Cook, Martin, 109
Cooper, Michael, 131, 148
Corso, Gregory, 18
Count Five, 191
Country Joe and the Fish, 34, 35, 37, 150, 185, 191
Cox, Tony, 159
Crazy World of Arthur Brown, 112, 199
Cream, 104, 107, 109, 195
Creation, 112, 195
Creedence Clearwater Revival, 92, 185
Crick, Francis, 149
"Crimson and Clover," 194
Crosby, David, 61
Crumb, R., 143
"Crystal Ship, The," 192

D

"Dance to the Music," 193–94
Dantalian's Chariot, 103, 198
"Darkness, Darkness," 195
"Day in the Life, A," 109
"Days of Pearly Spencer," 196
"Death of the Hippie" ceremony, 166
"Defecting Grey," 197
"Diamond Hard Blue Apples of the Moon," 199
Diggers, 118, 123, 162

Disraeli Gears, 104
"Dock of the Bay, The" 193
Donahue, Tom, 138, 139, 140
Donovan, 18, 21, 28, 30, 50, 83, 176, 195
Doors, The, 36, 152, 155, 192
Doors of Perception, 30
"Dream Magazine," 198
"Dream within a Dream," 194
Dryden, Spencer, 57
Dunbar, John, 28, 30, 38, 116
Duncan, Gary, 25, 54, 55, 91, 151
Dylan, Bob, 22, 54, 80, 109, 127, 190–91

E

Edwards, Dudley, 109
"Eight Miles High," 190
Electric Garden, 159
"Electricity," 191
Electric Prunes, 192
"Electric Sailor," 195
Elmore, Greg, 54
English, Michael, 103, 104
Esam, John, 17, 21
Evans, Mal, 133

F

Fagin, Larry, 22
Fairport Convention, 176, 198
Fairy Tale, 30
Faithfull, Marianne, 28, 72, 144
Family, 176, 199
Family Dog, 32, 33, 36, 54, 91, 96, 99
Farren, Mick, 116
"Faster Than Light," 199
"Feathered Fish," 191
"Feel the Music," 191
Ferguson, Michael, 14
Ferlinghetti, Lawrence, 18, 22
Fifth Dimension, 59
Fillmore Auditorium, 66–67, 91, 92, 94–96, 140, 181
Fillmore East, 156, 159, 172
Fillmore West, 92
"Fire," 86, 89, 199
"Flight from Ashiya," 197
Fool, The, 131, 133
"Foolish Woman," 191
"For What It's Worth," 154
14-Hour Technicolour Dream, 103, 112, 113, 116
"Frantic Desolation," 192
Fraser, Robert, 21, 28, 30, 144, 146
Freiberg, David, 54, 55, 94, 125
Fried, Art, 98
"From the Underworld," 197
Furay, Richie, 154

G

"Games for May" concert, 113, 130
Gannon, Joey, 60
Garcia, Carolyn "Mountain Girl," 62
Garcia, Jerry, 14, 62, 65, 140, 162
"Get Me to the World on Time," 192
Giant Sun Trolley, 89
Gibbs, Christopher, 21
Ginsberg, Allen, 16, 17, 18, 22, 29, 32, 33, 37, 107, 125, 126, 127, 146, 149, 185

"Give Peace a Chance," 177
Gleason, Ralph J., 68, 139, 140
Golden Gate Park, 124, 125, 162
"Go Now," 160
"Good Day Sunshine," 80
Goodrow, Gary, 22
"Good Vibrations," 192
"Got to Get You Into My Life," 80
Graham, Bill, 36, 37, 69, 91, 92, 94, 96, 99, 139, 176
Granny Takes a Trip (boutique), 133, 134, 135
"Granny Takes a Trip" (song), 89
Grateful Dead, The, 33, 43, 45, 62, 65, 66, 68, 69, 91, 95, 101, 118, 125, 126, 139, 140, 150, 152, 162, 175, 185, 194, 195
Great Society, The, 33, 36, 37, 191
"Green Circles," 196
Greene, Graham, 149
Greer, Germaine, 107
Gregory, Dick, 112, 177
Griffin, Rick, 98, 99, 100, 101, 103
Grogan, Emmett, 118
Gurley, Weird Jim, 62

H

Haight-Ashbury, 33, 40, 62, 80, 82–83, 118, 123, 140, 162, 166, 181, 182
Hall, Sue, 131
"Hallucinations," 193
Ham, Bill, 95
"Happenings Ten Years Time Ago," 195
Happy Trails, 55
Hapshash and the Coloured Coat, 103–4, 107
Harmon, Ellen, 33
Harrison, George, 104, 131, 133, 144, 166
Harrison, Pattie, 131, 144, 166
Hart, Mickey, 81, 139, 162
Hawkins, Spike, 50
Haynes, Jim, 158
Hayward, Justin, 160
Helms, Chet, 62, 91, 92, 93, 96
Hendrix, Jimi, 59, 88, 101, 107, 151, 152, 153, 156, 158, 195
Herd, The, 197
Heron, Mike, 156
Hesseman, Howard, 138
"Hey Joe," 156
Hirsch, Gary "Chicken," 35
Hitchcock, Billy, 18
Hog Farm, 186
Hollies, The, 103, 197
Hollingshead, Michael, 18, 21, 144
Honeybuckets, The, 93
Hopkins, John "Hoppy," 17, 48, 49, 72, 75, 76, 85, 86, 88, 116, 144, 145, 148
Horowitz, Michael, 17
Howe, Steve, 61, 86, 88, 89, 135, 146
Human Be-In, 124–27, 182, 185
Huxley, Aldous, 30
Hunter, George, 14, 98
Hyde Park, 146, 176, 177

I

"I Am the Walrus," 198
"I Can Hear the Grass Grow," 196
Idle Race, The, 198

"I Feel Free," 195
"*I-Feel-Like-I'm-Fixin'-to-Die Rag,*" 32, 34, 191
"I'm Five Years Ahead of My Time," 192
"I'm Looking Through You," 54
"Imposters of Life's Magazine," 198
"*In-a-Gadda-Da-Vida,*" 194
"Incense and Peppermints," 193
Incredible String Band, 75, 85, 156
Indica Books and Gallery, 28, 29, 30, 38, 40, 72, 107, 116, 148, 149
In Search of the Lost Chord, 160
Instant Action Jug Band, The, 34
International Times (IT), 38, 51, 72, 74, 75, 76, 85, 86, 103, 107, 112, 158, 176
"Interstellar Overdrive," 59, 107, 116, 196
"In Your Tower," 196
Iron Butterfly, 194
"Itchycoo Park," 161, 197
"It's All Too Much," 196
"It's Alright Ma, It's Only Witchcraft," 198

J

Jagger, Mick, 28, 29, 144, 146, 149, 176, 177
Jeff Beck Group, 176
Jefferson Airplane, 33, 36, 37, 57, 91, 93, 94, 101, 126, 175, 185, 186, 191, 1592
Jenner, Peter, 48, 59, 60, 76, 116, 176
Jenner, Sumi, 59
Jimi Hendrix Experience, 152, 156, 158, 196, 197, 199
"Johnny Was a Good Boy," 192
John's Children, 196
Johnson, Ginger, 50
Jones, Brian, 30, 144, 149, 152, 176, 177
Joplin, Janis, 62, 83, 95, 185, 188
"Jugband Blues," 199

K

Kak, 195
Kaleidoscope club, 154
Kaleidoscope (L.A. band), 192
Kaleidoscope (London band), 197
Kandel, Lenore, 127
Kantner, Paul, 57
Kaukonen, Jorma, 57, 151
Keen, Graham, 48, 51
"Keep Your Mind Open," 192
Kefford, Ace, 85
Kelley, Alton, 14, 33, 98, 99, 100, 101
Kerouac, Jack, 43
Kesey, Ken, 22, 42, 43, 66–68, 91
King Crimson, 176
"King Midas in Reverse," 197
"Kites," 198
Klose, Bob, 58
Knickerbockers, The, 14
Korner, Alexis, 112
Kreutzmann, Bill, 65, 162

L

Laing, R.D., 18, 21, 76
La Mortacella, Robert, 118

Langton, Daniel, 22
Laslett, Rhaunie, 48
"Last Time, The," 144
LaVigne, Robert, 22
League for Spiritual Discovery (LSD), 21
Leary, Timothy, 18, 24, 40, 42, 60, 80, 125, 127, 160, 177
"Legend of a Mind," 160
Lennon, John, 38, 40, 80, 116, 130, 133, 134, 143, 177
Lesh, Phil, 65, 140, 162
Lesser, Mike, 74
"Let's Get Together," 126
Levy, Stella, 22
Lewis, Peter, 172, 173
"Light My Fire," 155
"Like a Rolling Stone," 54
Loading Zone, 68
Lodge, John, 160
London Free School (LFS), 38, 48, 49, 51, 59, 60, 72, 76, 85
Longshoremen's Hall, 32, 33, 36, 37, 68
Lothar and the Hand People, 194
Love, 59, 152, 191–92, 193
Love Book, The, 127
"Love Is All Around," 198
Love Pageant Rally, 118, 185
Lownes, Victor, 21
LSD Theater, 95

"Machines," 194
"Madman Running Through the Fields," 198
Magical Mystery Tour, 103
"Magic Carpet Ride," 194
"Magic Hollow," 193
"Making Time," 195
Mamas and the Papas, The, 150
Mann, Manfred, 103
Marbles, The, 37
Marquee club, 50, 58, 59, 85, 103
Martin, Dewey, 154
Martin, George, 133
Mason, Dave, 160
Mason, Nick, 58, 60
"Matilda Mother," 197
Matrix, 93
Mayall, John, 101, 156
McCartney, Paul, 21, 28, 29, 30, 38, 40, 72, 88, 104, 109, 130, 133, 148
McClure, Michael, 22, 125
McDonald, Joe, 32, 34, 35, 188
McGivern, Maggie, 40
McGuinn, Roger, 155
McInnerney, Michael, 104, 112
McKenzie, Scott, 83
McKernan, Ron "Pigpen," 65
McLagan, Ian, 160, 161
McWilliams, David, 196
Mellow Yellow, 30
Melton, Barry, 34
Meltzer, David, 22
"Me My Friend," 199
Merry Pranksters, 42, 43, 66–67
Meyezove, Leland, 22
"Michael Angelo," 197
Michael X, 48, 49, 76
Michaels, Lee, 101
Middle Earth, 159
"Midsummer Night's Scene," 196
Miles, Barry, 28, 29, 30, 38, 40, 76
Millbrook, New York, 18, 60

Miller, Larry, 138
Miller, Stanley "Mouse," 33, 98, 99, 100, 101, 103
Miller, Steve, 37, 93, 150, 175, 194
Minault, Kent, 118
Mirror, The, 199
Mr. Fantasy, 160
"Mr. Farmer," 192
Misunderstood, The, 191
Mitchell, Joni, 186
Mitchell, Mitch, 156, 158
Moby Grape (album), 172
Moby Grape (band), 172, 173, 192
Monkees, The, 14
Monterey International Pop Festival, 150–53, 162, 185
Moody Blues, 144, 160, 176
Morgan, Dana, Jr., 65
"Morning Dew," 95
Moscoso, Victor, 36, 93, 98, 99, 100, 101, 127
Most, Mickie, 30
Mother McCree's Uptown Jug Champions, 65
Mothers of Invention, 150
"Mountains of the Moon," 195
Move, The, 59, 85, 89, 112, 156, 196
Murao, Shig, 22
Murray, Jimmy, 54
"My Friend Jack," 196
"My Little Red Book," 59
Mystery Trend, 69, 192
"My White Bicycle," 89

Nash, Graham, 103, 156
Neville, Richard, 107
Nice, The, 199
"Night of the Long Grass," 196
"Nights in White Satin," 160
"1983 . . .," 199
Nirvana, 199
"Norwegian Wood," 54
Notting Hill Fair and Pageant, 48

"Omaha," 172, 192
Ono, Yoko, 38, 74, 116, 117, 159, 177
Oracle, 118, 124, 138, 140, 181
Orlovsky, Peter, 22
Osiris Visions, 103, 104
"Otherside, The," 199
Oxford Circle, 191
Oz, 104, 107

Painted Faces, 193
"Paint It, Black," 195
Pallenberg, Anita, 30
Palmer, Bruce, 154
Panhandle, 118, 121, 123, 140
"Paper Sun," 196
Penrose, Roland, 21
People Show, 117, 158
Phillips, John, 150
Phillips, Tom, 130
Pink Floyd, 38, 48, 49, 51, 58–60, 72, 74, 75, 76, 85, 107, 109, 112, 113, 116, 130, 146, 156, 196, 197, 199
Poets, The, 196

"Poets of the World/Poets of Our Time" reading, 17
Pretty Things, The, 112, 197
"Pride of Man," 95, 194
Procol Harum, 156, 159
Psychedelic Experience, The, 18, 40
Psychedelic Reader, The, 18
Psychedelic Shop, 80, 82, 127, 140
Psychedelic Symphonette, 42, 66
"Psychotic Reaction," 191
Public Smoke-In, 80
Purple Gang, 89
"Purple Haze," 158

Queen Elizabeth Hall, 113, 130
"Question of Temperature, A," 193
Quicksilver Messenger Service (album), 55
Quicksilver Messenger Service (band), 25, 54, 55, 91, 95, 125, 127, 139, 151, 152, 175, 194

"Rainbow Chaser," 199
"Rainy Day Women #12 and 35," 80
Ratledge, Mike, 74
Ready Steady Go!, 60, 158
Redding, Noel, 156, 158
Redding, Otis, 193
Red Dog Saloon, 14, 22, 37, 95
"Red Telephone, The," 193
Rees - Mogg, William, 148
Reid, Keith, 159
"Relax," 197
Revolver, 38, 80
"Revolution," 198
Richards, Keith, 21, 30, 134, 144, 146, 149
Riley, Terry, 74
"Roller Coaster," 191
Rolling Stone magazine, 140, 143
Rolling Stones, The, 14, 22, 30, 41, 65, 103, 134, 144, 146, 148, 149, 152, 176, 177, 181, 195, 197
Roshi, Suzuki, 125
Roundhouse, 72, 73, 74, 75
Royal Albert Hall. *See* Albert Hall
Rubber Soul, 54

"San Franciscan Nights," 198
"San Francisco (Be Sure to Wear Flowers in Your Hair)," 83
San Francisco Mime Troupe, 32, 36–37, 118, 138
Santana, 92, 185, 186, 188
Satty, 98
Savages, Jook, 186
Scaggs, Boz, 93, 153, 175
"Season of the Witch," 195
"Section 43," 191
Seeds, The, 192
"See Emily Play," 113, 130
Sgt. Pepper's Lonely Hearts Club Band, 10, 103, 130, 131, 133, 148
"7 and 7 Is," 191–92
Shankar, Ravi, 151
Sharp, Martin, 104, 107
Simon Dupree and the Big Sound, 198
Slick, Darby, 37
Slick, Grace, 33, 37, 57, 83, 150
Slick, Jerry, 37

Sly and the Family Stone, 185, 193–94
Small Faces, The, 160, 161, 196, 197
Smoke, 196
Snyder, Gary, 125, 126
Social Deviants, 116
Soft Machine, 38, 51, 72, 73, 74, 75, 85, 112, 116, 146
"Someone to Love," 191
Somers, Andy, 103
"Song for Our Ancestors," 194
Sons of Adam, 191
Sopwith Camel, 192
Speakeasy, 104, 158
Spence, Alexander "Skip," 172, 194
Spirit, 194
Spontaneous Underground, 48, 50–51, 59, 72
Stanley, Augustus Owsley, III, 22, 126, 140, 151
Starr, Ringo, 133
"Star-Spangled Banner, The," 55, 195
"Stars That Play with Laughing Sam's Dice, The," 197
Status Quo, 198–99
Steppenwolf, 194
Steve Miller Band, The, 37, 93, 150, 175, 194
Stevens, Guy, 104
Stills, Stephen, 154
Stollman, Stephen, 48
Straight Theater, The, 99
Strawberry Alarm Clock, 193
"Strawberry Fields Forever," 195–96
"Street Fighting Man," 181
Summer of Love, 38, 162
Summers, Andy, 103
Summer Solstice, 162
"Sunny Goodge Street," 30
"Sunshine of Your Love," 104
Sunshine Superman (album), 30
"Sunshine Superman" (song), 30
Surrealistic Pillow, 57
Svensk, 198

"Tales of Brave Ulysses," 104
"That's It for the Other One," 194
Their Satanic Majesties Request, 103, 148, 149
Thelin, Ron and Jay, 80, 82, 127
Third Bardo, 192
Third Ear Band, 176
13th Floor Elevators, 191
Thompson, Hunter, 22
Tintern Abbey, 198
Tommy, 104
Tommy James and Shondells, 194
Tomorrow, 61, 86, 88, 89, 146, 198
"Tomorrow Never Knows," 40, 80, 195
Tower of Power, 92
Towle, Jack, 33
Townshend, Pete, 89
Traffic, 135, 156, 160, 176, 196
"Tribute to Dr. Strange, A," 32, 36, 37
"Tribute to Sparkle Plenty, A," 36
Trips Festival, 68–69, 80, 91, 185
Trocchi, Alexander, 21
Troggs, The, 196, 198
23rd Turnoff, The, 197
Tyrannosaurus Rex, 176

UFO club, 38, 48, 51, 58, 73, 75,

85–86, 88–89, 103, 107, 109, 112, 116, 117, 146, 156, 159
UFO Festival, 103
"Under My Thumb," 144

"Vacuum Cleaner," 198
Vaughan, David, 109
Vejtables, 191
Vinkenoog, Simon, 18
"Visions of Johanna," 190–91
Voznesensky, Andrei, 17, 18

"Wabash Cannonball," 33
Waldman, Brian, 159
Walker, Peter "Lucifer," 89
Warhol, Andy, 18
"War in Peace," 194
Warlocks, The, 42, 43, 45, 65, 66
Waters, Roger, 58, 59, 130
Wavy Gravy, 186
Waymouth, Nigel, 41, 103, 104, 107, 134
Wayne, Carl, 156
"We Can Work It Out," 80
"We Did It Again," 73
Weir, Bob, 45, 65
Welch, Lew, 22
"We Love You," 197
Wenner, Jann, 140
West, Keith, 61
Wheels of Fire, 104, 107
Whitaker, Robert, 107
White, Gary, 109
White Lightning, 194
"White Rabbit," 192
"Whiter Shade of Pale, A," 159
Who, The, 104, 144, 152, 153, 197
"Who Do You Love," 54
Wholly Communion, 17
"Why?," 61
Wilhelm, Mike, 14
"William," 194
Williamson, Robin, 156
Wilson, S. Clay, 143
Wilson, Wes, 98, 99, 100, 101
Winterland, 66, 94
Winwood, Steve, 156, 160
Wood, Chris, 160
Wood, John, 88
Wood, Roy, 85
Woodstock Music and Art Fair, 185–89
"Woodstock," 186
World Psychedelic Center (WPC), 18, 21, 144
Wright, Rick, 58, 59, 112
Wyatt, Robert, 74
Wyman, Bill, 149

Yardbirds, The, 195
'Yesterday' . . . and Today, 80, 107
Yogi, Maharishi Mahesh, 103, 104
Young, Neil, 154
Youngbloods, The, 195
"You Won't See Me," 54
Yuro, Timi, 161

Zoot Money's Big Roll Band, 103

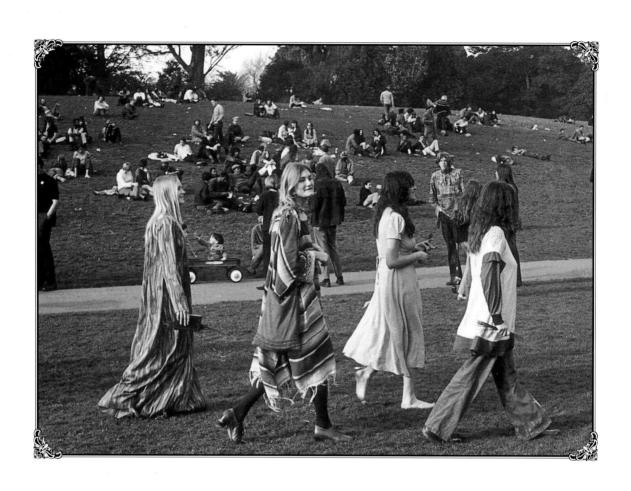